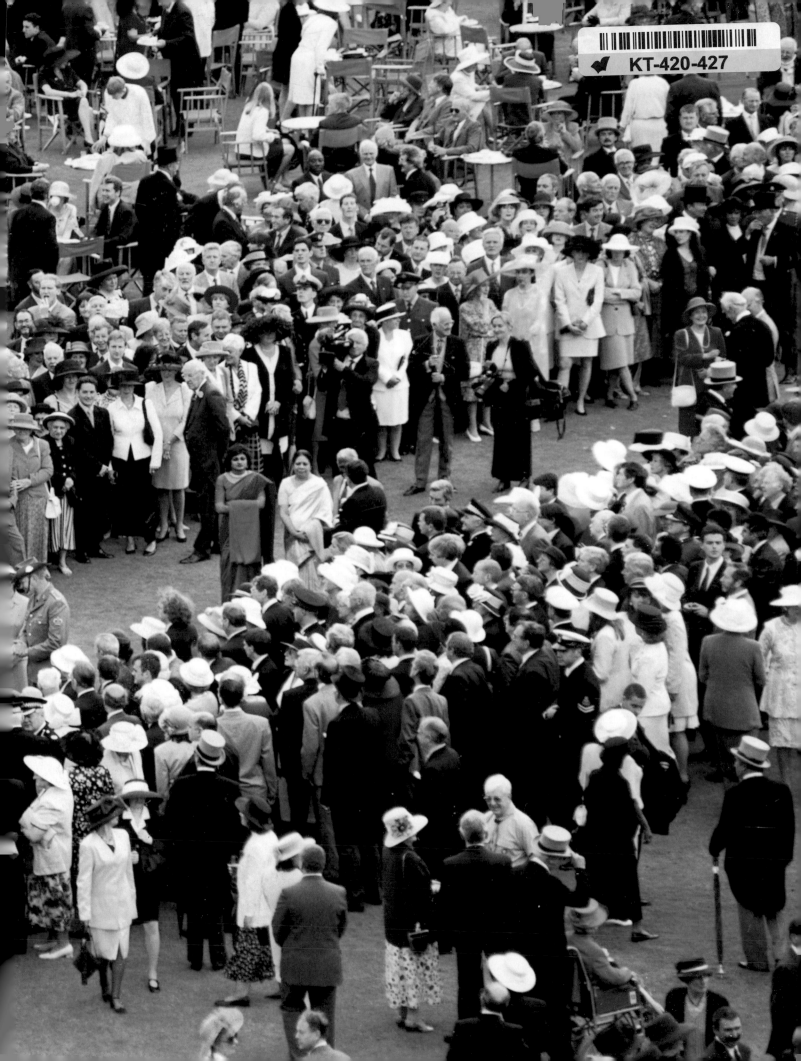

JUBILEE

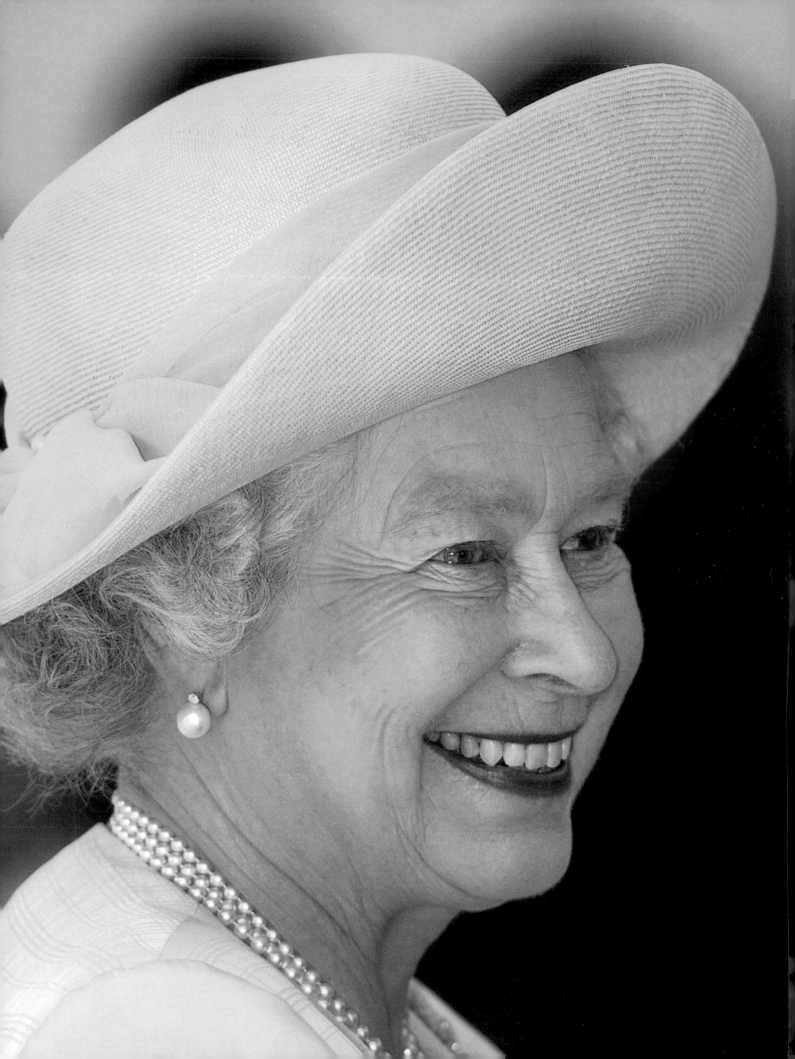

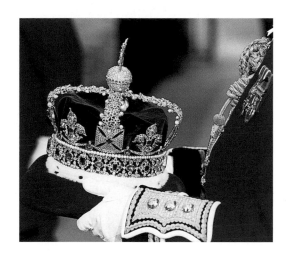

JUBILEE

A Celebration of 50 years of the Reign of Her Majesty Queen Elizabeth II

TIM GRAHAM

TEXT BY PATRICIA BURGESS AND TIM GRAHAM

CASSELL&CO

Contents

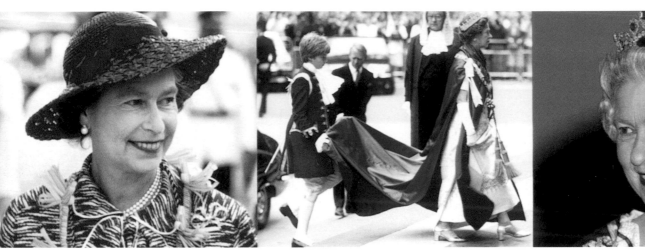

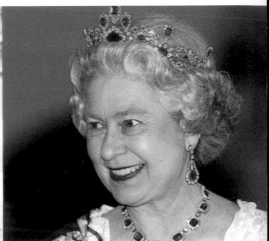

1

2

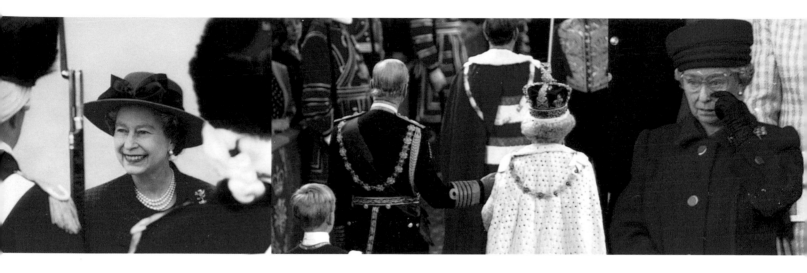

DEDICATION

FOR EILEEN, WITHOUT WHOM I COULDN'T HAVE
ACHIEVED SO MUCH NOR TRAVELLED SO FAR, AND FOR OUR
VERY SPECIAL CHILDREN, LUCY AND TOM

ACKNOWLEDGEMENTS

First, and most importantly, thank you to Eileen, my wife and agent for 25 years. Her help with the massive task of choosing over 700 photographs from the many thousands I have taken, and for helping me to recall accurate and interesting captions for them all, was invaluable.

Huge thanks also to Vivien, Kate, Wesley and Clare in my office for such enthusiastic and dedicated work on this book.

For all the help they have given me over the years my great thanks to the Queen's Press Secretary and Press Office team, both present and past. Thanks also to the Central Office of Information staff for their assistance on royal regional visits, the press officers in the Scottish Office and Welsh Office, and all the other press and PR personnel – military and civilian – whose efforts have helped me produce the pictures in this book.

Many of the Queen's personal bodyguards have helped with a photograph, either by keeping out of the frame – not easy considering their purpose – or by a discreet word in the ear of one of the 'great and the good' hogging the limelight. My thanks to them all.

My photographer colleagues should not go without a mention. The many long hours spent travelling or standing around waiting for a picture are always brightened by the unrelenting banter that pressmen are renowned for. Take yourself seriously at your peril!

An especially warm vote of thanks to editor Trish Burgess, whose professional judgement I have depended on heavily. I am also very grateful to the team at Cassells – Nigel Soper for his splendid design, David Rowley for his art direction and publisher Michael Dover – ringmaster par excellence.

Finally, thanks to our two children: Lucy for hours spent captioning and filing pictures, and Tom for cooking us dishes his hero Jamie Oliver would have been proud of while we worked late into the evening.

Foreword

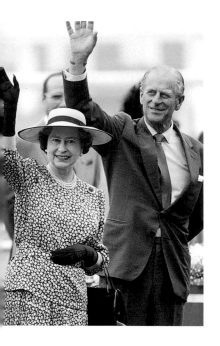

IT WAS TRAVELLING that first attracted me to photographing the Royal Family: they always seem to be going somewhere interesting. As a schoolboy, I'd been fascinated by photographs of distant places in my geography books and developed a longing to visit the likes of Shanghai, Cairo, Samarkand and Tonga. In fact, my job has taken me to more than a hundred countries, some of them several times, and given me a front-row view of the pageantry and ceremony that surrounds the Queen. I've witnessed countless welcomes and departures, attended all the major state occasions and, occasionally, even been privy to a memorable moment in history.

In the early days I worked with a simple manual camera, shooting one frame at a time, just 12 frames to a roll. Then came the revolution – motor-driven cameras that let you shoot several frames a second and catch the fleeting moment that makes a great picture. Now, thanks to technology, it's possible to have my photographs on a picture editor's computer screen anywhere in the world within a few minutes of taking them. I shoot on a digital camera, edit on a laptop computer and transmit via a mobile phone – a far cry from the days when I had to dash to the local airport to ship film by air freight to meet publishing deadlines.

Regardless of technological changes, my aim has always been to photograph the Queen and the Royal Family in ways that reveal the individuals as much as their working lives. I've also gone behind the scenes to discover what keeps the royal 'show' operating so smoothly, and this book lets you into some of those secrets.

I haven't been around to photograph the full 50 years of the Queen's reign, so I'm grateful to archive sources for the early pictures in this book. From my own collection of royal photographs – which I was amazed to find now number around a quarter of a million – I have chosen those that tell the story of the Queen's reign as I have seen it. Some of them will probably be familiar to you. Others, I hope, will offer surprises or insights to the woman who is both so well known yet so enigmatic.

TIM GRAHAM

Timeline

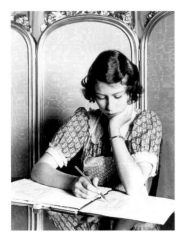

The heir to the throne doing her homework at Windsor Castle, 1940.

The Queen smiles with relief after making her first Christmas broadcast on television in 1957.

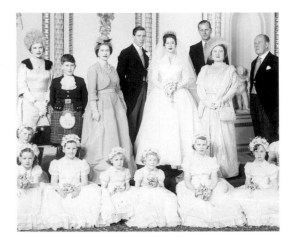

Princess Margaret's wedding to Antony Armstrong-Jones in May 1960.

1926
Birth of Princess Elizabeth, 21 April

1952
The Princess becomes Queen and Head of the Commonwealth, 6 February

The Queen announces that her children and descendants will bear the name of Windsor

The new Royal Family move into Buckingham Palace, 5 May

1953
Death of Queen Mary, aged 85

Winston Churchill invested as a Knight of the Garter

Edmund Hillary and Sherpa Tenzing become the first to reach the summit of Mount Everest

Coronation of Queen Elizabeth II in Westminster Abbey, 2 June

First Commonwealth tour begins: Bermuda, Jamaica, Panama, Fiji, Tonga, New Zealand

1954
First Commonwealth tour continues: Australia, Cocos Islands, Ceylon, Aden, Uganda, Libya, Malta, Gibraltar

Roger Bannister becomes the first athlete to run a mile in under four minutes

Food rationing ends in Britain

1955
Princess Margaret decides not to marry Peter Townsend

Sir Anthony Eden becomes prime minister following resignation of Sir Winston Churchill

State visit to Norway

1956
State visits to Nigeria and Sweden

The Queen lays the foundation stone of the new Coventry Cathedral

British troops withdrawn from Suez Canal Zone

Duke of Edinburgh opens 16th Olympic Games in Melbourne

1957
Harold Macmillan becomes prime minister

State visits to Portugal, France, Denmark and the USA

Duke of Edinburgh granted the title of Prince

Visit to Canada

The Queen's Christmas broadcast televised for the first time

1958
Prince Charles created Prince of Wales

State visit to the Netherlands

Gatwick Airport opened by the Queen

State Opening of Parliament televised for the first time

1959
First stretch of M1 motorway opened to traffic

Six-week tour of Canada, during which the Queen opened the new St Lawrence Seaway

State visit to the USA

Hovercraft makes first Channel crossing

1960
Birth of Prince Andrew

New-style £1 notes issued

Marriage of Princess Margaret to Antony Armstrong-Jones

The Royal Navy's first nuclear submarine, *Dreadnought*, is launched by the Queen

State visit to Denmark

On the last day of the year the farthing ceases to be legal tender

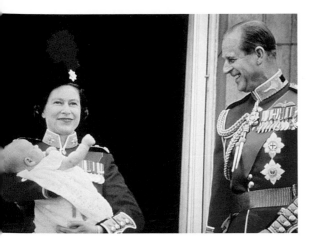

Prince Edward makes his first public appearance after the Trooping in 1964.

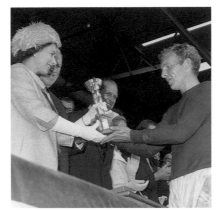

The Queen congratulates Bobby Moore, captain of the victorious England team, on winning the World Cup in 1966.

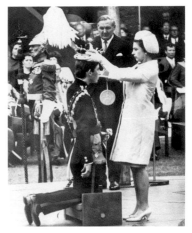

Caernarvon, 1969 – Prince Charles is invested as Prince of Wales.

1961
State visits to Cyprus, India, Pakistan, Nepal, Iran, Turkey, Italy, the Vatican, Ghana, Sierra Leone, The Gambia and Liberia

Yuri Gagarin becomes the first human being to fly in space

Antony Armstrong-Jones created Earl of Snowdon

The Queen becomes an aunt when Princess Margaret gives birth to a son

1962
Visit to the Netherlands for the Silver Wedding Anniversary of Queen Juliana and Prince Bernhard

The Queen attends the consecration of Coventry Cathedral

Dr Michael Ramsay enthroned as Archbishop of Canterbury

Jamaica and Trinidad and Tobago become independent

1963
Princess Alexandra marries Angus Ogilvy

Tour of New Zealand and Australia via Fiji

Sir Alec Douglas-Home becomes prime minister

President John F. Kennedy assassinated

1964
Birth of Prince Edward

The Queen opens new Forth Bridge in Scotland

Harold Wilson becomes prime minister

Visit to Canada for centennial celebrations

1965
Death of Sir Winston Churchill

Memorial stone to Churchill unveiled by the Queen in Westminster Abbey on the 25th anniversary of the Battle of Britain

State visits to Ethiopia, Sudan and the Federal Republic of Germany

1966
Caribbean tour and state visit to Belgium

England wins the World Cup

Aberfan coal tip engulfs primary school and claims 144 lives; the Queen is visibly distressed when visiting the site

1967
The liner *QEII* is launched in Scotland

State visit to Canada for 100th

anniversary of Confederation and visit to Expo 67

State visit to Malta

1968
British-built Concorde makes maiden flight

Cecil Day Lewis appointed poet laureate

Prince Charles invested as a Knight of the Garter

State visits to Chile and Brazil, via Scnegal on return

1969
Investiture of Prince Charles as Prince of Wales at Caernarvon Castle

State visit to Austria

The Queen officially opens the Victoria line on London Underground

British troops sent to quell conflict in Northern Ireland

The first human beings land on the moon

1970
Prince Charles takes seat in House of Lords

Edward Heath becomes prime minister

1970–1978

Huge crowds turn out to welcome the Queen on her 1970 tour of Australia.

The Gillies' Ball at Balmoral is a favourite annual event.

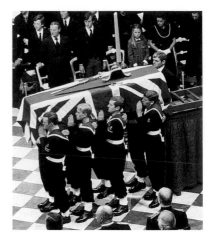

The funeral of Earl Mountbatten, killed in a terrorist attack in 1979.

Tour of Australia and New Zealand, via Fiji and Tonga

Visit to Canada for centennial celebrations of North West Territories and Manitoba

1971
Decimal currency introduced to UK

Visit to Canada for centennial celebrations of British Columbia

Princess Anne wins individual championship at European Horse Trials

State visit to Turkey

1972
Pakistan leaves the Commonwealth

Direct rule from London imposed on Northern Ireland

Death of the Duke of Windsor

State visits to Thailand, Singapore, Malaysia, Brunei, the Maldive Islands, the Seychelles, Mauritius and Kenya

Sir John Betjeman appointed poet laureate

State visits to France and Yugoslavia

Silver wedding anniversary of the Queen and Duke of Edinburgh

1973
Visits to Canada and Australia

Marriage of Princess Anne to Captain Mark Phillips

Britain enters the EEC

Introduction of 'Three-day Week' to save fuel

1974
Tours of New Zealand (via Cook Islands), Norfolk Island, New Hebrides, British Solomon Islands, Papua New Guinea and Australia

Harold Wilson becomes prime minister for a second time

Terrorist bomb explodes at the Tower of London, killing one and injuring 41

State visit to Indonesia

1975
Dr Donald Coggan enthroned as Archbishop of Canterbury

State visits to Mexico and Japan (via Hawaii, Guam and Hong Kong)

Visits to Bermuda, Barbados, Bahamas and Jamaica

First live radio broadcast of a Commons debate

The Queen formally inaugurates the flow of oil from the BP Forties field in the North Sea

1976
Princess Margaret and Lord Snowdon officially separate

James Callaghan becomes prime minister

State visits to Finland, the USA and Luxembourg

Visit to Canada to open the Olympic Games

The Queen officially opens the National Theatre in London

1977
Silver Jubilee celebrations

Birth of first grandchild, Peter Phillips

Tours of Western Samoa, Fiji, Tonga, Papua New Guinea, Australia, Canada, Bahamas, Antigua, British Virgin Islands and Barbados

The Queen opens extension of Piccadilly tube line to Heathrow Airport

1978
First radio broadcasts of parliamentary proceedings begin

Princess Margaret divorced from Lord Snowdon

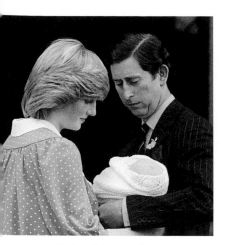

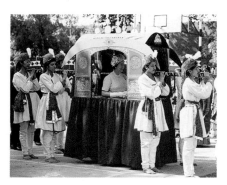

The Queen walks inside a palki *during her 1983 state visit to India.*

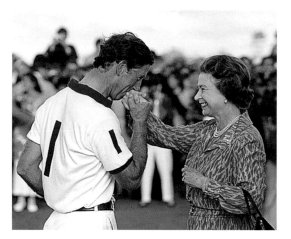

Newborn Prince William of Wales leaves hospital in June 1982.

Prince Charles affectionately greets the Queen after a polo match at Windsor.

State visit to Federal Republic of Germany

Visit to Canada for the Commonwealth Games

1979
Margaret Thatcher becomes prime minister

State visits to Saudi Arabia, Kuwait, Bahrain, Qatar, the United Arab Emirates, Oman, Denmark, Tanzania Malawi, Botswana and Zambia

Earl Mountbatten killed by terrorist bomb

1980
Dr Robert Runcie enthroned as Archbishop of Canterbury

State visits to Switzerland, Italy, the Vatican, Tunisia, Algeria, Morocco, Belgium and the Federal Republic of Germany

Visit to Australia (Canberra, Sydney and Melbourne)

1981
Marriage of the Prince of Wales to Lady Diana Spencer

Birth of second grandchild, Zara Phillips

State visits to Norway and Sri Lanka

Visits to Australia and New Zealand

1982
Birth of third grandchild, Prince William of Wales

Barbican Centre in London opened by the Queen

Visits to Canada, Australia, Papua New Guinea, Solomon Islands, Nauru, Kiribati, Tuvalu and Fiji

Falklands War (2 April–14 June)

Thames Barrier raised for the first time

1983
Visits to Jamaica, the Cayman Islands, Mexico, the USA and Canada

New £1 coin goes into circulation

State visits to Sweden, Kenya, Bangladesh and India

US troops, against British wishes and to the anger of the Queen, invade Grenada following a government coup

1984
Birth of fourth grandchild, Prince Henry of Wales

State visit to Jordan

Visits to France for 40th anniversary of the D-Day Landings, and to Canada

IRA bomb at Conservative Party Conference in Brighton kills five

Church of England votes for ordination of women

Ted Hughes appointed poet laureate

1985
House of Lords proceedings televised for the first time

State visit to Portugal

Commemoration of the 40th anniversary of VE day

Fire at Bradford City FC kills 55

Prince Andrew opens new Falklands airport

Visits to Belize, the Bahamas, St Kitts and Nevis, Antigua, Dominica, St Lucia, St Vincent and the Grenadines, Barbados, Grenada and Trinidad and Tobago

1986
The Queen's 60th birthday is celebrated at Windsor and London

Marriage of Prince Andrew to Miss Sarah Ferguson; they become the Duke and Duchess of York

State visits to Nepal and China

1986–1992

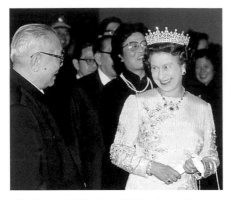

The Queen with President Li Xiannian during her state visit to China in 1986 – the first ever made by a reigning monarch.

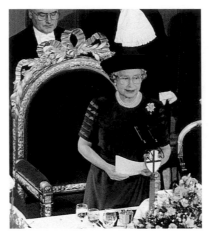

During a Guildhall luncheon the Queen declares 1992 an annus horribilis.

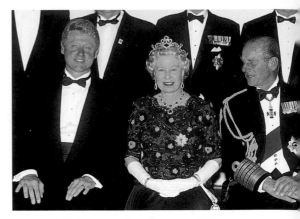

President Bill Clinton, the Queen and Prince Philip at a dinner for Allied Heads of State in Portsmouth to mark the 50th anniversary of D-Day.

Visits to New Zealand, Australia and Hong Kong

The Queen signs proclamation giving Australia legal independence

1987
The title Princess Royal is bestowed on Princess Anne by the Queen

Visits to the Federal Republic of Germany and Canada

The Queen steps down as monarch of Fiji following a coup

Hurricane devastates southern England and leaves 19 dead

1988
Birth of fifth grandchild, Princess Beatrice of York

Mikhail Gorbachev becomes president of Soviet Union

Visits to Australia and the Netherlands

Clapham rail crash kills 34

State visit to Spain

All-day opening of pubs introduced in England and Wales

Pan Am jumbo jet crashes on to Lockerbie, killing 270 on board and 11 residents

1989
Hillsborough disaster: 95 Liverpool supporters crushed to death

Hundreds of pro-democracy demonstrators killed in Tiananmen Square massacre

Romanian President Ceausescu executed

House of Commons proceedings begin to be televised

Demolition of Berlin Wall begins

Visit to Barbados

State visits to Singapore and Malaysia

1990
Visit to New Zealand to attend the Commonwealth Games

Nelson Mandela freed after 25 years in prison

To keep pace with inflation, the Civil List is fixed at £7.9 million for 10 years

State visit to Iceland

John Major becomes prime minister

Hostage Brian Keenan released from captivity in Beirut after four and a half years

Birth of sixth grandchild, Princess Eugenie of York

Visit to Canada (Alberta, Ontario and Quebec)

1991
Gulf War (17–27 January)

Civil war breaks out between Serbs and Croats

State visit to USA (Washington, Florida and Texas)

Hostage John McCarthy released from captivity in Beirut

IRA bomb attack on Cabinet meeting in Downing Street

Dr George Carey enthroned as Archbishop of Canterbury

Hostage Terry Waite released from captivity in Beirut

State visits to Namibia and Zimbabwe

1992
Visits to Australia for 150th anniversary of the founding of Sydney

Betty Boothroyd is elected first woman Speaker of the House of Commons

Duke and Duchess of York separate after five years of marriage

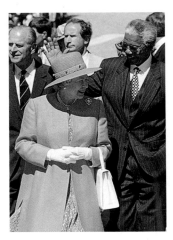

Nelson Mandela escorts the Queen in South Africa in 1995.

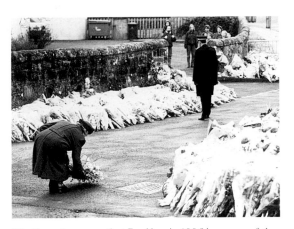

The Queen lays a wreath at Dunblane in 1996 in memory of the children and teacher slaughtered by a deranged gunman.

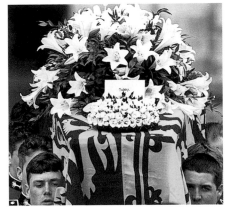

The coffin of Diana, Princess of Wales leaves Westminster Abbey for its final resting place at Althorp in 1997.

State visits to Malta, France and Germany

Princess Anne divorced from Captain Mark Phillips; marries Tim Laurence

Visit to Canada for Canada Day celebrations

Fire destroys part of Windsor Castle

The Prince and Princess of Wales separate

In her Christmas broadcast the Queen describes 1992 as an *annus horribilis*

1993
IRA bombs in Warrington kill two children

President Premadasa of Sri Lanka assassinated

State visit to Hungary

Buckingham Palace opens to the public

Benazir Bhutto becomes prime minister of Pakistan

Regimental visits to Cyprus and Germany

Downing Street Declaration by John Major and Taoiseach Albert Reynolds on the future of Northern Ireland

1994
State visits to Anguilla, Dominica, Guyana, Belize, Cayman Islands, Jamaica, Bahamas, Bermuda and Russia

Channel Tunnel is officially opened by the Queen

D-Day 50th anniversary celebrations in Britain and France

Nelson Mandela becomes president of South Africa

Visit to Canada (Nova Scotia, British Columbia and Northwest Territories)

IRA declares ceasefire

National lottery begins

1995
Barings Bank, which numbers the Queen among its clients, collapses

State visit to South Africa

Visit to New Zealand to attend the Commonwealth heads of government meeting

Prime Minister John Major survives leadership challenge in Conservative party

50th anniversary of VE and VJ Day

1996
State visits to Poland and the Czech Republic

Dunblane massacre of 16 schoolchildren and their teacher

The Duke and Duchess of York divorce

The Princess of Wales agrees to divorce settlement of £15 million, shared responsibility for the children and the loss of the title HRH

State visit to Thailand

Shakespeare's Globe Theatre re-opens for the first time since 1642

1997
Tony Blair becomes prime minister after landslide Labour victory

India and Pakistan celebrate 50th anniversary of independence

Visit to Canada for Cabot celebrations (Newfoundland, Ontario, National Capital Region)

Diana, Princess of Wales killed in a car crash in Paris

Death of Mother Teresa, aged 84

Referendum in Wales produces narrow majority in favour of a Welsh Assembly

1997–2002

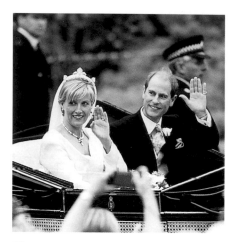

The new Earl and Countess of Wessex wave to the crowds after their wedding in 1999.

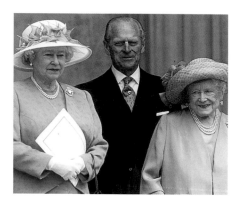

The Queen Mother's 100th birthday in August 2000 was an occasion for family and public celebrations.

A sombre Queen leaves St Paul's after the memorial service for victims of the attack on the World Trade Center, New York, in 2001.

State visits to Pakistan and India

Golden Wedding Anniversary of the Queen and the Duke of Edinburgh

Windsor Castle reopened as fire repairs completed

The Earl and Countess Spencer divorce

The Queen's Christmas broadcast is produced by ITV for the first time

1998
The Queen opens the new British Library

The remains of the last Russian tsar are reburied in St Petersburg

Mother of Duchess of York killed in car crash in Argentina

State visits to Brunei and Malaysia; rioting breaks out as the Queen closes the Commonwealth Games

Visits to France and Belgium

Northern Ireland politicians John Hume and David Trimble jointly awarded the Nobel Peace Prize

1999
State visit to Korea

Marriage of Prince Edward to Miss Sophie Rhys-Jones; they become the

Earl and Countess of Wessex

The Queen formally opens the new Scottish Parliament

Pakistan suspended from the Commonwealth following military coup

George Cross awarded to Royal Ulster Constabulary

Visits to Ghana, South Africa and Mozambique

Royal Opera House in Covent Garden is formally opened by the Queen

The Queen attends new millennium celebrations at the Dome in Greenwich

2000
Visit to Australia (New South Wales, Tasmania, ACT and Western Australia) four months after the country voted against becoming a republic

The Queen visits Germany to open new embassy in Berlin

Ken Livingstone becomes first directly elected mayor of London

Prince Charles speaks out against genetically modified foods

The Millennium Bridge is opened by the Queen, but closes two days later because of structural problems

The Queen Mother celebrates her 100th birthday

State visits to Italy and the Vatican

The Millennium Dome is revealed to be effectively bankrupt following poor attendance figures

2001
Outbreak of foot-and-mouth disease has disastrous effect on British farming

Terrorists bomb BBC Television Centre

Race riots break out in Oldham, Leeds and Burnley

Canada angry with UK over Honours List: they will not allow Canadians to accept any honours involving titles

State visit to Norway

The Queen attends a special memorial service for those killed by terrorists in the attack on the World Trade Center in New York

Royal visit to Australia cancelled amid fears of terrorism

US forces bomb Afghanistan to flush out perpetrators of Twin Towers attack

2002
Official celebrations of the Queen's Golden Jubilee

The Story of a Reign

THE YOUNG WOMAN who came to the throne in 1952 was only 25 – a princess shaped by the war years but destined to become a monarch of the modern age. Few could imagine the changes and challenges that lay ahead of her, but none doubted that she would face them with steadfastness and dignity. The story of her 50 years as Queen and Head of the Commonwealth is a fascinating one, encompassing an extraordinary variety of events and developments. The following pages chart her reign decade by decade, illustrating the enduring nature of duty and tradition in a world dominated by transience and change.

1952–1961

Four years into her reign, the young Queen had grown accustomed to the constant round of public engagements, and gave every impression of enjoying her role as monarch.

IN THE SAD DAYS THAT FOLLOWED THE DEATH of King George VI the young Queen had to cope simultaneously with private grief and public duties. Many thought it hard that she had to assume the mantle of office straight away. Winston Churchill believed there was 'too much care on that young brow', but work provided a distraction from personal concerns, and the burgeoning optimism of the postwar years was to prove invigorating.

Excitement was at fever pitch by the time of the coronation in June 1953. Huge crowds lined the rain-soaked streets and millions more watched the ceremony in glorious black and white on nine-inch television screens. The combination of centuries-old tradition with the latest technology seemed completely appropriate – a sign that past and present could happily co-exist, and that, surely, was a good omen for the future.

The first crisis of the Queen's reign struck soon afterwards: Princess Margaret had fallen in love with Peter Townsend, a divorced man. It's hard to comprehend now the stigma that once attached to divorce. In most circles, not least royal ones, divorcees were considered tainted by scandal and not safe to consort with. The fact that Townsend remained working for the Queen Mother after his divorce was a mark of her liberalism and a nod towards changing times, but it was

'I shall always work, as my father did throughout his reign, to uphold the constitutional government and to advance the happiness and prosperity of my peoples, spread as they are the world over… I pray that God will help me to discharge worthily this heavy task that has been laid upon me so early in my life.'

HM QUEEN ELIZABETH II ADDRESSING THE PRIVY COUNCIL

unthinkable that the Queen, Defender of the Faith, could allow her sister to marry in defiance of the Church's teaching about the indissolubility of marriage. As things turned out, the couple themselves reached this conclusion after two passionate but tortured years, and in 1955 decided to go their separate ways.

That same year saw the long-overdue resignation of the Queen's devoted but doddery prime minister, Sir Winston Churchill. His suave-looking replacement, Sir Anthony Eden, lasted less than two years in the job because his clumsy handling of the Suez Crisis antagonized many world leaders and destroyed his reputation and health in the process. So all-consuming was the crisis, though, that the harsh Russian suppression of the Hungarian uprising at the end of 1956 took something of a back seat. None of the world powers had time to intervene.

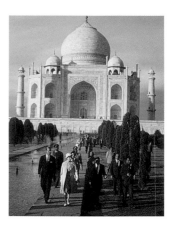

Unlike the Princess of Wales, who visited the Taj Mahal alone, the Queen visited this beautiful monument to love with her 'strength and support', the Duke of Edinburgh.

Conflicts on Earth were temporarily eclipsed in 1957 by activities in space. Russia, much to the surprise of the rest of the world, launched *Sputnik I*, an unmanned satellite that circled the planet in 95 minutes. Western powers were startled out of their technological complacency and soon the race was on to see who would be the first to land a man on the moon. Sadly, the arms race also took off, and fears about the proliferation of hydrogen bombs led in 1958 to the formation of the Campaign for Nuclear Disarmament. Meanwhile, the crusty British establishment finally admitted women peers to the House of Lords, shamed into it perhaps by the State Opening of Parliament (presided over by a woman) being televised that year for the first time.

Space travel for humans was still a gleam in scientists' eyes in 1959, but the pace of life was getting gradually faster nonetheless. The Queen opened Britain's first stretch of motorway, and the Hovercraft cut in half the time it took to cross the Channel. The following year Prime Minister Harold Macmillan spoke about the 'wind of change' blowing through Africa, but the Sharpeville massacre that occurred six weeks later showed that South Africa, at least, had a long way to go before things improved. Happier events also took place that year: the Queen began her 'second family' by giving birth to Prince Andrew in February, and three months later her sister married the photographer Antony Armstrong-Jones.

Looking slightly uneasy, the Queen rode on a gorgeously draped elephant during her 1961 state visit to India.

'Because she's the sovereign everyone turns to her. If you have a king and a queen, there are certain things people automatically go to the queen about. But if the queen is also the *Queen*, they go to her about everything. She's asked to do much more than she would normally do.'

HRH THE DUKE OF EDINBURGH

In what seemed like the blink of an eye the Queen was in the final year of her first decade as monarch. The Empire was shrinking as former colonies claimed their independence, but good will prevailed as many of them joined the Commonwealth. The Queen's role had simultaneously diminished and grown – a tribute to the tact and realism that were and are the hallmarks of her reign.

1962–1971

CHANGE, IF NOT ALWAYS PROGRESS, continued to be the keynote of the Queen's second decade on the throne. As London abandoned the last of its trolleybuses in 1962, Britain launched its first satellite, *Ariel*, from Cape Canaveral in Florida and exploded its first nuclear device under ground in Nevada.

The winter at the end of that year was particularly harsh: snow and frost plagued the country from December to the following March. As the days began to lengthen, a government minister, call-girls and Russian spics hit the headlines. The prime minister denied that John Profumo's antics had compromised national security, but the Queen was known to be dismayed at the government's inept handling of the crisis. This story dominated the newspapers until the 'Great Train Robbery' took its place, and this in turn was superseded by the resignation of Harold Macmillan and the assassination of John F. Kennedy.

A happier note was sounded in March 1964 when Prince Edward was born, but sadness again afflicted the country in January the following year when Winston Churchill died. As the great war leader was laid to rest, a conflict that was to scar a generation was beginning in Southeast Asia. US jets bombed South Vietnam in an attempt to stop the spread of communism, but, many would argue, succeeded only in uniting people against American imperialism.

Meanwhile, Britain's careful dismantling of Empire suffered a setback at the end of 1965 when the Rhodesian prime minister, Ian Smith, demanded independence for his country on his own, racist terms. When refused, Smith promptly issued a Unilateral Declaration of Independence from Britain. It was a sad day for the Queen and the Commonwealth.

Unity in Britain enjoyed an all-time high in 1966 when England's football team won the World Cup. The Queen presented the trophy before euphoric crowds in Wembley Stadium, and self-esteem rode high for some time afterwards. The next emotion to unite the country, however, was grief, when a slag heap engulfed a primary school in the Welsh village of Aberfan, killing 116 children and 28 adults. The Queen recalled her emotional visit to the site of the tragedy in her Christmas broadcast later that year.

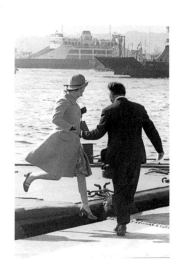

With less ceremony than usual, the Queen disembarks from a boat during a state visit to Turkey in 1971.

In February 1967 the Queen had her first meeting with a Soviet leader, when President Kosygin made a state visit to Britain. Elsewhere on the international political scene, things were less peaceful: an army coup deposed King Constantine of Greece and the Six-Day War broke out in the Middle East. These events were reported on the latest technology to arrive in Britain – colour television – and eager audiences also saw the launching of the *QEII* and heard, rather queasily, about the first human heart transplant.

As the 1960s progressed, voices of dissent were being raised in different places and in different causes. Race riots broke out in the USA, and Martin Luther King, a champion of peaceful protest, was assassinated. Not long afterwards, Senator Robert Kennedy was also gunned down by someone who disagreed with him. Meanwhile, students in Paris clashed with police in conflicts that seemed reminiscent of the storming of the Bastille nearly 200 years earlier. On the home front, clashes between people and police in Londonderry marked the beginning of renewed troubles in Northern Ireland.

By contrast, 1969 seemed a bit quieter. The Queen invested Prince Charles as Prince of Wales, and the first men landed on the moon. From Russia's crude *Sputnik* satellite to the USA's sophisticated *Apollo* spacecraft had taken just 12 years. Where would the space race go next?

The Queen's 20th year on the throne saw national stalwarts falling like skittles. Rolls-Royce collapsed, old money was abandoned in favour of decimal currency and a bomb wrecked part of the Post Office Tower. The decade was ending as it had begun: the future seemed to hold unimaginable promise, but the present was troubled and uncertain. Only the rituals and traditions of monarchy held firm, offering comfort and stability in times of change.

1972–1981

AFTER THE OPTIMISM OF THE 1950s and the youthful hedonism of the 1960s, perhaps it was in the natural order that the 1970s should be more downbeat. The miners' strike that hit Britain in January 1972 heralded a period of industrial unrest, economic uncertainty and social upheaval that shed gloom and sapped confidence. International events offered little respite: the Watergate scandal began to unfold, Idi Amin expelled 40,000 British Asians from Uganda and the Munich Olympics were marred by Arab terrorism. In the midst of these events, the Duke of Windsor died and Prince William of Gloucester was killed in an air race crash.

The following year seemed to offer hope of better things when Britain became a member of the European Economic Community and the Vietnam War ended.

Entering the third decade of her reign, the Queen looks relaxed, safe in the knowledge that the majority of her subjects approve of her.

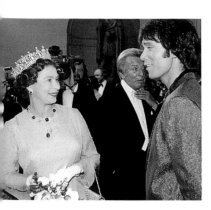

Looking like mutual fans, the Queen and Cliff Richard meet at the Royal Variety Performance in 1981.

Hope was shortlived, however. Against a background of relentless bomb attacks by the IRA, the so-called 'cod war' broke out between Iceland and Britain, and oil sanctions brought about the three-day working week. The wedding of Princess Anne to Captain Mark Phillips was a rare happy occasion at the end of that year.

As the IRA continued to wreak havoc around the country, with bombs at the Tower of London, Guildford, Woolwich and Birmingham, the Queen signed the Anti-Terrorism Bill, which proscribed the IRA and gave the police wider powers. Meanwhile, the cod war with Iceland worsened, Prime Minister Harold Wilson unexpectedly resigned and Princess Margaret separated from Lord Snowdon. Soon after that, the Queen swapped Britain's unusually long, hot summer of 1976 for its predictably humid counterpart in Washington, when she attended the USA's bicentennial celebrations.

Her Silver Jubilee year was a focus of celebrations at home and abroad. Overseas tours to Australia and Canada were interspersed with pageantry in London and parties up and down the country. Public approval of the Royal Family had never been higher and there was genuine warmth in the affection of the crowds who turned out to greet the Queen wherever she went. A happier year ended with the birth of her first grandchild, Peter Phillips.

Significant events in 1978 included the divorce of Princess Margaret, the birth of the world's first test-tube baby and three popes within as many months at the Vatican. Middle East conflicts raged throughout the year. In the following January the Shah of Iran fled his country and within weeks the exiled Ayatollah Khomeini returned to declare it an Islamic republic. In Pakistan a military government executed the former prime minister Ali Bhutto. There was little doubt that the world was in turmoil. In Britain, change came in the less violent but nonetheless revolutionary form of Margaret Thatcher, the country's first woman prime minister.

August of 1979 brought terrorism into the heart of the Royal Family when Prince Philip's uncle, Earl Mountbatten, was killed by a bomb planted on his boat in Sligo. Outrage fuelled a massive hunt, and within three months the perpetrator had been caught and sentenced to life imprisonment.

Unrest seemed to be touching every corner of the globe. Russia's treatment of its dissidents led the USA and 26 other countries to boycott the Moscow Olympics

'When I was 21, I pledged my life to the service of our people and I asked for God's help to make good that vow. Although that vow was made in my salad days when I was green in judgement, I do not regret or retract one word of it.'

HM QUEEN ELIZABETH II IN A SPEECH MARKING HER SILVER JUBILEE

in 1980, but British athletes did participate although many people were uneasy about it. Nobody was very surprised when war broke out between Iran and Iraq, but the Polish government's recognition of Solidarity, the country's first independent trade union, was seen as an important step in breaking free of communism. When former film star Ronald Reagan was elected US president it seemed like the cavalry had arrived to restore order.

The year 1981 will always be remembered for the marriage of Prince Charles to Lady Diana Spencer. Although the country was blighted before and after the event with riots in Liverpool, Manchester and London, the mood remained defiantly upbeat. At the end of the year the Queen learnt that her heir and his wife would be presenting her with a grandchild destined, in time, for the throne. Optimism about the future once again seemed appropriate.

1982–1991

LIKE EVERY OTHER DECADE of the Queen's reign, the period 1982–1991 included events both good and bad, but rarely had the highs and lows impinged so personally. It began with blizzards sweeping across Britain and plunging the country into chaos. The severe weather seemed to mirror the national malaise, as employment reached three million. Then Argentina invaded the Falkland Islands. The Queen took a particularly close interest in the unfolding events because her son, Prince Andrew, was involved in the conflict as a helicopter pilot. Her anxiety, and that of the whole country, was eventually relieved when a ceasefire was agreed in the middle of June. After the death and destruction, the birth of Prince William of Wales just one week later was greeted with rapture.

July revealed the terrible state of the Queen's personal security when a drunken intruder managed to get into her bedroom at Buckingham Palace. His appeasement and eventual arrest was largely thanks to her ability to keep cool in a crisis. However, the intrusion was deeply traumatic and she suffered delayed shock, necessitating a period of recuperation.

The following year, people were waking up to breakfast television, using the new £1 coin and protesting against cruise missiles at Greenham Common. The happiest event in 1984 was the birth of Prince Harry in September, but it was overshadowed a few weeks later by shock and outrage at the IRA bombing of the Grand Hotel in Brighton, which had many politicians staying there for the Conservative party conference. By the end of that year, amid ructions less explosive but equally divisive, the Church of England voted in favour of women priests. Nobody knows what the Queen, Defender of the Faith, thought of that.

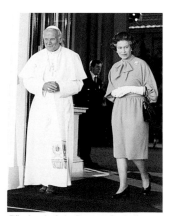

The head of the Roman Catholic Church and the Supreme Governor of the Church of England meet at Buckingham Palace in 1982.

'The advantage of a monarchy is that it doesn't enter into the political arguments of the day. It makes for a very good division of responsibilities: the prime minister does all the political business, and this means that those people who oppose him politically don't have to oppose him as head of state. The monarchy is above politics.'

HRH THE DUKE OF EDINBURGH

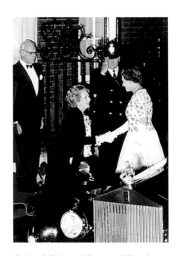

Prime Minister Margaret Thatcher curtsies to the Queen on her arrival for a formal dinner at 10 Downing Street in 1985. Both of these powerful women rely on the discreet and loyal support of their husbands.

British government went surprisingly public in 1985 when House of Lords' proceedings began to be televised. Among other notable events mid-decade were celebrations of the 40th anniversary of VE Day, on which the teenage Princess Elizabeth had taken to the streets 'in disguise' to enjoy the jubilation being expressed by the huge crowds around Buckingham Palace.

Against a background of national protest among the print unions and international unrest that had seen the assassination of prime ministers Indira Gandhi and Olof Palme, the Queen signed a proclamation granting Australia legal independence. The disastrous explosion at the Chernobyl nuclear plant that occurred a month later seemed symbolic not only of the crumbling Soviet Union, but of the changes occurring around the world. The mood was lightened a little when the Queen celebrated her 60th birthday with parties in London and Windsor, and a few months later the country had another reason to celebrate when Prince Andrew married Sarah Ferguson. A long-held ambition of the Queen's was fulfilled at the end of the year when she made her first-ever visit to China.

Another big freeze heralded the beginning of 1987, while the end of the year was marked by a hurricane. To the guarded enthusiasm of the world, President Gorbachev began the process of introducing democracy to the Soviet Union. Meanwhile, Fiji suffered a coup and the Queen stepped down as its monarch.

The following year saw Prince Charles narrowly escape death in an avalanche while out skiing, but the Royal Family grew as the Queen's second son and his wife presented her with a fifth grandchild. As a more open attitude to government led to the televising of proceedings in the House of Commons, so demands for democracy surged around the world. There were huge demonstrations in Beijing, and Germans from East and West began to knock down the Berlin Wall. Domestic unrest focused on the unpopular Poll Tax. To national rejoicing, hostages were released from captivity in Beirut and Margaret Thatcher resigned as prime minister.

The end of the Queen's fourth decade as sovereign began with the Gulf War, saw increasing turmoil in the Balkans and ended with the mysterious death of Robert Maxwell. At the request of the Queen, celebrations to mark her 40th anniversary focused on activities in which everyone could participate and which would have long-term benefits to individual communities. It was an appropriately unselfish way for both monarch and country to give thanks, and the anniversary celebrations were accompanied by genuine displays of patriotic affection in every corner of the land.

1992–2001

NO MATTER WHICH WAY it's looked at, 1992 was not a good year. Like everyone else, the Queen could only look on with horror as the Balkan conflict descended into genocide, the £ hit rock bottom and her government was tarnished by the sexual peccadilloes of its minister for culture, David Mellor. Could things be any worse? Yes, indeed. In February the Princess Royal and Mark Phillips were divorced. The following month the Duke and Duchess of York separated. In November, fire destroyed a large part of Windsor Castle, causing damage estimated at £50 million. Then, just in time for Christmas, the Prince and Princess of Wales officially separated. By way of compensation, the Queen attended the second wedding of her daughter – this time to Captain Tim Laurence in Crathie Church – a low-key affair that, although welcomed, could do little to rescue what the Queen described as an *annus horribilis*.

Nine months later, at the suggestion of the Queen, Buckingham Palace was opened to day-trippers – a gesture designed to appease those who balked at public money being spent to restore Windsor Castle. All the money raised would be Crown revenue and therefore payable to the government, so overstretched public resources would not have to foot the bill. It was a tactful thing to do.

While news from the Balkans continued to appal the world, more horror hit the headlines in 1994 when civil war broke out in Rwanda and journalists revealed genocide on a massive scale. Britain's domestic concerns centred on the growing BSE crisis, the morality of shopping on Sundays and the possibility of winning millions in the National Lottery.

The following year kicked off with a financial storm that affected even the Queen: Barings Bank collapsed, following reckless speculation by one of its employees. The next serious shock for London occurred exactly a year later, when a massive IRA bomb exploded in Docklands. Hardly had the dust settled than, just one month later, a gunman killed 16 small children and their teacher at a

There are few occasions when the Queen is not accompanied by the Duke of Edinburgh. During the 1990s, his support was needed more than usual.

A thoughtful moment for the Queen in a decade that gave her a great deal to think about.

school in Dunblane. The unspeakable brutality stunned the country, and the Queen's evident sorrow as she laid a wreath at the scene spoke for everyone.

Royal marital problems were dissected again in 1996, when, at the Queen's urging to sort things out, the Yorks and the Waleses finally divorced. Could they now live in peace? Unfortunately, the tabloids wouldn't let them. Not a day went by without press speculation or comment on their activities. So familiar did they become that when the Princess of Wales was killed in a car crash in Paris just a year after her divorce, the whole world felt the loss personally. Her state funeral brought the country to a standstill. No one who witnessed it will ever forget it.

It was with some relief that a new year dawned with scandals happening a long way from home. President Clinton's dalliance with Monica Lewinsky dominated the news for months. In 1999, Prince Edward married Sophie Rhys-Jones, and respectful interest was shown in the occasion. More significant, in political terms, was the formal opening of the Scottish Parliament. If the Queen had fears for the unity of the United Kingdom, she kept them to herself.

As the year turned, the Queen headed a glittering guest list at the Dome in Greenwich to welcome in the new millennium. Along with everyone else, she wished for better times, and a few months later was gratified to visit Australia, where a referendum on the monarchy had recently voted to keep her. On her return, Britain struggled with a fuel blockade mounted by militant road hauliers, and then suffered the misery of severe floods and storms.

It was in September 2001, when people reeled in horror at the terrorist attacks on the World Trade Center in New York, that the Queen showed a humanity that she had sometimes been accused of lacking. She ordered a special changing of the guard ceremony at Buckingham Palace, stipulating that the American national anthem should be played. The following day, having broken her holiday at Balmoral, she attended a memorial service in St Paul's Cathedral for the 4000 victims of the disaster. It was a moving occasion that brought a measure of comfort to all involved and left little doubt that the Queen who had survived five turbulent decades was a caring and compassionate woman – far more than a figurehead.

'…our "humble and hearty thanks" to all those in Britain and around the world who have welcomed us and sustained us and our family, in the good times and the bad, so unstintingly over many years… We are deeply grateful to you, each and every one.'

HM QUEEN ELIZABETH II IN A SPEECH MARKING HER GOLDEN WEDDING ANNIVERSARY

1

Starting with the magnificent and memorable day on which Queen Elizabeth II was crowned in Westminster Abbey, this section goes on to describe the structure of the Queen's year and the enormous amount of preparation that goes into organizing her engagements. It also includes fascinating details about her wardrobe and jewellery.

'To every thing there is a season and a time' – these words could have been written for the Queen as her time is mapped out months in advance. The only unknown quantity is the weather. Here on a visit to Cambridge University in April 1995 the Queen brightens up a wet and dismal day.

The Coronation

THE CORONATION is simply the most important state occasion in the reign of a monarch. The ceremony is steeped in ancient traditions and happens only once in a monarch's lifetime, so enormous care must be taken with the planning and preparation. The year of official mourning for the previous monarch allows the necessary time and also provides the new sovereign with a period of adjustment.

The Coronation of Queen Elizabeth II took place in Westminster Abbey on 2 June 1953, some 16 months after the sudden death of King George VI. That date, chosen because it had a history of being fine and sunny, let everyone down by being grey and drizzly. However, the air of optimism generated by the young queen lifted everyone's spirits.

Her dress, created by Norman Hartnell, was made of white satin embroidered with symbols of the United Kingdom and Commonwealth in silks, pearls, diamonds, amethysts and gold and silver bullion. With it she wore a crimson velvet robe of state, which was specially made for her, and which she continues to wear for the State Opening of Parliament. During the Coronation, the Queen removed the robe, and at different points during the ceremony she put on the coronation robes: a plain white garment (the *Colobium Sindonis*) went over her dress after the anointing. This was followed by a gold robe (the *Supertunica*, made in 1911 for the coronation of George V), the gold Imperial Mantle (made in 1821 for the Coronation of George IV) and a gold stole (specially made for her by some of the Commonwealth countries). The robes weighed 23 lb (10 kg).

On the journey to the abbey, the Queen wore the George IV State Diadem, changing to the Imperial State Crown for the journey home. Her other jewels included a diamond collet necklace with matching earrings, which had been made for Queen Victoria. The white bouquet she carried consisted of orchids, lily-of-the-valley, stephanotis and carnations, which came from various parts of the kingdom.

The Coronation ceremony, based largely on the service devised by Dunstan, Archbishop of Canterbury, for King Edgar in 973, is divided into five sections. The first of these is the recognition, when the Archbishop of Canterbury appeals to the congregation to confirm that the person he is to crown is the right one. This is followed by the oath, when the Sovereign promises to govern according to the law, to exercise justice with mercy and to maintain the Church of England. Then comes the holiest part of the ceremony, the anointing, when the Archbishop applies consecrated oil in the shape of a cross to the Sovereign's hands, breast and head. (The television cameras were not allowed to show this solemn part of the ceremony.) Next is the sequence of investiture, during which the Sovereign is given the insignia of the kingdom: St George's Spurs, the jewelled Sword of State, the Bracelets of Sincerity and Wisdom, the Stole Royal and Imperial Mantle, the Orb, the Wedding Ring of England, the Sceptres of Power and Mercy, and finally the crown of St Edward. At the moment of crowning everyone in the congregation shouts, 'God save the Queen!' Guns fired simultaneously at the Tower of London and in Hyde Park prompt people around the country to echo the cry.

In the final part of the service, known as the homage, the Sovereign's peers humbly knelt before her and pledged their loyalty. She then took Holy Communion, offered her oblation of an altar cloth and 1 lb (450 g) of gold, and retired to St Edward's Chapel to change her robes and crown.

The deliberately circuitous return journey to Buckingham Palace covered 5 miles (8 km) and took 1 hour and 40 minutes to complete. Millions of people lined the route to see the new young queen in her finery and regalia, and there was a palpable sense of joy and expectation in the air. It was a day never to be forgotten.

OPPOSITE: *Steady of gaze and calm of demeanour, the newly crowned Queen betrayed none of the emotion that must have filled her head and heart on Coronation Day in 1953. The crown, regalia and robes, which weighed over 30 lb (13.5 kg), were physical reminders of the burden of monarchy, and that burden has been borne with grace and fortitude since the time she pledged herself to the task 50 years ago.*

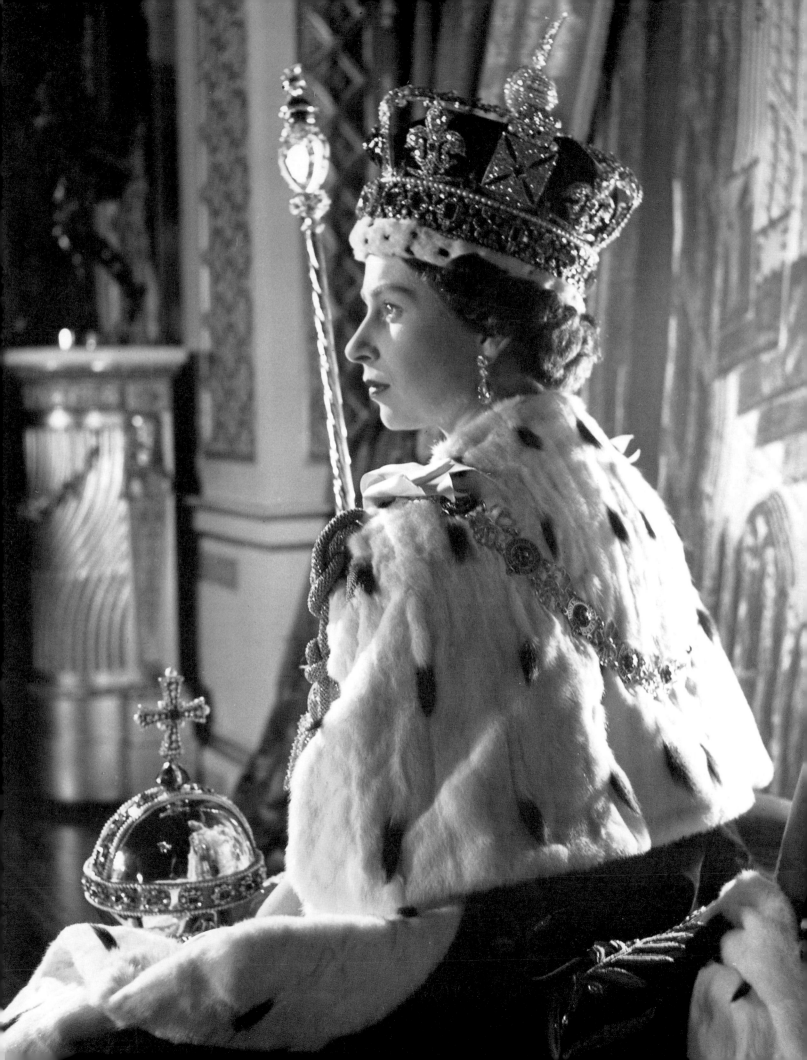

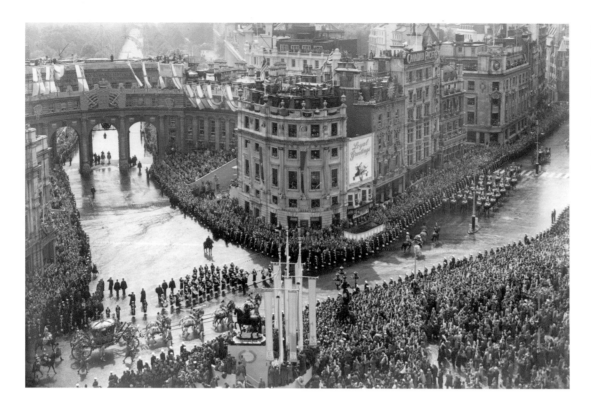

LEFT: *Camaraderie and good will united the millions of people who braved dismal weather to line the processional route on Coronation Day. Police later reported that even criminals had taken the day off, as street thefts and burglaries hit an all-time low.*

RIGHT: *On her way to the Coronation service at Westminster Abbey, the Queen looked happy, even excited, at what lay ahead. With her elaborate robes she wore the State Diadem, made for the Coronation of George IV in 1821. This crown has subsequently appeared at every State Opening of Parliament, and on all denominational postage stamps.*

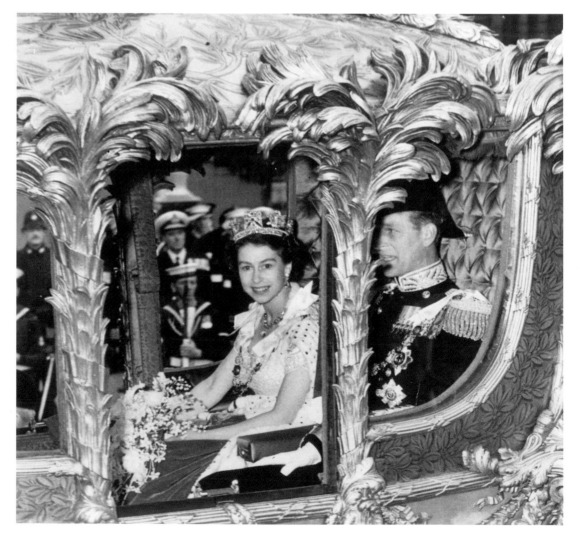

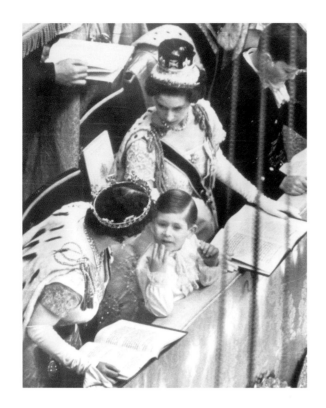

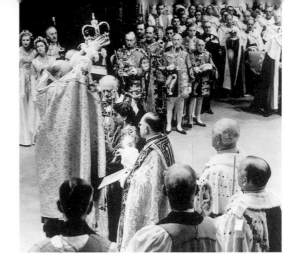

LEFT: *During the lengthy service, the Queen Mother patiently answered four-year-old Prince Charles's questions.*

BELOW: *Crowned heads and other distinguished guests joined the Royal Family to celebrate a remarkable day – the official beginning of a new Elizabethan era.*

ABOVE: *The Archbishop of Canterbury raised the Crown of St Edward on high so that congregation and broadcasters would know that the moment of crowning had arrived. As he placed it on the head of the young woman kneeling before him, the traditional cry went up: 'God save the Queen!'*

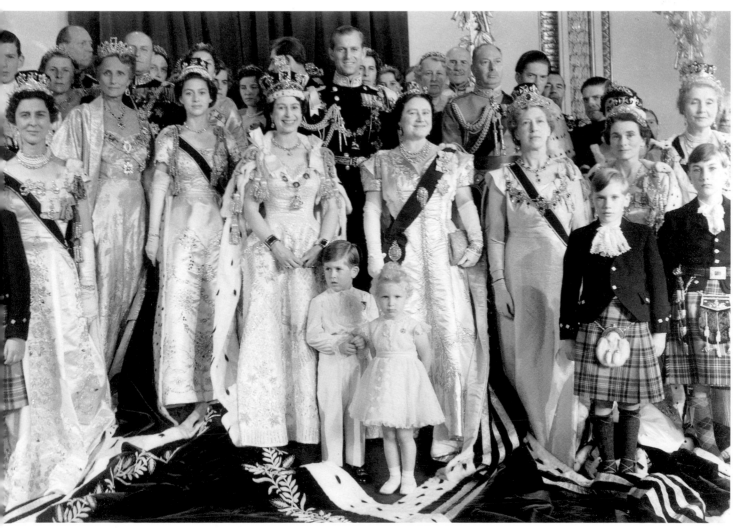

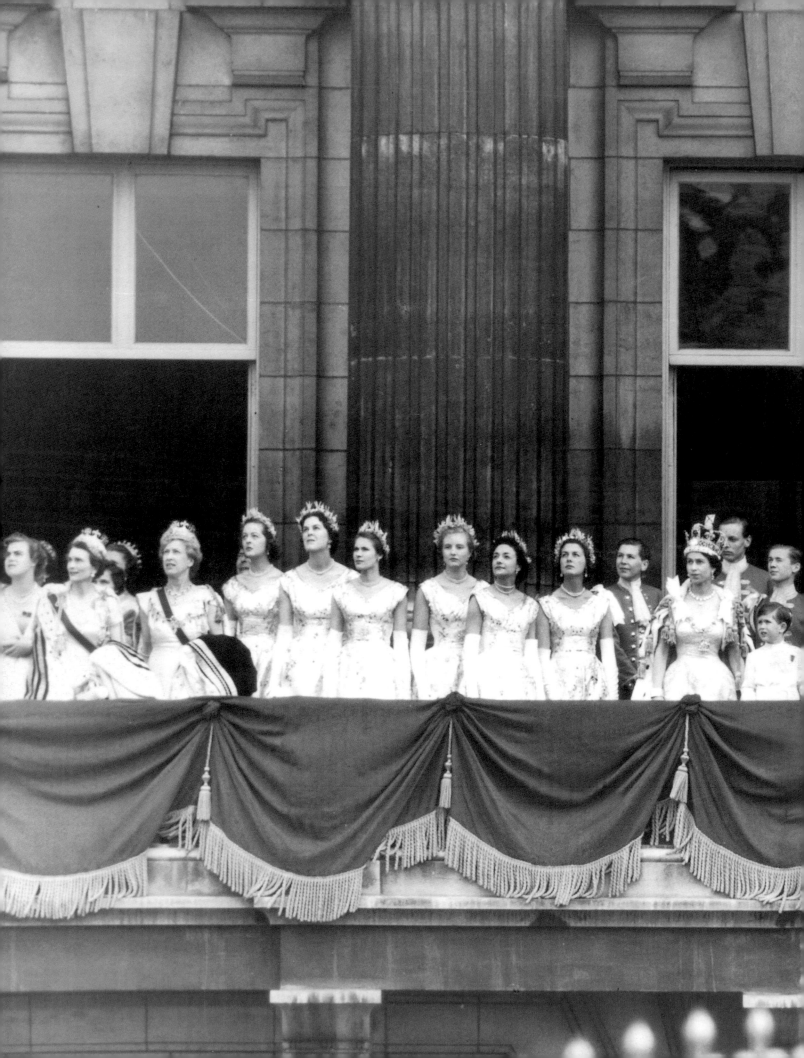

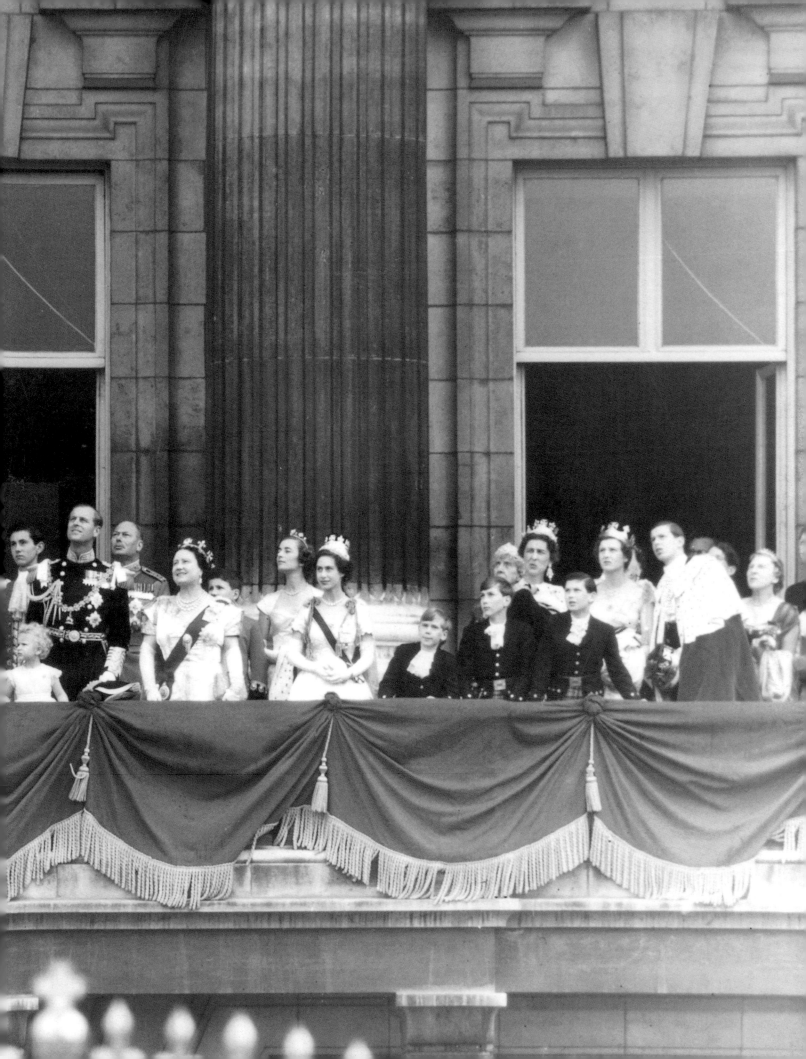

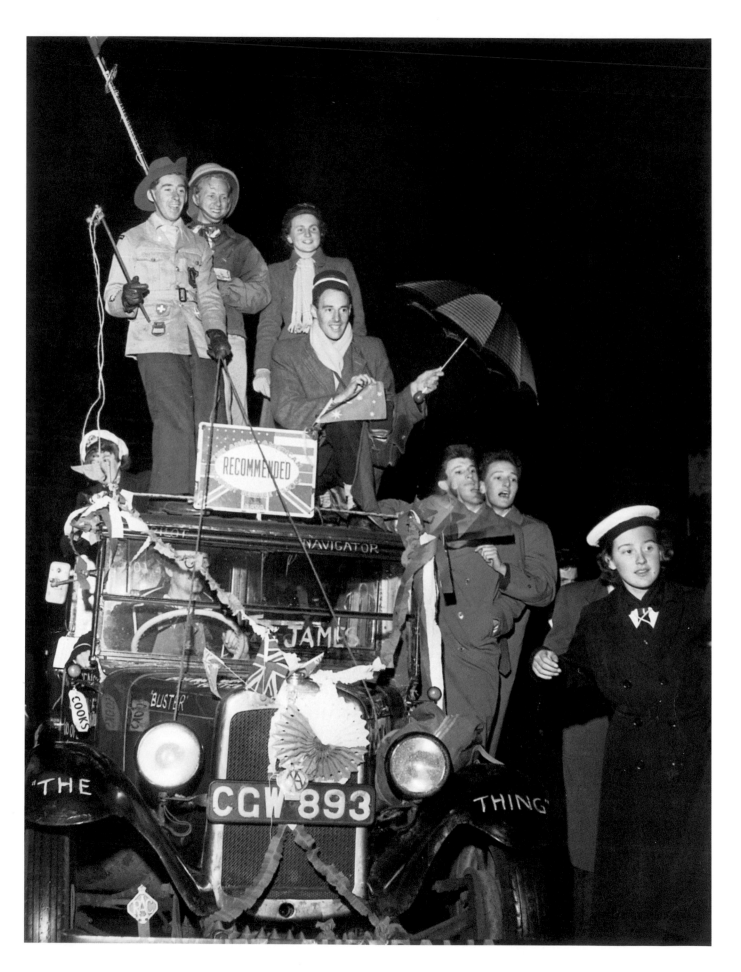

PREVIOUS PAGE: *The Queen, with her family, maids of honour and other guests, stands on the balcony of Buckingham Palace to watch the salute from 24 RAF Meteors.*

OPPOSITE: *People came from all over the world to witness the Coronation of Elizabeth II. This ancient-looking jalopy, apparently held together with string and willpower, was lucky to make it to London with its contingent of young Australians determined to have a good time.*

ABOVE: *Downpours interspersed with drizzle were not what the weather forecasters predicted, but nothing seemed to dampen the good spirits of those who lined the processional route. During the day they shared food, drink and shelter, and as darkness fell they danced and sang the night away.*

LEFT: *Many communities had organized fund-raising events over several months to finance their own Coronation celebrations. At street parties up and down the country, children overdosed on jelly and ice cream, grown-ups drank too much, and knees-ups continued long into the night.*

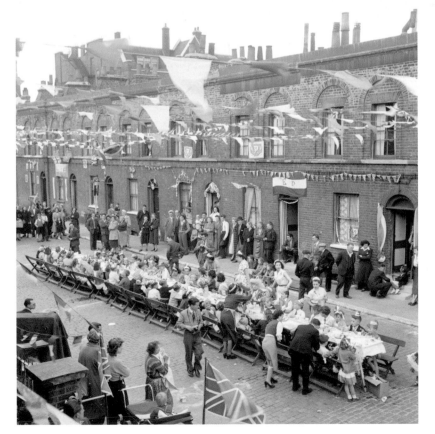

The Royal Round

LIKE EVERYONE ELSE, the Queen experiences a certain amount of repetition and predictability in her activities. In fact, her year is tightly planned around certain fixed events, so it can be tricky to accommodate changes at short notice, such as the State Opening of Parliament that occurred after the general election in May 2001. The year begins at Sandringham, where the Royal Family have taken to spending Christmas and New Year since the fire at Windsor Castle. The Queen spends a quiet six weeks in Norfolk, readying herself for the demands of the year ahead, but she always attends a meeting of the local Women's Institute and has tea with her fellow members.

Activities begin to hot up in February because an overseas tour is often planned for this time of year. Although the preparations will have begun up to two years in advance, the weeks leading up to departure are inevitably very busy.

In March the Queen is back at Buckingham Palace, where she has weekly meetings with the Prime Minister. On the second Monday she attends the Commonwealth Observance Service at Westminster Abbey and sends a special message to the children of the Commonwealth. Later in the month she attends a royal film performance.

Easter is a movable feast that falls in March or April. Before transferring to Windsor for the holiday, the Queen attends the Maundy Ceremony, which is held on the Thursday before Easter and in a different cathedral each year. In the year of her Golden Jubilee it will be at Canterbury .

In May the Queen stays at Windsor for the Royal Windsor Horse Show, of which she is patron. This popular contest attracts competitors from around the world, and many members of the Royal Family have taken part over the years, including the Queen herself. During the five days of the show the Queen holds a house party for family and other relatives. She then returns to work at Buckingham Palace and from there attends the Chelsea Flower Show – a favourite fixture in the royal diary.

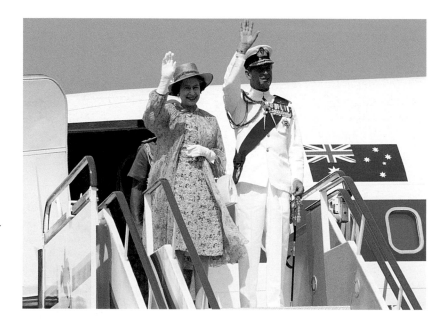

LEFT: *The Queen dresses down for her annual visit to the Women's Institute near her home in Sandringham. Often accompanied by the Queen Mother, who is also an honorary member of the WI, she turns up in her limousine at a modest church hall to join regular members for tea and a chat. This is usually the Queen's only public appearance, apart from Sunday church, during her winter break at Sandringham.*

BELOW: *February is usually the time for a royal tour to the far reaches of the world. Here the Queen, accompanied by Prince Philip in his tropical naval uniform, is arriving in Papua New Guinea for one of her Commonwealth visits. Such tours are always planned to take place during the most comfortable climatic conditions.*

June offers several opportunities for the Queen to indulge her passion for horses. First there is the Epsom Derby, then the Birthday Parade (Trooping the Colour). At Windsor, the Queen attends the annual Garter Ceremony on the Monday of Ascot week, then spends the next four days at the races with friends specially invited to stay.

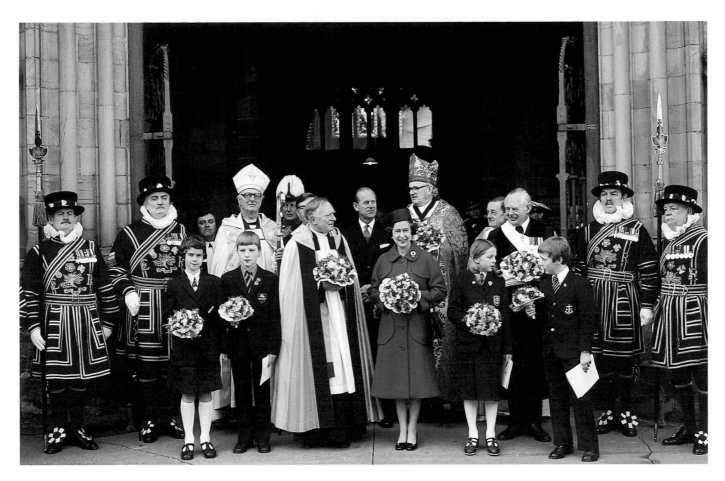

During July the main events are the garden parties held at Buckingham Palace and Holyrood. While in Edinburgh, the Queen attends a service for the Order of the Thistle, Scotland's highest honour, and installs any new members.

Returning to London, the whole Royal Family gathers at Clarence House for the Queen Mother's birthday, a jolly occasion marked by a marching band and crowds of well-wishers. Then begins the long summer holiday at Balmoral, during which the Queen always attends the Braemar Games.

Back at work in October, the first major event is often an overseas visit. This is followed in November by the State Opening of Parliament, the Royal Variety Performance and the Remembrance Ceremony at the Cenotaph. Then it's Christmas once more and the Queen is back where she started the year.

Around these fixed events are hundreds of other official engagements – about 400 at home and 100 overseas – many connected with the charities and organizations of which she is patron. The modern monarch may be privileged, but she also works very hard.

ABOVE: *Shortly before going to Windsor for the Easter break, the Queen takes part in the centuries-old Maundy tradition of giving money to the 'poor'. Nowadays the recipients are chosen not for their poverty but their good works for the Church and community. The posies carried by children of the parish are symbols of the nosegays that were originally used to mask the smell of the great unwashed.*

LEFT: *The Queen attending the Easter service at St George's Chapel, Windsor. After the service the Royal Family attend a sherry party at the home of the Dean of Windsor before heading back for their traditional roast lunch. The Queen, Queen Mother and Princess Margaret travel by car, the others go on foot.*

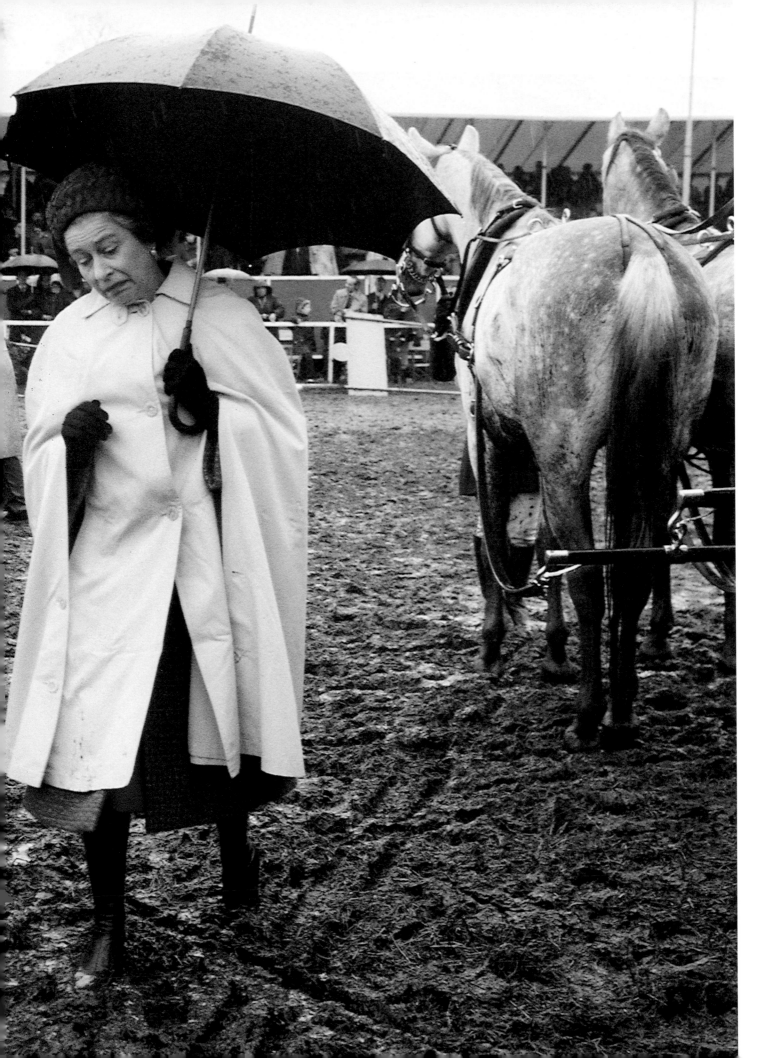

PREVIOUS PAGE: *The public face of royalty rarely slips, but there are always the unexpected moments when arrangements don't go quite according to plan and real feelings are shown to the world. The Queen felt as miserable as we all did on this muddy day in May 1978 when she stepped out to present prizes at the Royal Windsor Horse Show.*

RIGHT: *Royal patronage of the racing season is no hardship for the Queen as she has a great love of anything equestrian. She attends the Royal Windsor Horse Show, the Derby, Ascot and selected polo tournaments, but her greatest interest is flat racing. To date her stables have produced winners in four of the five British classic races – the 2000 Guineas, the 1000 Guineas, the Oaks and the St Leger.*

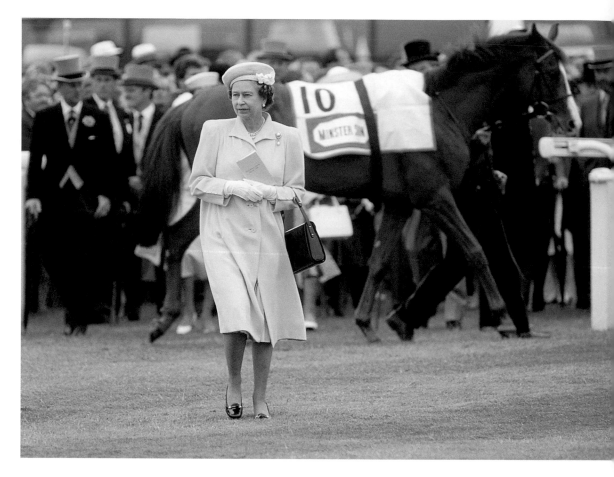

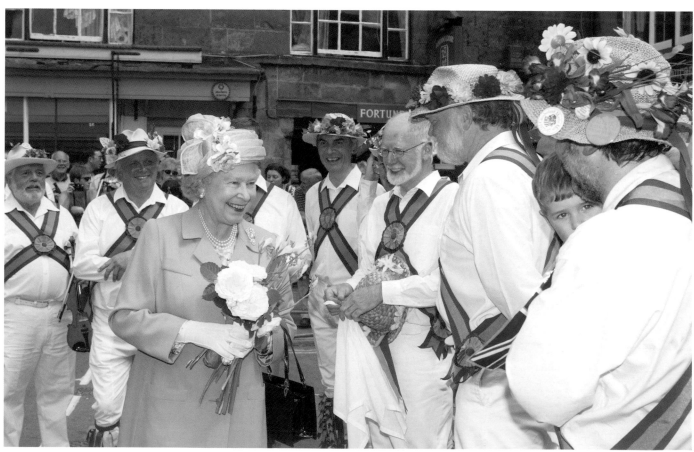

RIGHT: *The monarch, shown here in the uniform of Colonel in Chief of the Scots Guards, salutes her troops – a long-standing tradition. When her trusty mare Burmese retired in 1986, the Queen decided it was time to give up riding side-saddle for the annual Trooping the Colour ceremony. Since then she has worn 'civvies' and travelled in an open landau, which does not provide such a dramatic image from a photographer's point of view. Burmese had been a gift to the Queen from the Royal Canadian Mounted Police in 1969, and their expert training made this horse the ideal choice for the demanding discipline of the Birthday Parade.*

OPPOSITE: *During the year, the Queen travels the length and breadth of her kingdom, meeting as many of her subjects as she can. Here in the Market Square in Uppingham, the Rutland Morris Men had just performed 'The Queen's Delight' – much to the Queen's delight.*

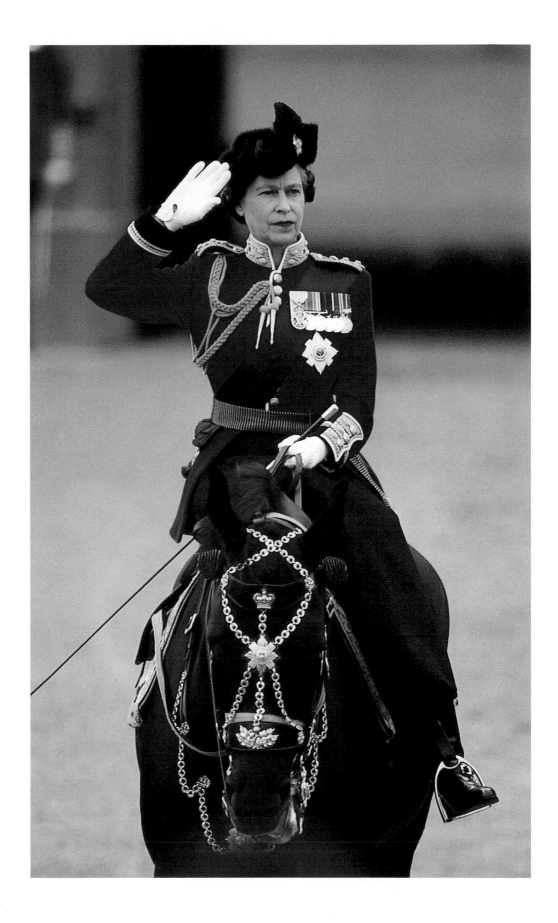

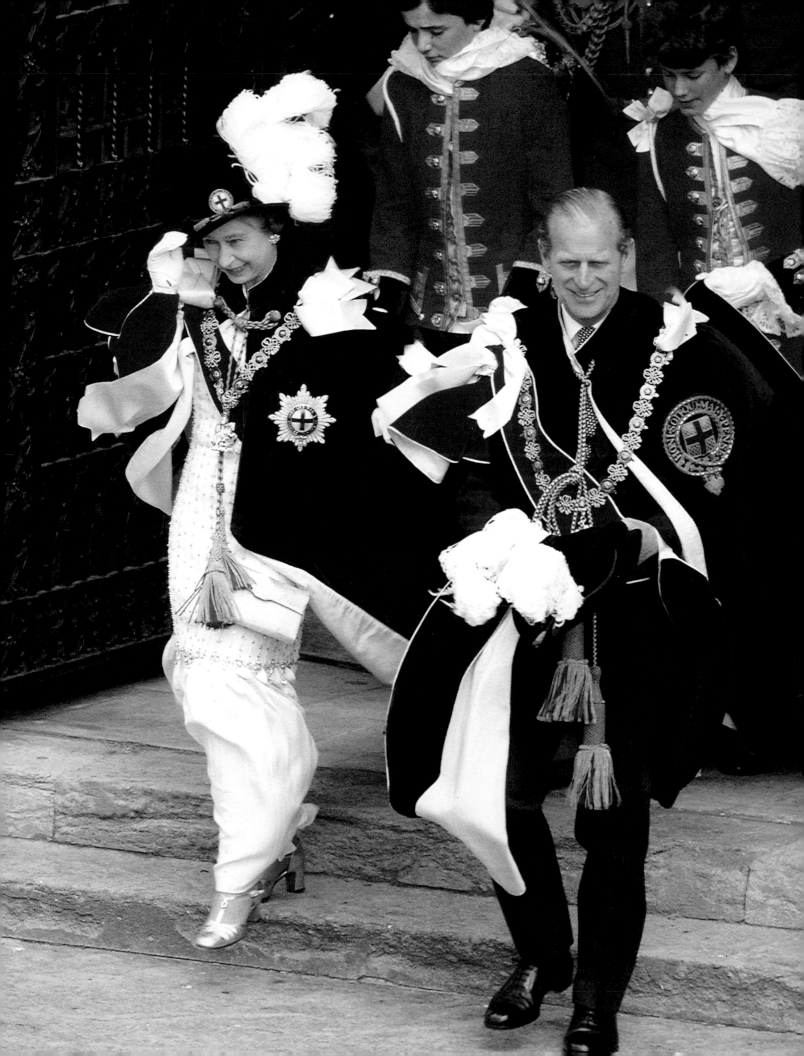

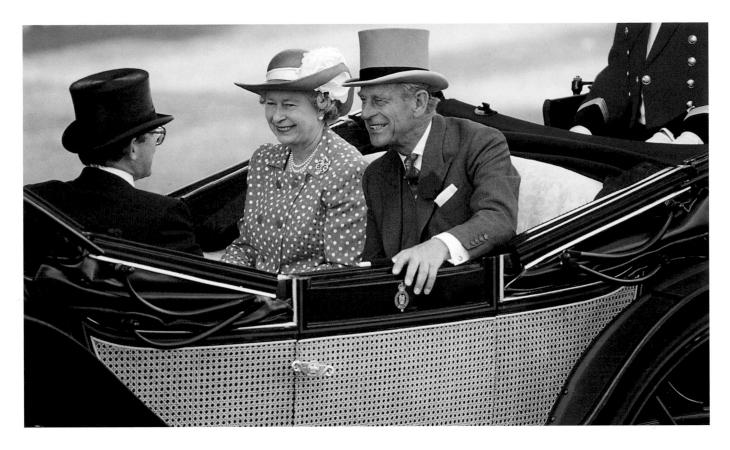

OPPOSITE: *I couldn't resist including this picture of the Garter Ceremony in 1980. With gusty winds, it isn't easy to maintain your dignity, and Prince Philip has taken the safe option of removing his hat.*

ABOVE: *On each of the four days of Royal Ascot, the Queen arrives by carriage with one or more of her house guests.*

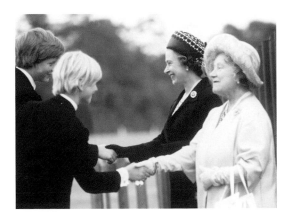

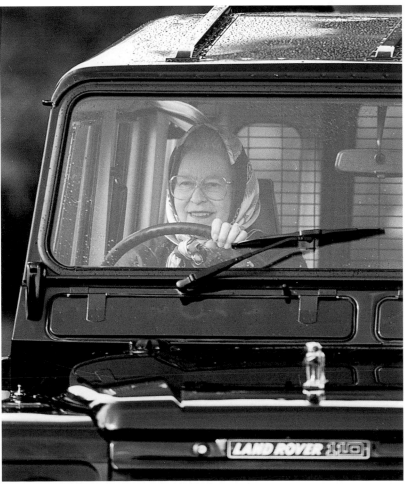

ABOVE: *In June the Queen and Queen Mother attend a tea hosted by Eton schoolboys. Here the Queen shakes hands with her godson Viscount Althorp, brother of the future Princess of Wales.*

RIGHT: *Limousines and carriages all play their part in the Queen's year, but she is just as happy behind the wheel of her own Land Rover driving around her estate at Windsor Castle.*

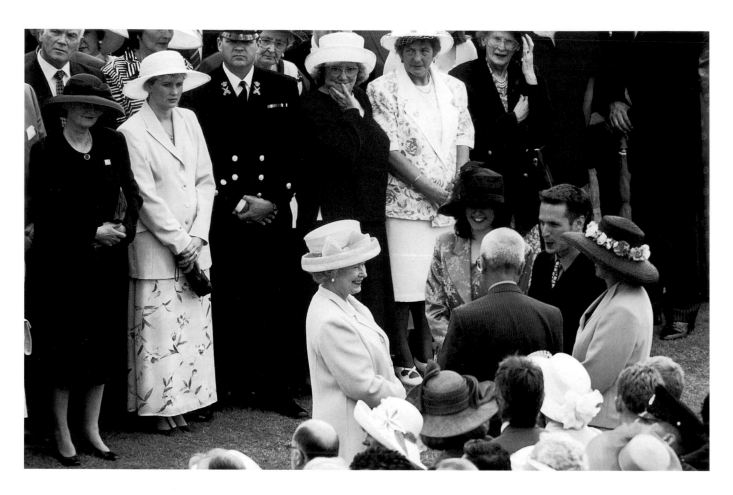

LEFT: *In July the Queen stays at Holyroodhouse in Edinburgh while undertaking a round of engagements, including a garden party, north of the border. While in Scotland, the Queen's ceremonial guard is the Royal Company of Archers.*

ABOVE: *The royals come together as a family four times a year – at Easter and Christmas, for the Queen's official Birthday Parade, and for the Queen Mother's birthday in August. Before lunch at Clarence House in London, the Queen Mother goes outside to acknowledge the good wishes of the crowd.*

OPPOSITE: *When 8000 people come for tea, it's impossible to chat to them all, so the Queen's Gentlemen Ushers choose a selection for her to meet. The annual garden parties at Buckingham Palace cause mayhem to the London traffic, but are a memorable way of saying thank you to people who have been nominated for their achievements in all areas of endeavour.*

RIGHT: *A long summer break in Scotland has been an annual event in the royal calendar since Queen Victoria bought Balmoral in 1852. One excursion that is never missed is the annual Highland Games at Braemar, nine miles from the castle. From the age of seven, when she accompanied her grandfather King George V, the Queen has been a regular patron of this timeless display of feats of strength, Scottish dancing and much more.*

RIGHT: *The end of the holiday for all, including the Queen's corgis. Although it looks as though the officer of the Queen's flight is standing to attention for the dogs, he is in fact waiting for the Queen to descend, as she is never far from the royal pets.*

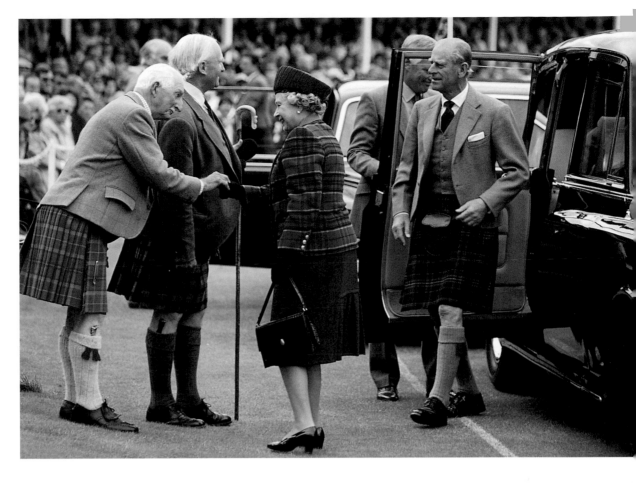

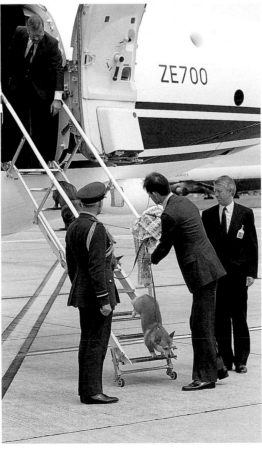

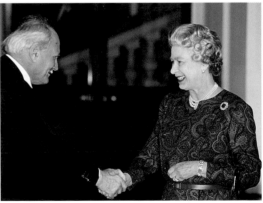

ABOVE: *During her reign the Queen has hosted over 80 state visits, averaging about two a year. Exceptionally, in the year 2000 the only state visit planned – for the King and Queen of Jordan – was postponed for a year. Here the Queen greets Hungarian President Goncz in November 1991.*

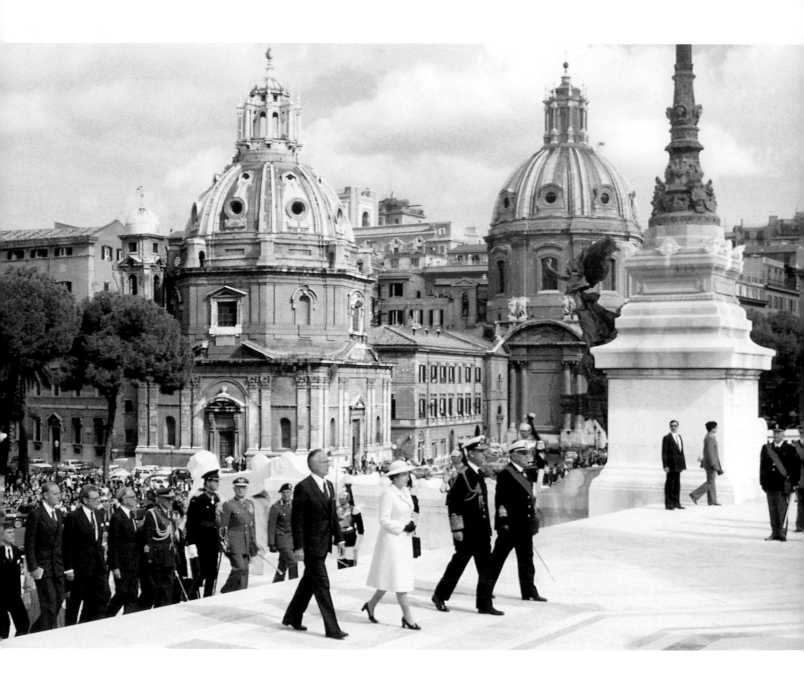

These two pictures
illustrate well the
continuing round
of the Queen's life.

ABOVE: *During a visit to Italy
in October 1980 the Queen
laid a wreath at the Tomb of
the Unknown Warrior in
Rome.*

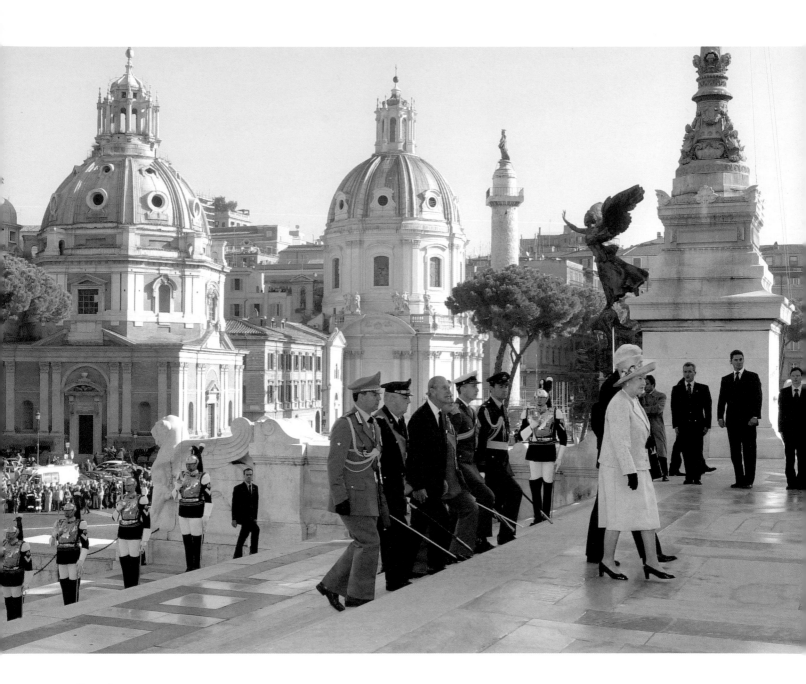

ABOVE: *Same place, same routine 20 years later. I was the only photographer to shoot both occasions.*

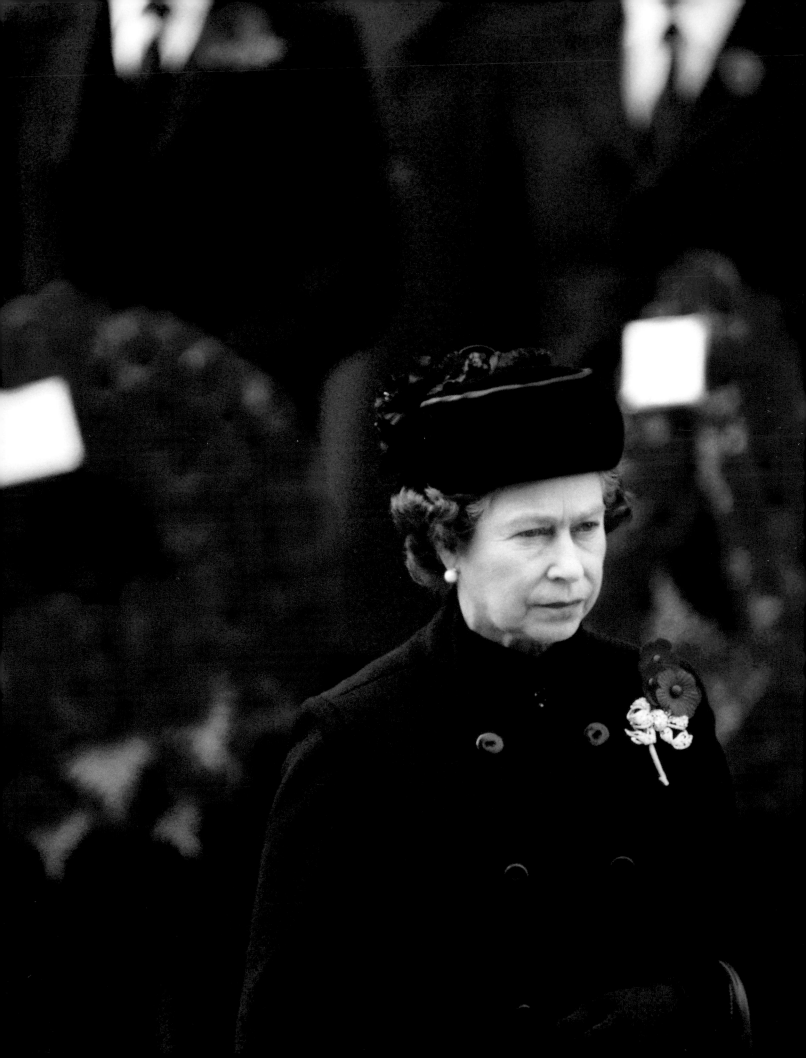

OPPOSITE: *Every year at the eleventh hour on the Sunday closest to the eleventh day of the eleventh month a sombre Queen, as monarch and patron of the British Royal Legion, leads members of the Royal Family and her government in a memorial service at the Cenotaph in London's Whitehall. Here they pay tribute to those who died or were injured in two world wars and more recent conflicts.*

NEAR RIGHT: *For 50 years the Queen has donned the Imperial State Crown for the State Opening of Parliament. This ceremony normally takes place in November, or immediately after a general election, as in 2001.*

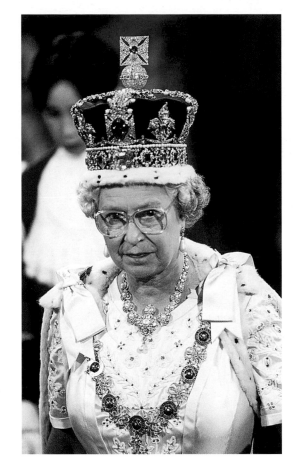

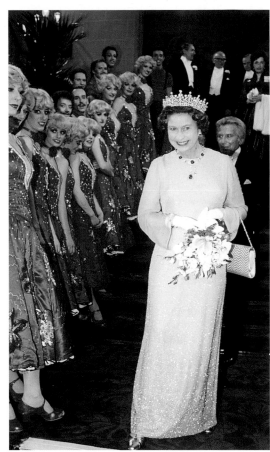

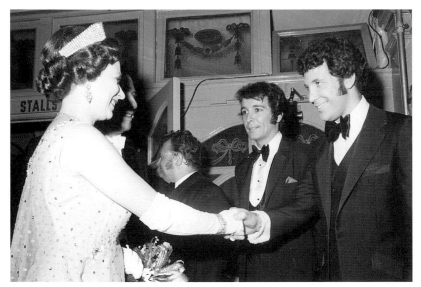

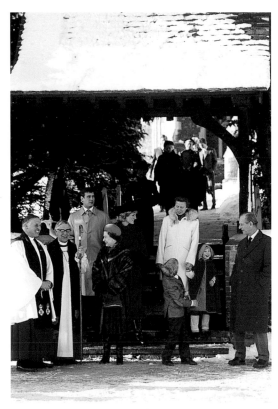

TOP RIGHT: *Newspapers reported a discreet request from Buckingham Palace to curtail the length of the Royal Variety Performance after 'too much variety' in 1981. Among the entertainers that year were dancers from the Moulin Rouge in Paris.*

ABOVE: *Tom Jones's sideburns help to date this much earlier picture. The Queen met the Welsh singer in November 1969 after he had performed at that year's Royal Variety Show. Looking on is the trumpeter Herb Alpert.*

RIGHT: *At last a white Christmas! In all the times I have photographed the Royal Family on Christmas Day, this occasion in 1985 is the only one where I can remember it being a 'traditional' wintry scene.*

Travels at Home

ODD AS IT MIGHT SEEM, Buckingham Palace keeps no tally of the Queen's official engagements within the UK. This self-appointed task is undertaken by Tim O'Donovan, a retired insurance broker, who compiles the figures every year from the details provided by the Court Circular in *The Times*.

In 2000, the most recent year for which figures have been compiled, the Queen undertook 418 engagements in the UK. Of these, 245 were investitures, meetings and audiences, 108 were official visits, opening ceremonies and other engagements, and 65 were receptions, lunches, dinners and banquets.

Every year the Queen receives literally thousands of invitations and requests, and these are whittled down at two major diary meetings in March and November. A provisional list is drawn up for the Queen's approval, then acceptances are sent out. The engagements she eventually undertakes may be broadly divided into theme days, regional visits and London engagements, great care having been taken to ensure an even spread of visits around the country.

Wherever she goes, the Queen's aim is to meet people and to be seen by as many as possible. Days out are therefore planned to encompass several events within a manageable distance of each other. A typical itinerary might involve opening an art gallery, touring sheltered accommodation for elderly people, visiting a school or giving a speech to an organization of which she is patron.

Before any visit takes place, however, members of her staff go on a reconnaissance trip, working out and timing the route to be followed, establishing the needs of local and national media, and examining what to do in the way of security. They also meet those who are to be her hosts to find out what they expect from the visit. For example, do they want her to cut a ribbon, unveil a plaque, attend a lunch or go on a walkabout? (If food and drink are involved, the hosts will be informed of

any likes and dislikes.) They also advise on certain aspects of royal protocol, such as when and how to greet the Queen, present flowers, or offer a gift.

On returning to Buckingham Palace, the staff work out a detailed itinerary, which is then presented to the Queen for her approval. Once agreed, the hosts are sent the details and all is made ready for the royal visit.

When undertaking any public engagement, the Queen is always attended by a lady-in-waiting, whose function is to help her in whatever way is appropriate. In the usual course of events, the lady-in-waiting is most often seen carrying some of the many flowers the Queen is given by well-wishers. After the event she will send handwritten letters of thanks to all those involved in the visit.

Now in the 50th year of her reign and the 76th year of her life, the Queen has slightly reduced the number of engagements she undertakes — only her due when you consider that most of the population retires at 65. She nonetheless remains the most hard-working monarch the world has ever known, and looks set to continue for many years to come.

ABOVE: *The royal Rolls-Royce has huge windows so that people in the crowd get a good view of the Queen.*

OPPOSITE, TOP: *The people of Torquay turn out in July 1988 to see the Queen's arrival for celebrations to mark the 300th anniversary of William of Orange and his wife Mary landing in England. By accepting the throne and thereby ousting James II, they ensured that the monarchy would remain in Protestant hands.*

OPPOSITE, RIGHT AND FAR RIGHT: *Determined to get his photograph, one spectator climbed a yacht's mast, while an on-duty policeman used his vantage point to take his own surveillance shots.*

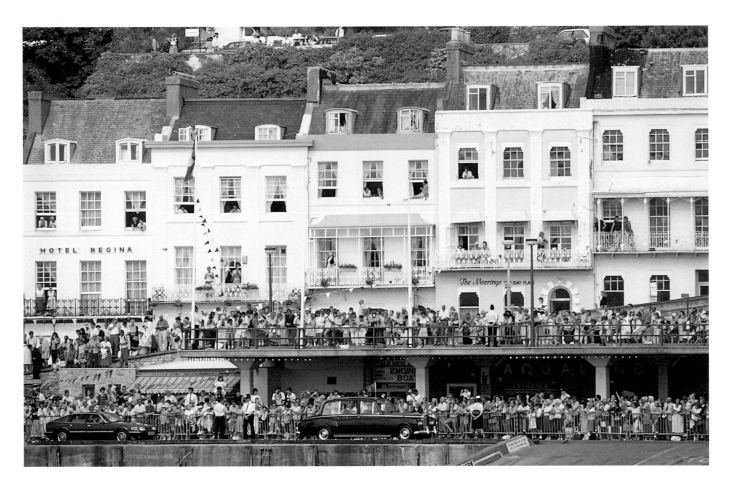

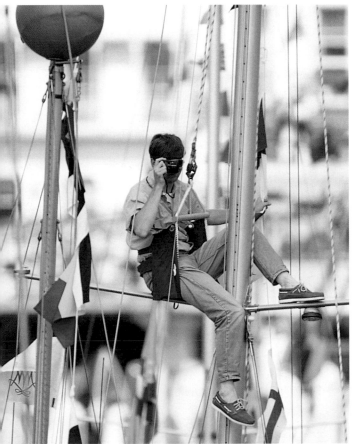

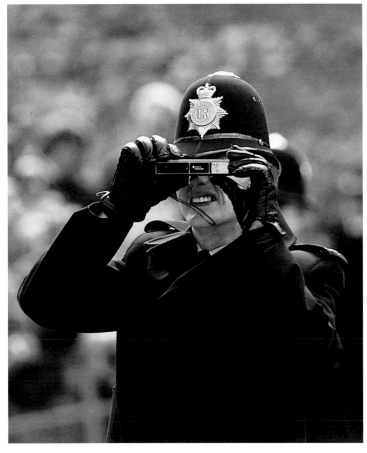

LEFT: *The Queen would have been glad of the sentiment, if a bit surprised by the spelling, during this visit to the University of East Anglia in June 1968. This is the first published photograph I ever took of the Queen. I was 19 and working for a London photo news agency as an assistant photographer. The man on the left scowling at me was the Queen's police bodyguard at the time, Mr Perkins. Nowadays the Queen's protection necessitates a far greater number of specialist police officers, but they remain as immaculate and discreet as their predecessors. Her lady-in-waiting (centre) remains a loyal companion to this day.*

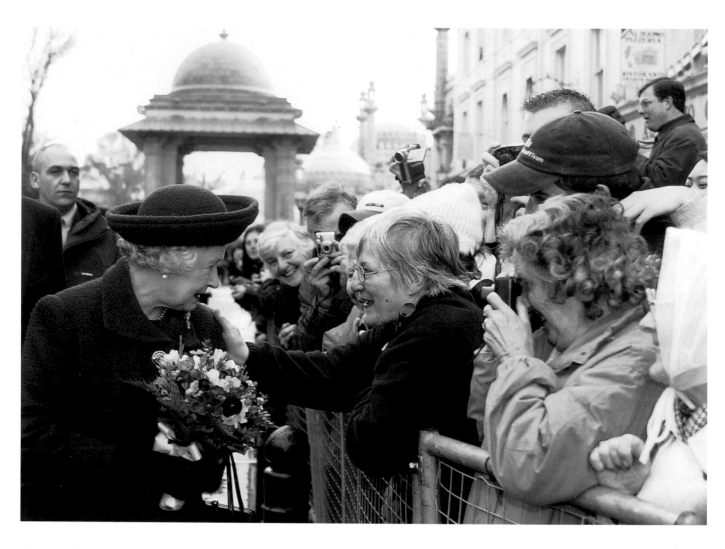

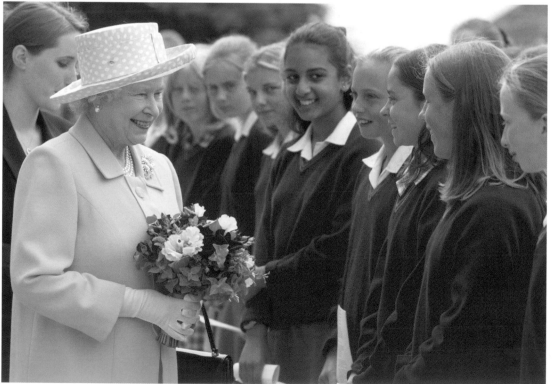

ABOVE: *A pat on the shoulder for the Queen during a visit to Brighton in March 2001. Although I have photographed many walkabouts, I've noticed that few people have had the courage to reach out and touch.*

LEFT: *Visiting the Channel Islands in July 2001, the Queen visited Jersey College for Girls and chatted with pupils as she was leaving.*

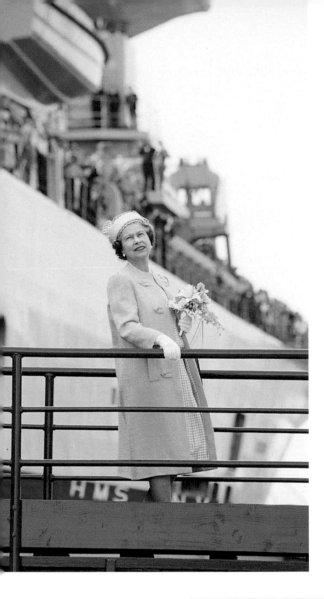

RIGHT: *It so happened that in 1984 we had a female monarch, a female prime minister and a female lord mayor of London for the first time in history. Here, during a visit to St Paul's Cathedral that November, the Queen laughed with the mayor, Lady Donaldson.*

ABOVE AND RIGHT: *Perhaps because HMS* Invincible *had been home to her son, Prince Andrew, during the Falklands conflict, the Queen was particularly happy to accept an invitation to attend its recommissioning ceremony at Portsmouth in May 1989. Here she joined the crew in singing hymns before meeting members of the ship's company and their families.*

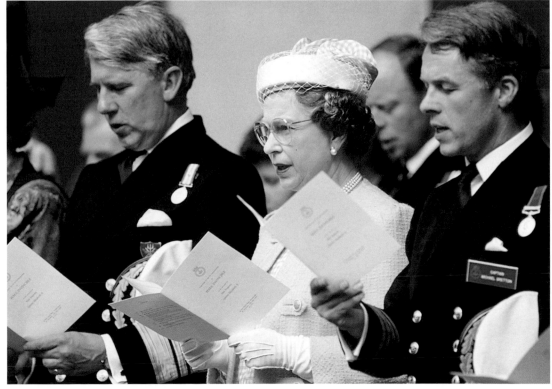

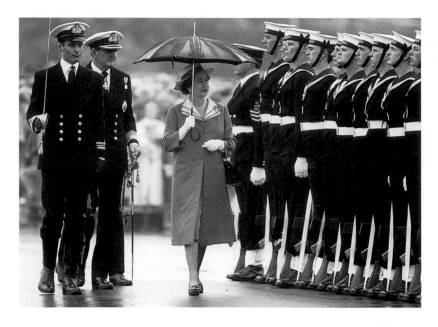

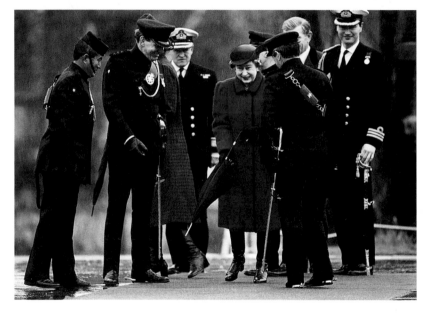

As head of the armed forces, the Queen visits many of her troops in the UK and overseas each year.

TOP: *Inspecting a naval guard of honour in Plymouth in July 1988 and (above) dodging the rain showers while visiting Queen Elizabeth's Own Gurkha Rifles at Church Crookham in Hampshire in February 1989.*

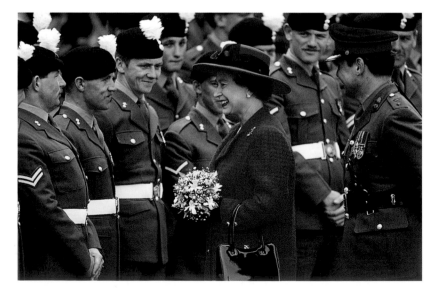

LEFT AND ABOVE: *Laughing with soldiers at Powys Castle in Wales when on a visit to the Royal Welch Fusiliers. The Queen also met American soldiers in uniforms worn at the time of the American War of Independence. That day was the regiment's 300th birthday and the Queen's 63rd.*

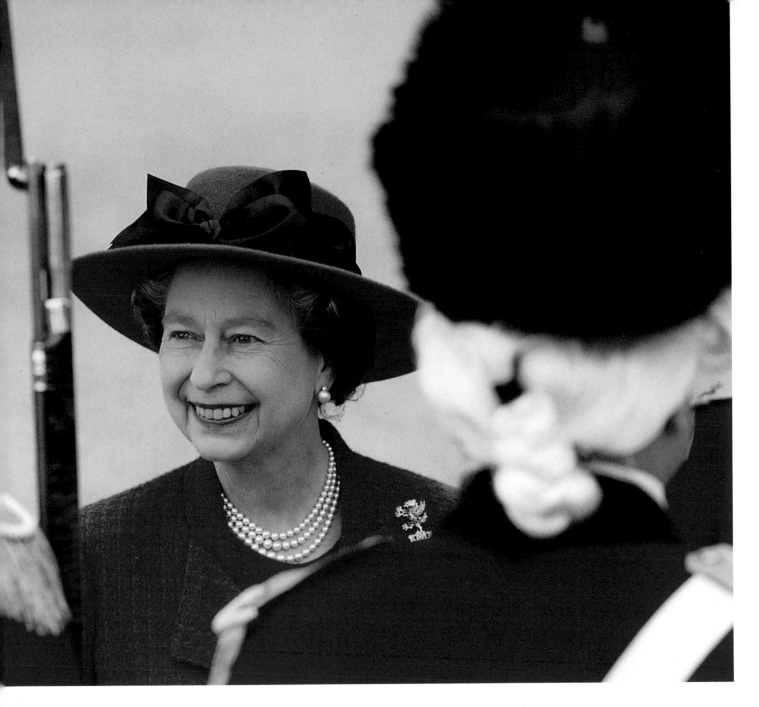

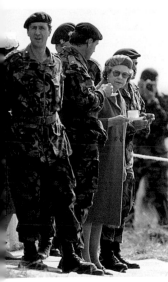

RIGHT: *Another guard of honour – this time the 5th Airborne Brigade at Salisbury Plain in May 1990. Later that day, while balancing a cup of tea in her hand (left), the Queen watched as dozens of her troops dropped from the skies.*

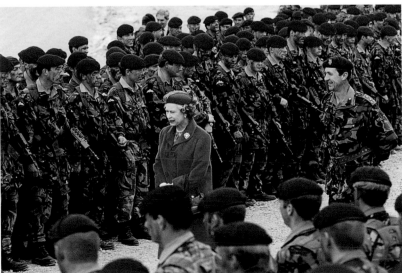

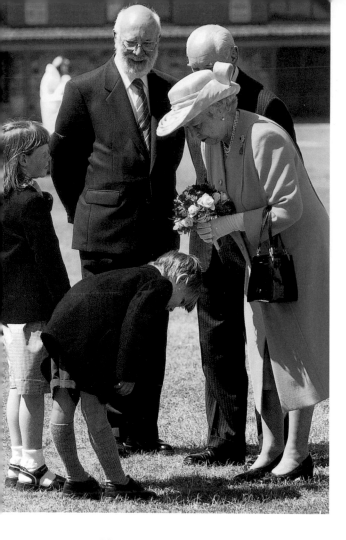

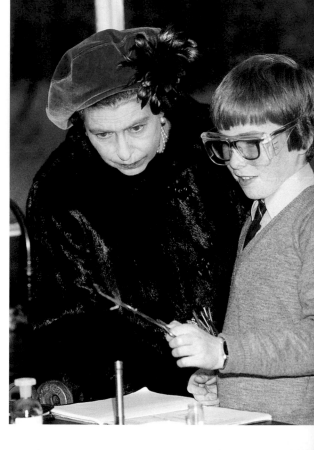

LEFT: *After presenting a posy to the Queen on her arrival in Alderney in July 2001, a local schoolboy gives a well-practised bow – so low, I thought he'd topple over.*

RIGHT: *During a visit to Parmiter's School near Watford in December 1981, the Queen was shown a scientific experiment in the chemistry lab. It was a bitterly cold day, so she wore her mink coat, but nowadays she is rarely seen in fur.*

RIGHT: *The not-so-young raise a smile during a visit to Portsmouth in May 1987 to mark the 200th anniversary of the departure of the first fleet to Australia.*

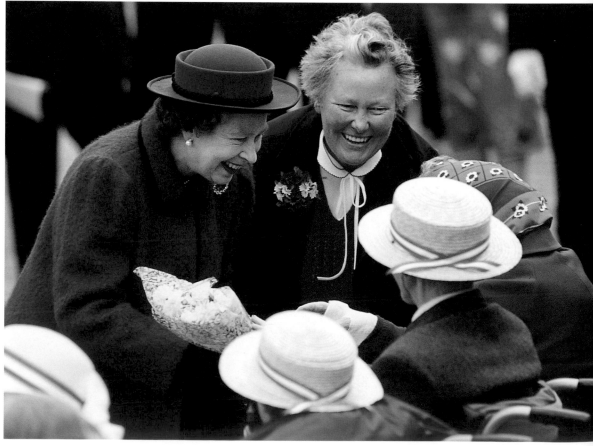

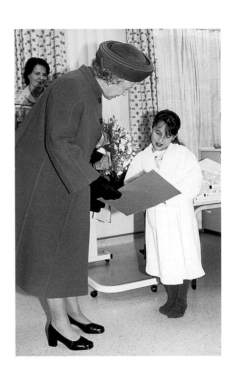

LEFT: *During a visit to Winchester in November 1993, a camera that should have been photographing the Queen instead landed at her feet, giving its owner a special memory of the day.*

RIGHT: *A young patient presents the Queen with a card she has made to mark her visit to Bedford Hospital in 1996. Many children's charities feature among the Queen's patronages, including Barnardo's, the NSPCC, National Children's Homes, Save the Children Fund and hospitals for sick children.*

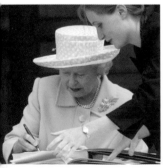

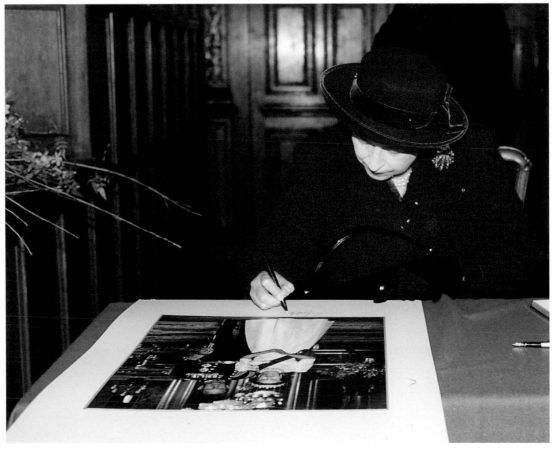

ABOVE: *Signing a visitors' book in the Channel Islands in 2001. The Queen always takes her own pen for signing sessions as, on occasion, her hosts have invested in a smart new pen for her signature but haven't checked the ink flow.*

RIGHT: *During a 1991 visit to her grandchildren's school, Port Regis in Dorset, I caught the Queen signing one of my photographs. It was part of a series I had been invited to take for official purposes.*

BELOW: *Chatting with the Dean of Westminster Abbey after arriving for the Commonwealth Observance Service in March 1990. This day is celebrated throughout the Commonwealth every year on the second Monday in March.*

ABOVE: *Although it looks like she's returning a salute, the Queen is just holding on to her hat as she comes ashore on a blustery day in the Isle of Man in August 1989.*

LEFT: *The Queen looks happy and relaxed on a sunny day at Windsor.*

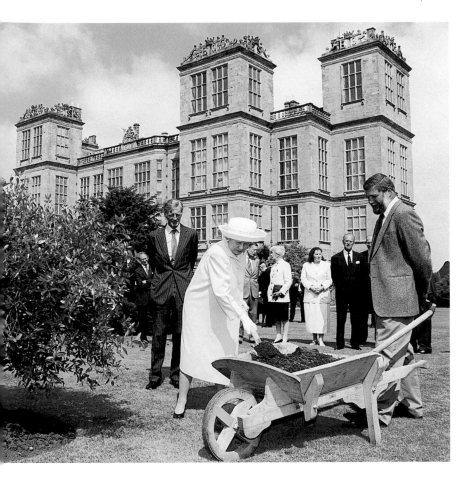

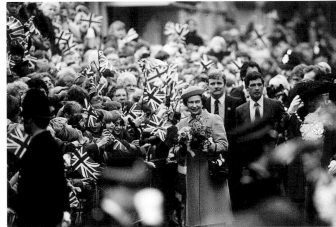

LEFT: *Unlike Prince Charles, who usually chats to any tree he plants and wishes it well, the Queen simply does the spadework. She planted this tree during a visit to Hardwick Hall in Derbyshire in July 1997 to mark its 400th anniversary. The building is one of Britain's foremost Elizabethan houses.*

BELOW: *A typical walkabout scene in the UK. Union Jack flags, policemen in uniform and the Queen in a brightly coloured outfit so she can be spotted in the crowd were all part of a visit to Maidstone, Kent, in October 1984.*

RIGHT: *Something to tell the piglets later – the Queen's visit to the Festival of Food and Farming in May 1989.*

FAR RIGHT: *Ducks at the Wildfowl and Wetlands Trust at Slimbridge in Gloucestershire are fed by their patron, the Queen, in March 1996.*

OVERLEAF: *Bikes, buggies and babies help to make this picture as the people of Alderney say farewell to the Queen after her two-day visit to the Channel Islands in July 2001. The helicopter in the background carries her entourage.*

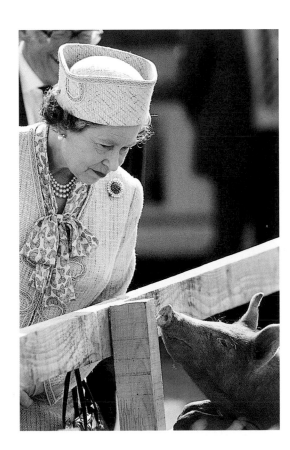

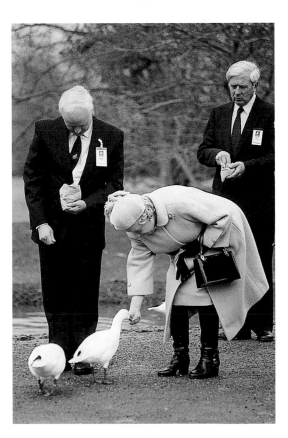

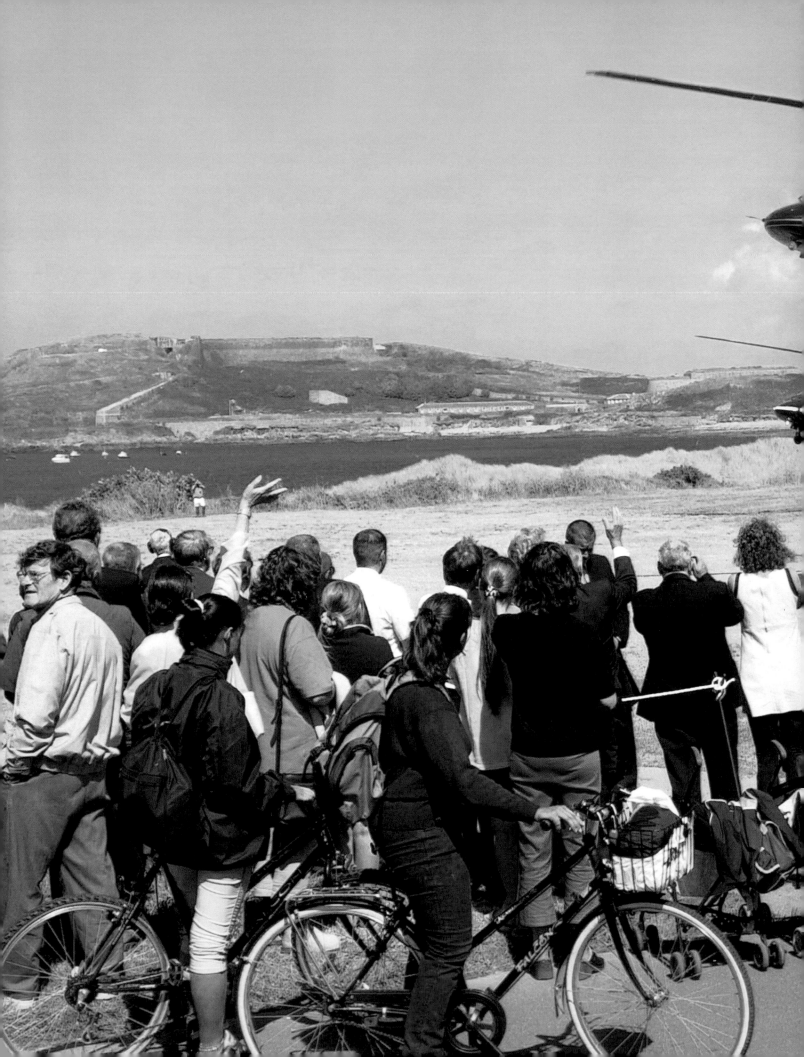

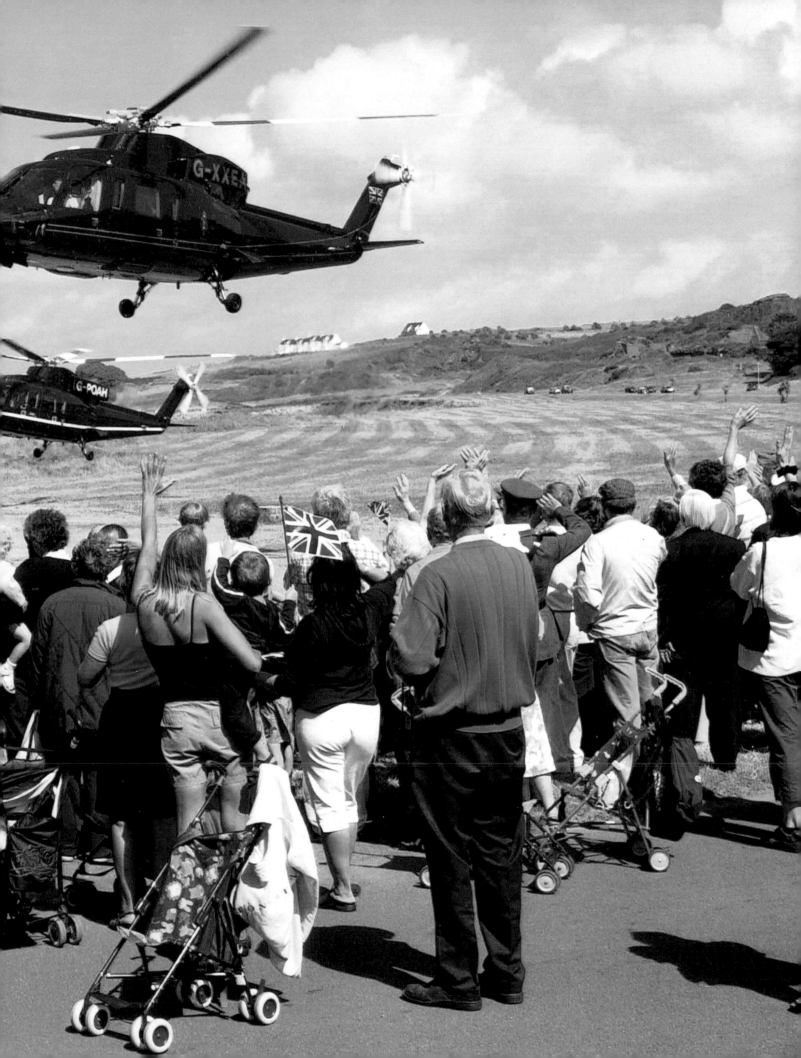

Clothes and Couturiers

I have to thank the girls in my office for researching the Queen's outfits and jewels in this section. My own knowledge of ladies' fashions is sparse and I have no great wish to increase it.

BELOW: *At Hardy Amies special books are kept of all the outfits created for the Queen. They contain tiny fabric swatches and brief descriptions of each design, many for overseas tours.*

THE QUEEN COULD NEVER be described as a style icon, but there is no doubt that she has style, and it is very much of her own making. While some may condemn her appearance as frumpy, others argue that it perfectly complements the demands of her job, being neat and largely unremarkable in an age when individuality has been exalted at the expense of dignity, and fashion muddles have reigned among the masses.

As so much of her life is spent under public scrutiny, her clothes must be smart, coordinated and practical. There is no place for fabrics that crease easily or colour combinations that distract from the woman herself. Look at photographs of her taken over the years and there is always a nod towards fashion trends, whether in the length of the hemline, the size of lapel or the width of sleeve. But the fact remains that her style has changed little since the 1950s. Its essence is simple tailoring with a striking brooch and a string of pearls.

Like the monarchy itself, the Queen's clothes have a timelessness, and no one element dominates the whole. She is a figurehead, not a fashion icon, and this has allowed her to ignore any criticisms levelled at her appearance.

The best known of her couturiers have been Hardy Amies, who has a quintessentially English county style, and the late Norman Hartnell, who had more theatrical leanings and was rather fond of sequins and beading. The outfits designed by these two fashion houses were for town and public appearances, and it is reported that the Queen would wear them even when she didn't like the colours – a clear indication that she regarded them as 'work clothes', a uniform that went with the job.

The Queen's evening dresses, often made of rigid-looking satin, are frequently worn with royal regalia, such as sashes with decorations, and with ornate tiaras and jewellery. For this reason, the gowns are usually quite simple, providing a plain background to show the accoutrements to best

advantage. Again, the clothes are part of the job rather than a reflection of the wearer.

Being well known for her personal frugality, the Queen would not be ashamed to admit that she wears her clothes on multiple occasions. New items tend to be acquired for overseas visits, and these are initially selected from sketches and swatches presented by her regular couturiers. Attempts are sometimes made to add a little local flavour to the designs, and this has met with varying degrees of success. For example, on a visit to the West Coast of the USA the Queen wore what was universally regarded as an unflattering suit patterned with yachts (see page 67). Fortunately, her evening dress embroidered with California poppies (see page 102) elicited much more approval.

When dressing to suit herself, comfort and ease are the key words, so she opts for tweedy skirt and jacket, headscarf and flat shoes – a style that suits the inner woman, who loves dogs, horses and country pursuits.

After 50 years on the throne, the Queen understands the demands of her job better than anyone, and her subjects have come to realize that it is substance rather than style that makes a good monarch.

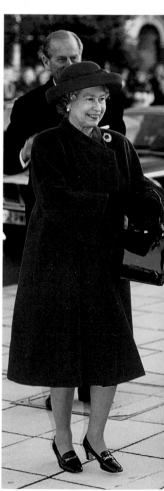

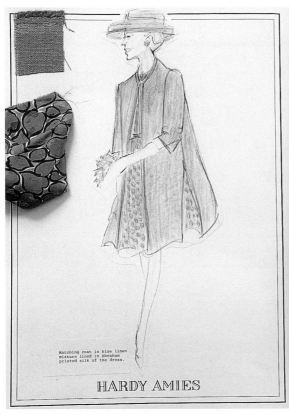

Matching coat in blue linen
mixture lined in Abraham
printed silk of the dress.

HARDY AMIES

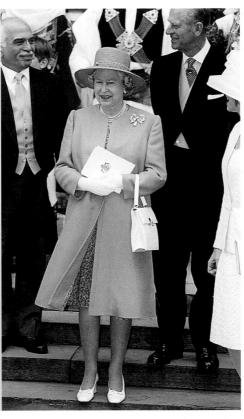

LEFT: *The Queen wore this blue linen coat and printed silk dress to the wedding of Crown Prince Pavlos of Greece to Marie Chantal Millar at St Sophia's Cathedral in London in 1995. She wore the same outfit to meet President Mandela when she visited South Africa. The sketch shows that the coat is lined with a patterned silk to match the dress.*

BELOW: *During her visit to Durban, South Africa, the Queen chose this bright yellow printed silk dress and jacket by Hardy Amies. As with all her light summer clothes, it is lined with organza to prevent static cling, and the hemline is weighted to prevent breezes playing tricks.*

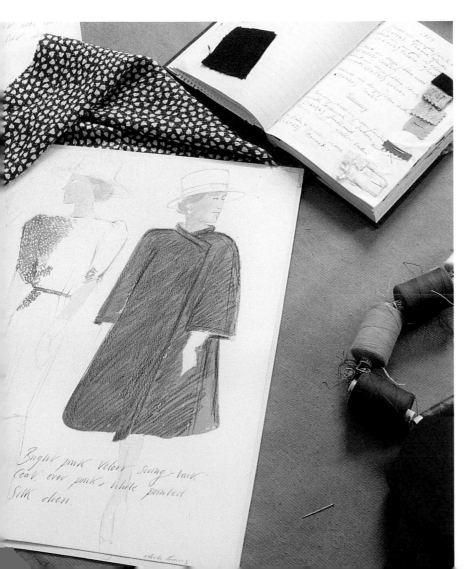

Bright pink velvet swing-back
coat over pink white printed
silk chon.

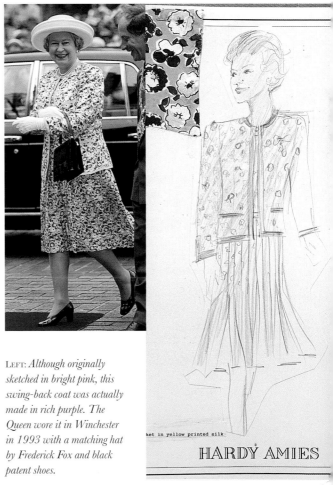

LEFT: *Although originally sketched in bright pink, this swing-back coat was actually made in rich purple. The Queen wore it in Winchester in 1993 with a matching hat by Frederick Fox and black patent shoes.*

ket in yellow printed silk

HARDY AMIES

Day Wear

RIGHT: *Couturier John
Anderson sketching at his
Chiltern Street showroom.
Working with Karl-Ludwig
Rehse, he designed and made
outfits for the Queen and the
Queen Mother.*

BELOW: *The fabric on John
Anderson's desk can be seen on
the Queen in Cyprus in 1993
where she wore his design with
a dramatic matching hat by
Philip Somerville.*

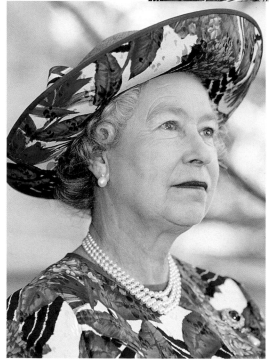

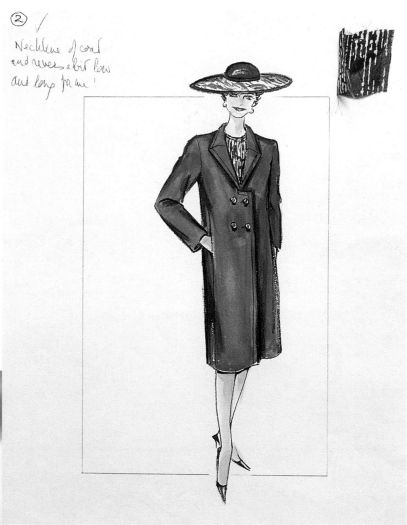

RIGHT: *John Anderson
designed this coat in 1990.
A note from the Queen on the
sketch says, 'Neckline of coat
and revers a bit low and long
for me', so the finished outfit
has been modified accordingly.
The wide-brimmed hat was
replaced by something smaller,
designed by Philip Somerville.*

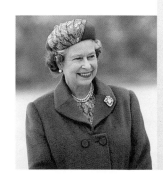

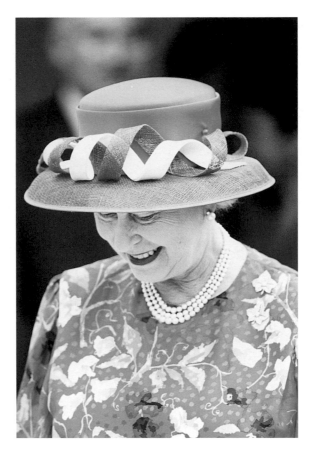

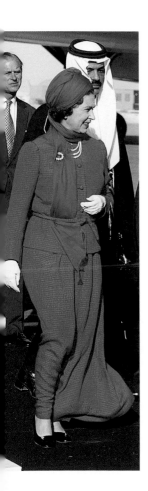

FAR LEFT: *In deference to Saudi Arabian custom, the Queen wore a full-length outfit to meet King Khalid in 1979. A year later in Tunisia (near left), the same outfit appeared shortened to knee-length and minus its scarf.*

ABOVE AND RIGHT: *This orange spotted dress and jacket underwent a similar transformation.*

BELOW, LEFT TO RIGHT: *The pink coat, with pink and taupe dress, was designed by Ian Thomas, while the hat was by Marie O'Regan. The outfit, for the Queen's visit to France in 1992, was worn, unusually, with taupe accessories ; the Karl-Ludwig Rehse blue bouclé suit with flecks of pink, yellow and turquoise was worn with a bright pink hat and blouse for a visit to Newmarket in 1994; for her 1993 visit to Hungary the Queen chose an unusual eau-de-Nil three-quarter-length coat and matching dress, with a hat trimmed in soft pink, repeated in the colour of her gloves; the pale green wool crêpe coat with a printed jacquard silk dress worn to the Derby in 1998 is another Karl-Ludwig design, matched by a Philip Somerville hat; the rich red wool coat by Peter Enrione, and hat with upturned brim, matched Prince Philip's university gown on this day in Cambridge in 1996.*

LEFT: *This mint green silk coat with matching dress typifies the Queen's style during the 1970s, when Sir Norman Hartnell was designing many of her outfits. The white accessories tie in with the white flowers on the hat.*

ABOVE: *The Queen has teamed this dark blue coat designed by John Anderson with a yellow-brimmed hat. Jewels are always an important feature, with some outfits being specifically designed to complement them. In this case the Queen has chosen Cartier gold flower clips with sapphires and brilliant-cut diamonds in the centre.*

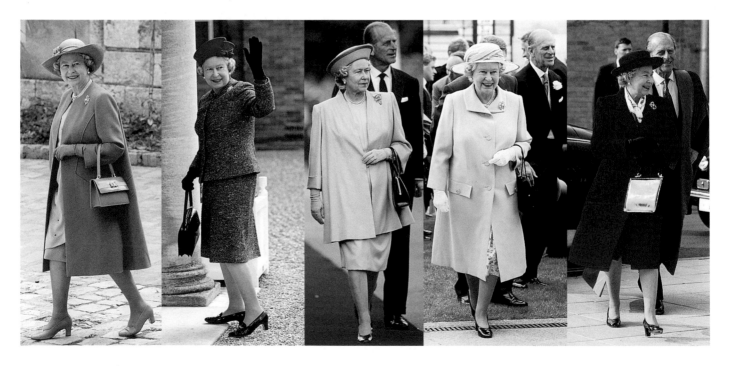

ABOVE: *Commentators referred to this as the Queen's 'Smartie' outfit because the multicoloured polka-dots resembled the well-known sweets. Designed by Ian Thomas, with a hat by Marie O'Regan, it made her easy to spot among the crowds in Budapest in 1993.*

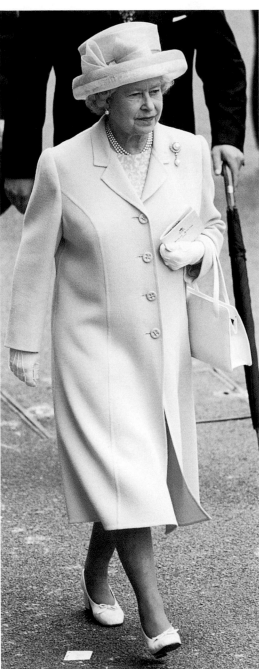

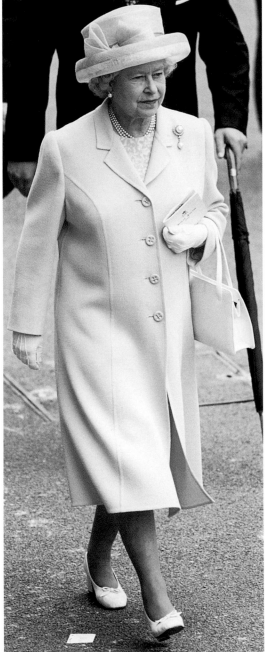

LEFT: *This peach wool coat and silk dress was designed by Hardy Amies and teamed with a hat by Frederick Fox for Ascot in 1999.*

BELOW: *This warm red wool coat and hat by Peter Enrione and Marie O'Regan were ideal for the Queen's visit to Warsaw, Poland, in 1996.*

ABOVE: *Sir Norman Hartnell designed what fashion writers dubbed the 'Pearly Queen' suit for the Queen's first visit to California in 1983. In fact, the blue and white outfit had a nautical theme – perhaps as a compliment to the sailors of the US Pacific Fleet whose ships she was to visit that day.*

LEFT: *The French, who know about fashion, deemed this Hardy Amies blue and white silk shantung outfit 'chic' when the Queen wore it to a luncheon in Paris in June 1992. Frederick Fox provided the flattering hat.*

Evening Wear

TOP LEFT: *The Queen arrived for a 1973 film premiere in London wearing this sequinned lace evening dress by Hardy Amies. With it she wore a white fur stole and a diamond tiara that had been a wedding gift to Queen Mary from the Girls of Great Britain and Ireland.*

NEAR LEFT: *Another Hardy Amies dress was the choice for a banquet given by the States of Guernsey in July 2001. On this occasion the Queen wore pearls rather than more formal diamonds.*

BOTTOM LEFT: *During her tour of Sri Lanka in 1981, the Queen wore this glamorous Hardy Amies evening dress – a cream and gold chiffon bodice over a full gold skirt – for a state banquet given by President and Mrs Jayewardene. With it she wore Queen Alexandra's Kokoshnik tiara, designed to resemble a Russian peasant girl's headdress, and Queen Victoria's collet necklace and earrings made from 28 stones removed from a Garter badge and a ceremonial sword.*

ABOVE: *This primrose-yellow silk dress by Hardy Amies, worn in 1986 in Nepal, is gathered on one shoulder where a diamond brooch, known as Queen Mary's Kensington Bow, completes the effect.*

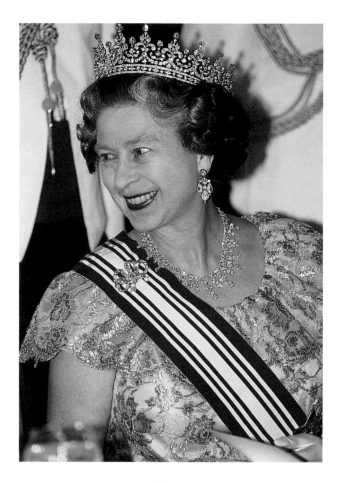

LEFT: *Glittering jewels complement this cream and gold lace evening dress by John Anderson, worn for a banquet in Singapore in October 1989. The collar of diamonds was given to the Queen by King Khalid in 1979, while the diamond bow brooch, made by Garrards in 1858, originally belonged to Queen Victoria and is one of a set of three. The Queen also wears the sash of the Singapore Order of Temasek – an honour bestowed by her hosts.*

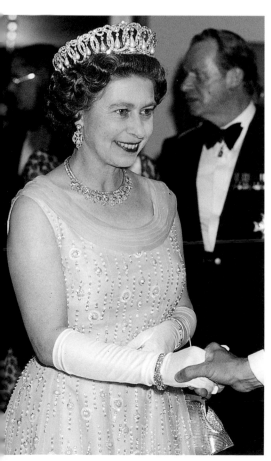

NEAR LEFT: *To celebrate her Golden Wedding anniversary, which was marked by a gala concert at the Royal Festival Hall in November 1997, the Queen chose an embroidered gold evening dress by Maureen Rose, teaming it with contemporary diamonds.*

FAR LEFT: *For a state banquet in Kiel, Germany, in 1978 the Queen is wearing an acid yellow, sequinned evening dress, the neckline of which is edged with chiffon. The fringe necklace of drop diamonds set with brilliants and baguettes was a gift from King Faisal of Saudi Arabia, while the tiara, originally made for the Grand Duchess Vladimir of Russia, is one the Queen inherited when she became monarch.*

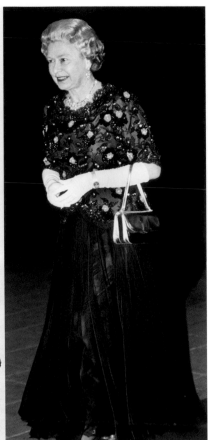

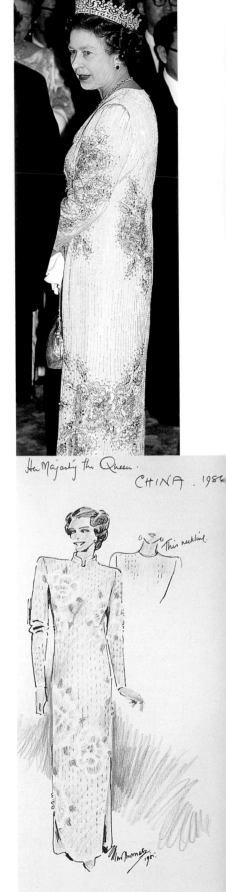

ABOVE: *This purple evening dress by John Anderson has a floating chiffon skirt and a fitted bodice decorated with coloured sequins. The designer's sketch for it is shown top left.*

Her Majesty the Queen.

CHINA. 1986.

This neckline.

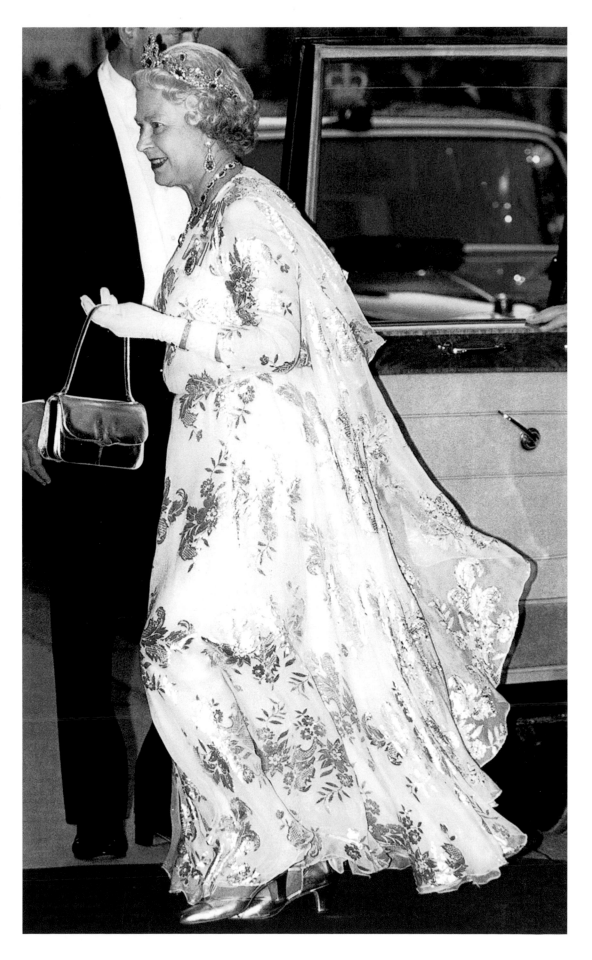

RIGHT: *For the banquet given by the Amir of Kuwait at Claridges in 1995 the Queen selected a white and silver chiffon evening dress by Maureen Rose. To add colour to the outfit she chose diamond jewellery studded with sapphires. The tiara had been specially made at the Queen's request to match the necklace and earrings that were a wedding gift from her father, George VI.*

OPPOSITE, TOP RIGHT AND BOTTOM RIGHT: *For the Queen's meeting with President Li Xiannian at a banquet in Beijing in 1986, Ian Thomas designed a pink crêpe dress embroidered with crystal peonies, the national flower of China. The original sketch shows that he planned a further subtle compliment to the Chinese by including an oriental-style side-slit from ankle to knee and a mandarin collar. The Queen, however, opted for a simple round neckline so that she could wear her diamond and ruby necklace.*

OPPOSITE, CENTRE AND FAR LEFT: *The Queen wore this evening dress of embroidery and sequins by John Anderson during her state visit to Budapest in May 1993. Pale pink chiffon floats over one arm.*

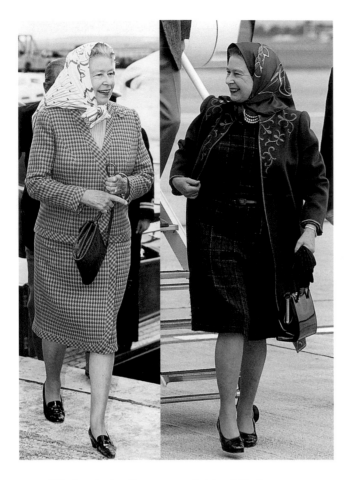

ABOVE: *Wearing a headscarf
tends to signify that the Queen
is off duty. Here, in 1995,
she had just arrived in the
tiny fishing port of Scrabster,
en route to join her mother for
lunch at the Castle of Mey.*

ABOVE: *Arriving at Heathrow
in June 1988, the Queen
wears a checked dress with
a dark green overcoat and
toning headscarf.*

ABOVE: *On a warm spring
day the Queen looks happy
and relaxed in an informal
white blouse teamed with a
checked skirt and leather belt.*

Casual Wear

LEFT: *The vagaries of the
English weather call for layer
dressing. Here the Queen
wears a variety of styles to
suit the conditions.*

NEAR RIGHT: *The Queen, always a keen photographer, is taking a shot of the horses at the vet inspection at the Badminton Horse Trials in April 1973. Like Prince Philip, she is wearing suede for this occasion. Her dark brown jacket and toning gloves show her eye for detail even when dressing casually. A wool, box-pleated skirt, thick wool tights and tassled brogues complete the look.*

FAR RIGHT: *Warmly dressed in a herringbone coat and headscarf, the Queen waits to photograph her husband, who is competing in the carriage-driving competition at the Royal Windsor Horse Show in May 1981.*

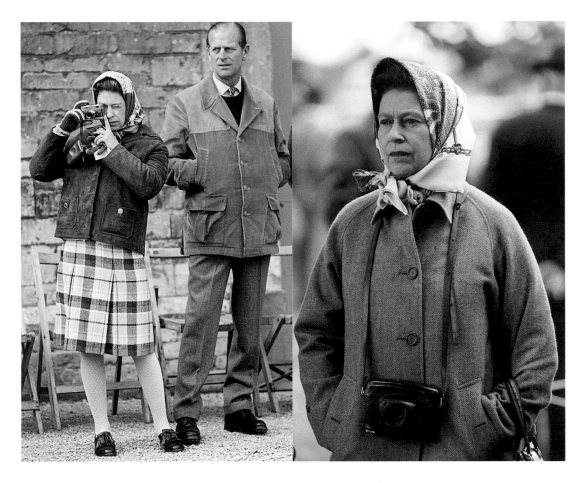

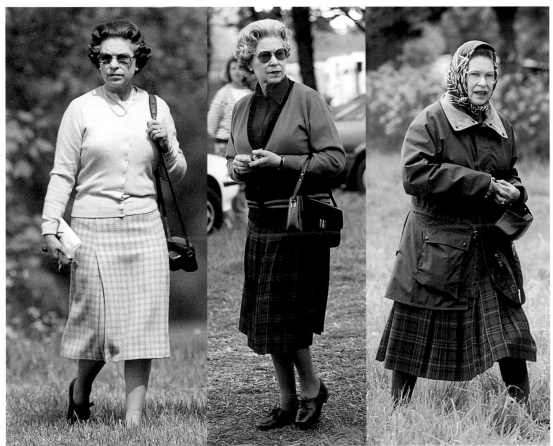

LEFT: *When out and about the Queen favours heavy lace-up shoes, which she usually teams with a wool skirt, casual blouse and cardigan. Royal warrants granted to firms such as Austin Reed, Barbour, Burberrys, Countrywear of Ballater, Daks, Lillywhites and Pringle indicate some of the Queen's preferences when choosing off-the-peg clothes.*

Hats and Hatmakers

ABOVE: *Milliner Philip Somerville, awarded a Royal Warrant in 1994, sits in his workroom with a sketch of a new hat for the Queen. To ensure a coordinated look, sketches and fabric swatches are passed from dress designer to milliner. Each of the Queen's milliners tends to work in collaboration with one of her dress designers. In Philip Somerville's case, it was John Anderson, and then his successor Karl-Ludwig Rehse, who was later awarded a Royal Warrant in his own right.*

OPPOSITE, BOTTOM LEFT: *This feathered hat, designed by Frederick Fox, was worn for the christening of Prince William. The Queen wore it again during her tour of the Solomon Islands in 1982.*

HOW MANY WOMEN these days feel underdressed without a hat? Very few indeed, but we would be surprised to see the Queen at a public function without one. In these informal days, they are a symbol of formality – a substitute for a crown – and help to make her stand out from the crowd. Her hats are stylish accessories designed to flatter her face and her outfit, but they also tend to be real talking points.

Always aware of the need for people to see her and for photographers to get clear shots, the Queen rarely wears hats with a wide brim. Apart from obscuring her face, they cast unhelpful shadows and are more likely to be whipped off by high winds.

The longest-established of theQueen's hat-makers is Frederick Fox, who has been her milliner since 1969. Born in Australia, he began making hats for fun at the age of 12, but came to prominence in 1963, when he took over the high-class English millinery firm of Langee. He became a Royal Warrant Holder in 1974 and usually makes the hats that accompany the Queen's Hardy Amies outfits.

In recent years, one of his most popular creations was the simple headdress he designed to go with the Queen's widely praised outfit for the wedding of Prince Edward to Sophie Rhys-Jones in 1999 – an airy concoction of lilac feathers with pearl stamens.

Philip Somerville is a newer recruit to the Queen's millinery team, although his designs have graced many royal heads over the years. He began his career in New Zealand, but spent his most formative hat-making years with Otto Lucas, Britain's premier hat designer during the 1960s. He went on to open his own millinery business and quickly established a reputation for producing collections that could be dramatic and eye-catching while still being totally wearable.

A Royal Warrant Holder since 1994, Philip Somerville often works now in collaboration with Karl-Ludwig Rehse, who designs many of the Queen's clothes. Among the hats he has created for the Queen is the wide-brimmed royal blue creation with a white bow that she wore on arrival in Spain in 1988. (King Juan Carlos had to duck under the brim in order to greet her with a kiss.) A more

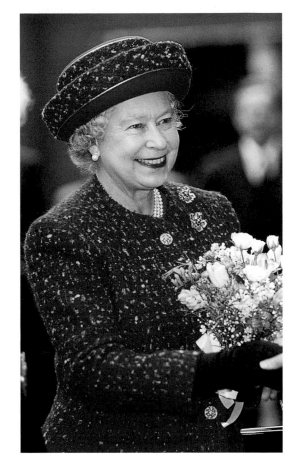

LEFT: *A close-up of Philip Somerville's workbench shows a hat for the Queen in the final stages of being trimmed. The original sketch sits next to it.*

RIGHT: *The Queen wears the hat shown left with a suit designed by John Anderson.*

BELOW: *A sketch by Philip Somerville of a hat worn by the Queen in Singapore (see page 82).*

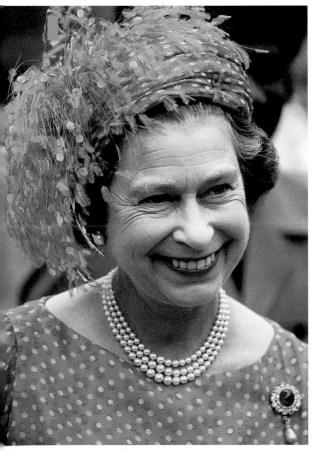

BELOW: *Frederick Fox at his showroom in Mayfair, London. His hats are usually teamed with outfits designed by Hardy Amies.*

BELOW RIGHT: *A milliner's block, sized for the Queen, is used by Frederick Fox to make all the hats he designs for her.*

recent design was the purple, cavalier-style hat with ostrich feathers that she wore to the inaugural opening of the Scottish Parliament in 1999.

The Queen and her designers do a huge amount to keep the millinery trade flourishing in these casual times. In fact, hats are an area of fashion in which the Queen might almost be described as trend-setting. Just look at the range of styles she's worn in recent years…

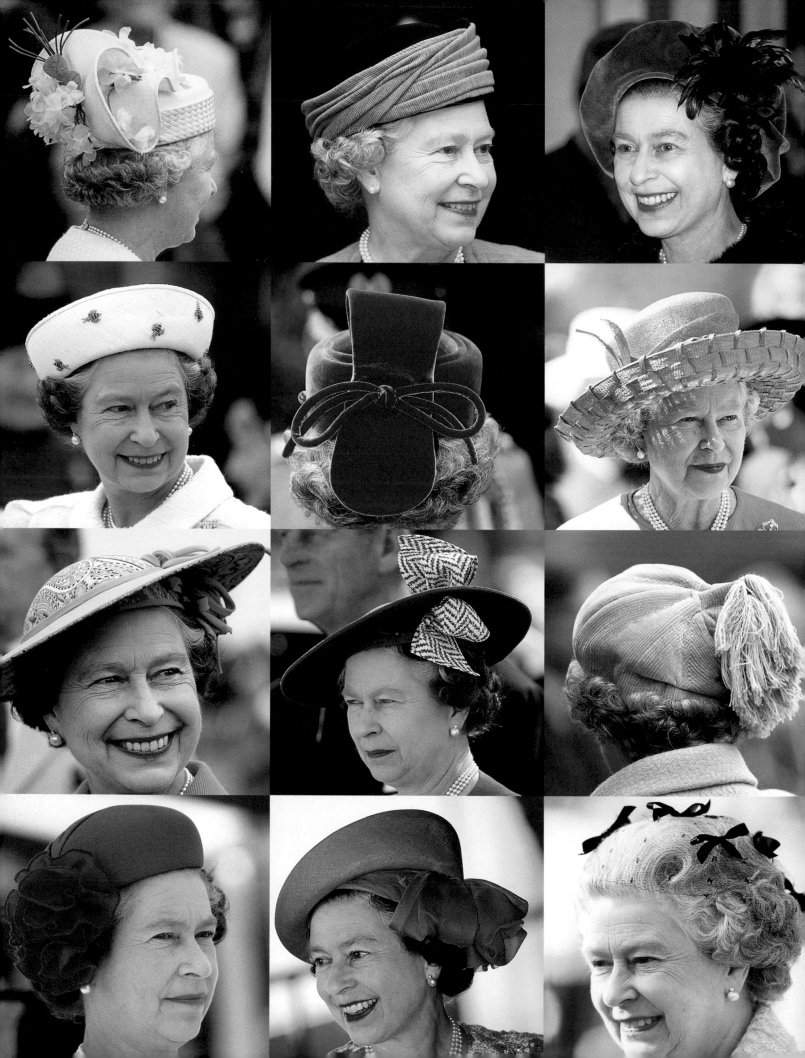

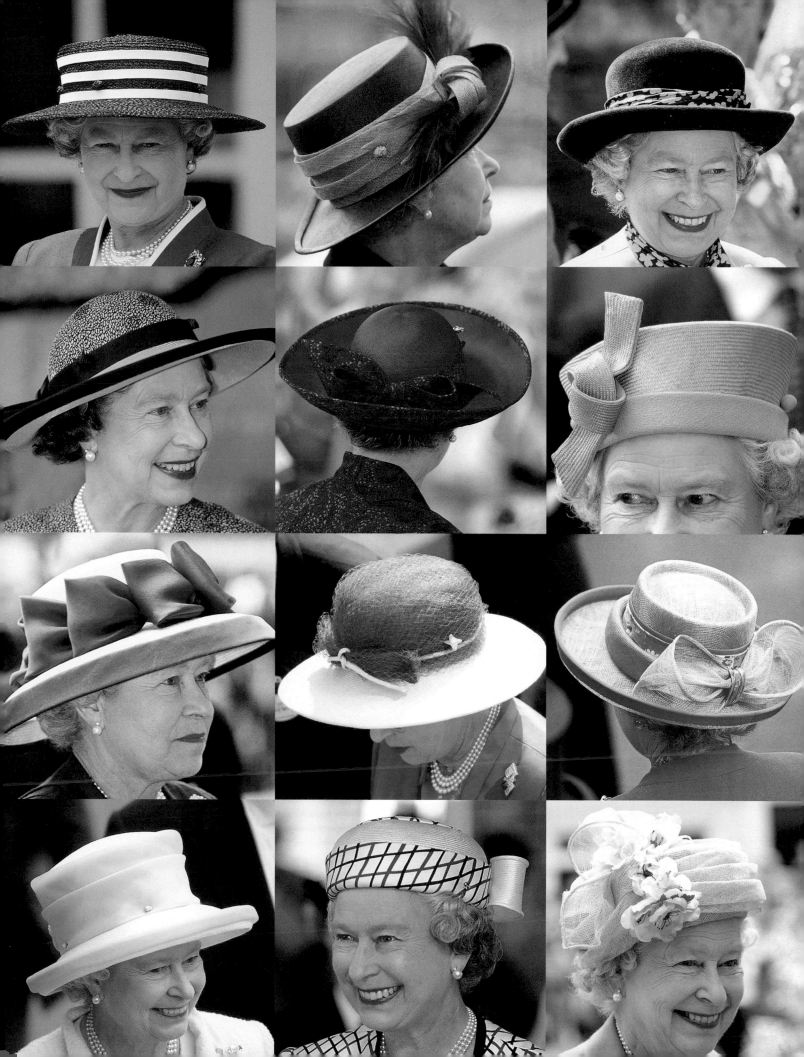

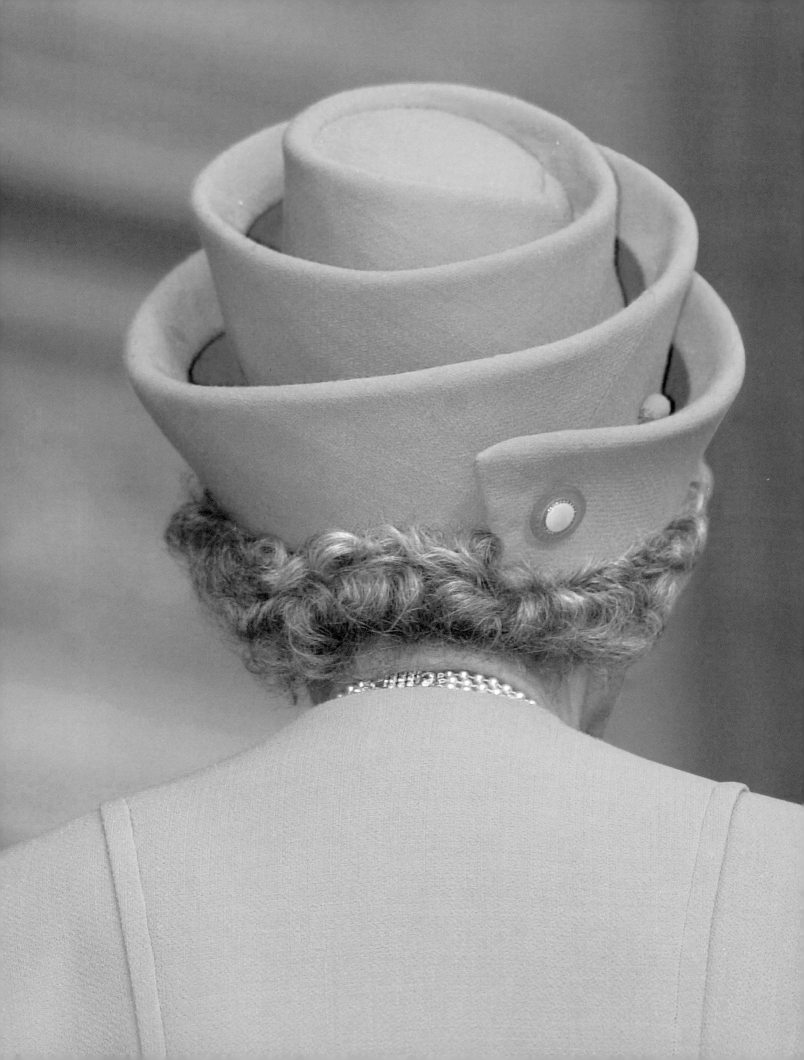

PAGES 76–7: *Some of the hundreds of hats that have been made for the Queen during her reign.*

OPPOSITE: *Reminiscent of a helter-skelter, this hat was made by Marie O'Regan and worn with a dress and coat by Maureen Rose for the Queen's visit to Rome in October 2000. The Italians know a thing or two about fashion, and were full of praise for the outfits worn by the Queen during this tour.*

RIGHT: *Inspired by Robin Hood? The arrow-tail detail on this Frederick Fox hat certainly looks jaunty. It was worn on a visit to Wales in April 1989.*

ABOVE: *This topi-style hat by Marie O'Regan was a bold choice with the matching turquoise outfit the Queen wore during her visit to Hungary in May 1993.*

ABOVE: *Frederick Fox created this unusual hat with a ruched crown to match a printed silk dress by Hardy Amies for the Queen's tour of India in 1983.*

ABOVE: *Photographers are often left with only a back view of the royal they want to photograph. In this case I captured the detail of the Queen's sun-hat worn in Bangladesh in 1983.*

Accessories and Jewels

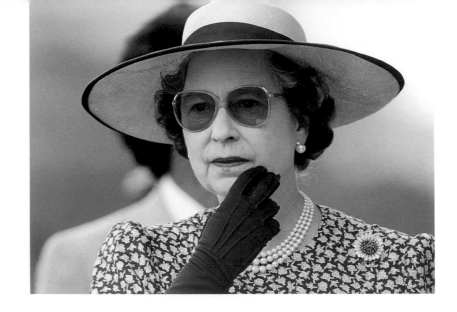

THE QUEEN'S SHOES are supplied by Anello & Davide, a London-based company that has specialized in handmade footwear since 1922. Originally renowned for theatrical and dance shoes, the company is now known for its innovative styles and attention to detail. The Queen tends to wear very plain styles with minimal detailing. Her generally simple court shoes have sensible low heels – ideal for walkabouts, but hardly the epitome of fashion, high or otherwise.

With evening dress, she sometimes departs from daytime simplicity and wears strappy slingbacks in silver or gold, or more ornate embroidered styles that may be dyed to match her gown. In every case they are made of the finest leather, silk or satin.

Many of the Queen's handbags are made by Launer, a company based near Birmingham, the traditional centre of leathergoods manufacturing in England. All their products are handmade from the finest leathers, lined with suede, fitted with pockets and finished with gold-plated fittings, including the company's twisted rope emblem.

Some designs are fitted with chains or adjustable straps, but the Queen seems to prefer short leather handles for everyday use. The classic Launer design that she took on her state visit to Italy in 2000 is typical of her taste and cost £360.

The Queen's gloves are made by Cornelia James, a company established in Brighton during the 1940s. Its traditional skills combined with first-rate materials saw it prosper, and it currently makes 10,000 pairs of gloves a year.

Cornelia James's first royal commission, which came via Hardy Amies, was to make gloves for Princess Elizabeth – to be worn at her wedding to Prince Philip. She was subsequently appointed glovemaker to the Queen and remained so until her death in 1999. The company continues its fine work and has thus retained its Royal Warrant.

The Queen's personal jewellery consists mainly of pieces that were gifts or bequests from close family members. The pearl-and-diamond button earrings that she most often wears were originally made as a wedding present for her grandmother, Queen Mary, who passed them on to her as a wedding present in 1947. The three-strand pearl necklace that she usually wears with them was a present from her grandfather, King George V, on the occasion of his Silver Jubilee in 1935. These items are usually accompanied by a brooch worn just below the left shoulder, and she has many brooches to choose from. They are stored in special leather cases which have separate trays for each type of stone – diamonds, sapphires, emeralds, and many more.

The collection is constantly expanding because organizations for whom the Queen opens buildings, launches ships or inaugurates production lines often present her with a piece of jewellery as a token of their thanks and appreciation. Similarly, the hosts on her state visits overseas tend to give her jewellery as a memento. Among those who hold Royal Warrants to supply jewellery to the Queen are Collingwood, Asprey and Garrard.

Inevitably, the pieces to which the Queen is most attached are the engagement ring and wedding bracelet given to her by Prince Philip. Both were made from a tiara belonging to his mother and remade to his own designs. The platinum ring has a large solitaire diamond in the centre and five smaller diamonds on either side. The bracelet is a favourite piece for evening wear.

ABOVE AND OPPOSITE: Simple sunglasses, a pair of gloves, discreet earrings and always a brooch – the Queen has very traditional tastes and is no slave to fashion.

ABOVE: The Queen favours a classic style of shoe with a medium heel for walkabouts and standabouts. This pair were made by H. & M. Rayne.

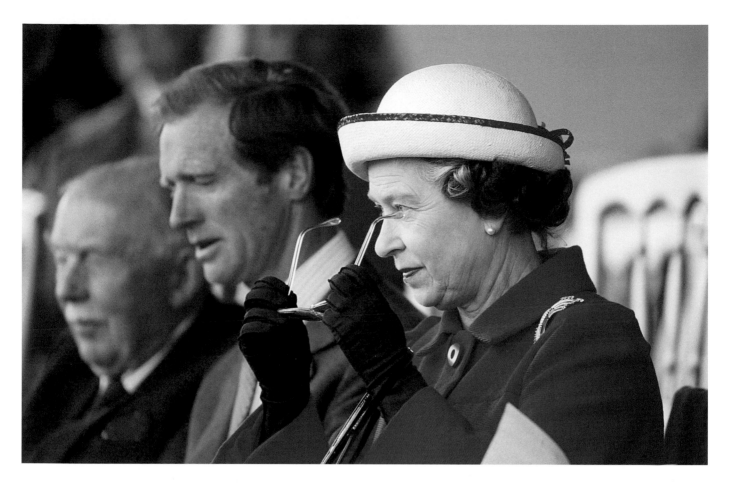

LEFT: *Over the years the Queen has enjoyed using successive models in Leica's M Series of range-finder cameras. Here she has an M6 engraved with her own cypher. The results from these cameras are stunning, but they are not as easy to use as some contemporary designs, and are normally favoured by professionals.*

RIGHT: *The newspapers at the time referred to this as the Queen's 'Nora Batty look', but woollen stockings and sturdy lace-ups have often been her choice for informal appearances on very cold days – as they were here at the Royal Windsor Horse Show in May 1989.*

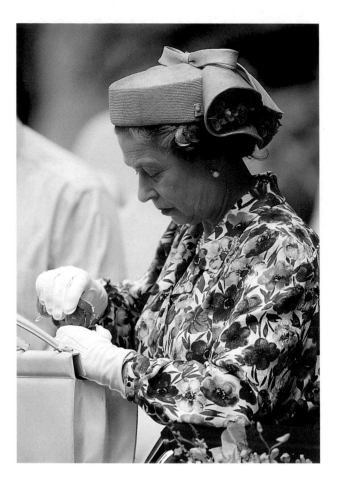

ABOVE: *When off duty, the Queen keeps things very simple – a silk scarf to match her outfit, a plain belt and a classic, leather-strapped watch.*

LEFT AND OPPOSITE: *The Queen's handbag goes everywhere with her. Even at home in Buckingham Palace she is rarely without it. While she was visiting the USA, one of the daily newspapers ran a competition to guess what she carried in it. There are definitely spare gloves stored within, particularly on days when white gloves are in use and there is much hand-shaking going on.*

It has been reported that the Queen uses her handbag to pass discreet signals to her staff by changing it from one wrist to another. In this way she can ask to be rescued from someone claiming too much of her time.

BELOW: *White, black and silver are the usual colours for the Queen's handbags. Her taste in bags has altered little over the years.*

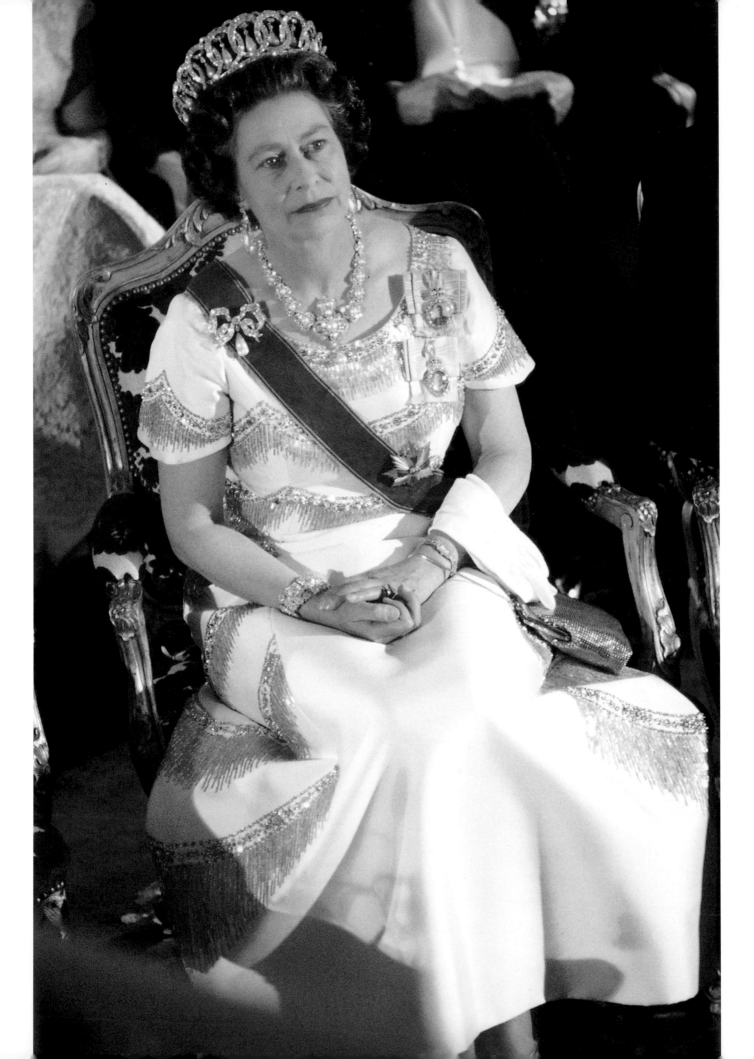

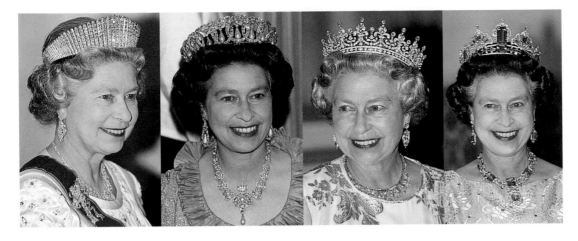

LEFT: *Some of the Queen's many tiaras. Far left is a diamond tiara made for Princess Alexandra in 1873. Second left is a diamond and pearl tiara, originally made for the Grand Duchess Vladimir of Russia. Third left is the Girls of Great Britain and Ireland Tiara. Near left is an aquamarine suite, a Coronation present from the president and people of Brazil.*

Royal jewellery is a symbol of the ongoing tradition of monarchy. Passed down from generation to generation, each glittering item has its own fascinating story.

OPPOSITE: *During a state visit to Germany in 1978, the Queen wore a dazzling array of royal jewels – the Grand Duchess Vladimir of Russia's tiara dating back to 1890, a diamond and pearl necklace that had been a gift to Queen Victoria on her Golden Jubilee, and a brooch that had been a wedding gift to Queen Mary.*

ABOVE RIGHT AND FAR RIGHT: *Brooches feature with every outfit, formal or informal. Here the Queen wears a drop pearl brooch and an amethyst and diamond brooch, the latter being part of one of the oldest sets she owns.*

LEFT: *As a change from the more usual tiara, the Queen wore a diamond hairclip for a banquet in Spain in 1988. Her other jewels were a gift from the Amir of Qatar.*

RIGHT AND FAR RIGHT: *Pearls are a daytime favourite for the Queen. She has three triple-strand necklaces – one a gift from her grandfather.*

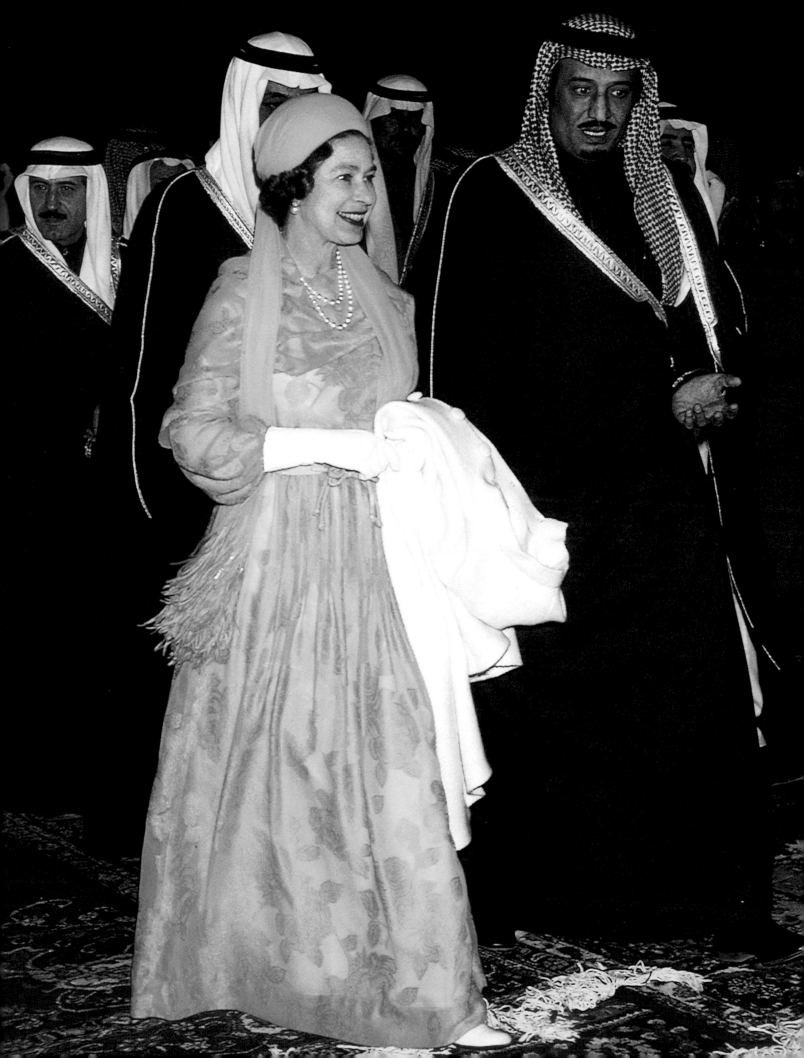

2

From Switzerland to the South Pacific, this section shows some of the exotic places the Queen has visited during her 50-year reign. It also looks at other important events that punctuate her year, including honours ceremonies and her famous garden parties.

The Queen carried out a three-week tour of the Gulf States in February 1979, visiting Kuwait, Bahrain, Saudi Arabia, Qatar, the United Arab Emirates and Oman. This was her first visit to the Middle East, and she was the first woman to be accorded equal rights in a male-dominated society. In Saudi Arabia, protocol demanded that she be clothed from head to foot with her hair covered when meeting the ruler, King Khalid. Here she is guided along a carpeted walkway in the desert to meet the King for a tented evening picnic.

Travels Abroad

HER MAJESTY QUEEN ELIZABETH II is the world's most-travelled head of state. Her tenure has, of course, been considerably longer than others in similar positions, but her annual mileage would rival that of any frequent flier. In the year 2000, for example, she clocked up nearly 30,000 miles on overseas visits – no mean achievement for a woman of 74.

Most of this mileage comes from visits to the 54 member countries of the Commonwealth, of which the Queen is symbolic head. However, as she said in her 1953 Christmas broadcast, 'I want to show that the Crown is not merely an abstract symbol of our unity, but a personal and living bond between you and me.' Her way of doing this is to take an active interest in each member country, and she has visited all of them at least once during her reign.

Preparations for the Queen's journeys begin about two years in advance. Once a destination is confirmed, a schedule is drawn up in consultation with the host country and, of course, the Queen herself. This careful planning, completed about a year before departure, ensures that all eventualities can be considered and that the final timetable will not be too taxing. A few weeks before the tour is to take place, a group of palace officials visits the host nation(s) and goes over every detail of the itinerary with local officials. The ultimate aim is for the Queen to see and be seen by as many people as possible, but taking care that her safety is never compromised.

Anyone who thinks official visits are a perk of the job would be well advised to look at the itinerary for a typical overseas tour. Every day, often 14 hours long, is strictly timetabled, with perhaps a dozen or more separate engagements to fulfil, many miles to travel, numerous people to meet and hundreds of hands to shake. If the Queen has seen and done it all before, you'd never guess it from her demeanour. Every display of singing

and dancing, every factory or hospital visit, every lunch and banquet are treated with interest and pleasure.

The benefits of the Queen's efforts are instantly apparent on one level: people are delighted to see her, glad that she has taken the trouble to visit and find out about them and their country. Other benefits may be less obvious to the world at large, but they undoubtedly occur. On her 1983 visit to the West Coast of the USA, for example, local branches of British banks and companies enjoyed a significant increase in business. Although the Queen did not specifically lobby for this, her presence alone was enough to inspire it.

To keep the Queen happy and healthy on all her journeys, certain items are always packed in the royal luggage. These include a hot-water bottle and a favourite feather pillow, Malvern water, an electric kettle, China and Indian tea, fruit cake and shortbread, barley sugar, jam, sausages and mint sauce. These familiar things are a welcome change from the more exotic tastes the Queen experiences in the line of duty. Other important items in the luggage are the gifts for her hosts, which, although modest, are fine examples of British workmanship in silver and leather.

The Queen is always careful to dress appropriately for the country or individual she is visiting. In Saudi Arabia, for example, where female flesh is always fully covered, her skirts were ankle-length and her sleeves long. In places where the dress code is less demanding, the Queen and her couturiers

ABOVE AND OPPOSITE, TOP: *The choice of Concorde to transport the Queen for her tour of the Gulf had more to do with flag-waving and encouraging exports than speedy arrival. At an earlier briefing in London we had been told that the Queen would wear a full-length day dress when in the presence of King Khalid, as Saudi custom demands. Nevertheless, as she stepped from Concorde, we were amazed to see her wearing a bright blue floor-length outfit and a turban-style hat – the most unusual outfit I had ever photographed her in.*

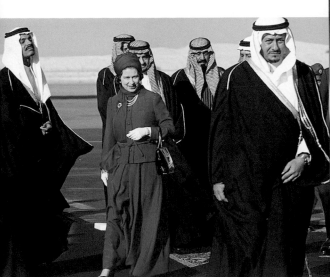

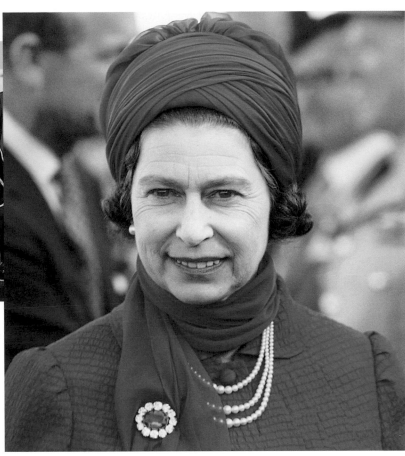

The Gulf

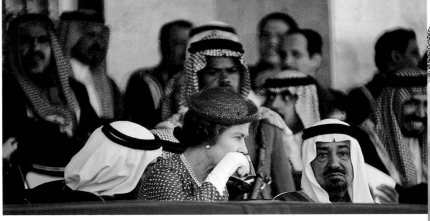

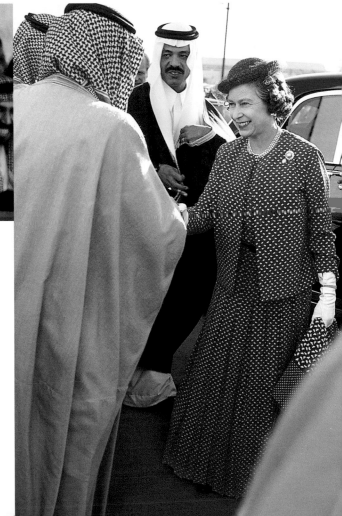

will still acknowledge local history or traditions by incorporating motifs, such as the national flower, into the designs of her clothes. Such courtesy does much to engender goodwill between the visitor and the visited.

The world has changed enormously during the 50 years of the Queen's reign. Her first tour of the Commonwealth, undertaken by ocean liner in 1954, lasted over five months and took her right round the world. Since then, tours have become shorter, not least because jet travel makes the

RIGHT: *The Queen arriving at the races in Riyadh in a full-length dress and jacket to meet King Khalid and spend an afternoon watching horse and camel racing.*

ABOVE: *Sitting with King Khalid and sipping mint tea between races.*

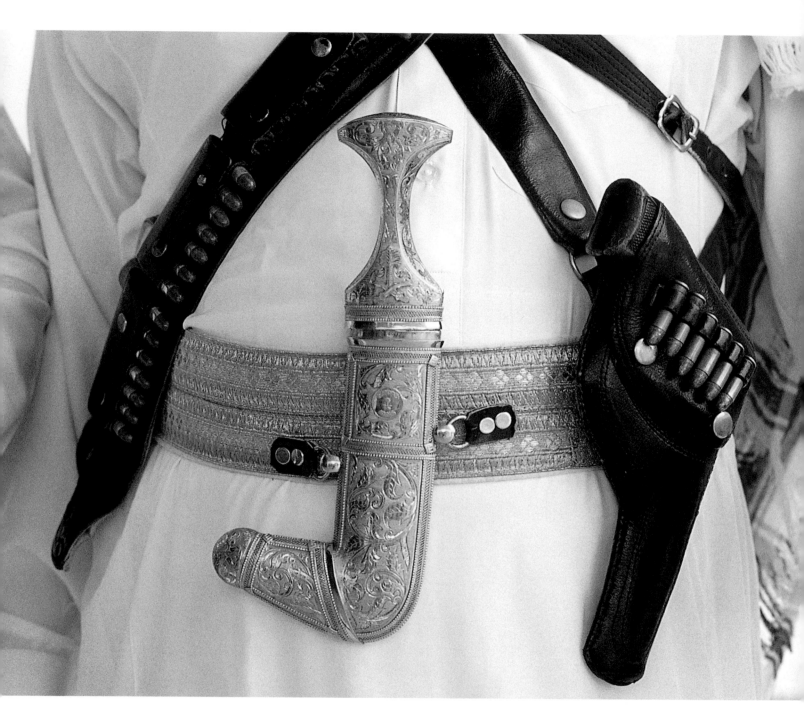

ABOVE: *Weaponry ancient and modern on the belt of the Royal Guard at the King's palace in Riyadh, Saudi Arabia.*

RIGHT: *The Queen was keen to see a traditional Bedouin tent. Here its occupant, holding burning incense, awaits her arrival.*

process much quicker. Now she can achieve in days or weeks what previously took months. She can visit her realms more frequently, but there are now, of course, fewer of them. The first decade of her reign saw many imperial colonies opting for independence, although a number of them chose to retain their links with the Crown by joining the Commonwealth. Although her role is a symbolic one, the Queen strongly believes in the organization's power to maintain peace and stability. Her continuing commitment to it is undoubtedly a force for good.

RIGHT: *Formal occasions can give rise to informal moments. In full jewellery and wearing the Order of King Abdul Aziz, which had been presented to her by King Khalid, the Queen was laughing with him before hosting a banquet in his honour on the Royal Yacht* Britannia.

For more than 40 years the Royal Yacht served as the Queen's floating palace when she travelled the world. During the course of a tour overseas, the Queen would invite the local and travelling press to join her and Prince Philip for drinks and an informal chat. On board the yacht you could be sure of a navy-sized stiff gin, which, after a hectic day, would be followed very quickly by the next one.

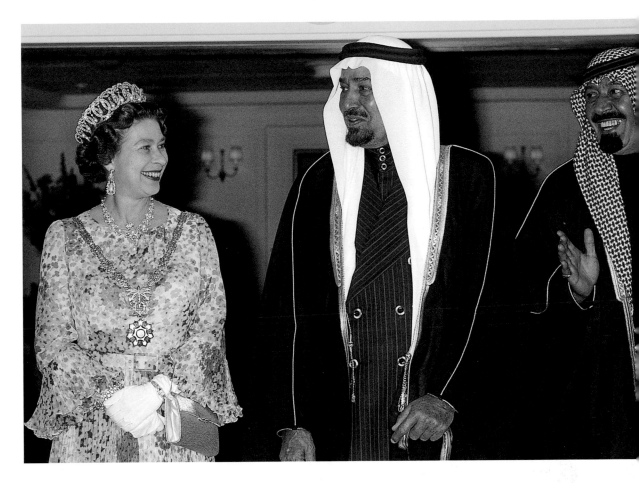

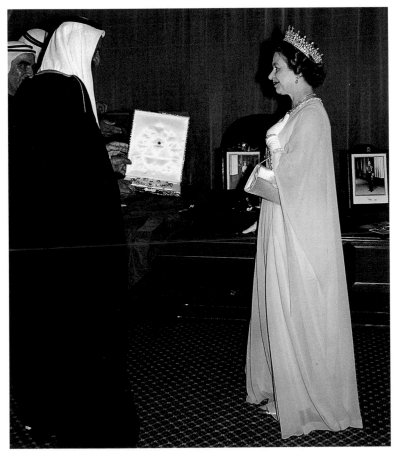

LEFT: *Genuine delight shows on the Queen's face as she is presented with diamond and sapphire jewellery by Sheikh Rashid, the ruler of Dubai. She, in turn, appointed him a Knight Grand Cross of St Michael and St George, presenting him with the badge of the order and a solid silver salver featuring an engraving of the Royal Yacht* Britannia.

ABOVE: *The gifts exchanged by the Queen and the Sheikh are displayed in the royal palace in Dubai. A solid gold sculpture of a camel and its calf standing beneath two palm trees was another gift from her generous host. The dates hanging from the palms are rubies.*

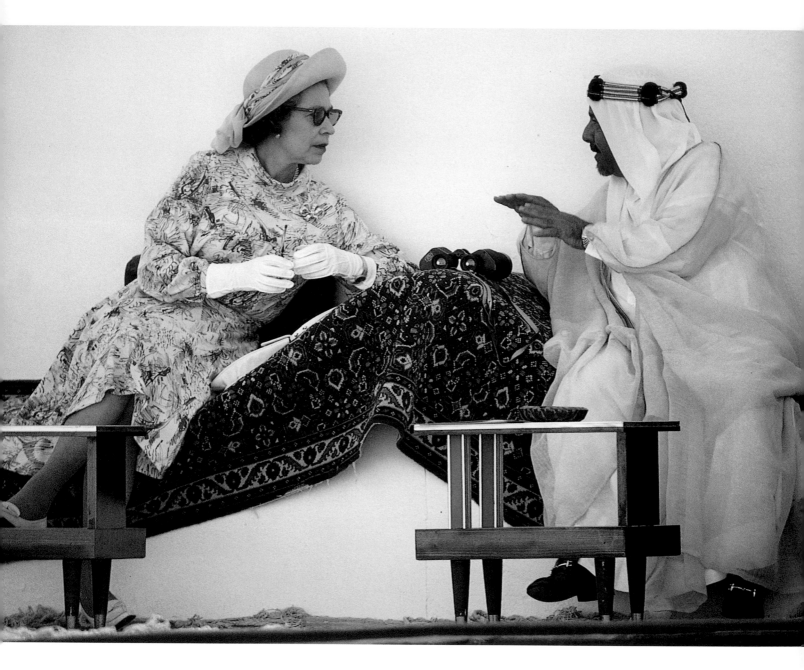

ABOVE: *The Queen at the races in 1979 with the Amir of Bahrain, His Highness Sheikh Isa bin Sulman Al-Khalifa.*

This was not an easy picture to take as I had to shoot straight into the sun across the width of the racecourse.

The Queen was later amused to learn that the press corps had run a book and that the naval photographer aboard the Royal Yacht – 'Snaps' as he is known to everyone, including the Queen – had picked the winner and managed to relieve us of a considerable sum of money.

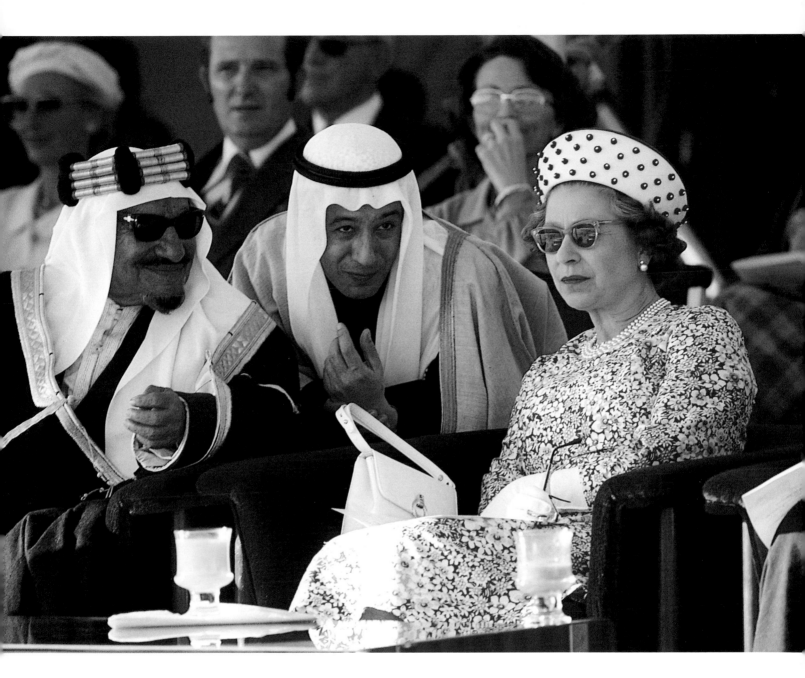

ABOVE: *After visiting the Kuwait Towers, which contain reservoirs for desalinated water, the Queen watched a display of Arab dancing while sitting in the shade of a tent. With her is her host for the day, Sheikh Abdullah Jabir, special adviser to the Amir of Kuwait, and said at the time to have more than 40 wives. In between, an interpreter helps them to chat.*

LEFT AND BOTTOM: *A Union Jack welcome for the Queen from lively drummers and local people in the streets of Muscat, the capital of Oman.*

ABOVE: *An honour guard, wearing traditional daggers, awaits the Queen's arrival deep in the desert at the ancient city of Nizwa, the original capital of Oman.*

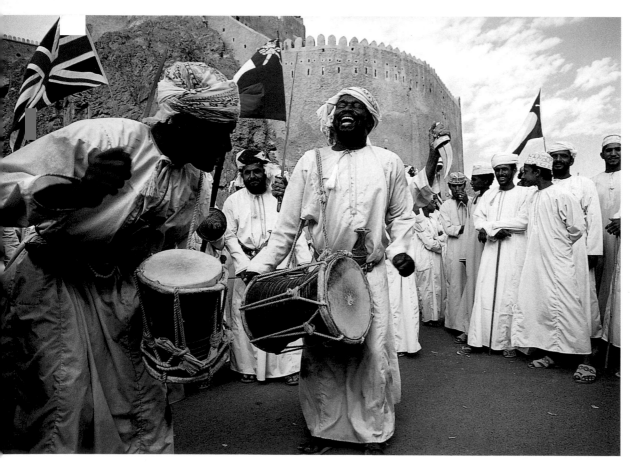

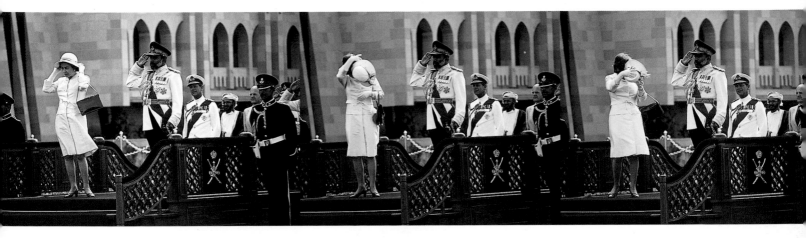

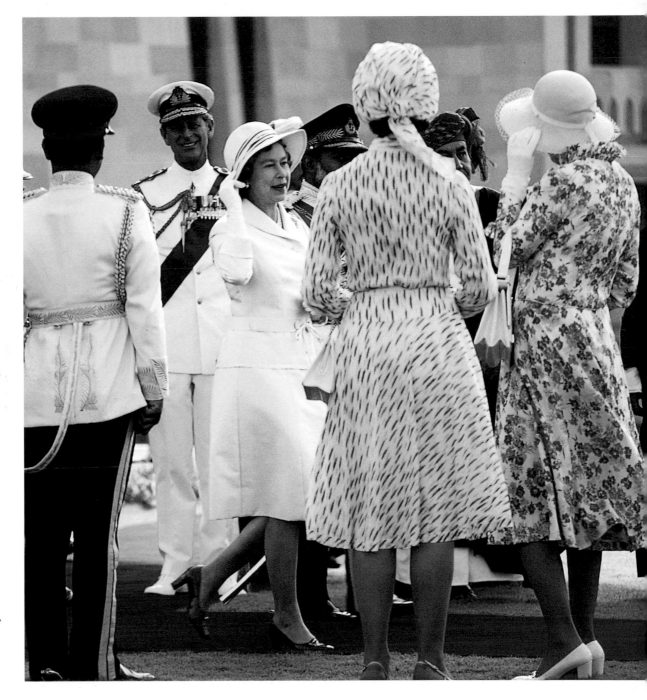

ABOVE: *All over the world welcoming ceremonies have come and gone in time-honoured fashion, but the gusty wind from the Arabian Sea proved too much for what is always a securely pinned hat. Sultan Qaboos of Oman stands implacably to attention as the Queen loses the battle.*

RIGHT: *Following the ceremony, there is sympathy from her ladies-in-waiting and an amused smile from Prince Philip.*

OVERLEAF: *Taking no chances, the Queen holds on to her hat as she inspects the Sultan's Royal Bodyguard in front of the palace in Muscat.*

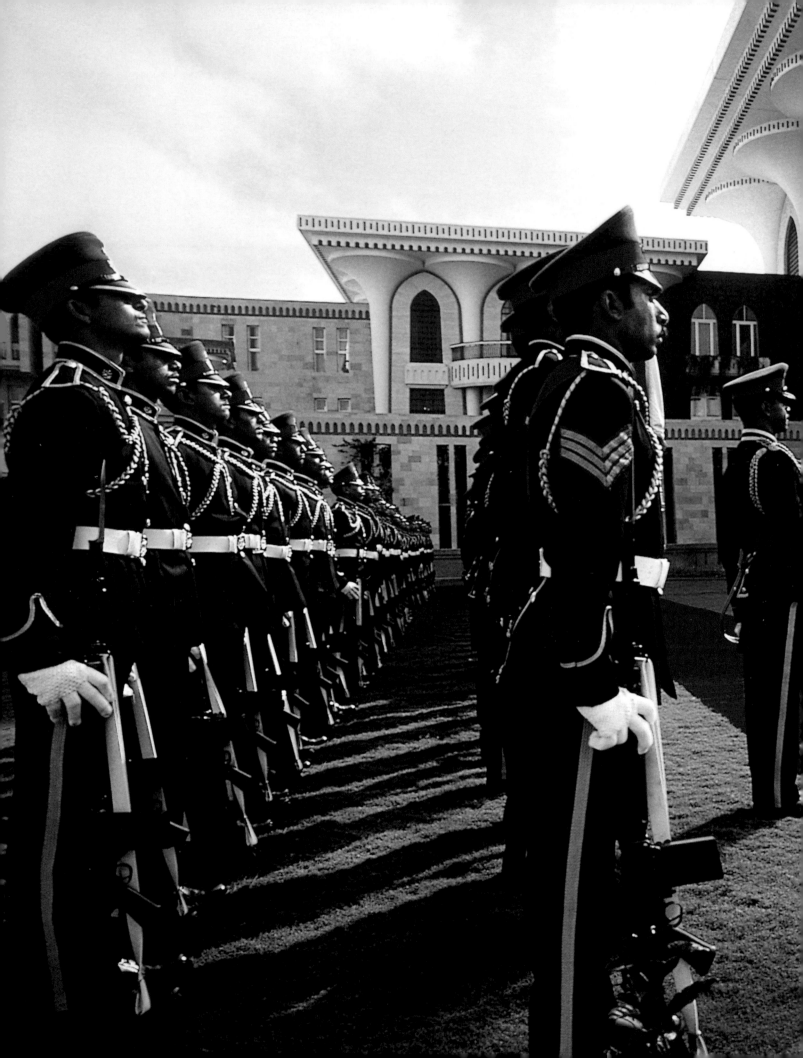

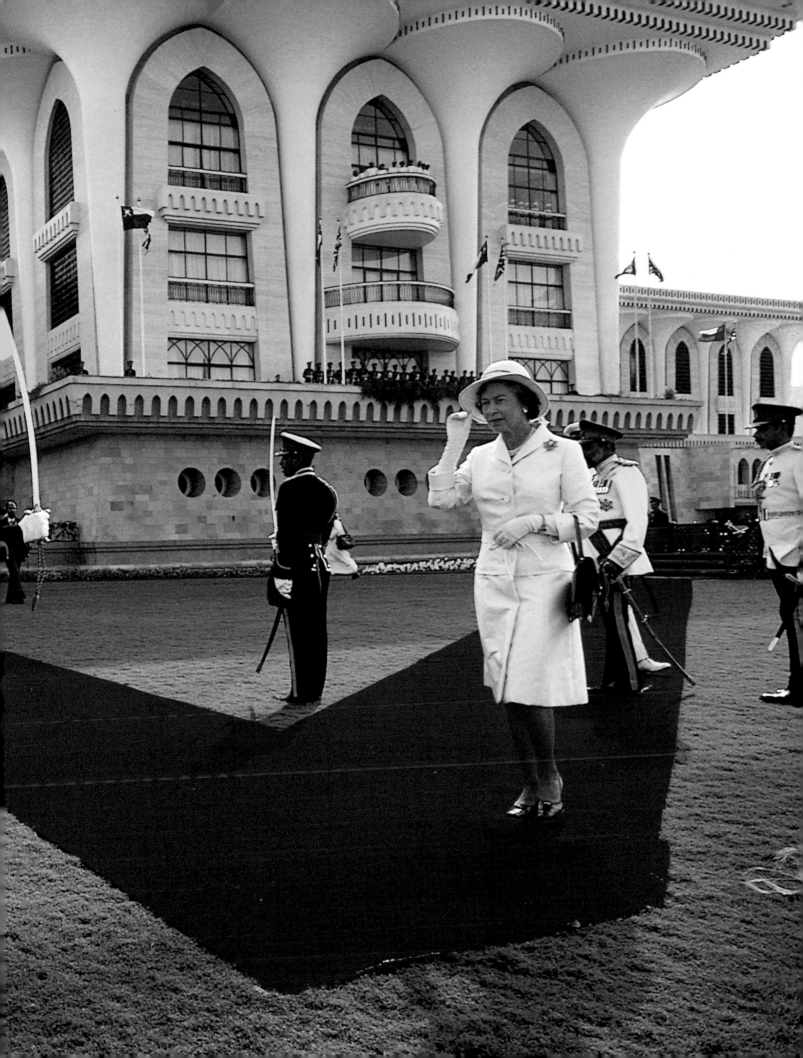

LEFT: *A Bedouin boy with a camel watches the Queen's arrival.*

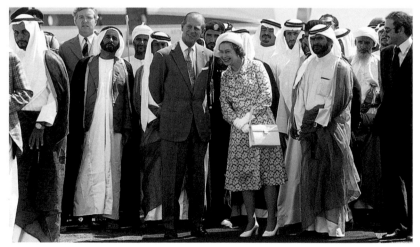

ABOVE: *Laughter from the Queen and Prince Philip as they watch the ruler of Abu Dhabi, Sheikh Zayed bin Sultan Al-Nahyan, joining in a frenetic welcoming dance deep in the desert at the oasis city of Al Ain.*

OPPOSITE: *Local tribesmen escort the Queen as she travels in the ruler's stretch Mercedes through Abu Dhabi, her standard flying from the front. The unusual outriders make an interesting contrast between ancient and modern.*

RIGHT: *While the Queen and Prince Philip attended a lunch given by Sheikh Zayed at the Hilton Hotel in Al Ain, the ruler's heavily armed bodyguards remained on duty in the hotel lobby.*

RIGHT: *A wide brim and a wide smile – the Queen visiting the Khubairat Community School in Abu Dhabi in February 1979.*

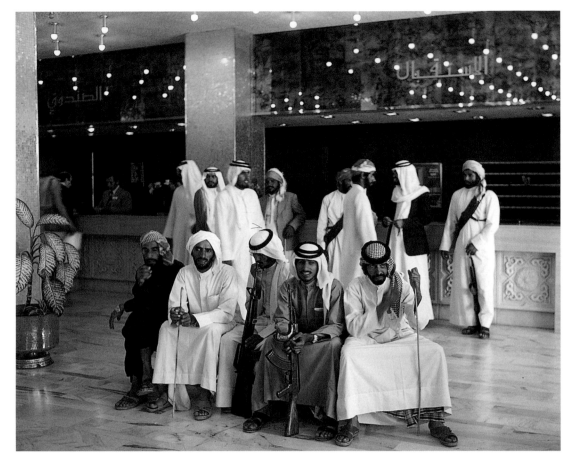

Jordan

RIGHT: *Follow-my-leader on a guided tour of Petra in Jordan in March 1984. Queen Noor's elegant dress and turban-style hat contrast with the Queen's sensible dress and cardigan. Security was tight for the visit, as it had been threatened by terrorist activity and a bomb had gone off in Amman the day before the Queen's arrival. King Hussein often drove his royal guests himself in a fleet of identical Mercedes cars, varying position in the convoy for each journey.*

RIGHT: *Royal visitors at the Treasury Building in Petra, the ancient capital city of the Nabateans. This is the first view I had of one of the greatest sights in the world – a city carved out of the rose-red rock of Petra. Like thousands of visitors before me, I walked through the 'alley', a narrow path just a few feet wide at the bottom of a tall canyon, and as the scene opened up, it took my breath away. This picture was taken from that point.*

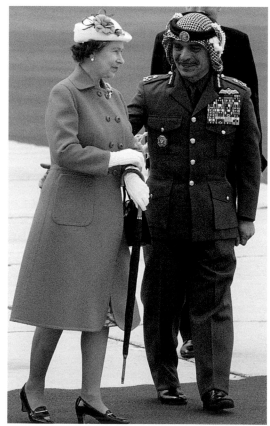

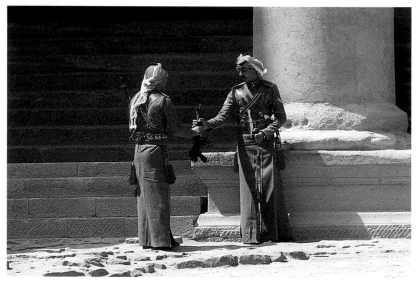

LEFT: *King Hussein of Jordan puts a guiding hand behind the Queen at the welcoming ceremony in Amman. The two royal families have been friends for many years, the King's grandfather having been a guest of George VI at Balmoral. Interestingly, King Hussein acceded to the throne in the same year as our Queen.*

ABOVE: *Members of the Camel Corps on duty at Petra. Security was very tight for the Queen's visit, as a bomb had gone off in Amman just prior to her arrival.*

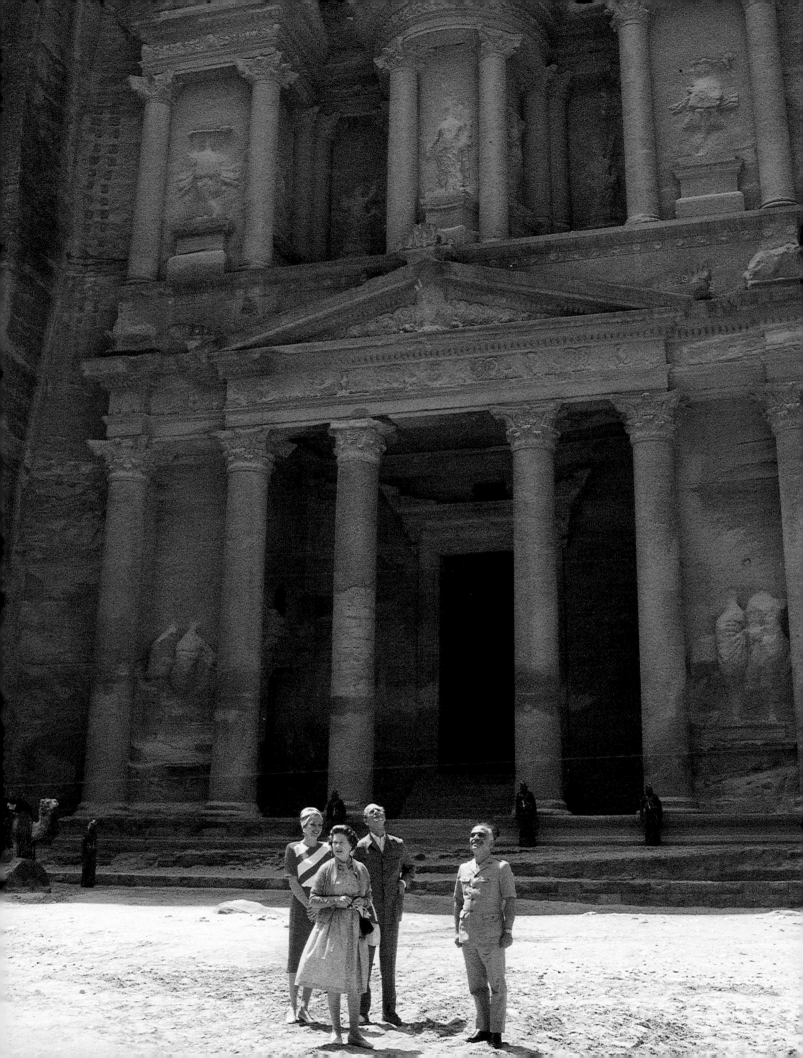

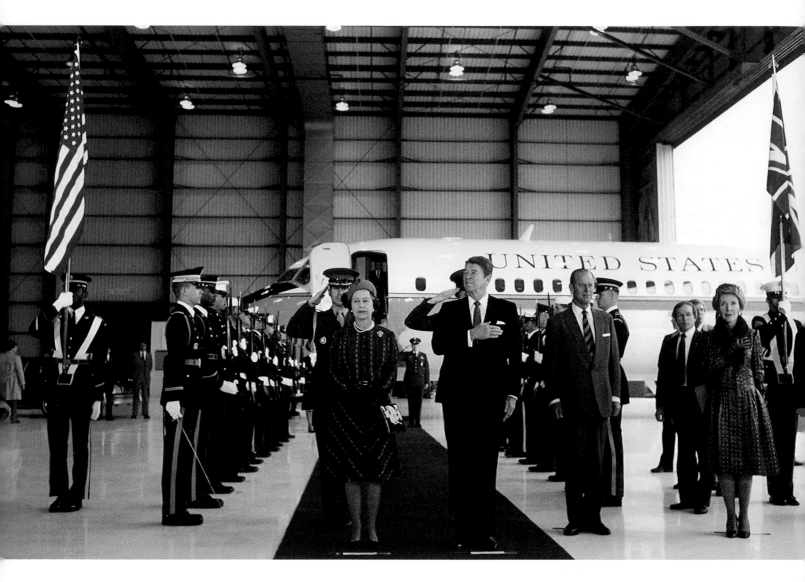

The United States of America

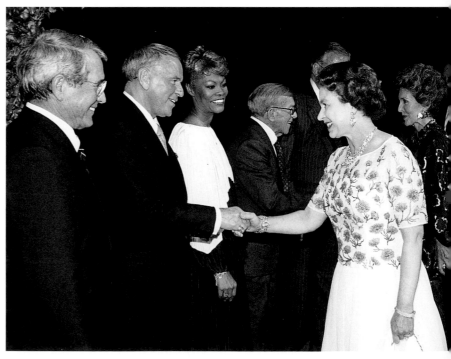

ABOVE AND RIGHT: *The Queen's dress for a gala at the studios of 20th Century-Fox was embroidered with California poppies – a diplomatic choice for this venue. Accompanied by Nancy Reagan, she met* *many show-business stars, including Perry Como, Frank Sinatra, Dionne Warwick and George Burns. Familiar faces from home included Michael Caine, Dudley Moore and Elton John.*

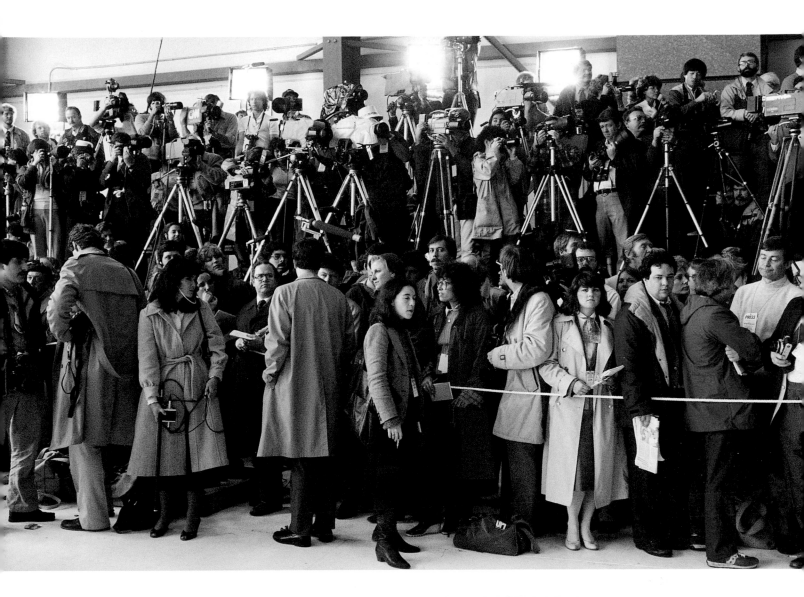

OPPOSITE, TOP: *The weather couldn't have been worse for the Queen's visit to the USA in March 1983. Driving rain meant that the official welcoming ceremony had to be rescheduled to an aircraft hangar. Cards positioned on the red carpet showed the Queen and President Reagan where they should stand for the hastily rearranged ceremony.*

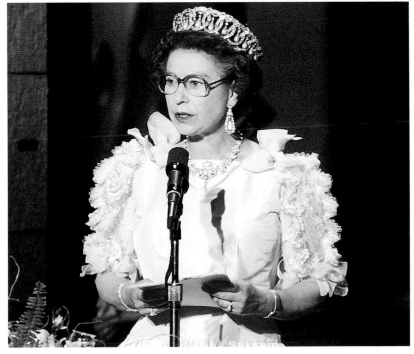

ABOVE: *This was the view just 30 ft (10 m) in front of the VIPs. It can't be easy to face such a battery of cameras, but the Queen has made many state visits and is well used to it now.*

LEFT: *British and American newspapers were very critical of the Queen's outfit for the banquet at the De Young Museum in San Francisco. Opinion was unanimous that the combination of frills and elaborate jewellery was just too much.*

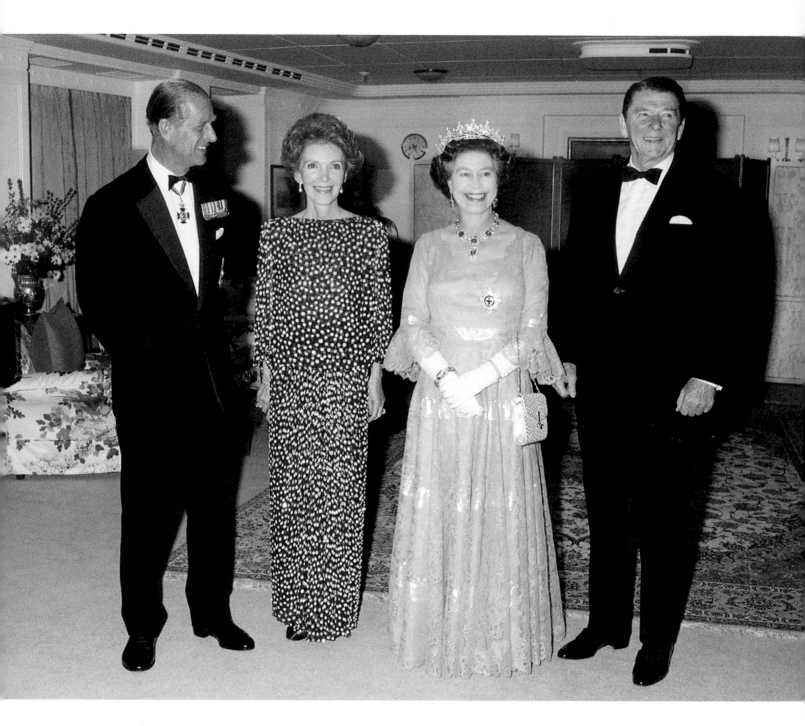

ABOVE AND OPPOSITE: *I like the contrast between these two pictures. Tuxedos and jewels on the Royal Yacht* Britannia, *raincoats and jeans at the Reagans' ranch in Santa Barbara. The schedule had allowed for the Queen and the President to go horse-riding, but the appalling weather put paid to that idea.*

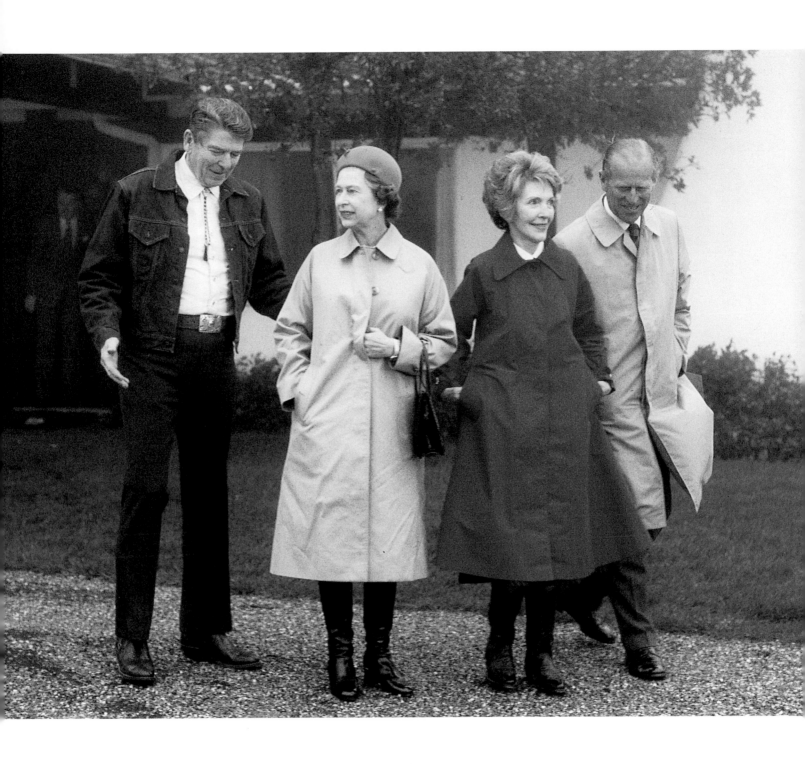

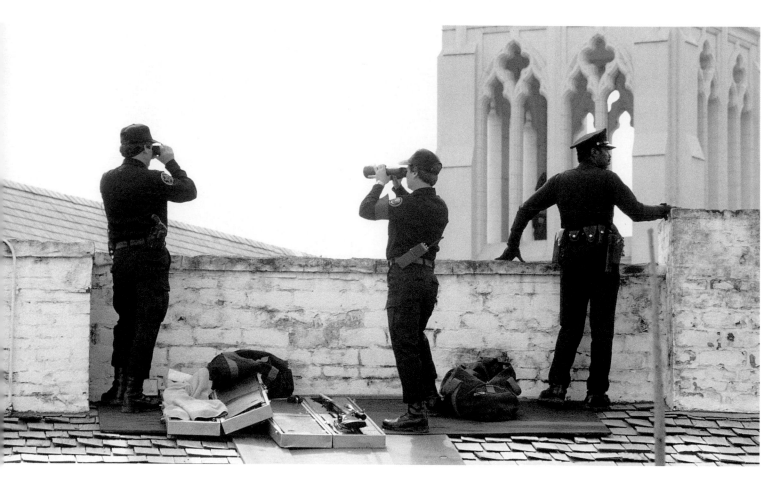

ABOVE: *Security officers get a bird's-eye view from the rooftops during the Queen's visit to Sacramento.*

RIGHT: *The Queen smiles broadly after seeing a slice of American history at Sutter's Fort in Sacramento. The site is a Gold Rush settlement, dating from the 1840s.*

RIGHT: *A young boxer shows his protective helmet to the Queen during her visit to the Richard England Club House in Washington.*

BELOW: *The massive presidential limousine flies the Stars and Stripes and the Royal Standard during the Queen's visit to the USA. It makes a change from her usual Rolls-Royce.*

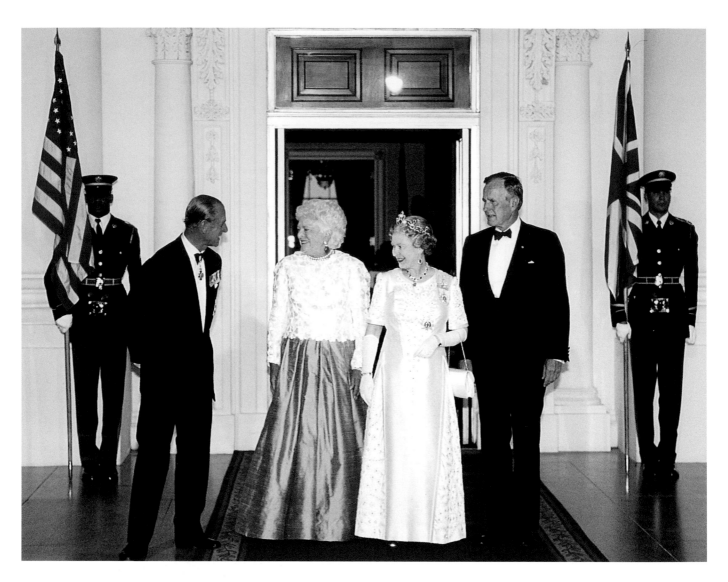

ABOVE: *Eight years on and the Queen meets another president and first lady at the White House – this time George Bush and his wife Barbara.*

Although I've been to the White House five times on royal tours, it wasn't until I returned on holiday in the year 2000 that I got to see more than the portico and the White House lawn. Photographers are always rushing on to the next stop.

RIGHT: *A diplomatic faux-pas reveals that the microphones have been positioned to suit the President rather than his guest.*

LEFT: *The Queen, though passionate about horses, declined the chance to try her hand at throwing horseshoes. Instead, she is content to let President Bush demonstrate his skill at this American pastime.*

BELOW: *The more predictable guard of honour ceremony took place on the White House lawn in Washington. It's remarkable how a back view of someone so well known is immediately recognizable.*

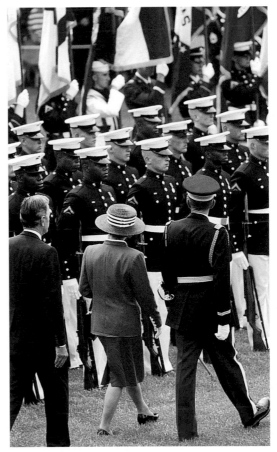

LEFT: *A smile that says, 'No offence taken' when the President apologizes to the Queen about the microphones.*

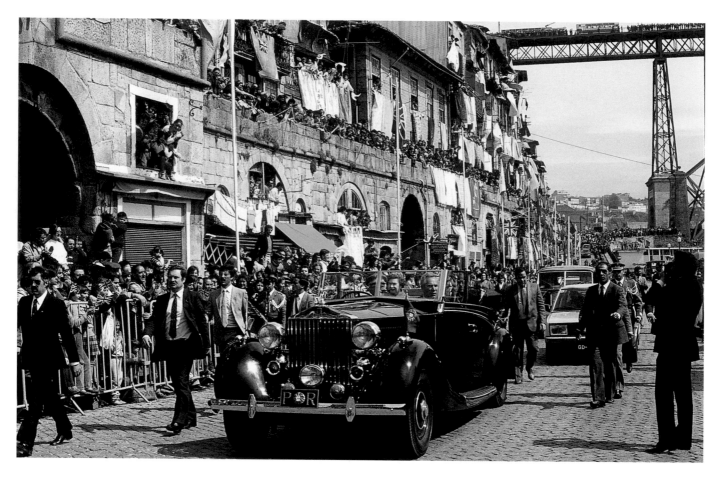

Portugal

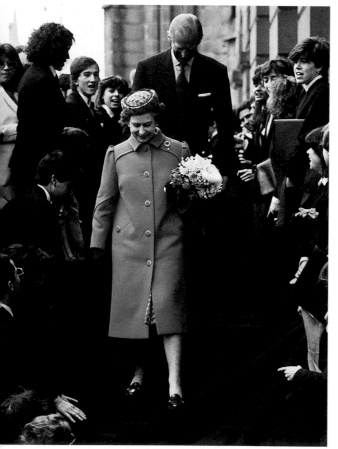

LEFT: *University students in Oporto follow the tradition of making a carpet for their honoured visitor to walk on by spreading their gowns on the ground.*

RIGHT: *The Queen checks the programme during a display of horsemanship by the Portuguese Riding School in Evora.*

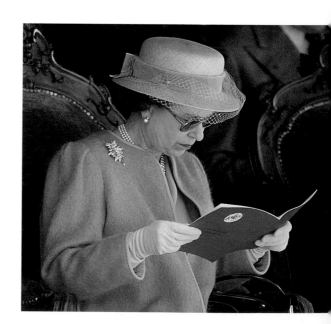

ABOVE: *An elderly spectator watches the Queen come to town.*

RIGHT: *Another local finds a vantage point from which to see the display of horsemanship and get a clear view of the royal visitor.*

BELOW: *More students honour the royal guest. The Queen smiles as students at Evora University cloak her in one of their gowns.*

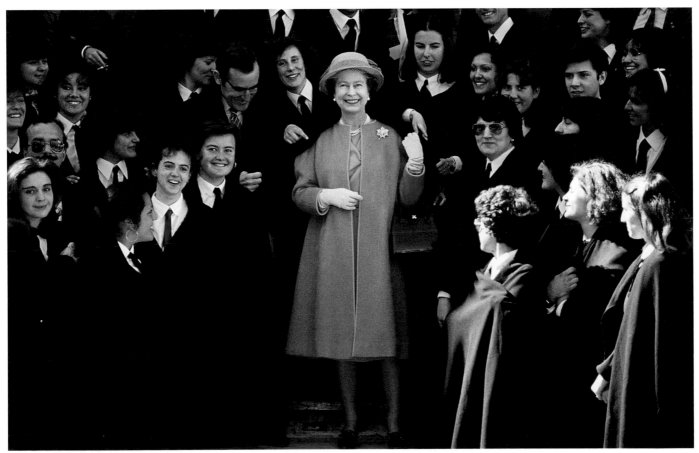

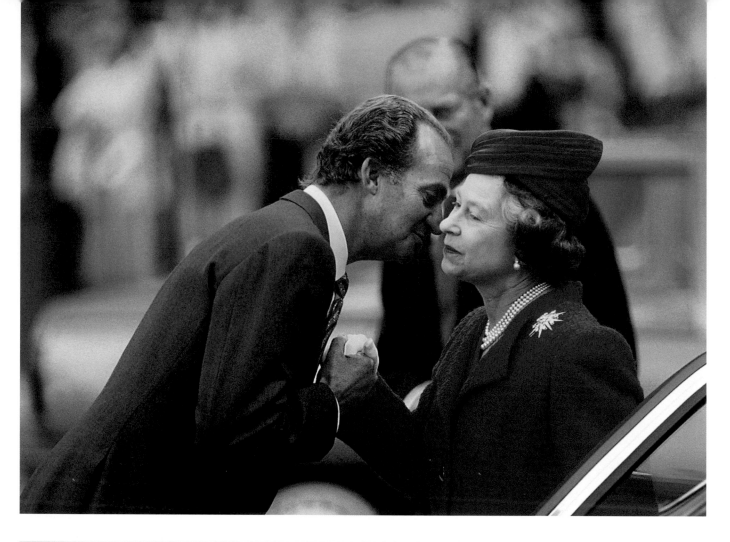

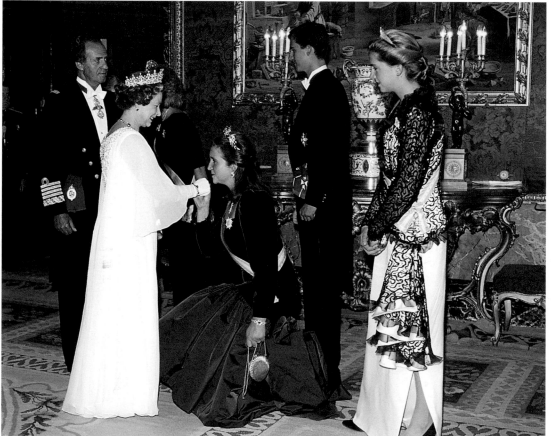

ABOVE: *The British news-papers call them 'kissing cousins' because their great-great grandmother was Queen Victoria. The day before, King Juan Carlos of Spain had to negotiate the Queen's wide-brimmed hat to greet her with a kiss on both cheeks. This time in Barcelona in October 1988 there was no problem.*

LEFT: *In the throne room at the Oriente Palace in Madrid Infanta Elena gives a deep curtsy to the Queen while her brother Prince Felipe and sister Infanta Cristina wait to pay their respects. The palace, originally the official royal residence, is now used only for state banquets. Earlier the Queen had conferred the Order of the Garter on the King.*

Spain

RIGHT AND BELOW: *The King has seen the show a million times, but for the Queen and Prince Philip it was something different. Flamenco dancers in their traditional costumes performed for the royal visitors in the gardens of the Alcazar Palace in Seville.*

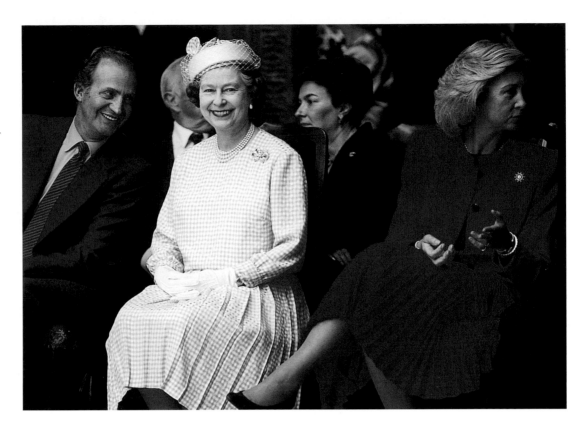

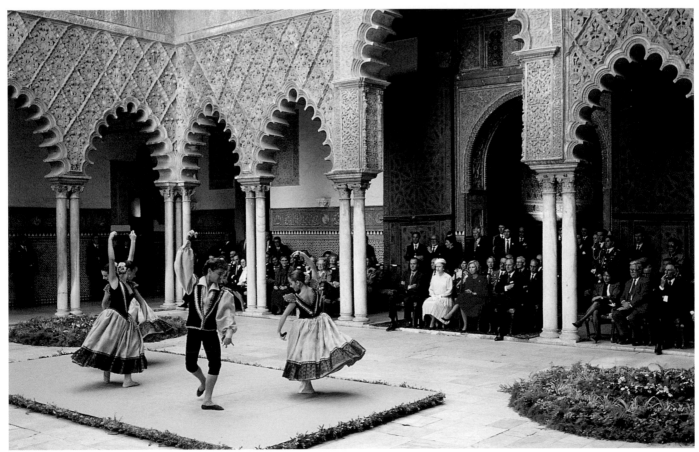

Italy and the Vatican

Protocol decrees that women visiting the Pope in the Vatican should wear long dresses and veils – white for Roman Catholics, black for those of other religions. In 1980 there was a sharp intake of breath among the press corps when the Queen made her appearance in such a dramatic outfit. It made all the front pages the next day.

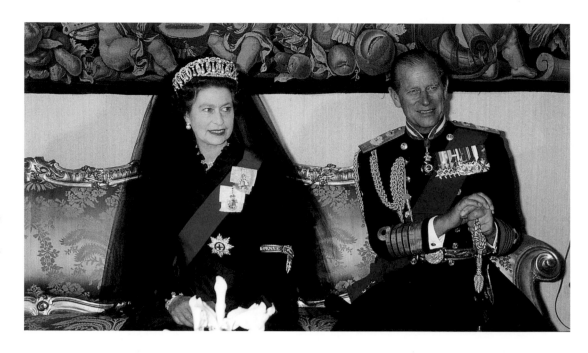

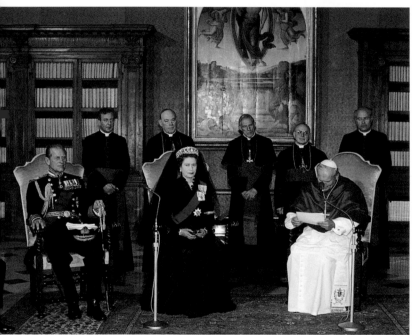

ABOVE: *Pope John Paul II speaks several languages, including English, fluently. Here, surrounded by cardinals, he reads his speech of welcome to the royal visitors.*

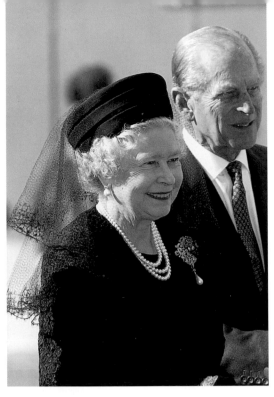

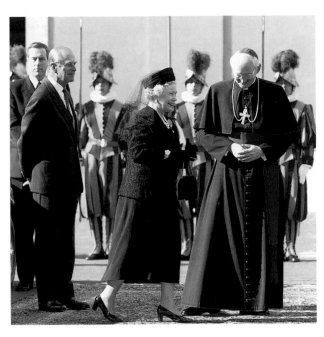

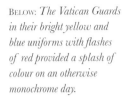

LEFT AND RIGHT: *The Queen adopted a more modern look for her second visit to the Pope 20 years later. Although still wearing traditional black and a veil, she left the tiara and decorations at home.*

BELOW: *The Vatican Guards in their bright yellow and blue uniforms with flashes of red provided a splash of colour on an otherwise monochrome day.*

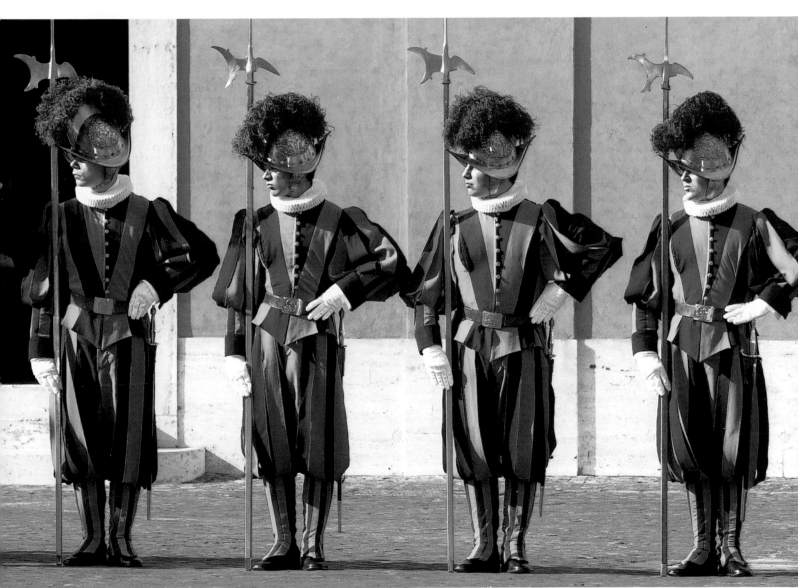

ABOVE AND OPPOSITE: *The changing world is clearly shown in these two pictures taken 20 years apart. When President Sandro Pertini accompanied the Queen to inspect a guard of honour in the Presidential Palace in October 1980, it was a formal event following long-standing tradition.*

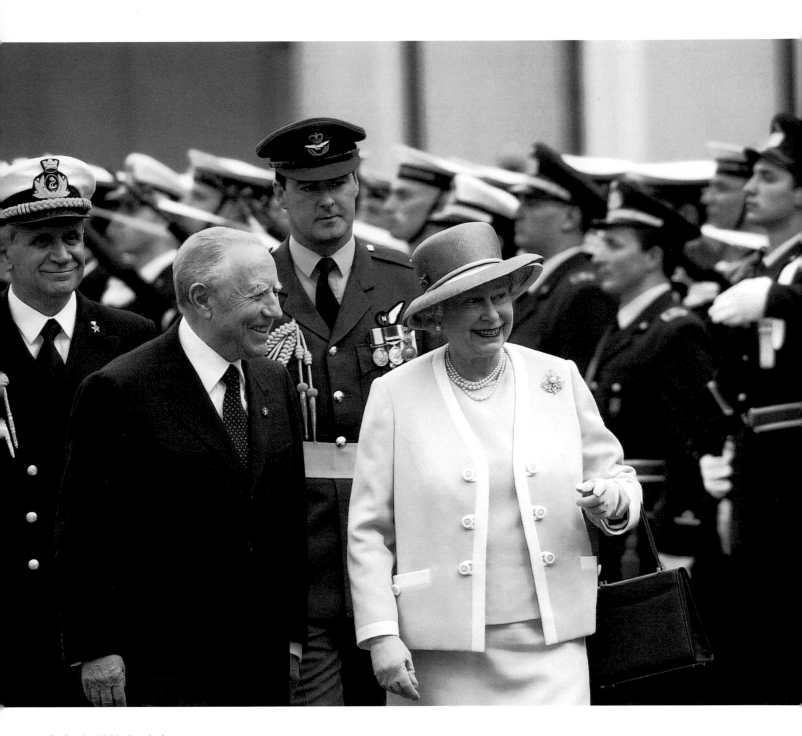

By October 2000, times had
changed and an altogether
more relaxed Queen was led
by President Carlo Ciampi
along a guard of honour
again at the Quirinale
Palace. Before the monarchy
was abolished by a
referendum after the Second
World War, the palace had
been home to the kings of
Italy. Now it is the
President's official residence.

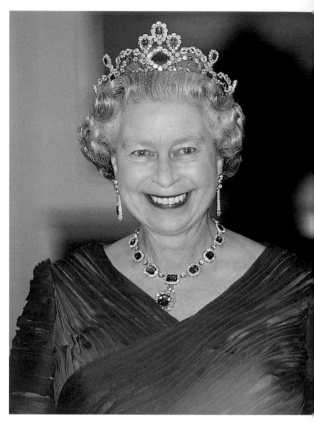

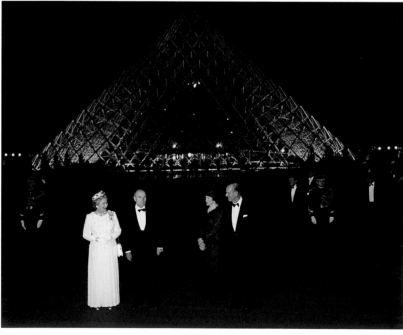

France

ABOVE LEFT: *The Queen's first state visit to France took place in April 1957. Here she is shown attending a banquet at the Elysée Palace hosted by the-then president, René Coty.*

LEFT: *Although it meant that the Queen and the President would be small in the frame, I wanted to include the whole 'Pyramide' as a record of this visit to the Louvre in Paris. After the state dinner at the Elysée Palace, President Mitterrand had brought the Queen and Prince Philip to see some of the gallery's latest acquisitions.*

ABOVE: *At a state banquet in France in June 1992, the Queen wears a wedding gift from her father – the King George VI Victorian Suite of diamond and sapphire necklace and earrings. In 1963 the Queen had a tiara made to match the original pieces.*

RIGHT: *The Queen's signature in the visitors' book after her visit to Bordeaux.*

LEFT: *A tour of the Château de Blois in the Loire Valley courtesy of Culture Minister Jack Lang.*

RIGHT: *The French are proud of their republic, but are nonetheless fascinated by the British Royal Family. These two spectators were curious to see the Queen.*

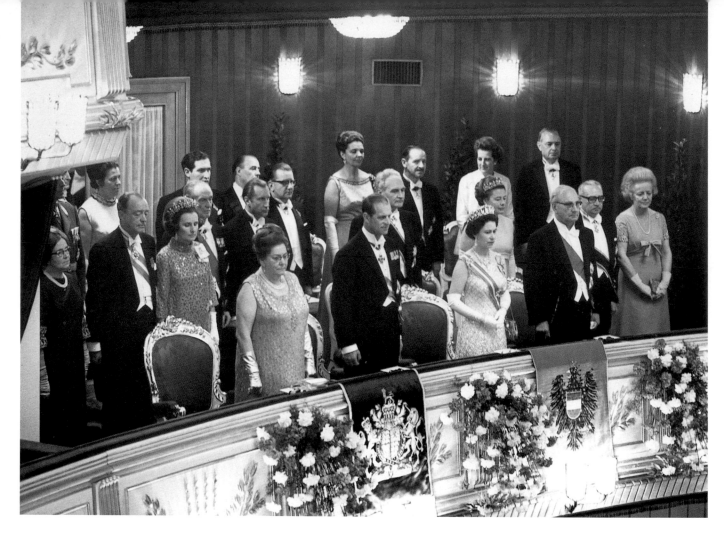

Austria and Switzerland

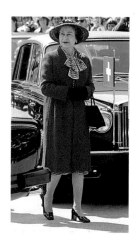

My first royal tour was the Queen's visit to Austria in 1969, when she was accompanied by Prince Philip and 18-year-old Princess Anne, also on her first royal tour.

ABOVE: *A gala performance at the Vienna Opera House.*

RIGHT: *The teenage Princess Anne stole the limelight from her mother, who proudly presented her at this banquet in Vienna.*

ABOVE LEFT: *I'm not sure if the Queen wearing red for a visit to the Red Cross headquarters in Geneva is coincidence or a discreet compliment, given that she is patron of the organization in Britain.*

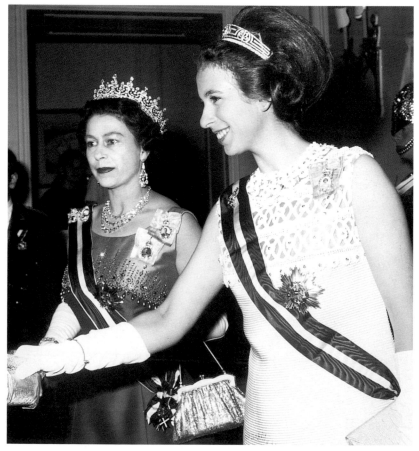

Germany

RIGHT: *During her visit to Germany in 1992 the Queen is accompanied by President von Weizsaecker at the state banquet held in the 18th-century Schloss Augustusburg in Bruhl, near the former German capital of Bonn.*

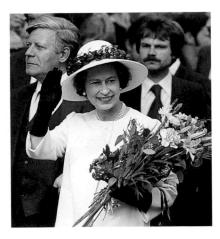

RIGHT: *After posing for a final picture with President von Weizsaecker, the Queen re-enters Schloss Bellevue. Gallant ushers have failed to realize that their umbrellas will drip straight down on to their esteemed guest. The main purpose of the Queen's visit had been to celebrate the country's unification after the fall of the Berlin Wall.*

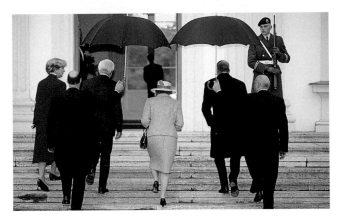

ABOVE: *Fourteen years earlier, in 1978, it was Chancellor Helmut Schmidt who escorted the Queen – here seen in the square at the Schloss Charlottenburg in Berlin.*

BELOW: *Lighting chandelier candles before a formal banquet in Germany.*

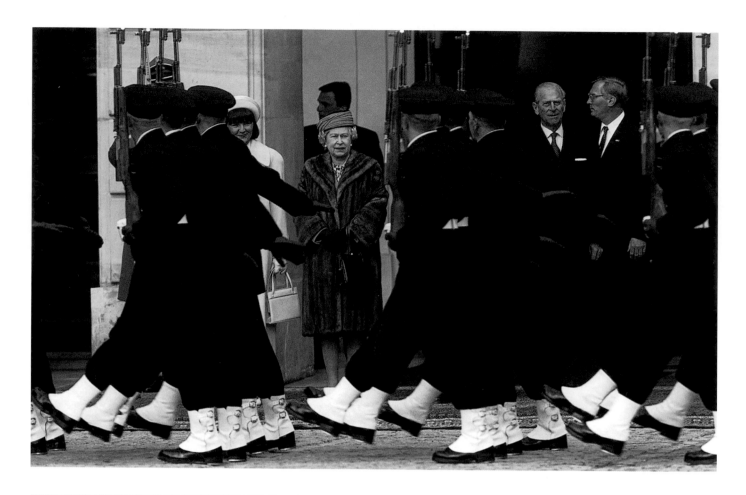

Poland

At home the Queen tends to leave her fur coats in the wardrobe, but the low temperatures in eastern Europe in March 1996 prompted her to take them out of mothballs.

ABOVE: *Watching the guard of honour march past at the welcoming ceremony in Warsaw.*

LEFT: *President Kwasniewski of Poland guiding the Queen during her visit to Warsaw.*

Hungary

OVERLEAF: *I had just 20 seconds to grab this photo at the Opera House in Budapest. Before the start of the national anthems, I jammed the camera against the balcony rail to keep it steady and shot a slow exposure. This gave a more atmospheric picture and was far less intrusive than shooting with flash. It was the first time a British monarch had visited Hungary since the time of Richard the Lionheart.*

RIGHT: *Wherever she goes, the Queen's attention can always be caught by skilled horsemanship. At Bugac on the Great Plain of Hungary in 1993 (below), spectacular feats with charging horses provided the Queen and Prince Philip with a dramatically different display.*

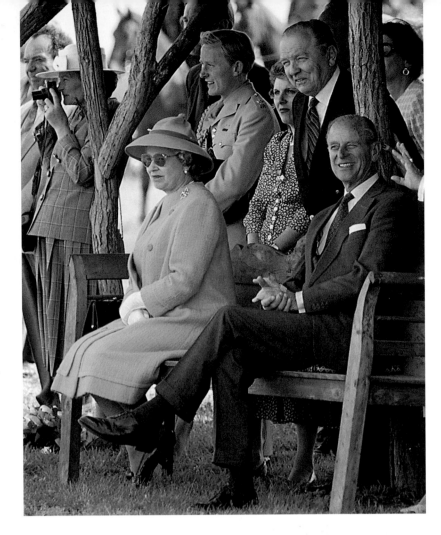

ABOVE: *Sipping a glass of water during the interval, it no doubt crossed the Queen's mind that rural Hungary had probably changed very little since the days when Attila the Hun rode the plain. One local commented, 'The Queen does us a great honour by wearing a hat so like our own kucsma.'*

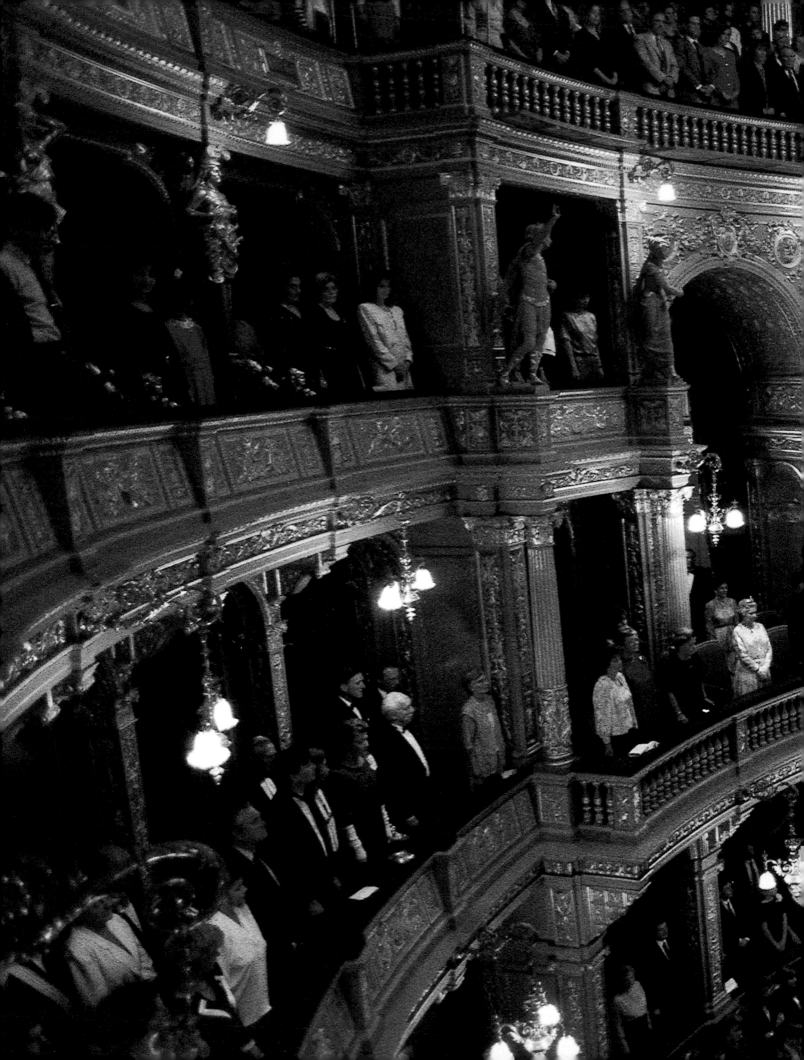

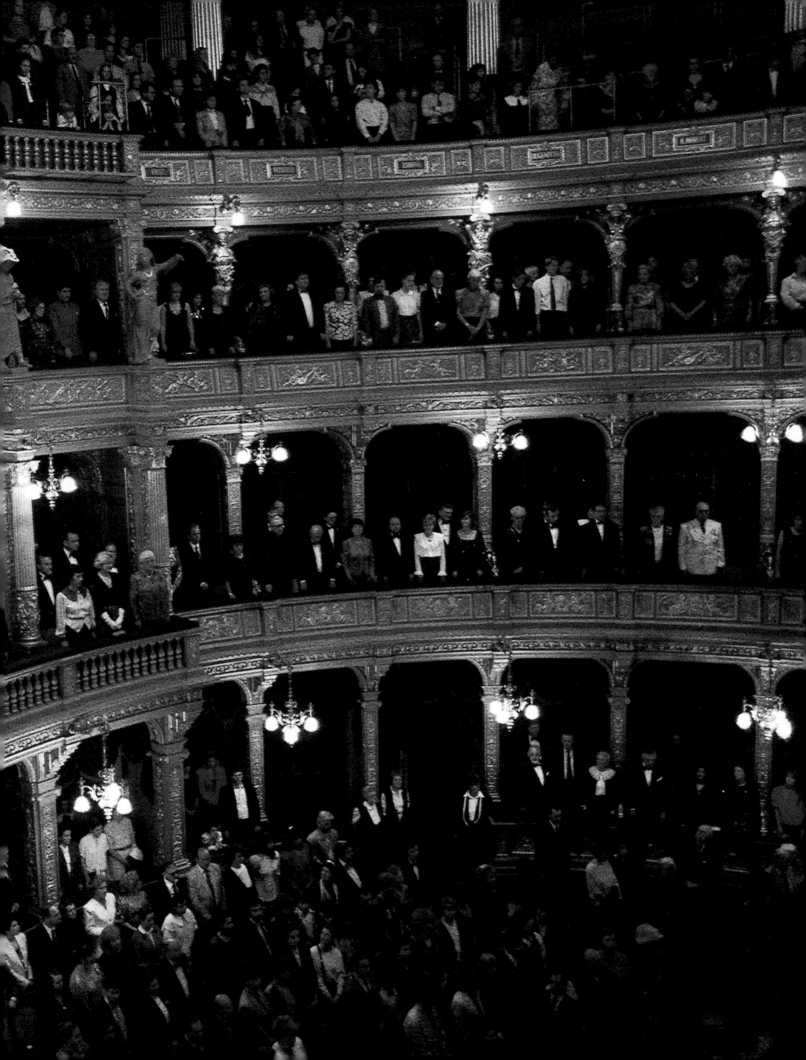

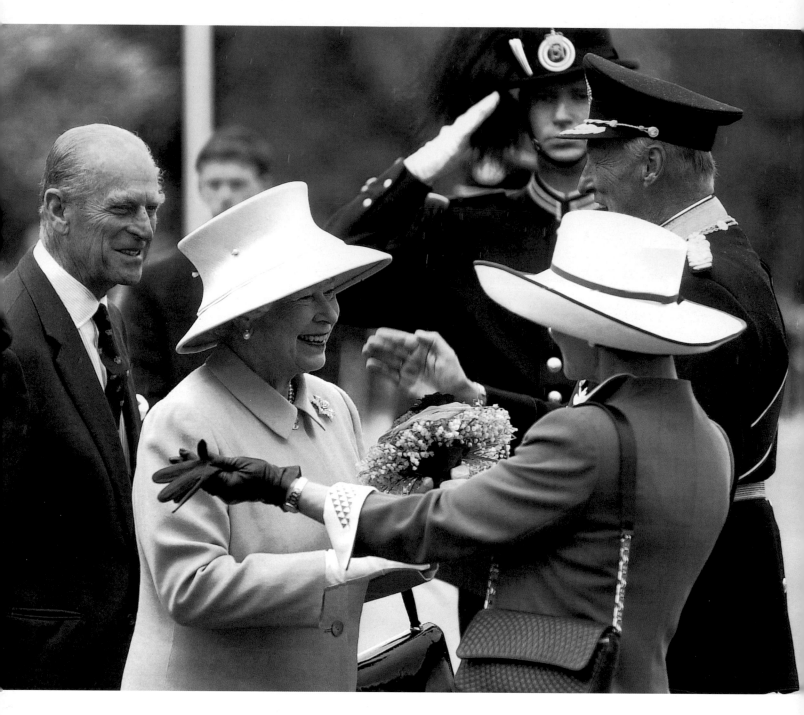

ABOVE: *There is no doubting the friendship that exists between the Queens of Britain and Norway, and it made for a charming photograph on the Queen's arrival in Oslo for her state visit in 2001.*

OPPOSITE: *Although I don't normally like wide-brimmed hats because they throw shadows on to the face, I think this hat rather makes the picture. Luckily, it was taken in the soft light of a cloudy day.*

China

By 1986 I had visited dozens of countries covering the Royal Family's travels. When it was announced that the Queen would visit China in October, I looked forward to this trip more than any other. No reigning monarch had visited China before, so it was an historic occasion for both countries.

LEFT: *Children taking part in a welcoming ceremony spot the Queen's approaching plane.*

BELOW: *The Queen and Prince Philip arrive in Shanghai to a welcome from more than 2000 children.*

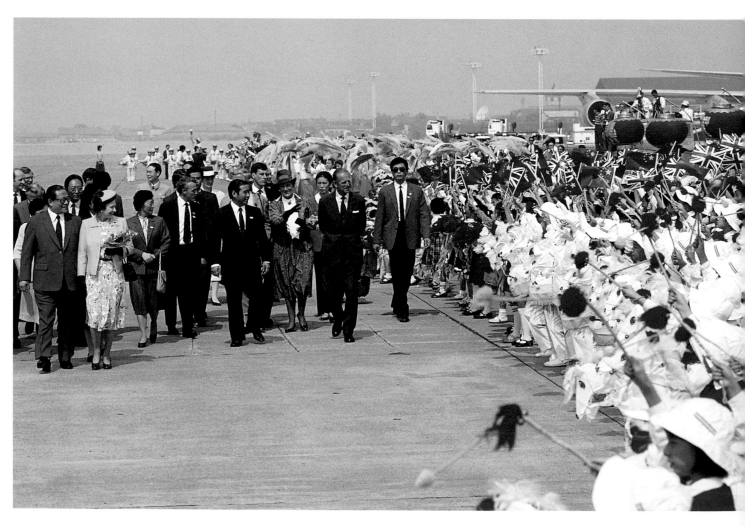

LEFT AND RIGHT: *Dancers and drummers wait expectantly for the Queen's arrival. They have been rehearsing for weeks for this special day.*

BELOW: *These entries from the official programme for the Queen's visit give some idea of the detailed planning that every royal tour involves. In fact, this is only the media schedule, which gives timings, time zones, distances and suggested dress code: Lounge Suit (LS) for men, Long Dress for women. Another schedule for the Royal Household includes more detail to make sure that nothing is left to chance. Before any visit, members of the Queen's staff make a 'recce' trip to plan and agree every detail with the hosts.*

CHINA

Tuesday 14th October (continued)

THE QUEEN AND THE DUKE OF EDINBURGH

2.30 p.m.	Leave by car. (70 km)
3.40 p.m.	Arrive Great Wall at Badaling.
	Short walk along the Wall.
	Photographs.
4.20 p.m.	Leave by car. (25 km)
5.00 p.m.	Arrive Ming Tomb at Changling.
5.40 p.m.	Leave by car. (50 km)
6.30 p.m.	Arrive State Guest House, Villa 18.
6.45 p.m.	Call by Premier Zhao Ziyang.
7.15 p.m.	Farewells.
later	Private Dinner.

Wednesday 15th October

9.20 a.m.	Leave State Guest House by car. (24 km)
	Dress: L.S.
10.00 a.m.	Arrive Peking Airport.
10.05 a.m.	Leave in British Airways Tristar. (1 hour 50 minutes flying time)
11.55 a.m.	Arrive Shanghai Airport.
12.00 p.m.	Leave by car. (4 km)
12.10 p.m.	Arrive Xi Jiao Guest House.
	Retire.
12.30 p.m.	Lunch given by Mayor of Shanghai. (150 guests)
	Exchange of toasts.
2.15 p.m.	Retire.

- 14 -

CHINA

Wednesday 15th October (continued)

THE QUEEN

2.25 p.m.	Leave by car. (10 km)
2.50 p.m.	Arrive British Consulate-General.
	Received by Mr. Trevor Mound (British Consul-General).
	Meet Consulate Staff.
3.00 p.m.	Reception for British and Commonwealth Communities in the garden. (170 guests)
	Sign Visitors' book.
3.45 p.m.	Leave by car. (10 km)
4.05 p.m.	Arrive Yuyuan. (Shanghai Old City).
	Walk through City.
	Stop at Tea House for tea.
	Walk through Yuyuan Garden.
4.45 p.m.	Leave by car. (5 km)
5.00 p.m.	Arrive HMY BRITANNIA.

THE DUKE OF EDINBURGH

2.20 p.m.	Leave by car.
3.10 p.m.	Arrive the Shanghai Yaohua Pilkington Glass Company Limited.
	Tour factory site and view company Headquarters.
4.00 p.m.	Leave in Chinese motor vessel.
5.00 p.m.	Arrive Pier 5, Shanghai Harbour.
	Leave by car.
5.05 p.m.	Arrive HMY BRITANNIA.

THE QUEEN AND THE DUKE OF EDINBURGH

| 8.00 p.m. | Return Banquet. |
| | Dress: L.S./Long Dress (T) |

- 15 -

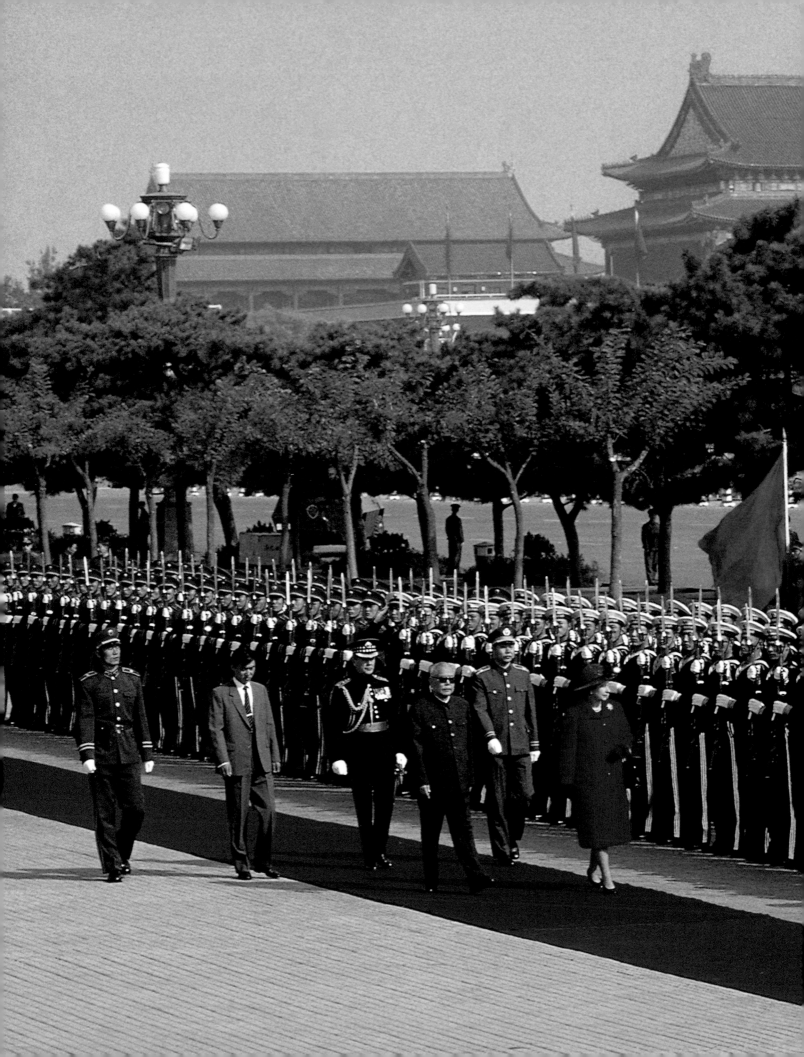

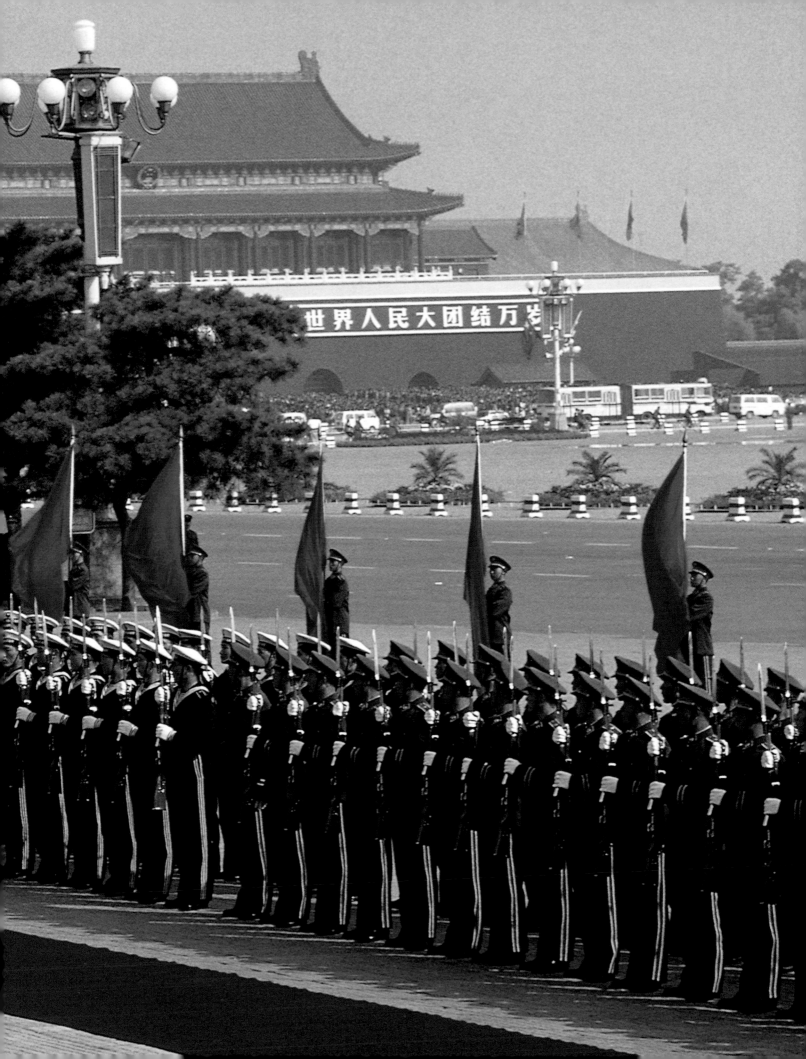

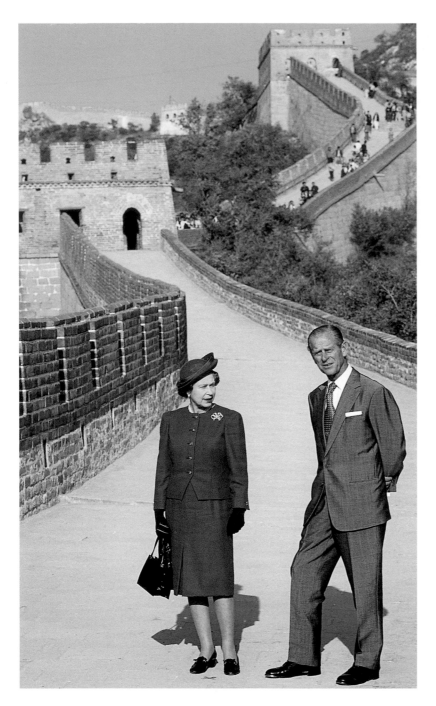

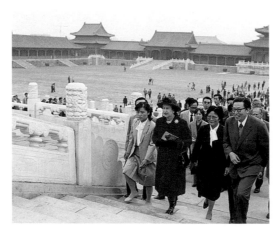

PREVIOUS PAGE: *The Queen's red outfit for the welcoming ceremony in Tiananmen Square, Beijing, really makes this picture come together. It's a sad thought that the square was the scene of brutally repressed pro-democracy demonstrations less than three years later.*

TOP LEFT: *Although it looks as though the Queen and Prince Philip are alone on this section of the Great Wall of China, they were facing dozens of cameras for this historic picture of the first British monarch to set foot on the Great Wall.*

LEFT: *The Queen tours the Forbidden City, so called because only the Emperor and his entourage were allowed inside.*

ABOVE: *In a pit at Lintong near Xian the Queen saw the tomb of Emperor Qin Shi Huang, who was buried with hundreds of life-size clay warriors, horses and chariots – the Terracotta Army. First discovered in 1974, the tomb is deservedly called the Eighth Wonder of the World. For me, having access to such sites makes up for all those days of routine and less rewarding picture opportunities.*

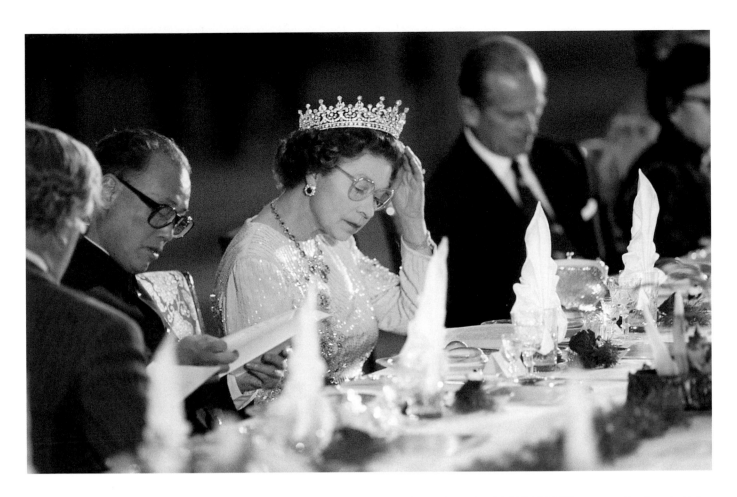

Above: *Sea slugs, shark's fin and dragon's eyes (lychees) are on the menu at this banquet in the Great Hall of the People in Beijing. Sitting next to the Prime Minister of China, the Queen skilfully wielded chopsticks during the 10-course feast given in her honour.*

Left: *The Queen's place setting for the state banquet.*

ABOVE: *Well-behaved crowds wait to see the Queen as she arrives in Shanghai, but police officers line the processional route in case anyone is tempted to step out of line.*

LEFT: *The fame of the British Royal Family has spread around the world, so it's no surprise that this young mother wants to see the Queen and point her out to her child.*

LEFT: *A small boy queuing among the adults to visit Chairman Mao's tomb in Beijing has the added bonus of seeing the Queen pass by.*

RIGHT: *Chinese tourists –*
their small son in a Red
Army cap – take a photo in
front of the Gate of Heavenly
Peace, the entrance to the
Forbidden City.

Beijing was a photographer's
dream. I was glad I had
arrived a few days early
and could spend time photo-
graphing this fascinating city
and its people.

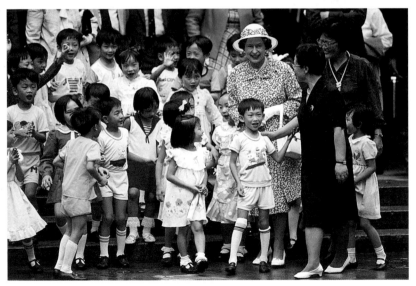

LEFT: *At the last stop on her*
tour of China, before moving
on to Hong Kong, the Queen
was greeted with a bouquet
at Canton airport by the
grandson of the governor
of Canton Province.

ABOVE: *Dozens of excited*
children clamoured to meet
the Queen at the Children's
Palace in Canton.

Morocco

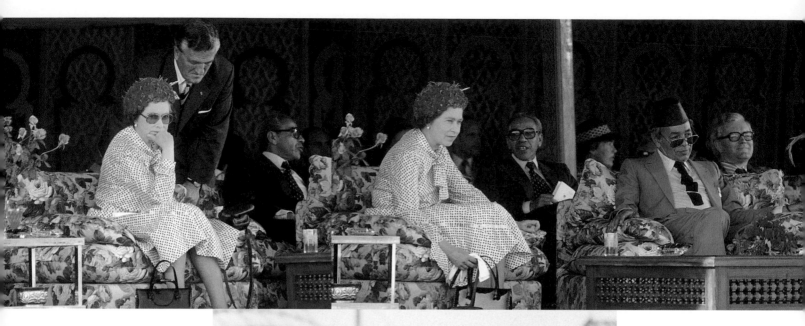

ABOVE: *The Queen is not used to being kept waiting, but had rather a lengthy taste of it in Morocco in 1980. When the chair for her host, King Hassan, remained empty many minutes after the traditional Fantasia show was due to begin, the Queen grew restless and consulted her private secretary. In due course King Hassan arrived and his casual treatment of his royal guest was glossed over.*

RIGHT: *The Queen and King Hassan leave the tented pavilion from which they have watched the Fantasia, all slights, intended or otherwise, apparently forgotten.*

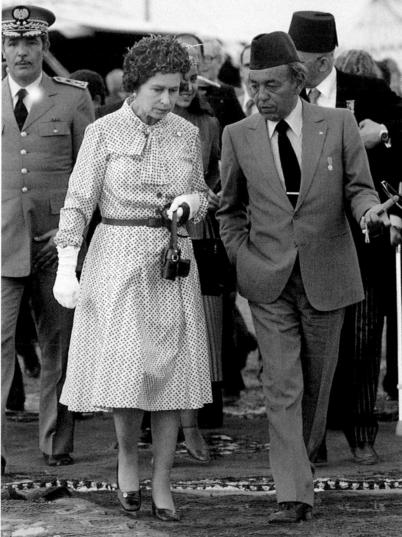

RIGHT: *Skilled horsemen salute the Queen as part of the Fantasia equestrian display in the desert.*

OVERLEAF: *The whole of Tunis, or so it seemed, turned up to greet the Queen as her motorcade passed through the city. President Bourguiba of Tunisia escorted the Queen in an open-topped Rolls-Royce, his bodyguards running alongside or clinging to cars travelling behind. Together with my colleagues, I was hanging out the back of an army truck to capture this scene. For most of the journey from the airport the Queen and the President had been seated, but they stood when they reached the city centre so that people could see them clearly. At the end of our journey in the truck we were bruised and battered but had a great picture in the can.*

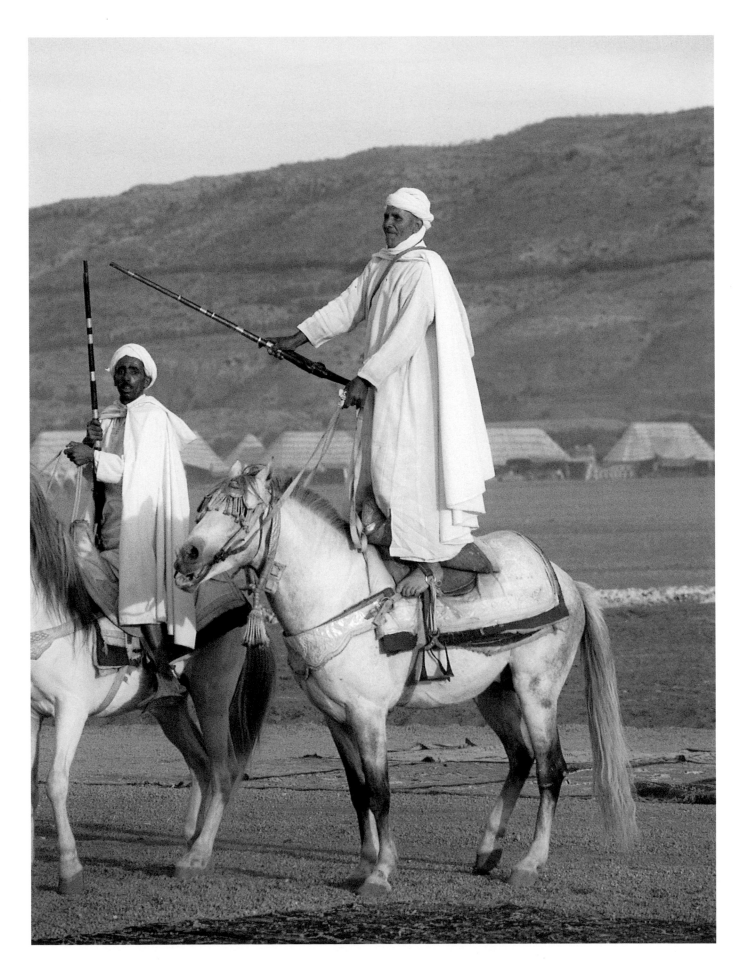

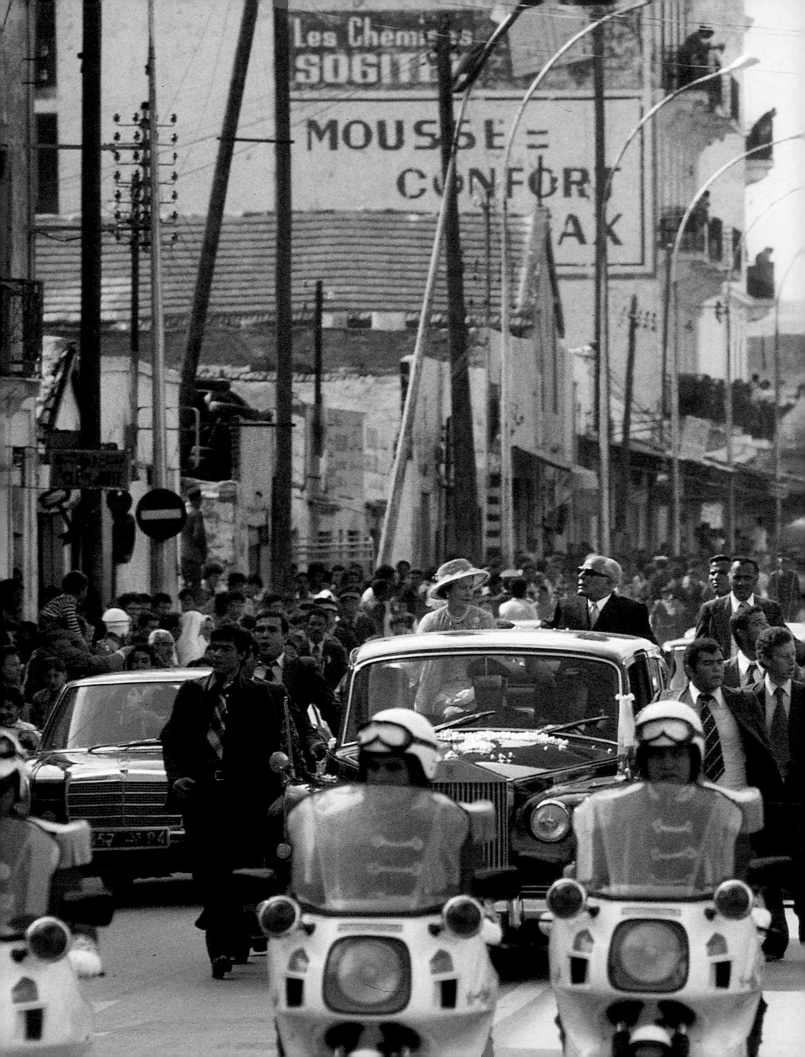

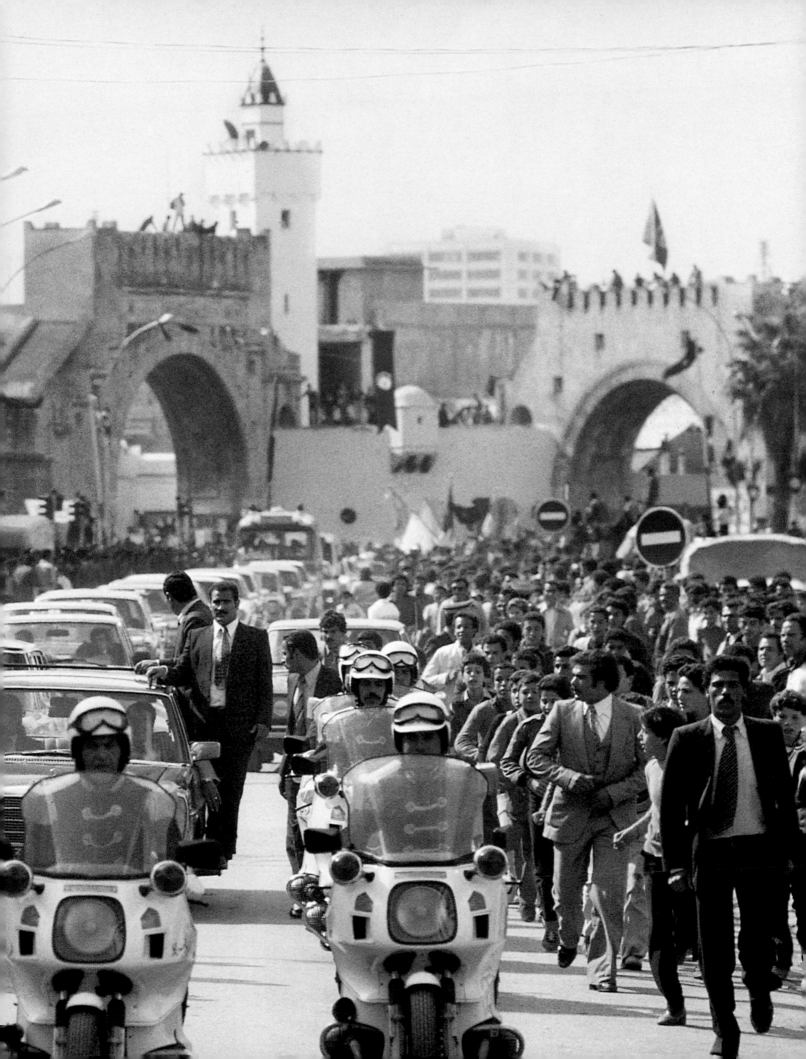

Remembrance Sunday

OPPOSITE: *The Queen lost in her own thoughts as the two-minute silence is about to begin at the Cenotaph in 1988. The spray of poppies pinned to her coat provides a poignant splash of colour in an otherwise sombre picture.*

FEW BATTLEFIELD SURVIVORS of the First World War are alive at the beginning of the 21st century, but their valour and that of their fallen comrades inspired a ceremony of national mourning that takes place every year. Nowadays, it also remembers those who died in the Second World War and subsequent conflicts.

On the Sunday nearest to 11 November – the date that the armistice was signed in 1918 to conclude the First World War – the Queen, members of the Royal Family, politicians, service men and women, and members of the public gather at the Cenotaph in Whitehall. Military bands play music that is patriotic, emotional and increasingly sad: 'Rule Britannia', 'The Minstrel Boy', 'Nimrod'…

As Big Ben strikes the hour at 11 o'clock, a two-minute silence is observed, and the atmosphere is sombre and laden with feeling. It is time to reflect on the sacrifice of those who died in battle, and to remember that the world is still riven with conflicts in which soldiers die every day.

The end of the silence is marked by a gunshot, then the Queen places a wreath of red poppies on the Cenotaph on behalf of the nation. Other members of the Royal Family then offer their tributes, followed by those of political party leaders. After the national anthem is played, service men and women past and present march past the Cenotaph, saluting the war dead.

It is a moving ceremony that loses none of its poignancy for having been celebrated so often. Old soldiers, infirm remnants of their gallant young selves, shed a tear for long-lost comrades, and we who have never experienced war at close quarters pay our respects to those who 'gave their tomorrow so that we could have our today'.

ABOVE: *The Queen paying tribute to the war dead at the Cenotaph. Behind her (left to right) stand the Duke of Kent, Prince Philip, Prince Charles and Prince Michael of Kent. This solemn service is never easy to photograph, but on this occasion the greyness of the November day was relieved by a shaft of sunlight.*

LEFT: *Accompanied by Prince Philip, Prince Charles and Prince Andrew in naval uniform, the Queen attends the 1997 Day of Remembrance at the Cenotaph in Whitehall.*

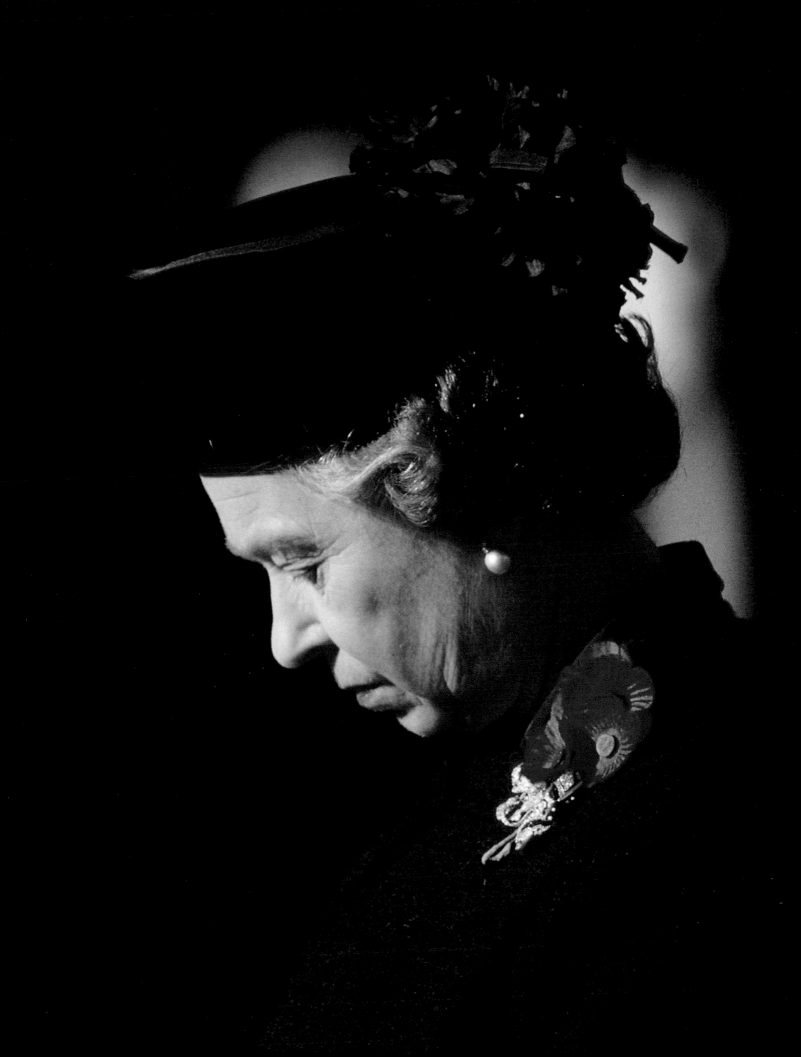

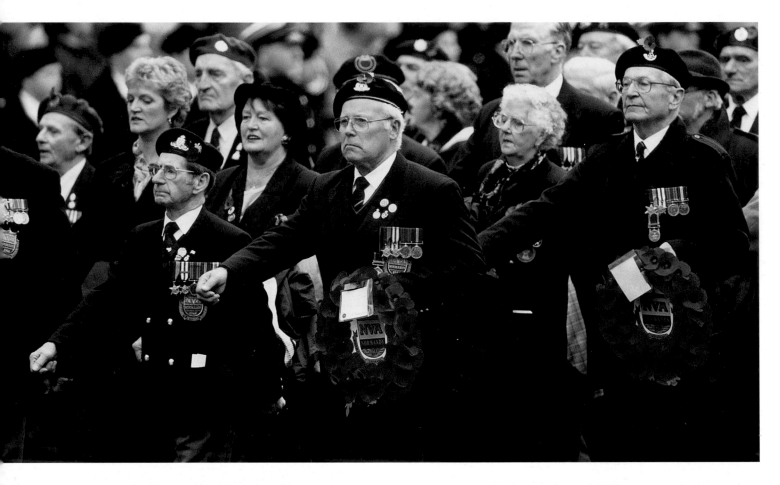

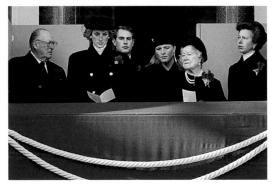

ABOVE: *Until his death in 1991, King Olav of Norway always joined members of the British Royal Family to watch the traditional Remembrance Ceremony at the Cenotaph. On this occasion in 1988, the Princess of Wales, Prince Edward, the Duchess of York, the Queen Mother and the Princess Royal were with him.*

RIGHT: *The 1981 service at the Cenotaph was conducted in wintry sunshine. Her Majesty's Government and Opposition (facing the camera) hold the wreaths they will lay later in the service.*

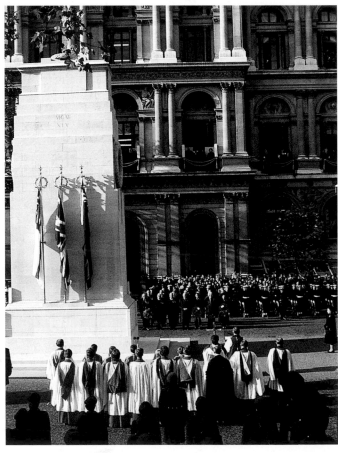

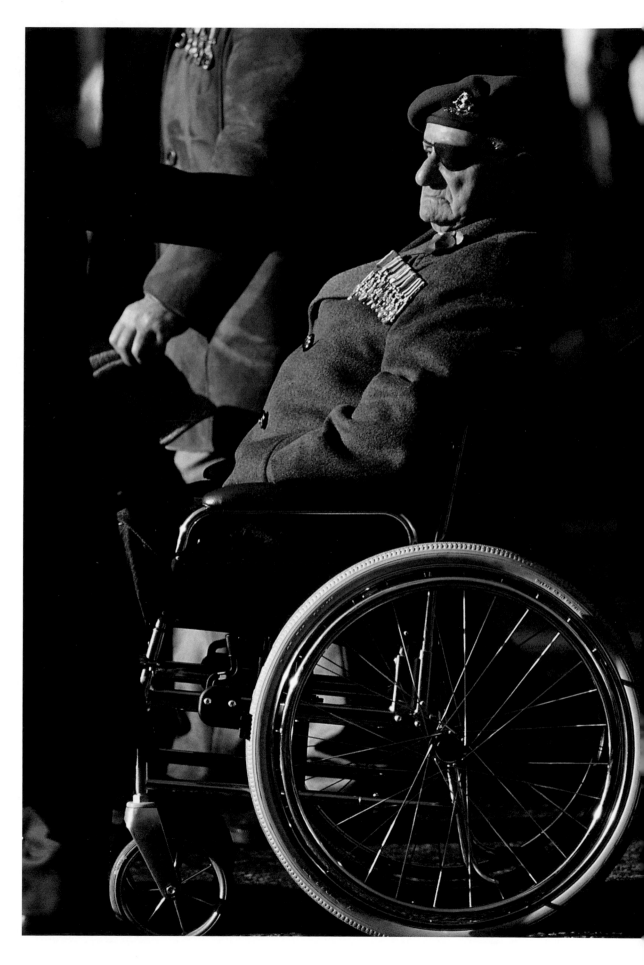

OPPOSITE: *Veterans of the Second World War march past the Cenotaph to lay wreaths in memory of their fallen comrades. The medals they wear with pride honour the valour they showed in the most difficult of times.*

RIGHT: *The sacrifices made by old soldiers are sometimes poignantly apparent in the march past the Cenotaph. The elderly and infirm heroes are supported by comrades who escaped more lightly.*

Wherever in the world she finds herself on Remembrance Sunday, the Queen pays tribute to those who gave their lives so that others could live in freedom. On a visit to Paris in 1998, she attended the Remembrance Ceremony at the Arc de Triomphe.

ABOVE: *The wreath laid by the Queen at the Tomb of the Unknown Soldier in Paris.*

RIGHT: *Veterans sit alongside serving soldiers with their respective colours during the Remembrance Service in France.*

RIGHT: *At the end of the Remembrance Ceremony in Paris, the Queen signed the visitors' book as President Chirac and prominent members of the military looked on.*

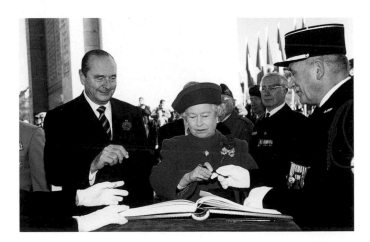

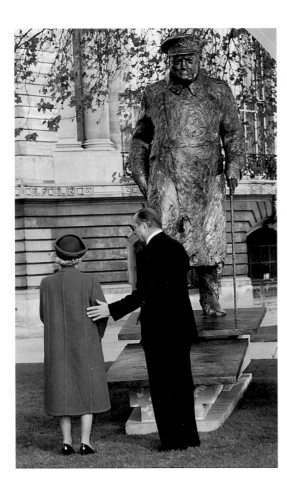

ABOVE: *Accompanied by President Chirac, the Queen gazes at the statue of Sir Winston Churchill she has just unveiled in Paris.*

BELOW: *The Queen, wearing the reading glasses that have become a necessity in recent years, takes a last-minute glance at the speech that she is about to deliver in fluent French.*

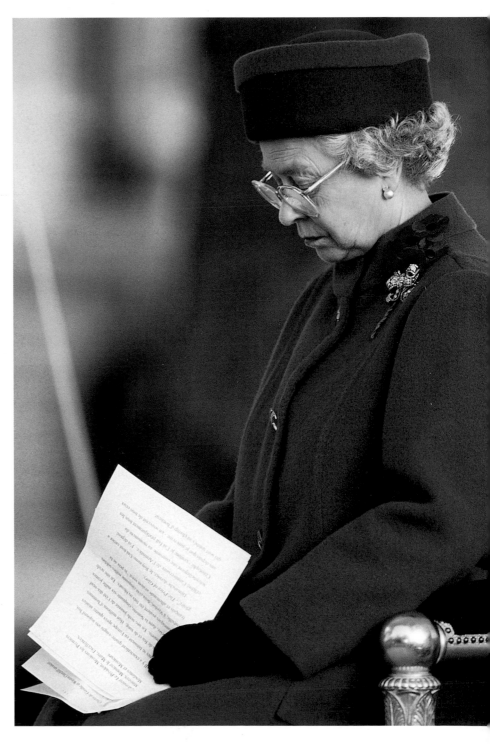

Royal Honours

BELOW: *The Queen attending a banquet given by President Vaclav Havel during her state visit to the Czech Republic in 1996. She wears a sapphire and diamond necklace and earrings that were a wedding present from her father, King George VI. During her visit to Prague, she was presented with the highest order of chivalry, the Order of the White Lion First Class, which she wore on a red sash for the first time at the state banquet in her honour.*

THE PRACTICE OF rewarding people for loyal service, charitable work or conspicuous achievements is a long tradition and can be marked in a number of ways. Those chosen to be honoured are named in the Honours List, which is issued twice a year – at New Year and on the Queen's official birthday.

Most honours are conferred by the Queen on the advice of the prime minister's office, which scrutinizes recommendations from a wide variety of organizations and people in all walks of life. The majority of the 1100 or so names eventually approved are appointed to one of the five classes of the Order of the British Empire – Members (MBE), Officers (OBE), Commanders (CBE), Knights and Dames Commanders (KBE and DBE), or Knights and Dames Grand Cross (GBE).

The British Empire Medal is also awarded for meritorious service, but is restricted to those who have not already been recognized by an appointment to the Order of the British Empire. Recipients of the medal may add the initials BEM after their name.

Each Honours List usually includes a small number of peerages, knighthoods (non-chivalry) and appointments to Privy Councillor, which are often conferred on political figures. Distinguished service awards, such as Companion of Honour, are bestowed upon an elite few who have given service of national importance. (Sir Winston Churchill was a notable recipient.)

Certain honours, mainly those relating to orders of chivalry, remain in the personal gift of the Queen. These include the Order of the Garter, the Order of the Thistle, the Order of Merit and the Royal Victorian Order.

Investiture ceremonies, usually held at Buckingham Palace, are regular events in the royal calendar. There are about 14 ceremonies a year and the Queen presents the awards herself, unless on an overseas tour, which makes the event all the more memorable for those honoured.

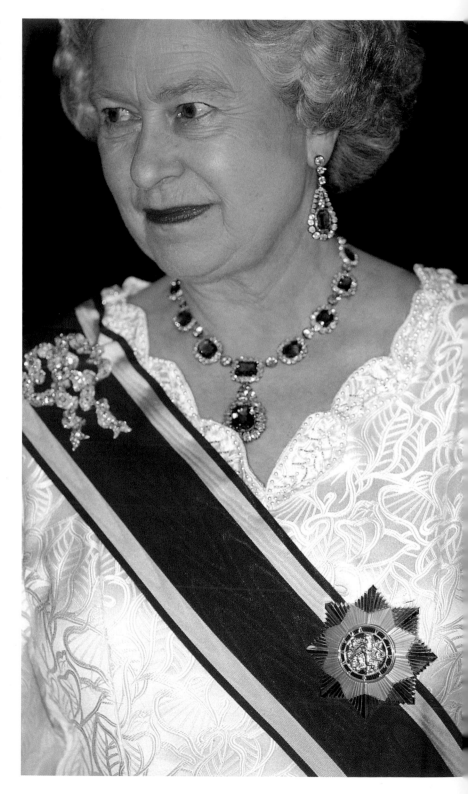

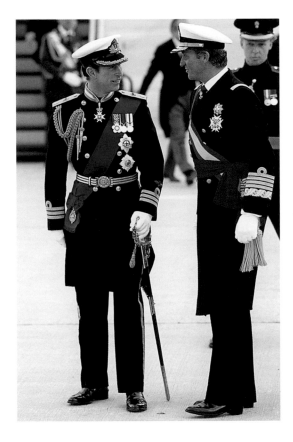

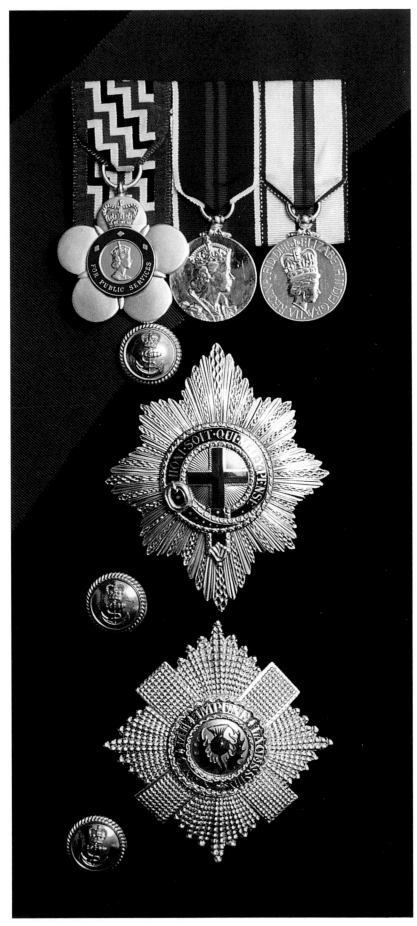

ABOVE: *The Prince of Wales, wearing No. 1 naval uniform, meets King Juan Carlos of Spain at Heathrow Airport at the beginning of his state visit to Britain. The prince wears several honours, seen in close-up, right.*

RIGHT: *On the naval uniform of the Prince of Wales can be seen (top left to right) the Queen's Service Order (New Zealand), the Queen's Coronation Medal and the Queen's Silver Jubilee Medal; below are the stars of the Garter and the Thistle.*

LEFT: *At a state banquet in Hobart, Australia, the Princess of Wales wears the Family Order of Queen Elizabeth, given to her shortly after her wedding. Royal Family orders were first introduced by King George IV and are worn by female members of the Royal Family on formal occasions.*

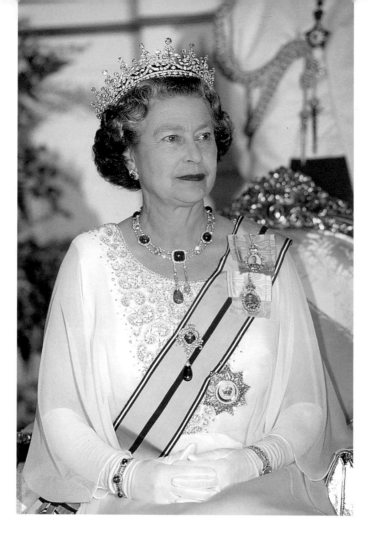

RIGHT: *Inevitably, there is a strict protocol about the wearing of orders. At a state banquet in Kuala Lumpur, the Queen wears the Malaysian Order of the Crown, presented to her on an earlier visit, with a yellow sash. Yellow is the royal colour in Malaysia, so the press corps and Queen's staff were asked not to wear this colour in the presence of the Malaysian Royal Family. On the Queen's left shoulder are the Family Orders of her father and grandfather – King George VI and King George V.*

BELOW: *The Malaysian Order of the Crown is again worn by the Queen at a Buckingham Palace state banquet for the Agong Yang Di-Pertuan. The state visitor is wearing the Order of the Bath. The Queen Mother wears the family orders of her late husband and her daughter.*

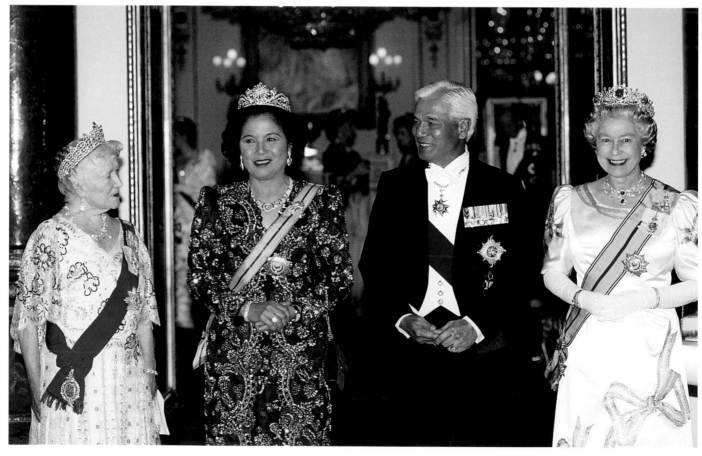

RIGHT: *The gifts exchanged during state visits usually include royal honours. While visiting Bahrain in February 1979, the Queen appointed the Amir a Knight of the Grand Cross of the Order of St Michael and St George. In return, he presented her with his family order, the Star of Al Khalifa.*

BELOW: *Queen Sofia of Spain with the Duke of Edinburgh at a gala dinner in Madrid during a state visit in 1988. The Duke is wearing the Order of Merit around his neck. Below his medals are the Order of the Garter and the Grand Cross of the Order of Carlos III. His blue sash matches that worn by the Spanish royal family.*

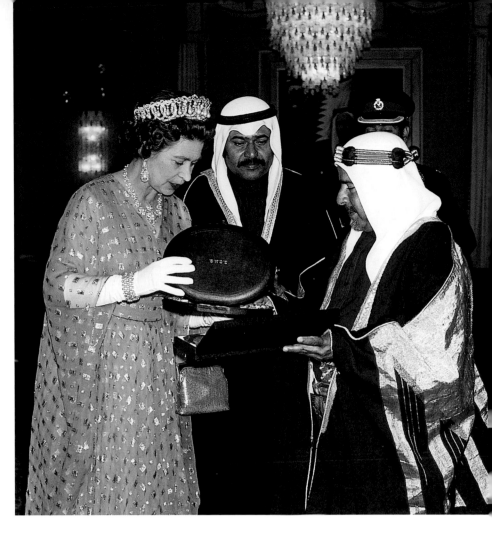

The Garter Ceremony

ABOVE: *In recognition of the Princess Royal's public service, the Queen installed her as a Lady of the Garter in 1994.*

BELOW: *St George's Chapel at Windsor Castle is the scene of the annual Order of the Garter ceremony, which is conducted with much pomp and pageantry.*

THE STORY BEHIND the Most Noble Order of the Garter may be apocryphal, but it bears retelling nonetheless because it offers insight to a bygone age of chivalry. It is said that during a ball held by King Edward III in 1348 to celebrate a victory over the French, a young woman's garter fell from her leg. This was deeply embarrassing for her because such a gesture was associated with loose women. With quick-witted gallantry, the King picked up the garter, tied it round his own leg and declared, 'Honi soit qui mal y pense' (Evil he who evil thinks). To further distance the young woman from any unkind interpretations of her loss, the King decreed that an elite order of knights he had recently formed would adopt a blue garter trimmed with gold as its emblem, and that his admonitory words would be its motto.

While many doubt this version of events, the Order of the Garter has certainly existed since 1348 and remains the country's highest order of chivalry. Since its inception, the order has given automatic membership to the sovereign and the Prince of Wales, and 24 companions may be appointed at the sole discretion of the monarch.

Foreign royalty may be honoured in a relatively recent category called Extra Knights. Current members include the Queens of Denmark and the Netherlands, and the Kings of Sweden and Spain.

Although women never enjoyed full membership of the order, they participated in some of its rituals until 1509, when Henry VII decreed that women other than reigning queens should be excluded. This ruling was changed in 1901, when Edward VII installed his wife as a member. More women have been admitted since then, and in 1987 the Queen decided that eligibility for membership should be the same for men and women.

The spiritual home of the order is St George's Chapel at Windsor Castle, and every year, following a lunch in the Waterloo Chamber, the Queen and other members proceed to the chapel, where new companions are installed. They sit in elaborately carved stalls, above which each member must display his or her 'achievements' – a banner of arms, a helmet, crest and sword. An enamelled stall plate, positioned at the same time, is the only item that remains in place after a knight's death.

All members of the order wear the traditional blue velvet mantle with the badge of the order on the left shoulder, a vestigial hood of red velvet over the right shoulder, and a black velvet hat adorned with white feathers. The emblem of the order (a blue garter or ribbon) is worn by men below the left knee and by women on the left arm.

The order, founded in uncertain times, was to assure the monarch that his hand-picked companions would be loyal come what may. In more recent times, membership has been conferred on those who have given dedicated service to Crown and country. The current roll of honour includes three former prime ministers, several dukes and military men, and distinguished figures such as Sir Edmund Hillary. Unchanging, however, are the colour and ritual of the Garter Ceremony – a historic tradition that has found a modern significance.

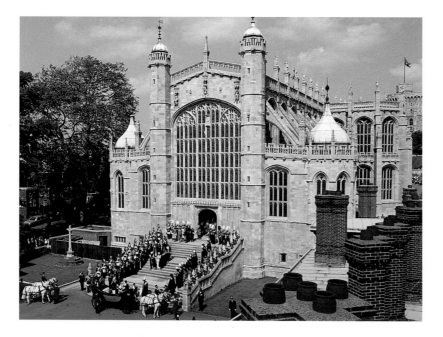

ABOVE AND RIGHT: *The Garter Ceremony is a day of great pageantry, involving knights, heralds, Yeomen of the Guard, and soldiers of the Life Guards and Blues and Royals. Their colourful uniforms add to the spectacle that attracts large crowds.*

BELOW: *The Queen was installed as a Lady of the Garter in 1948, the year that Prince Charles was born.*

OVERLEAF: *A lighthearted moment on the way back to Windsor Castle after the Garter Ceremony.*

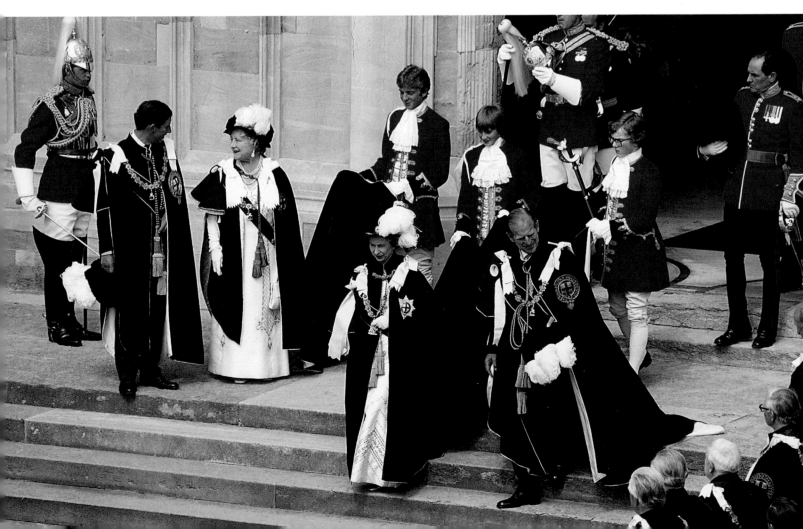

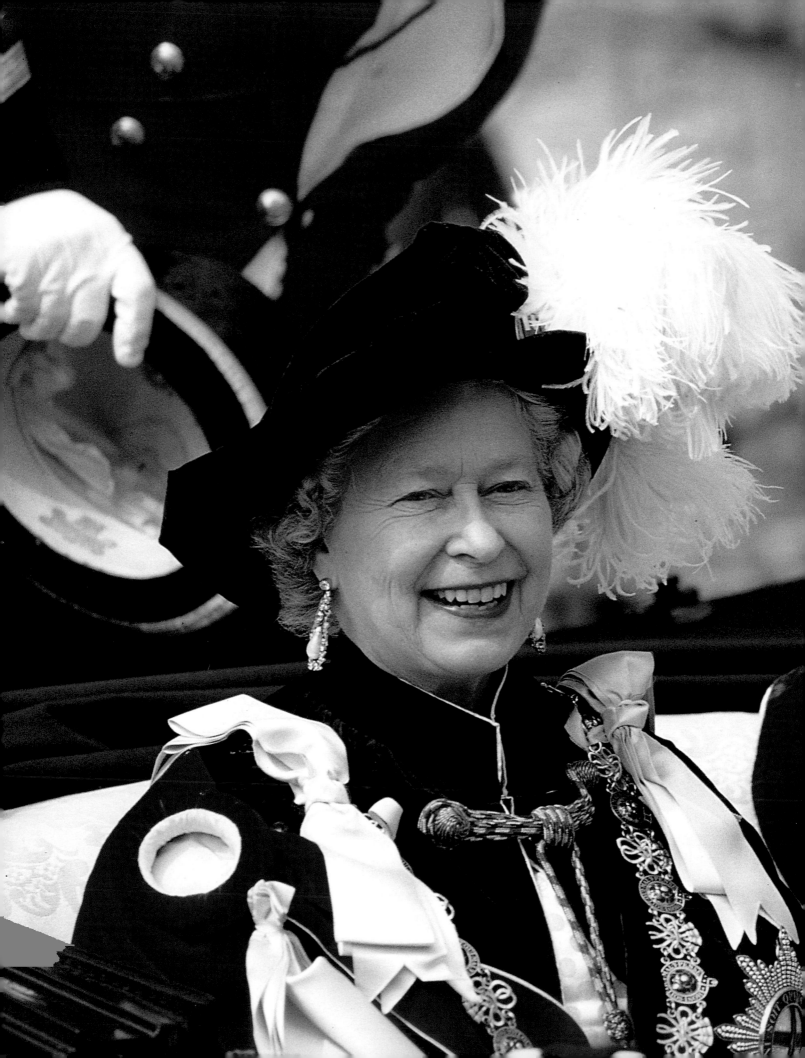

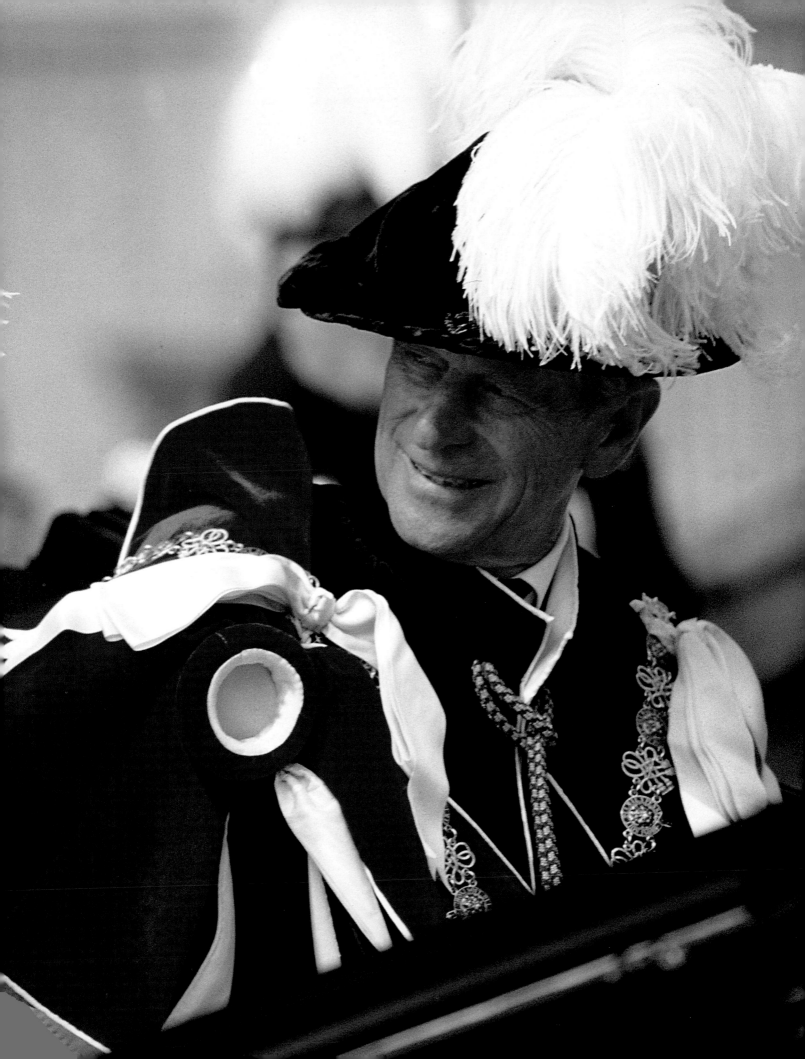

Garden Parties

AN INVITATION TO A Buckingham Palace garden party is not the rarity that many people imagine. Around 10,000 individuals are invited to each of the July parties, and about 8000 turn up. The stiff white invitations come from the Lord Chamberlain, and each is accompanied by a map and a small numbered card. No reply is necessary: the numbered card is simply handed over on arrival at the palace, and this allows the staff to know who actually turned up.

As with all royal occasions, preparation is paramount. The Lord Chamberlain's office draws up the guest list, referring to suggestions submitted by various sponsors, such as the government, the civil service, the forces and many professional bodies, charities and societies. They also consult their own databank of previous invitees to see how many times they have accepted and who accompanied them. Married invitees may bring their spouse and unmarried daughters (no sons) over the age of 18, but unmarried women must attend alone. This ruling harks back to the days (pre-1958) when the parties were designed to launch well-connected young women into society and on to the marriage market.

The tradition of holding 'afternoon parties', as they are properly known, dates back to the 1860s, when Queen Victoria instigated them in order to meet more of her own kind (she waved at them from her carriage). Nowadays, the guest list is much more wide-ranging and includes people from every social stratum and all walks of life. Dustmen rub shoulders with dukes, and those chosen to be presented to the Queen are frequently surprised by her (well-briefed) knowledge of their lives and families. Nonetheless, certain conventions remain, not least those relating to dress. Although the invitations state that lounge suits are acceptable, many men still wear formal morning dress with top hat. Women generally wear afternoon dress and hats (never trouser suits).

Since 1958, when presentation parties for debutantes were abandoned, the Queen has given four garden parties – three at Buckingham Palace, and a fourth at Holyroodhouse in Edinburgh. In most years an extra party is held in London to honour a national organization that is celebrating a particular occasion. In 1998, for example, a special garden party was held to celebrate the 50th anniversary of the National Health Service, and all the guests were serving members of it.

On the day of a party, guests are allowed into the palace grounds from about 3 p.m., but the Queen and the Duke of Edinburgh, plus other members of the Royal Family, enter the garden at precisely 4 p.m., their arrival heralded by a band playing the national anthem. After some formal presentations, the royals circulate among the guests, who have been divided into 'lanes'. The Queen works slowly along her particular lane and a gentleman usher whispers a briefing before making each presentation. (The usher has done his homework in advance, selecting a variety of people that he knows the Queen would like to meet and noting a few interesting facts about them.) This system allows the Queen and members of the Royal Family to meet a representative cross-section of the guests before arriving at the royal tea tent, where they meet high-ranking diplomats and officials.

Garden parties are expensive affairs: the current cost is in the region of £100,000 per party, and the bill is met from the Civil List. A typical menu, provided by outside caterers, includes 40,000 sandwiches, 6000 scones, 5500 fruit tartlets, 2500 eclairs, 27,000 cups of tea, 10,000 glasses of iced coffee and 20,000 glasses of fruit squash. The fare in the royal tent is slightly different, being prepared in the palace kitchens and served on monogrammed china.

At 6 p.m. the Queen and the Royal Family return to the palace and the national anthem is played once again to mark the end of the party.

RIGHT: *It's not easy to keep ice-cream at the right temperature when you are catering for 8000 people. Here a trolley of 3500 individual portions arrives at the last minute.*

ABOVE LEFT: *The carpet in the tea tent is given the once over with a leaf-blower before the first guests arrive.*

LEFT: *A final polish for some of the 12,000 tea cups and saucers needed for the party.*

OVERLEAF: *Steve Marshall, assistant yeoman (left), and Richard Buchanan, under-butler in the glass pantry (right), carrying tablecloths out to the royal tea tent.*

ABOVE: *The scale of the catering at a garden party means that most of the food is prepared offsite and wheeled in on multistorey trolleys that hold dozens of plates of sandwiches and cakes. Here executive chef Eric Bradley in the tented kitchen is cutting some of the many Majorca slices that will be served.*

RIGHT AND OPPOSITE: *The cups in the royal tea tent all bear the Queen's cypher. A special blend of tea is produced exclusively for the Buckingham Palace garden parties. Called Maison Lyons, it is a blend of Assam and Darjeeling leaves, which gives a unique flavour of peaches or muscat grapes. For non-tea drinkers, glasses of iced coffee or fruit squash are available.*

BELOW: *A last-minute briefing and a quick shoe-shine for the waiters before the doors open at 3 o'clock. Around 400 waiters are needed on the day.*

ABOVE: *Around 27,000 cups of tea are served during the average garden party.*

LEFT: *Staff wait to serve guests with 40,000 sandwiches, 5500 bridge rolls, 6000 scones, 5500 fruit tartlets, 5000 Majorca slices, 4300 slices of Swiss roll, 2500 coffee eclairs, 2200 lemon drizzle slices, 2000 fondant fancies and 2000 pieces of shortbread.*

LEFT: *Fondant fancies served on silver salvers are great favourites with garden party guests.*

OVERLEAF: *Ranks of chicken and tarragon bridge rolls await a final sprinkling of chopped herbs.*

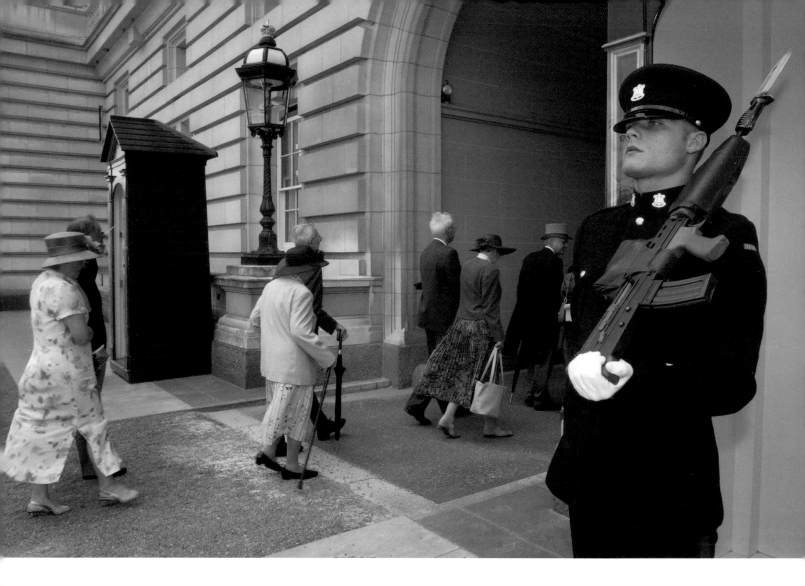

ABOVE: *A sentry stands guard as guests arrive at the front of Buckingham Palace.*

LEFT: *There's no pushing and shoving in this queue snaking across the quadrangle at Buckingham Palace. The guests patiently inch their way towards the Grand Entrance, which leads them through state rooms and on to the terrace.*

OPPOSITE: *People from all walks of life are invited to garden parties – either directly by the palace or on the recommendation of sponsors who submit lists on a pre-arranged quota system. Individuals cannot propose themselves – they have to wait to be asked. Here some of the guests stroll in the palace gardens.*

LEFT: *Men attending garden parties wear morning dress, lounge suits, uniform or national dress.*

BELOW: *The majority of ladies wear afternoon dress, usually with hats, but national dress is also welcome.*

ABOVE: *There is a special tea tent for the Diplomatic Corps. On 11 July 2001 the guests included the high commissioners of Australia, Canada, Lesotho, Malta, Zambia and St Vincent & the Grenadines. Also present were the ambassadors of Armenia, Burma, Ecuador, Ethiopia, Iran, Libya, Mongolia, Madagascar, Niger, Romania and Vietnam.*

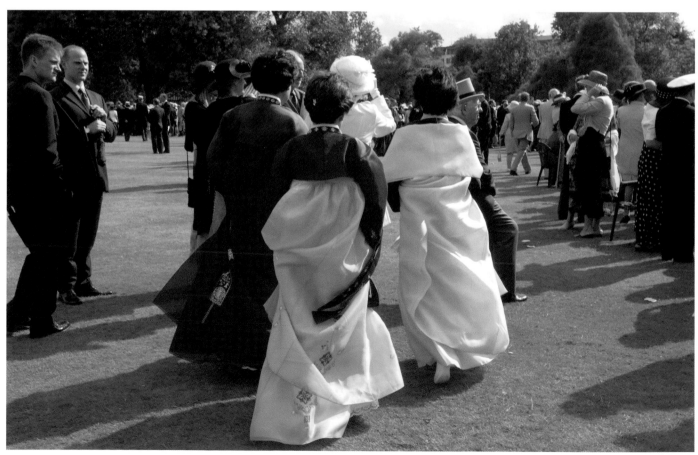

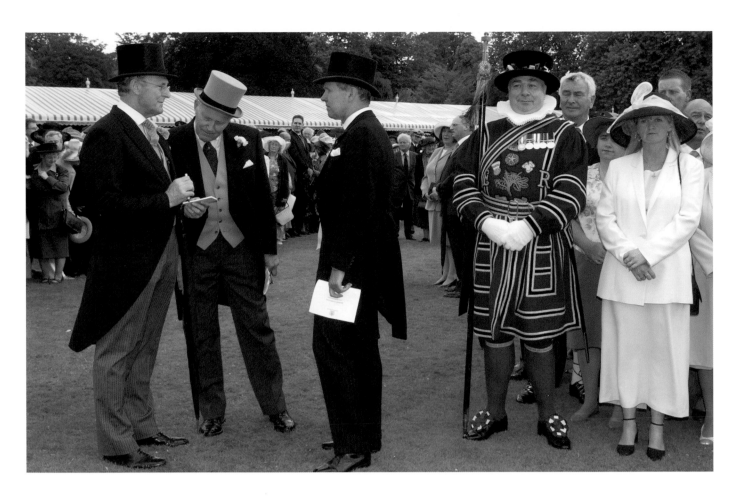

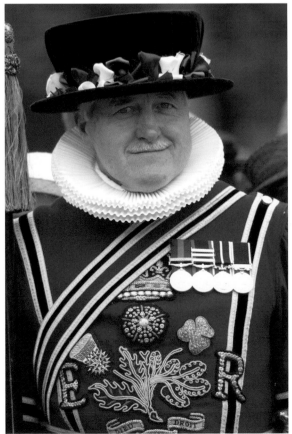

ABOVE: *Gentlemen at Arms (members of Her Majesty's Body Guard of the Honourable Corps of Gentlemen at Arms) and Gentlemen Ushers blend into the crowd at palace garden parties because they wear morning dress. Yeomen of the Guard, who are also in attendance as bodyguards, are much easier to pick out.*

LEFT: *Although rowdy behaviour is unlikely at a garden party, the colourful presence of the Yeomen of the Guard will deter anyone tempted to try it. All the members of this elite body are former officers in the armed forces.*

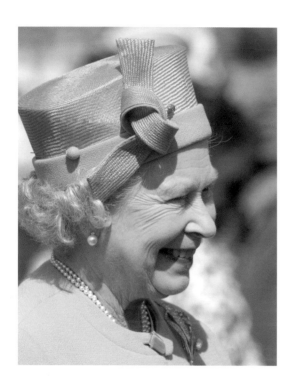

ABOVE, RIGHT AND OVERLEAF:
*On the dot of 4 o'clock the
Queen appears on the terrace
and the national anthem is
played. On this occasion she
is accompanied by the Duke
of Edinburgh, the Prince of
Wales and the Duke of York.
People keen to meet the royals
are formed into a series of
lanes, one for each royal
present. The Queen,
normally in a brightly
coloured outfit, and the
members of her family move
along the lanes, stopping to
chat to a cross section of
guests selected by Gentlemen
Ushers, until they reach the
royal tea tent at the end of
the garden.*

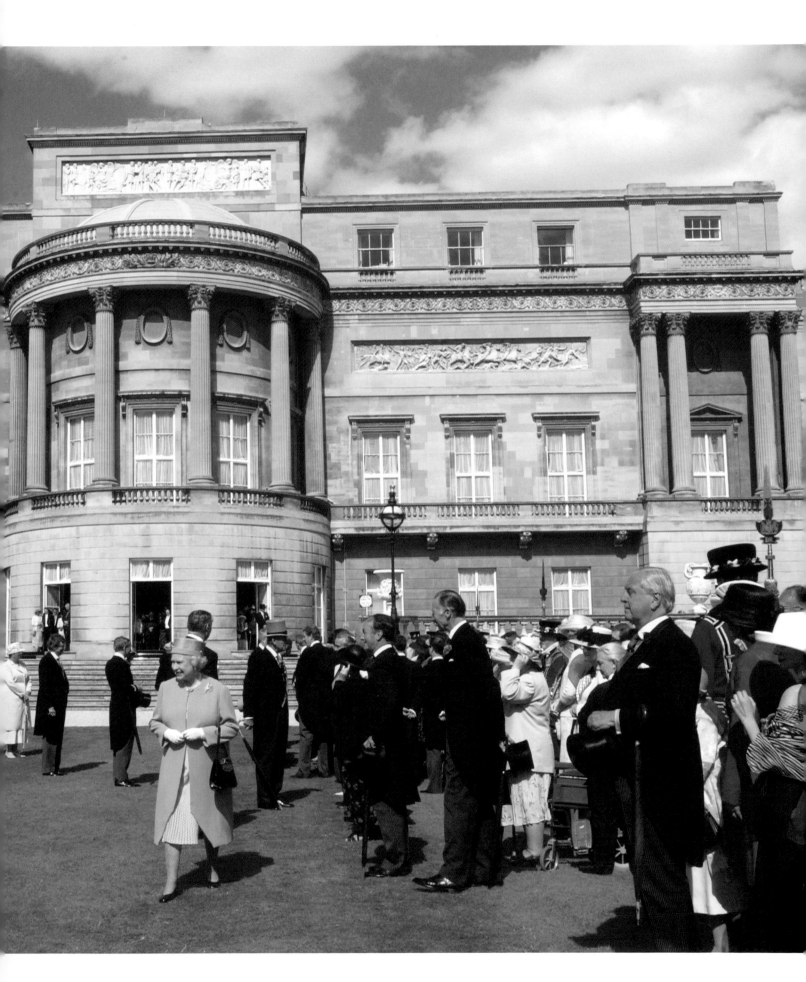

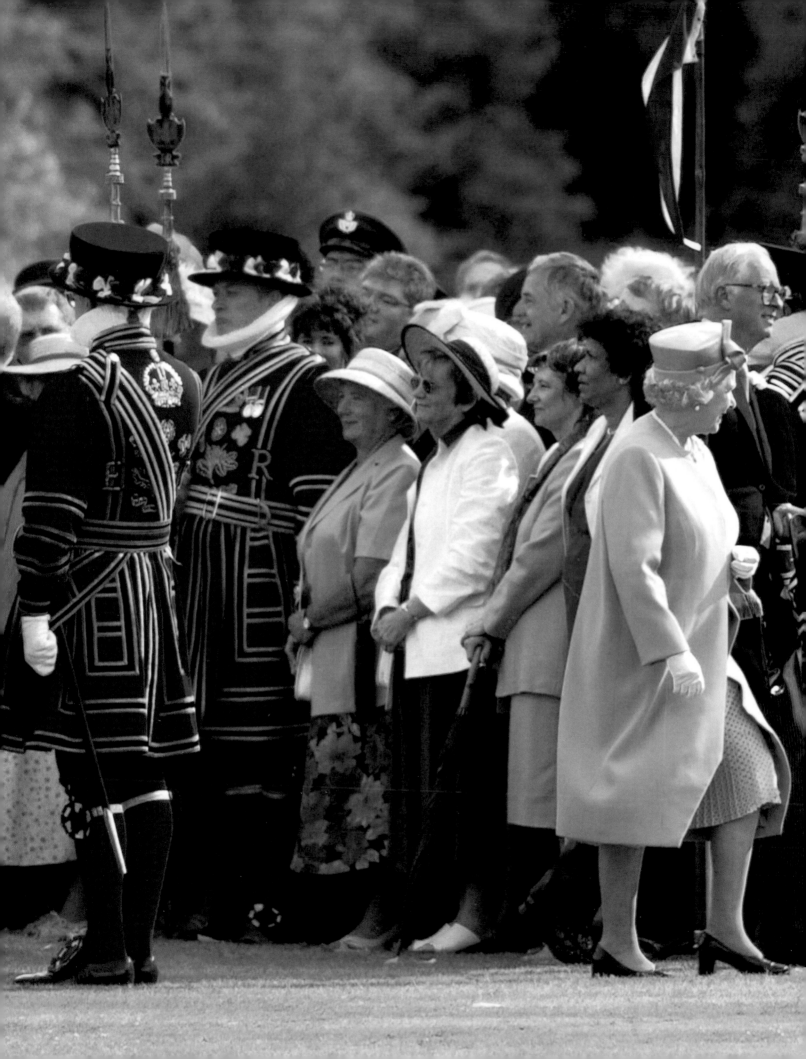

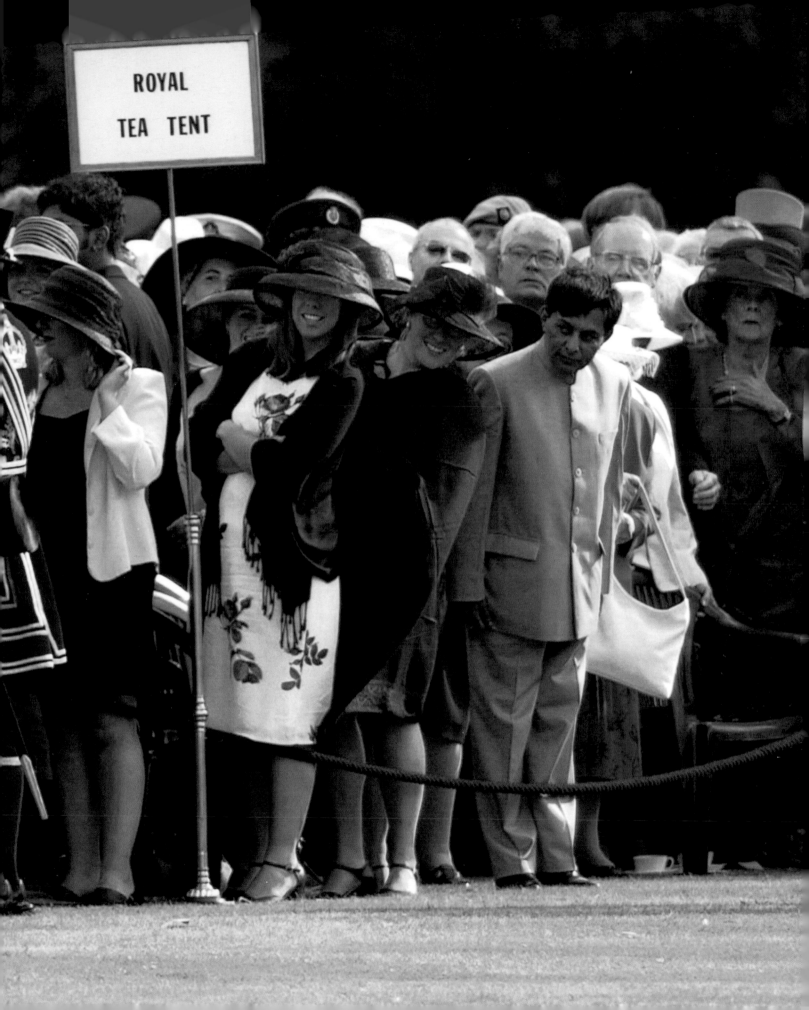

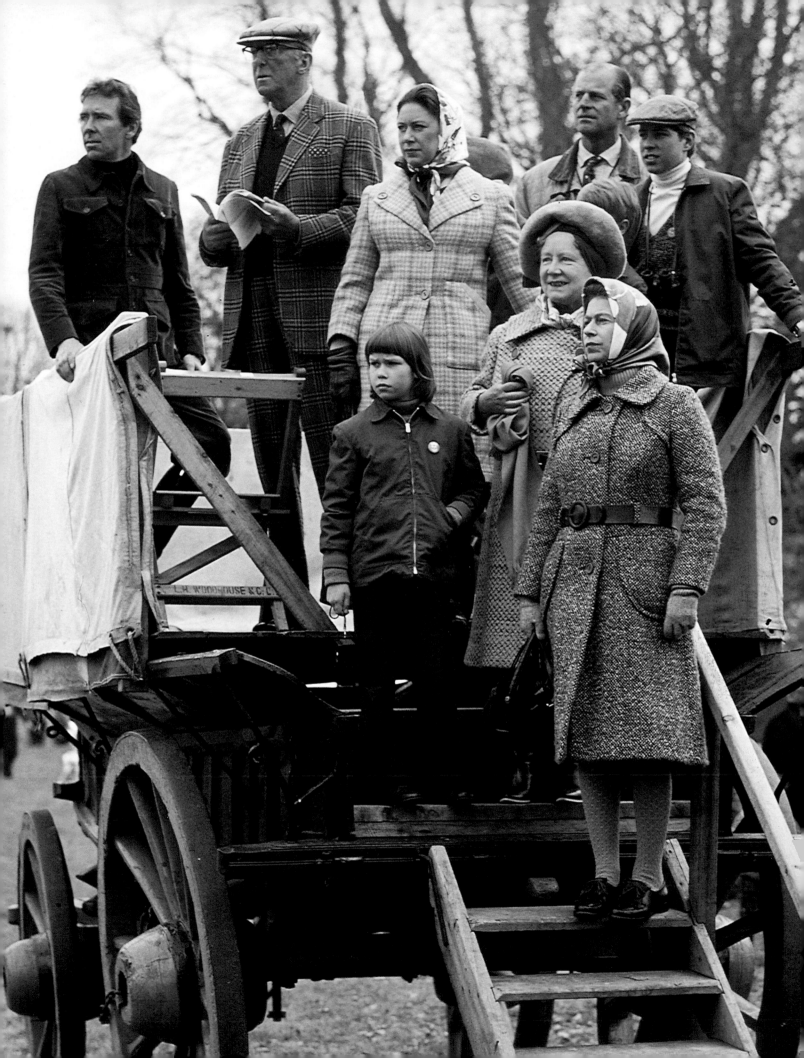

3

Pageantry is the hallmark of most royal occasions, and this section looks at some of the events that have inspired it. By contrast, it then illustrates more relaxed moments in the Queen's life, which allow her to enjoy family gatherings and indulge her passion for horses.

Until his death in 1984, the 10th Duke of Beaufort (second left) annually played host to the Queen and other members of the Royal Family for the Badminton Horse Trials on his estate. The event was won four times by Captain Mark Phillips in his eventing career, and Princess Anne was a keen competitor for many years. Using a haywagon as a vantage point, the Queen, accompanied by the Queen Mother, Prince Philip, Princess Margaret, Lord Snowdon, Lady Sarah Armstrong-Jones and Prince Andrew, keenly watches the cross-country phase of the event in 1973.

Celebrations and Commemorations

PUBLIC AND PRIVATE HAVE a habit of meshing together in the life of the monarch. People expect significant occasions to be marked by some kind of ceremony, and the Queen is not one to let them down. In fact, she seems to enjoy the pageantry that attaches to them.

Every year, with unflattering regularity, there is a colourful parade to mark the Queen's birthday (see page 200), but certain numbers seem to excite more attention than others. Her 60th birthday, for example, sparked more celebrations than usual, and parties were held in London and Windsor. Irreverent journalists at the time reminded us that many people retire at 60 and speculated fruitlessly about whether the Queen would abdicate in favour of Prince Charles. Sixteen birthdays later, she's still going strong and shows no sign of relinquishing the throne.

Other family birthdays have also excited attention in recent years, but 2000 was probably the busiest: Princess Margaret reached 70, the Princess Royal was 50, the Duke of York turned 40 and his daughter, Princess Eugenie, joined them all in double figures by reaching 10. Most memorably, the Queen Mother, demonstrating the stamina and will-power that have typified her life, celebrated her 100th birthday, thereby becoming eligible to receive a telegram of congratulation from her own daughter. Her century was publicly marked by a special pageant on Horse Guards Parade. Led by one of her own corgis, it involved marching bands, choirs, carnival floats, race horses, camels, dancers, celebrity performers and thousands of people. The funny and happy occasion ended with one million rose petals floating down on to the assembled throng.

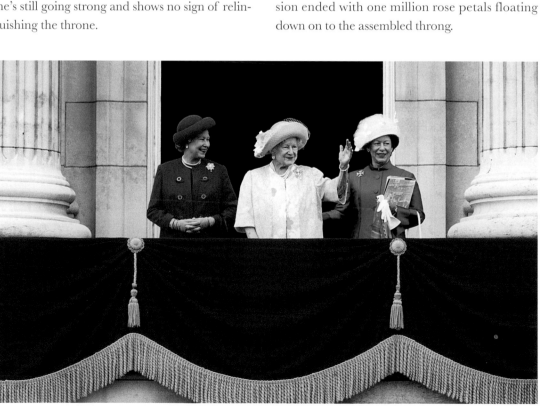

LEFT: *Over the years, I have taken many photographs of the Royal Family on the balcony of Buckingham Palace. In May 1995, to celebrate the 50th anniversary of VE Day, the Queen, the Queen Mother and Princess Margaret re-created their appearance on the balcony from 50 years earlier.*

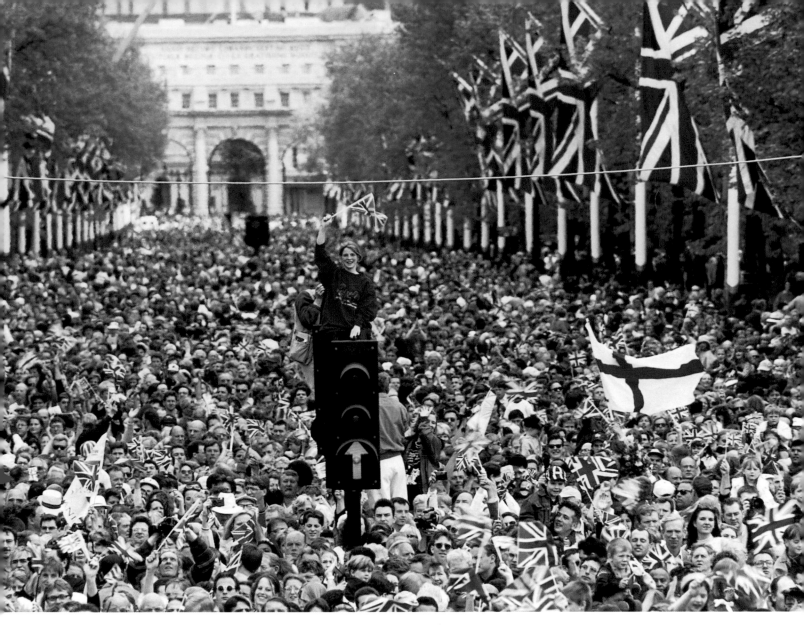

Just as everyone loves a wedding, so everyone is keen on wedding anniversaries, especially if a decent length of service is involved. In 1972, on the occasion of their Silver Wedding, the Queen and the Duke of Edinburgh enjoyed a special celebration involving a carriage procession to Westminster Abbey and a service of thanksgiving, which was attended by relatives from near and far. Just a short while later, or so it seemed, they were celebrating their Golden Wedding. Once again, there was a service of thanksgiving conducted by the Archbishop of Canterbury, but the main public event was a banquet hosted by the Prime Minister. In her speech of thanks the Queen paid fulsome tribute to her husband, describing him as her 'strength and stay'. The anniversary celebrations climaxed with a glittering ball at Windsor Castle, which was attended by many members of European royalty. It was a happy ending to a year

that had been touched by the tragic death of Diana, Princess of Wales.

The tragedy of war has also inspired many commemorations in recent years. The euphoria of VE Day and VJ Day was remembered in 1995, half a century after people took to the streets to celebrate victory over Germany and Japan. Inevitably, joy was tinged with sadness for all the lives lost or irreparably damaged, just as it was in commemorations of the later victories in the Falklands and the Gulf.

In publicly sharing triumphs, sorrows and disasters, Queen and country demonstrate an affinity that bridges the gulf created by accidents of birth. As she said in her Golden Wedding speech, 'I believe that there is an air of confidence in this country of ours just now. I pray that we – people, Government and Royal Family, for we are one – can prove it to be justified…'

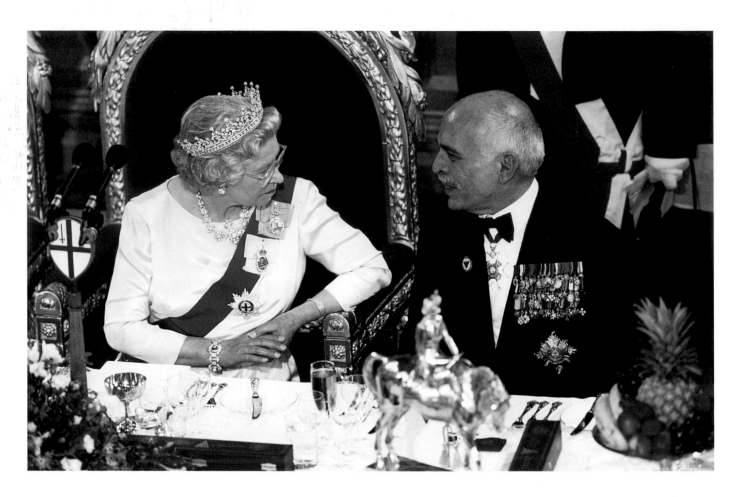

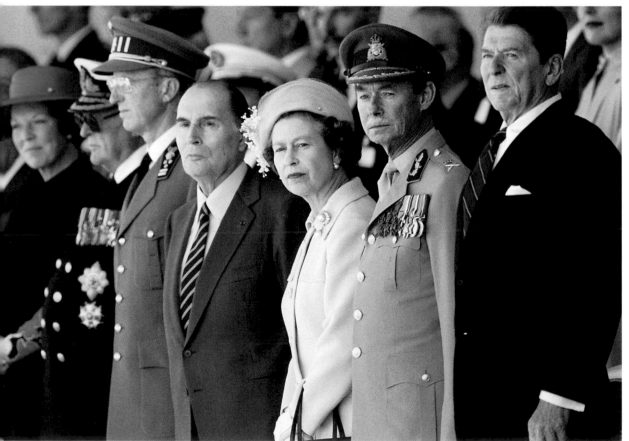

ABOVE: *King Hussein of Jordan talks to the Queen at a banquet given in May 1995 by the Lord Mayor and City of London for visiting heads of state celebrating the 50th anniversary of VE Day.*

LEFT: *This gathering at Utah Beach in France, to mark the 40th anniversary of the D-Day Landings, included King Baudouin of Belgium, President Mitterrand of France, the Grand Duke of Luxembourg and President Reagan of the USA. With so many heads of state in one place, the security was intense, but I found it a great help. The French police had closed the roads to all traffic except the VIP convoys and those of us with media badges, so we sped along deserted autoroutes wishing media travel could always be so easy.*

ABOVE: *This firework display over HMY Britannia at Tower Bridge marked the 50th anniversary of VJ Day in August 1995. To catch sufficient showers of light, the camera shutter had to be opened and closed several times on the same frame.*

BELOW AND RIGHT: *The official parade to mark the 50th anniversary of VJ Day was very lengthy – perhaps a little too much for the young princes. As the parade wound on, both boys checked their watches and Prince Harry kicked off his new shoes.*

OVERLEAF: *When the Queen and Prince Philip visited the Bayeux Cemetery as part of the D-Day commemorations, I knew that the picture needed to be them on their own with rows of graves. Only this would convey the scale of the loss of life.*

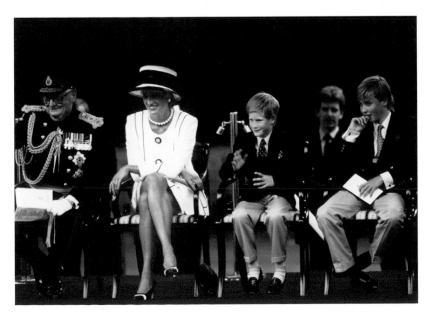

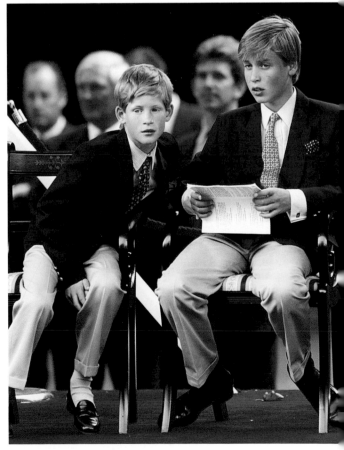

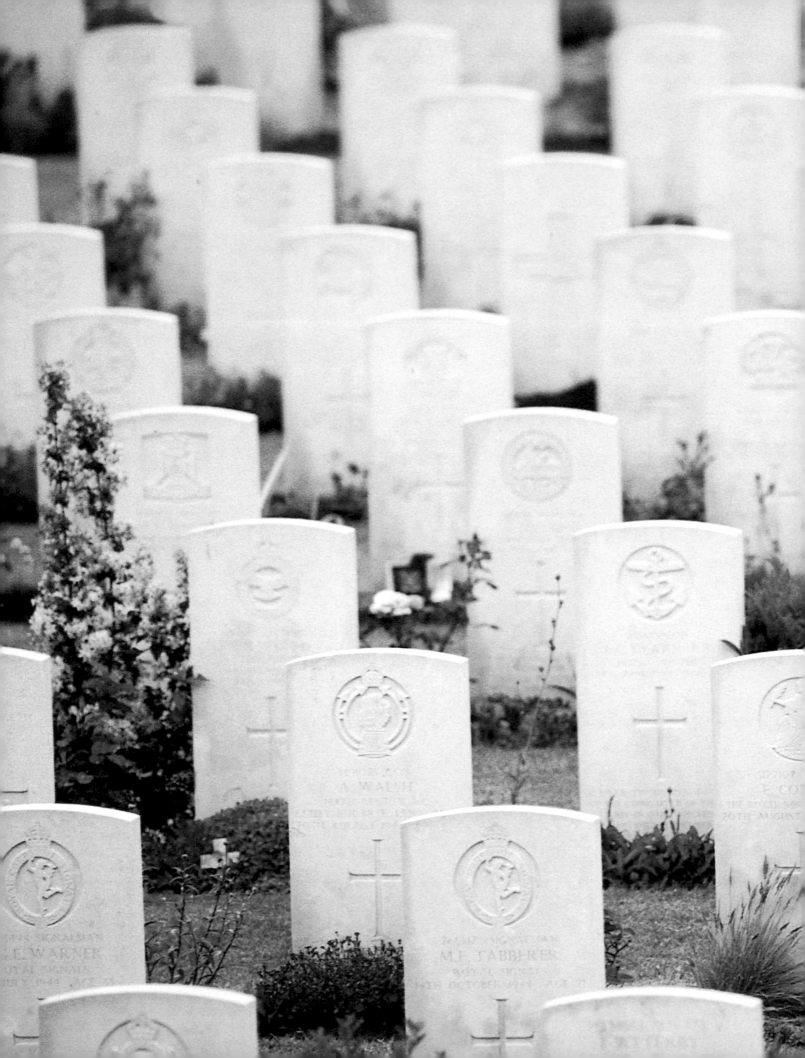

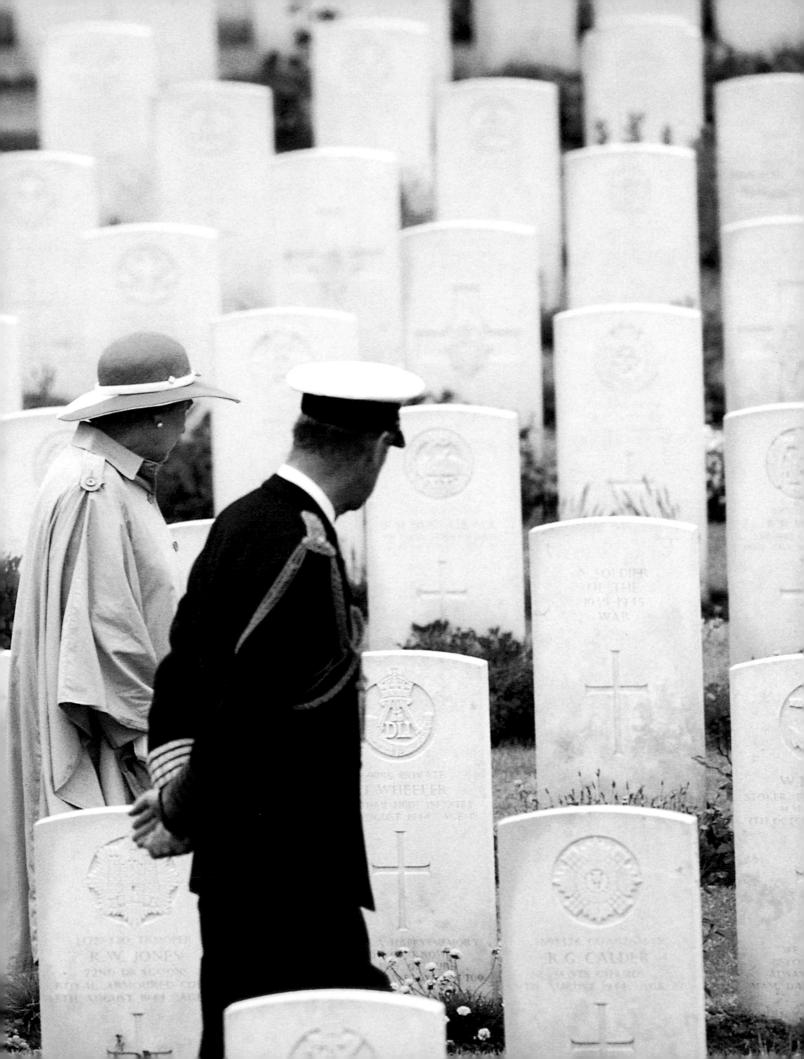

BELOW: *For the Queen's 60th birthday in April 1986 thousands of schoolchildren marched along The Mall towards the palace carrying daffodils for their monarch, who was wearing a daffodil yellow outfit for the occasion.*

RIGHT: *At the end of the public tribute, the Queen invited the newly engaged couple, Prince Andrew and Sarah Ferguson, to join her and Prince Philip on the palace balcony. It was the bride-to-be's first experience of the public life that lay ahead of her.*

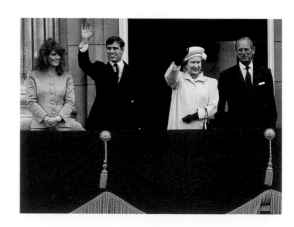

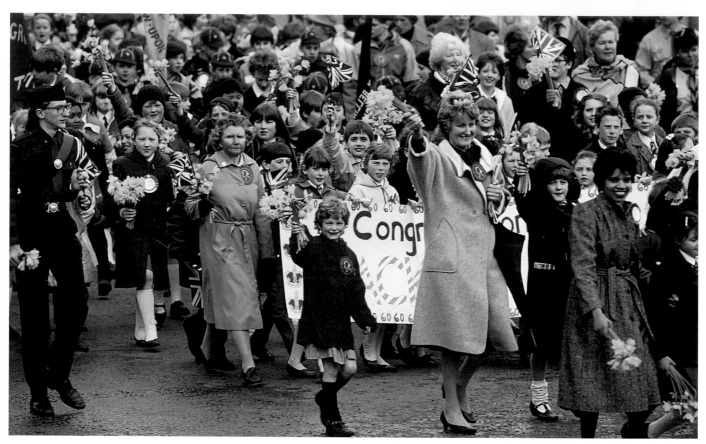

LEFT: *Even London buses joined in the celebration by carrying birthday greetings in their destination panels.*

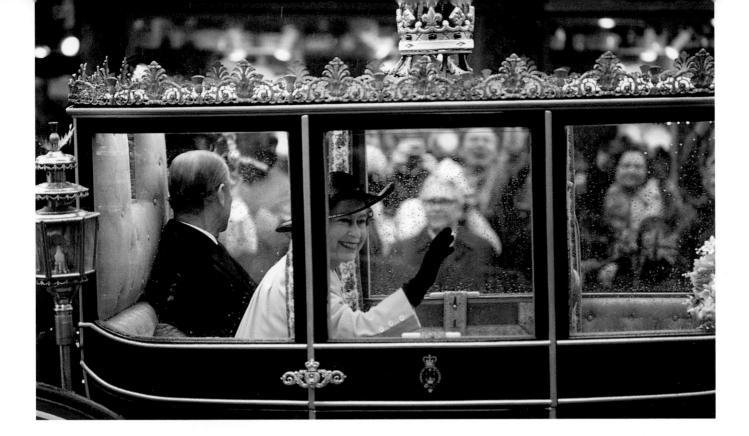

ABOVE: *It was a safe bet that April showers would disrupt the birthday procession planned in Windsor. Rain always means closed carriages in place of open-topped landaus. This makes it harder to get a clear, uncluttered shot, but as she passed next to my camera, the Queen leant forward with a smile and a wave.*

LEFT: *For three-year-old Prince William, following in a carriage behind the Queen's, the day was a bit overwhelming, but he managed a wave to the crowds.*

RIGHT: *A very special royal fan – a border terrier dressed to impress. (I had to include this picture as my own house is run by a border terrier!)*

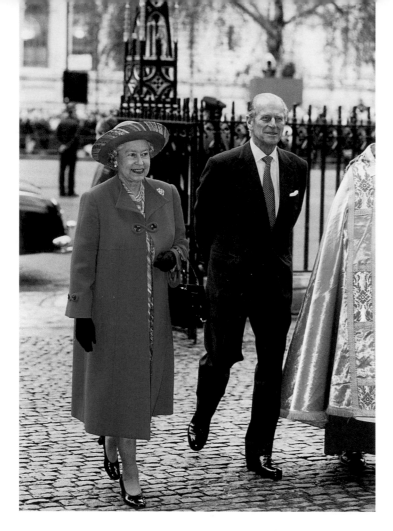

LEFT: *A service at Westminster Abbey was chosen as an appropriate way of marking the Golden Wedding Anniversary of the Queen and Prince Philip. To the couple's immense pleasure, the five-year restoration of fire-damaged parts of Windsor Castle was completed that day – a perfect anniversary present.*

BELOW: *Cheers and raised caps from one of the Queen Mother's regiments for her birthday.*

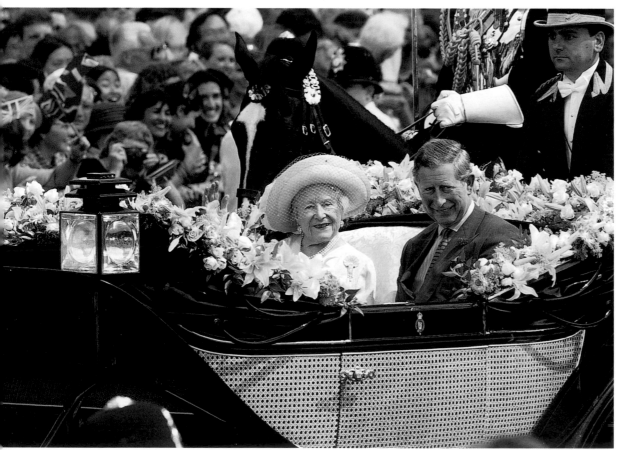

LEFT: *Nearly 50 years separates the Queen Mother and her first grandson, but there is no doubt that they have a special bond. She has been escorted by Prince Charles on many occasions, and the parade to mark her 100th birthday on 4 August 2000 was no exception.*

OPPOSITE: *For the Ruby Wedding Anniversary of the Queen and Prince Philip in 1987 I was invited to take some new official portraits of them at Windsor Castle. The one-to-one nature of this session made me extremely nervous. The most difficult thing is trying to keep a clear head over the technical aspects of the shoot while attempting a sensible and coherent conversation. It's a bit like patting your head and rubbing your tummy at the same time.*

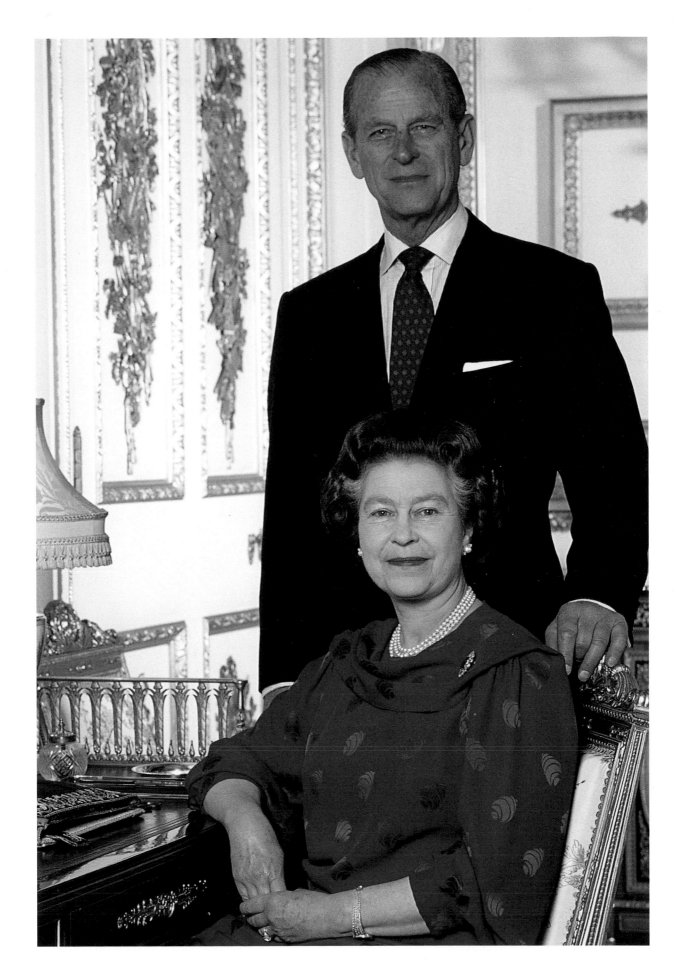

RIGHT: *A thoughtful look from the Queen towards the assembled ranks of the three services at the Falklands Memorial Service in St Paul's Cathedral in 1982.*

It was a war that touched her as both mother and monarch because Prince Andrew, a serving naval pilot, flew helicopter missions from HMS Invincible.

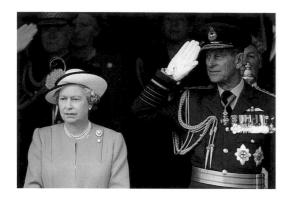

ABOVE AND BELOW: *From a pavilion at the Mansion House in London in June 1991, the Queen and distinguished guests watch the welcome home parade for those who had served in the Gulf War. Joining the* *Queen, Prince Philip and the Prince and Princess of Wales were representatives of the Gulf States, Prime Minister John Major, Foreign Secretary Douglas Hurd and the Lord Mayor of London.*

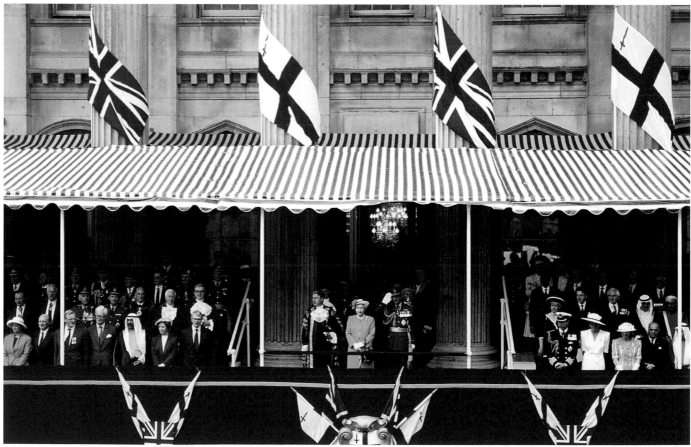

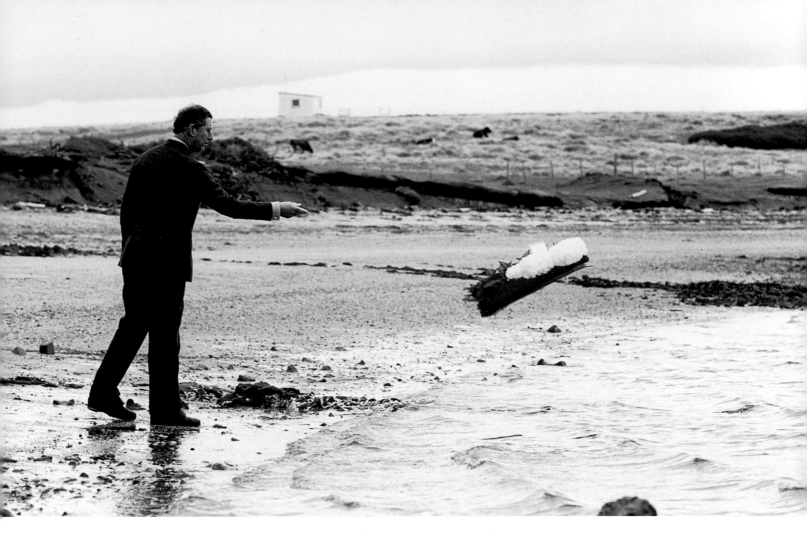

ABOVE: *In isolated San Carlos Bay, some 17 years after the Falklands War, Prince Charles represented the Queen at another memorial service. This culminated with his throwing a wreath into the sea to commemorate those who had given their lives in the conflict.*

RIGHT: *From the back of a Range Rover bearing the Royal Standard, the Queen, accompanied by Prince Philip, acknowledges 10,000 British D-Day veterans of the Second World War who gathered at Arromanches in France for the 50th anniversary of the Normandy Landings.*

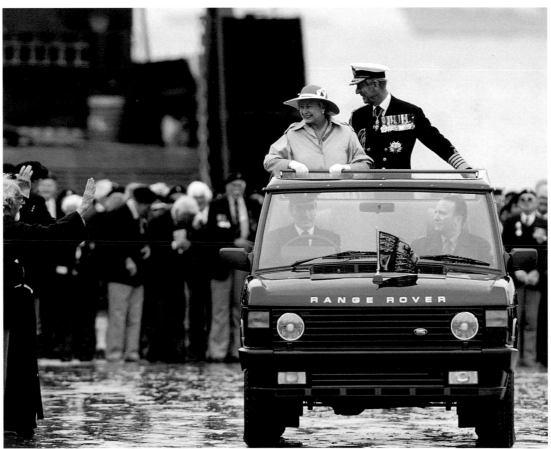

Silver Jubilee

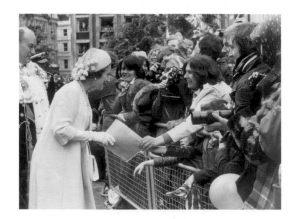

IN THE HISTORY OF the monarchy, jubilees (a term strictly applied to 25th and 50th anniversaries of accession to the throne) have been relatively rare occasions because few monarchs have lived that long. King George III was the first British monarch to survive 50 years on the throne, and the celebrations held for him in 1809 marked the beginning of a tradition that has been upheld ever since.

The Silver Jubilee of Queen Elizabeth II was celebrated over May, June and July in 1977. Following loyal addresses from both Houses of Parliament, the Queen asserted that unity was to be the theme of her jubilee and immediately began to fulfil her declared aim of meeting as many people as possible throughout the kingdom.

The first tour began in Glasgow on 17 May, and over the next 10 weeks the Queen visited 36 counties, finishing her marathon travels with a visit to Northern Ireland. Vast crowds turned out to cheer her wherever she went, an affirmation of pride in the monarchy and an acknowledgement of the dedication she had brought to her task.

Perhaps the most visible sign of the unity the Queen desired was demonstrated on 6 June, when she lit the first of a series of beacons that formed a chain of solidarity and goodwill from one end of the kingdom to the other.

The next day, declared an official holiday, was marked by a service of thanksgiving at St Paul's Cathedral. Millions of people lined the processional route from Buckingham Palace to the City to watch the Queen drive past in the Gold State Coach. After the service the Queen delighted the crowds by going on a walkabout, then a relatively recent innovation, and was obviously moved by the warmth and affection of the people.

Those who did not brave the crowds in central London staged their own celebrations. Thousands of street parties took place, gallons of beer and ice cream were consumed, millions of fireworks lit up the sky and the total length of bunting strung between houses and lampposts was enough to encircle the globe.

Commonwealth countries also joined in the celebrations. Among those the Queen managed to visit were Western Samoa, Fiji, Tonga, Papua New Guinea, Australia and New Zealand. On a second tour later in the year she went to Canada, the Bahamas, Antigua, the British Virgin Islands and Barbados.

Whatever troubles had touched the first 25 years of her reign – the dismantling of Empire, the Suez Crisis, the marital problems of Princess Margaret, the Aberfan disaster, Northern Ireland – there was no doubt that people admired and appreciated her. She brought a sense of stability and dignity to the country, and the popular wish was that she would continue to do so for many years to come.

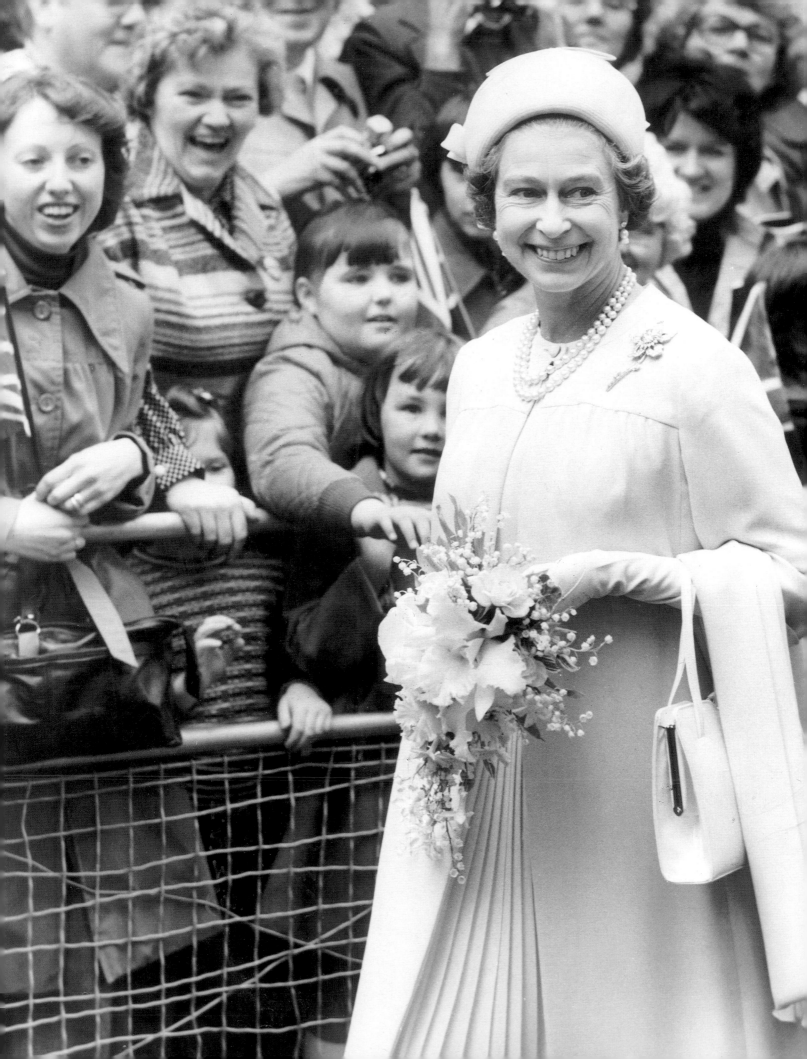

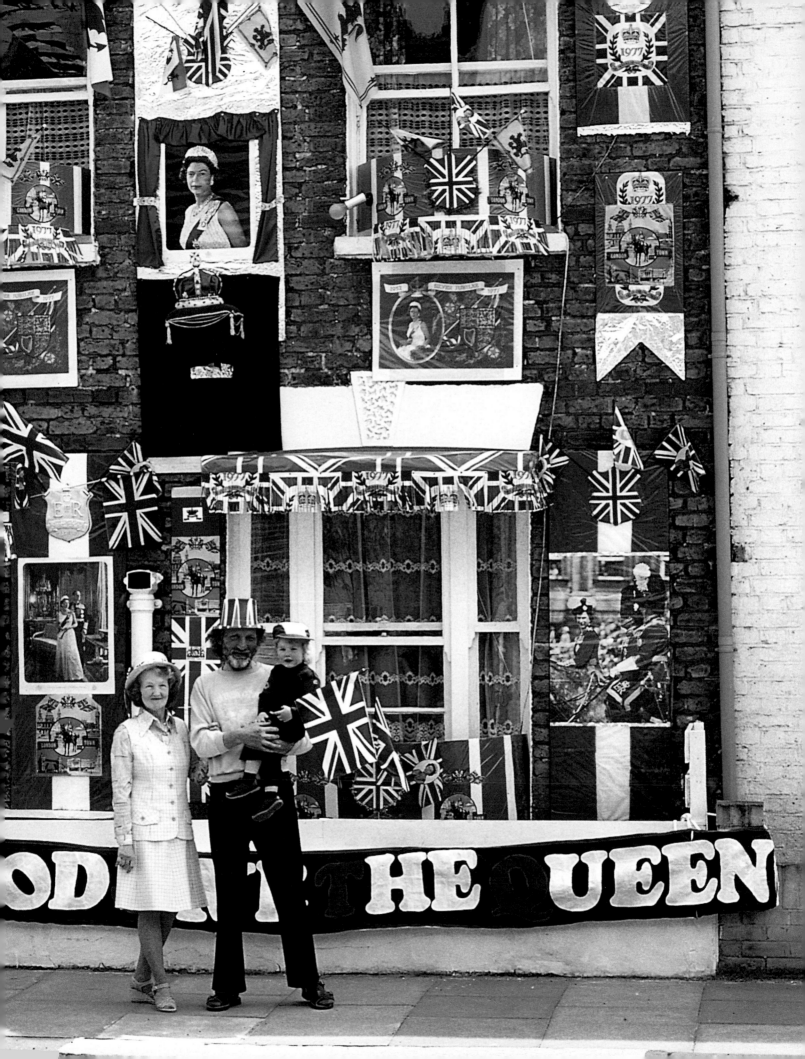

GOD SAVE THE QUEEN

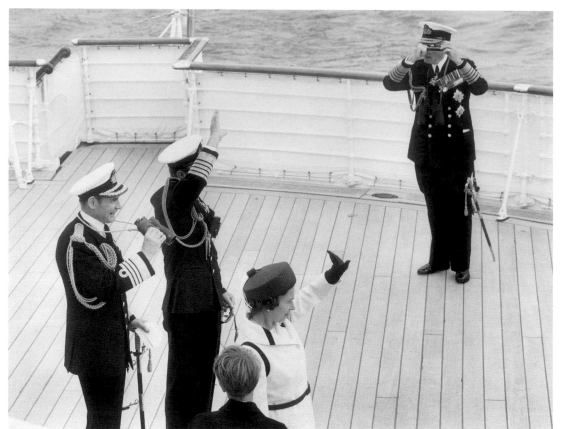

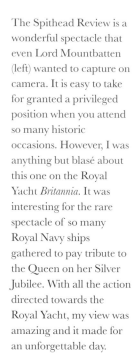

The Spithead Review is a wonderful spectacle that even Lord Mountbatten (left) wanted to capture on camera. It is easy to take for granted a privileged position when you attend so many historic occasions. However, I was anything but blasé about this one on the Royal Yacht *Britannia*. It was interesting for the rare spectacle of so many Royal Navy ships gathered to pay tribute to the Queen on her Silver Jubilee. With all the action directed towards the Royal Yacht, my view was amazing and it made for an unforgettable day.

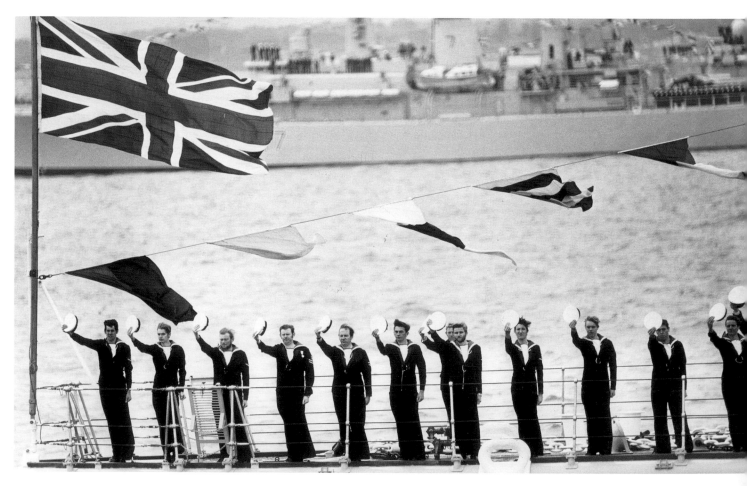

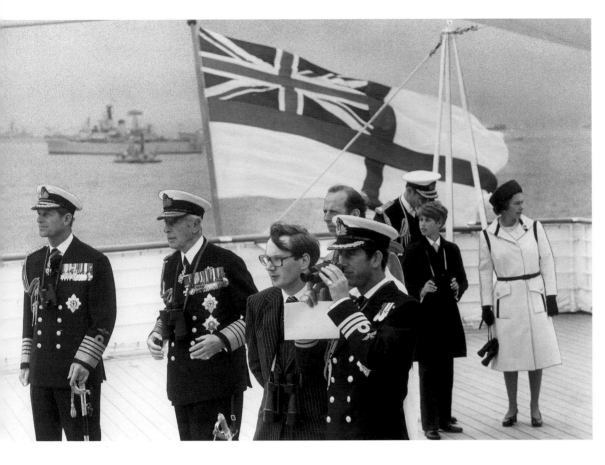

LEFT: *Thirteen-year-old Prince Edward joined the Queen, Prince Philip, Prince Charles, the Duke of Gloucester, the Duke of Kent and Earl Mountbatten on the Royal Yacht to watch the review.*

BELOW: *The Queen and Prince Philip wave in acknowledgement to the sailors taking part in the review.*

LEFT: *At the Spithead Review in Portsmouth in 1977, the royals brought their own cameras along. Earl Mountbatten of Burma used an Instamatic, while the Queen opted for a Leica.*

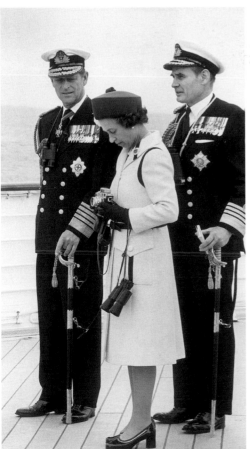

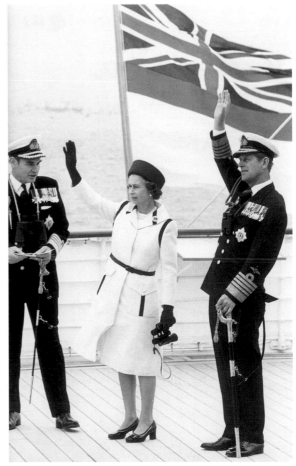

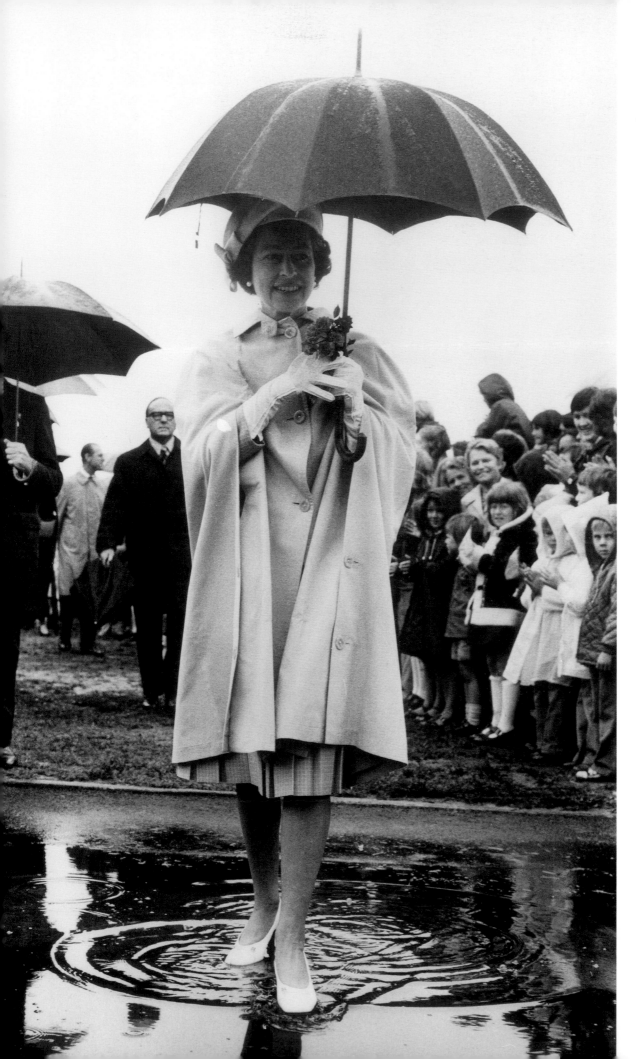

South Pacific Jubilee Tour

Travel arrangements for the press can be very varied – extremely first class on the Royal Flight, if there's room, or, as on this trip, harnessed into canvas seats on a Hercules transport plane, courtesy of the Royal New Zealand Air Force. It was noisy and bumpy, but fun for short flights.

LEFT: *During the Queen's 1977 visit to New Zealand, she did many walkabouts, and it was hard to know when some little incident might produce an interesting shot. When first published, this picture was captioned, 'What, no Sir Walter?'*

RIGHT: *The Queen inspects a guard of honour in Canberra, Australia.*

LEFT: *Wearing a cloak of kiwi feathers, Prime Minister Muldoon greets his similarly clad British visitors. The Queen and Prince Philip's cloaks were given to them by the Maoris on a previous visit. Such cloaks are a rare gift and reserved for the most esteemed visitors.*

BELOW LEFT: *Traditional Maori greetings are huge fun. The guttural chants, fearsome shouts and dramatic gestures are followed by the Maori challenge (below right), here given by the unlikely named Mr Callaghan – namesake of the Queen's prime minister at the time – in his Sunday-best loincloth.*

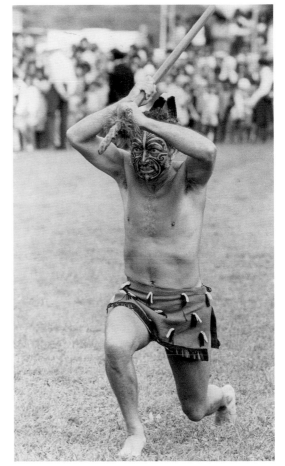

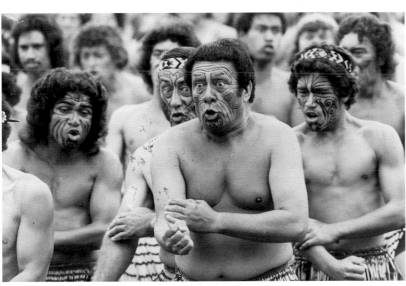

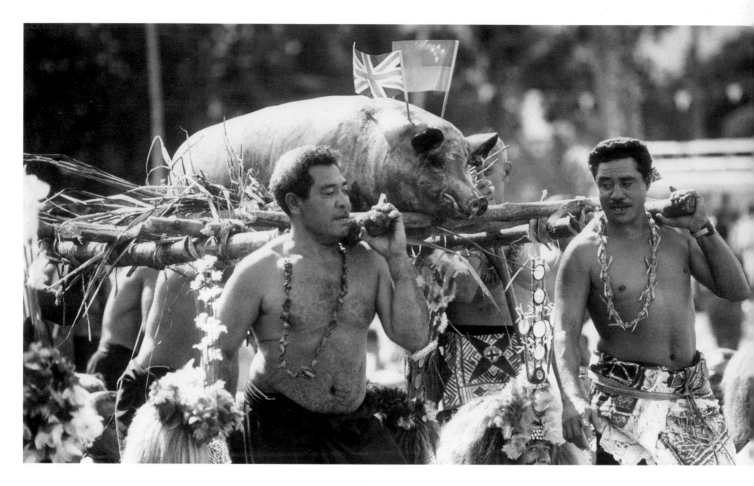

From a photographer's point of view, the South Pacific is, without doubt, one of the best places to enjoy a royal tour and to take royal pictures. I think it's because the people of the South Pacific are so welcoming and full of fun.

ABOVE: *A roasted pig, carried by warriors from Western Samoa, arrives for a feast in the Queen's honour.*

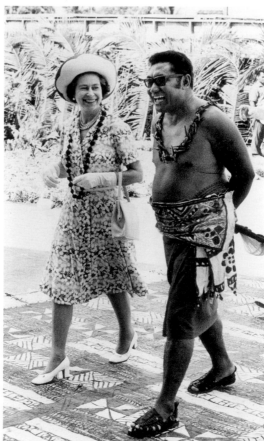

LEFT: *What I like about this picture of the Queen in Pago Pago, Western Samoa, is that it shows how relaxed she was throughout her amazing Silver Jubilee tour of the South Pacific. It was an exhausting tour for everybody because of the heat and the amount of travelling, but it produced marvellous pictures and was one of the greatest experiences of my life.*

RIGHT: *King Tupou IV of Tonga, son of Queen Salote, has a huge personality to match his physique.*

BELOW: *It's very easy to miss a picture, so you have to be attentive to the subject all the time. In the stifling February heat of Fiji the Queen was watching a display by traditional warriors and dancers, which was great fun and certainly distracted me and my colleagues. Glancing back over my shoulder, I saw the Queen reaching into her handbag. As I brought my camera up, she swiftly reapplied her lipstick, then popped it back into the bag. I had a picture my colleagues didn't – always a photographer's goal – of a human moment in the life of the monarch.*

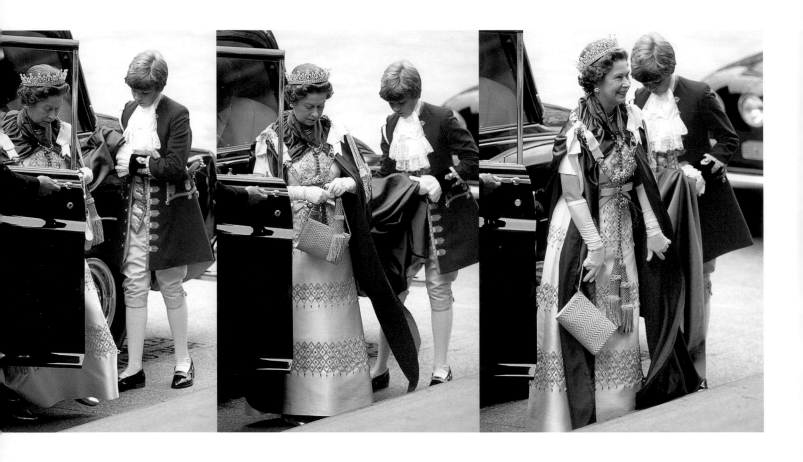

Ceremonial Robes

ABOVE AND OPPOSITE: *The Queen arrives for the Service of St Michael and St George at St Paul's Cathedral in London. She finally smiles when her Page of Honour has sorted out her train.*

In England the Queen has four Pages of Honour, whose job is to carry her train on ceremonial occasions, such as the State Opening of Parliament. Usually aged between 12 and 15, the pages are chosen from among the children of the Queen's friends.

NO ROYAL OCCASION would be complete without some accompanying pageantry and colour, and more often than not these ingredients are supplied by the elaborate robes worn by the main participants.

New appointees to various orders of chivalry are installed with much pomp and ceremony, and the garments worn at these occasions reinforce the ancient roots of the tradition. Here and in the following pages the robes belonging to the five most distinguished orders are described and illustrated. (All are made by the Royal Warrant holders Ede & Ravenscroft.)

The robes worn for the Garter ceremony have changed little since the order was established in 1348. The dark blue velvet mantle, lined in white, has the badge of the order on the left shoulder. On the right shoulder are folds of red fabric representing a hood. Women members wear long white dresses under the mantle, while men wear suits or

uniform. All wear a black velvet hat trimmed with a cockade of white feathers, and across the chest is a collar (similar to a mayor's chain of office), which consists of gold knots alternating with enamel medallions depicting blue garters enclosing red roses. A badge showing an image of St George is suspended from the bottom of the collar.

Scotland has its own ancient order of chivalry, which is believed to date from the 15th century. The Order of the Thistle, which commemorates its founding on St Andrew's Day, requires members to wear a mantle of dark green velvet lined with white. On the left shoulder is the embroidered emblem of the order, and on the right shoulder is a hood of blue velvet. The gold and enamel collar worn across the chest has depictions of the thistle and interlocking sprigs of rue. The badge of St Andrew suspended from the bottom of the collar shows him carrying the crucifix on which he was

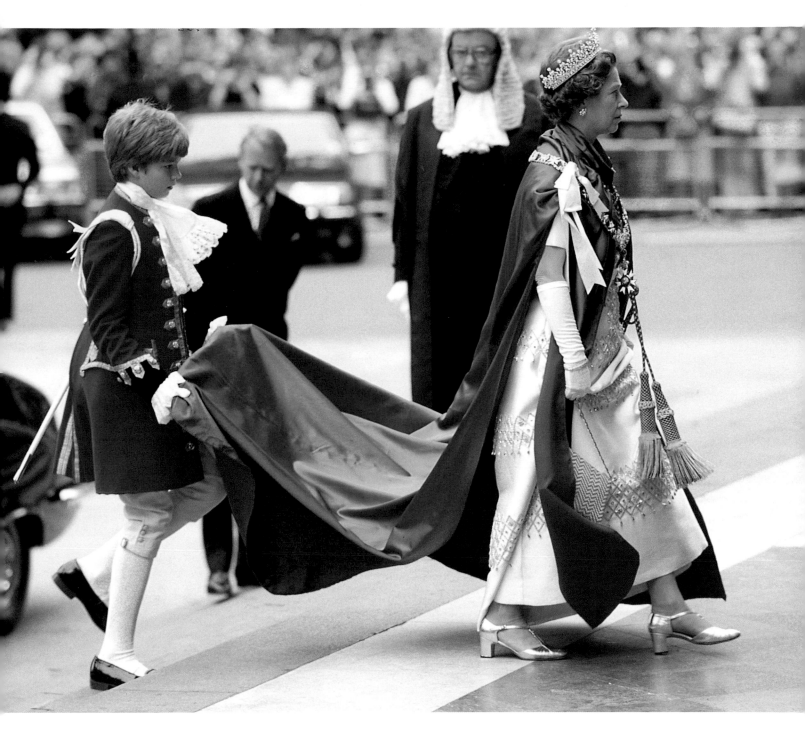

martyred. The outfit is topped with a black velvet hat to which white feathers are fastened by the embroidered badge of the order.

The Most Distinguished Order of St Michael and St George was established in 1818 to honour the inhabitants of strategic Mediterranean islands seized by Britain during the Napoleonic Wars. Nowadays the order is awarded for outstanding service overseas. Its spiritual home is St Paul's Cathedral, and at installation ceremonies members wear a mantle of blue satin lined with scarlet silk. On the left shoulder is the embroidered badge of the order, and across the chest is a collar in which lions, Maltese crosses and the initials SM and SG are linked together. The badge of the order – a cross of 14 points – hangs from the bottom of the collar. On non-ceremonial days the emblem of the order is worn without the robes, and takes slightly different forms, depending to which class of the order the wearer belongs.

The Most Honourable Order of the Bath was established in 1725 as the highest military order of

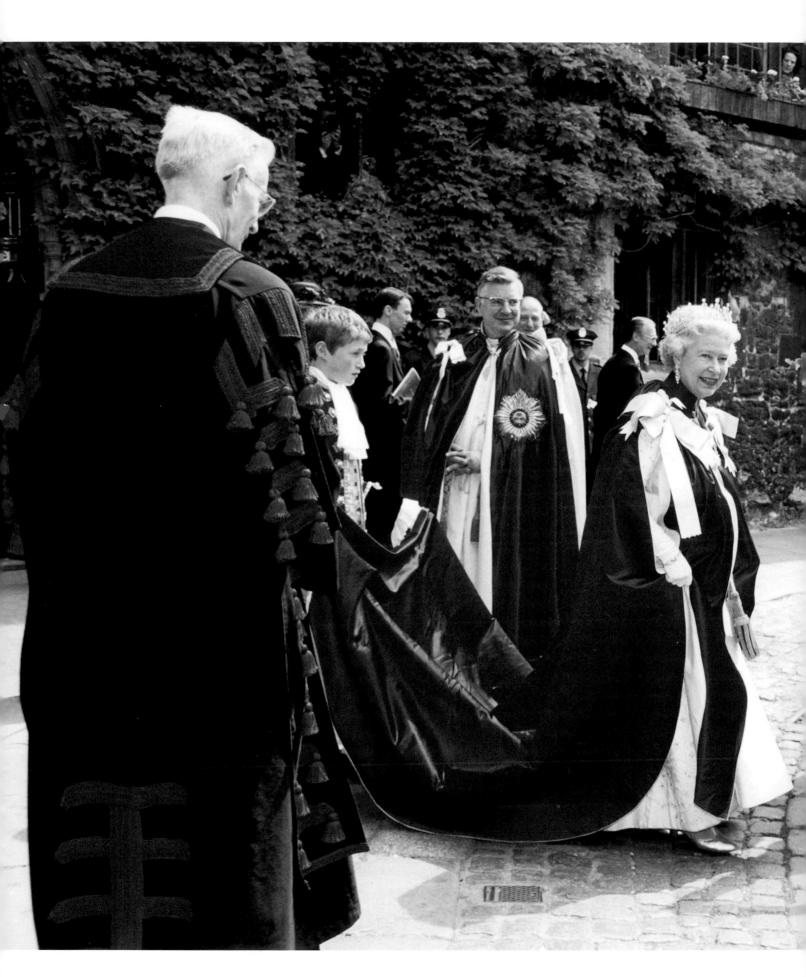

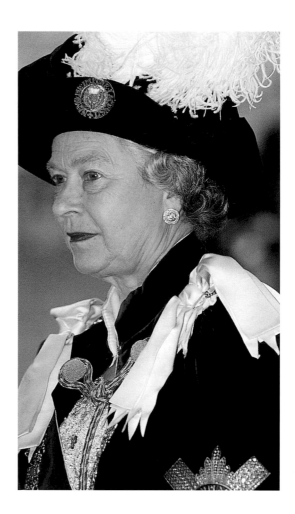

LEFT: *Dr Wesley Carr, the Dean of Westminster, smiles as the Queen leaves Westminster Abbey after a Service of the Order of the Bath.*

RIGHT: *Wearing the dark green velvet robes of the Order of the Thistle, the Queen attends an installation at St Giles' Cathedral in Edinburgh. The order is the highest honour in Scotland.*

knighthood, but was subsequently expanded to include civilian appointments. Members of the highest class attend a service of remembrance, dedication and praise at St George's Chapel, Windsor, every four years, and wear a mantle of wine-coloured satin lined with white taffeta. On the left shoulder is the embroidered badge of the Grand Cross, and across the chest is a gold collar with links of enamelled crowns, roses, thistles and shamrocks. The badge of the order hangs from the bottom of the collar.

The Order of the British Empire has five classes of members, as outlined on page 146. Only those appointed to the highest class (Knights and Dames Grand Cross) undergo an investiture ceremony requiring special robes. These consist of a rose-pink satin mantle lined with grey silk. On the left shoulder is the embroidered badge of the class. Across the chest is a collar consisting of circular medallions interspersed with crowns and sea lions. The badge of the class hangs from the bottom of the collar.

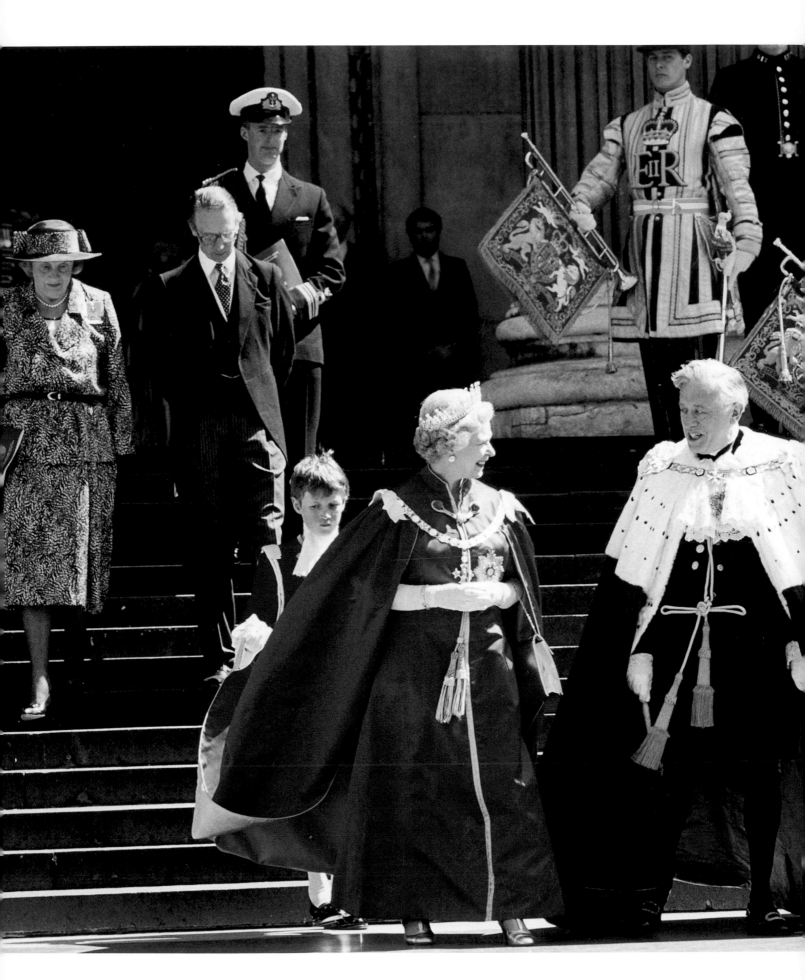

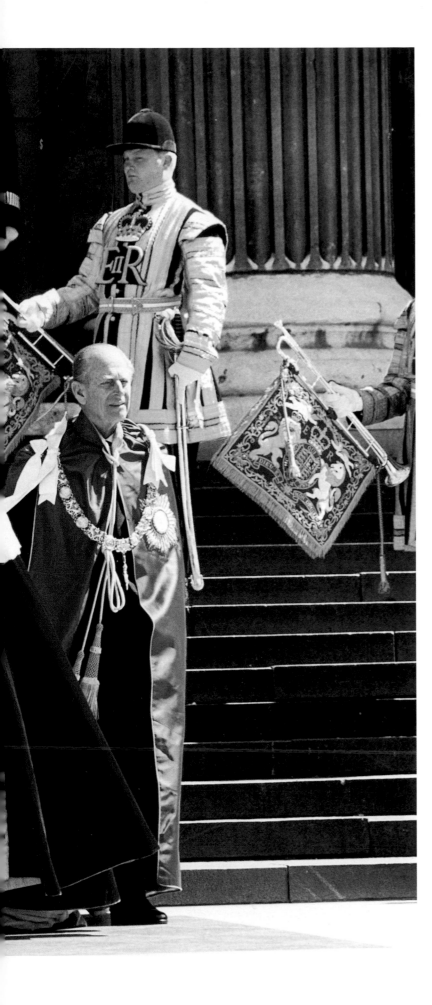

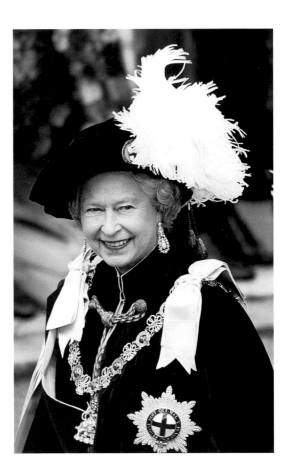

LEFT: *Wearing the rose-pink robes of the Order of the British Empire, the Queen and the Duke of Edinburgh (Grand Master of the order) leave an investiture ceremony at St Paul's Cathedral in May 1996. The Queen is talking to the Lord Mayor of London. Behind (left to right) are her lady-in-waiting, the Duchess of Grafton, her private secretary, Sir Robert Fellowes, and her equerry.*

ABOVE: *The highest and best known of the nine royal orders is the Order of the Garter, for which there is a service at St George's Chapel, Windsor, every June. The dark blue velvet robes have remained virtually unchanged since 1348.*

Trooping the Colour

THE QUEEN HAS TWO BIRTHDAYS: her actual birthday on 21 April, which is a little early in the year to rely on clear skies, and her official birthday in June, when the chances of sunshine are greater.

The official birthday is celebrated each year with a military parade and march-past on Horse Guards Parade in central London. Trooping the Colour is actually just part of the historic three-hour ceremony – the other part is called Mounting the Queen's Guard – but the former is the name by which the Birthday Parade is best known.

The roots of the ceremony go back to at least the late 17th century, when Charles II formally established the army and each regiment adopted colours (flags) that its troops would rally to in battle. Although modifications have been made over the years (usually to improve the spectacle for the public), the ceremony remains basically unchanged. It begins with the Queen riding at the head of her regiments from Buckingham Palace along The Mall to Horse Guards Parade, arriving at exactly 11 a.m. Until 1986, the Queen wore the uniform of the regiment whose colour was being trooped and rode side-saddle, but since her regular mount, Burmese, retired, she has worn ordinary clothes and ridden in a carriage.

On arrival, the national anthem is played and a 41-gun salute is fired in Hyde Park. The Queen, as colonel in chief, then reviews the massed ranks of the Household Division, which comprises the Life Guards, the Blues and Royals, and five regiments of Foot Guards, taking the salute from a dais. Having attended every birthday parade in her honour (the one in 1955 was cancelled because of a national rail strike), the Queen is an expert on every detail of the event and will inform participants later if certain aspects were not up to scratch.

The drums and music that accompany the ceremony convey instructions to the troops, a practice originally devised because many early soldiers were foreign mercenaries who spoke no English.

Every year a different colour from a Foot Guards battalion is trooped before the Queen – a marriage of military and ceremonial duties that also indicates the close link between the Guards and the monarch, who is their colonel in chief.

Massed bands give a display of marching, then a lone drummer signals the beginning of the trooping. The regimental sergeant major hands the colour to the youngest ensign, who carries it along the ranks of guards while the massed bands perform complicated marching manoeuvres. When the colour has passed through all the ranks, the soldiers march past the Queen for the salute, and the colour is lowered as it reaches her. Once the Household Cavalry has passed by, the Queen re-enters her carriage and leads the troops back to Buckingham Palace. There she joins the rest of the Royal Family for the traditional fly-past by the Royal Air Force – a suitably dramatic end to a colourful day.

It's an early start for me on the day of Trooping the Colour. I need to take my place by 7 a.m. to make sure I have a central position in front of the palace balcony for the family group shot.

BELOW: *The essential job of smartening up the gravelled forecourt of Buckingham Palace also begins early.*

ABOVE: *Another early bird is Prince Harry, aged nearly seven in this picture. Not waiting for the other members of the family, he braves the balcony on his own to face dozens of cameras and thousands of people.*

RIGHT: *A battery of long-lens cameras awaits the day's ceremonial. This picture shows just how far away from the palace photographers are to get the pictures you see above and on pages 208 and 209. We therefore shoot with a variety of long lenses — 1200 mm for the picture of Prince Harry above.*

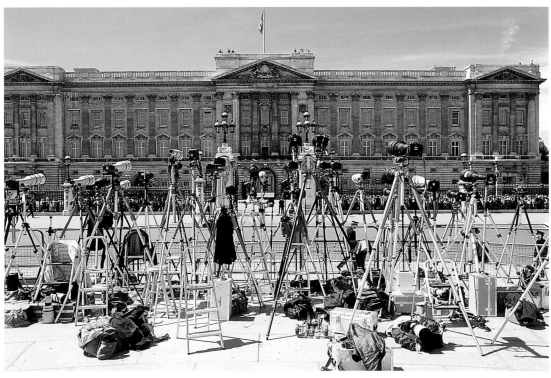

LEFT AND OPPOSITE, FAR RIGHT: *The attention to detail in the design, production and maintenance of uniforms shows military standards at their best.*

OPPOSITE, NEAR RIGHT: *Prince Charles, in uniform as colonel in chief of the Welsh Guards, attends the Trooping the Colour ceremony in 1990. Every Guards regiments has a different insignia on the collar – here a leek emblem of Wales. The 'busby' hat – more correctly known as a 'bearskin' – is stored in a tall, cylindrical metal case when not in use.*

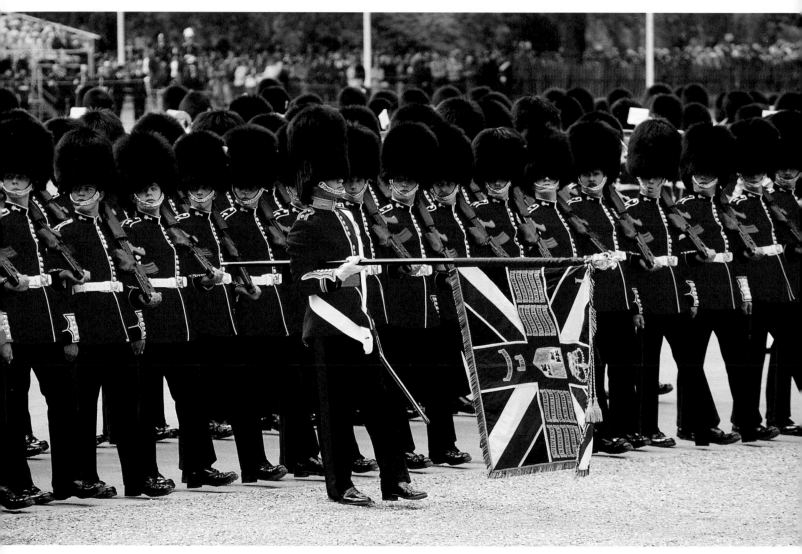

LEFT: *The colour (flag) is trooped (paraded) before the Queen on Horse Guards Parade, the honour of doing so being given to a different regiment every year. On this occasion it is the Welsh Guards.*

'Trooping' actually means 'saluting by beat of drum', and military commanders rallied their men together in battle by giving particular drum signals and displaying the colour.

The grouping of buttons on the Guards' tunics identifies the regiment. Here groups of five indicate the Welsh Guards. (The Irish Guards have groups of four, the Scots Guards three, and the Coldstream Guards two; the Grenadier Guards have single buttons evenly spaced.)

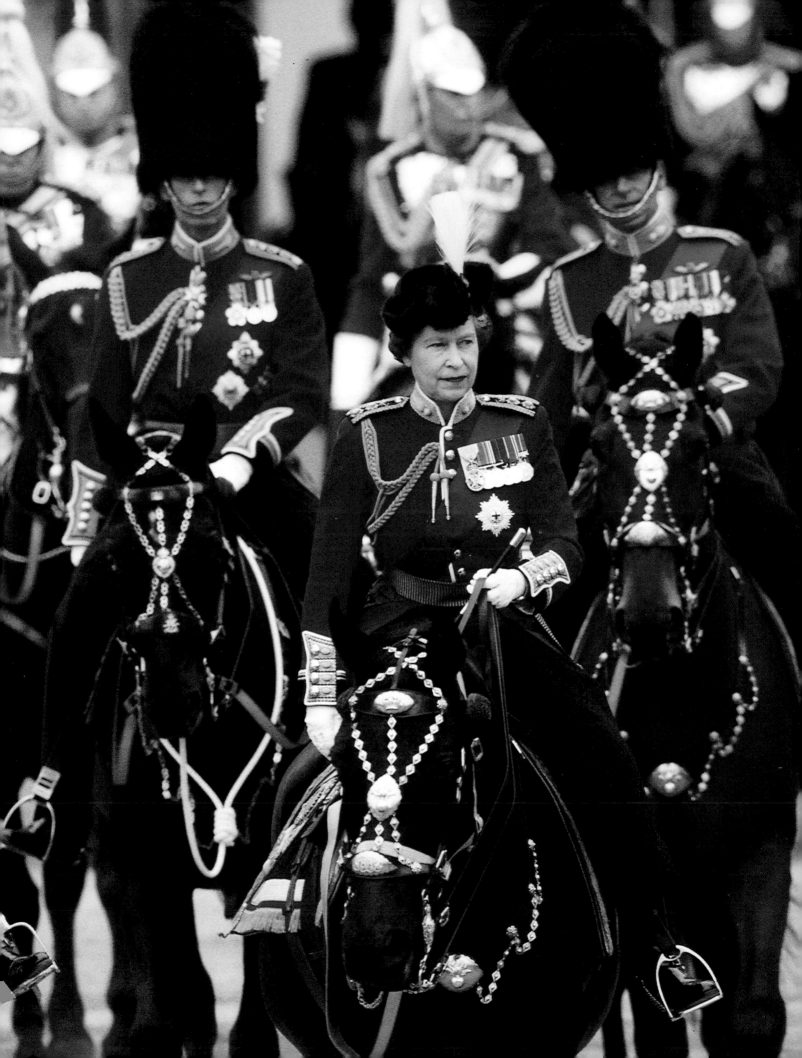

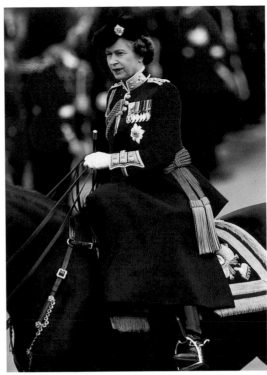

OPPOSITE: *Flanked by her husband and son, the Queen, in uniform as colonel in chief of the Grenadier Guards, wears a white plume, the riband and star of the Order of the Garter, and her medals: the Order of the Crown of India, the 1939–45 Defence Medal, the 1939–45 War Medal, the 1935 King George V Silver Jubilee Medal, the 1937 King George VI Coronation Medal, and the silver Canadian Forces Decoration.*

RIGHT: *The parade goes ahead whatever the weather. Although, of course, rain is a real problem for ceremonial uniforms and plumed hats (red here for the Coldstream Guards), it's a disaster for motor-driven cameras. Here, in June 1982, as the Queen was getting drenched in the final moments of the parade, a large cape covering my head, the camera and its 600-mm lens enabled me to capture this moment.*

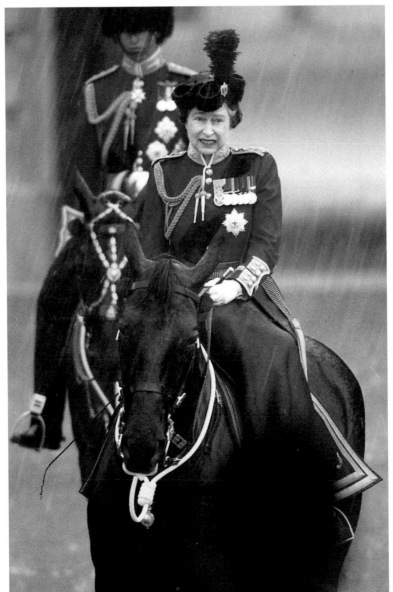

ABOVE: *For many years, until her trusted mare, Burmese, retired, the Queen rode side-saddle at her Birthday Parade. This quaint skill – not as easy to master as it looks – was once the only way that women were expected ro ride, the astride position being considered inelegant. The Queen had been riding side-saddle in 1981 when a man in the crowd fired blanks from a pistol, startling her and her mount. Of course it was an important news picture, but not one that we were able to take from our position on the Queen Victoria Memorial at the top of The Mall. Any photographer wants to get <u>the</u> picture on the day as that's what the newspapers and magazines around the world will be wanting – particularly since the charge brought against the gunman was treason – but you can't plan for the unexpected. The only pictures available of this disturbing incident were taken by members of the crowd.*

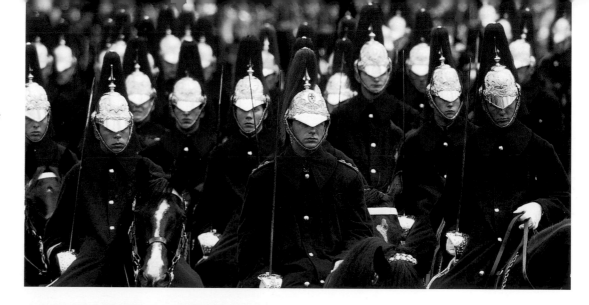

RIGHT: *Wet-weather capes protect the elaborate uniforms of the Blues and Royals. Along with the Life Guards, they make up the Household Cavalry, one of the seven regiments known as the Household Division. This division has the duty of guarding the sovereign and the London metropolis. They combine ceremonial duties with full active service.*

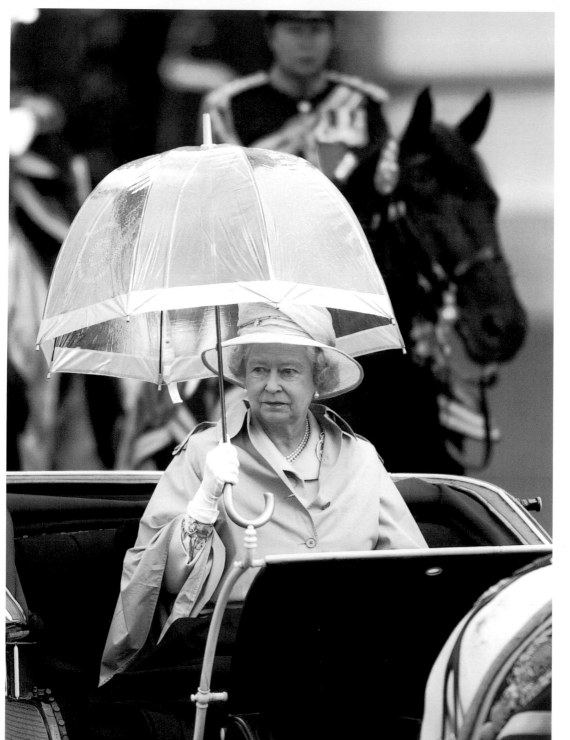

LEFT: *The Queen has followed the Queen Mother's lead in using see-through umbrellas which allow the public to have a clearer view of her. Since 1987 and the retirement of Burmese, she has abandoned the practice of riding side-saddle at the Trooping and travels instead by carriage. The journey down The Mall is timed to the second so that as the Queen reaches her position on Horse Guards Parade, the clock above her strikes the first chime of 11 o'clock.*

OPPOSITE: *Prince William, a week before his fifth birthday, joined his great-grandmother for his first appearance in the procession at Trooping the Colour. He gets a reassuring smile from his mother, the Princess of Wales.*

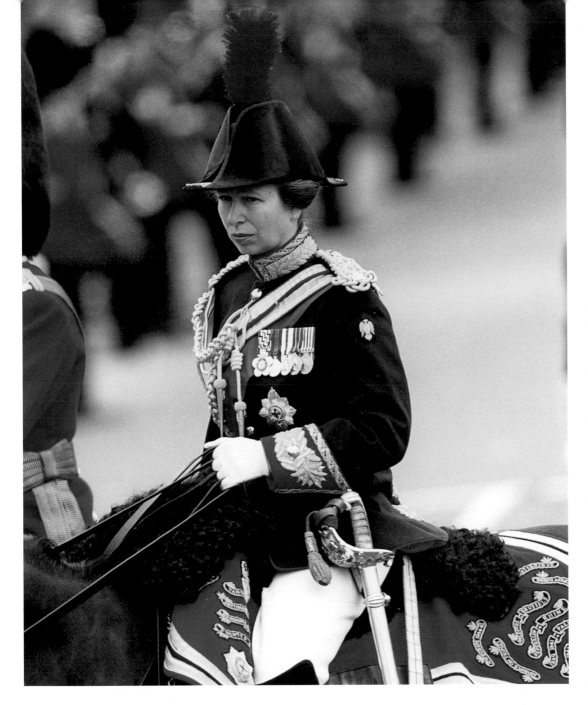

LEFT: *Keeping it in the family, the Princess Royal first appeared in uniform as the new colonel of the Blues and Royals at the Birthday Parade in June 1999. She had also been appointed Gold Stick – a title deriving from the staff of office topped with gold. The holder of this title, along with another officer, called Silver Stick, was originally supposed to keep close to the Sovereign and protect him or her from danger.*

BELOW: *Just one week before their wedding, Prince Edward and his bride-to-be, Sophie Rhys-Jones, joined the Queen Mother for the Trooping procession. Sophie's hat is a fashion writer's dream but a photographer's nightmare as it casts shadow over her face, but it does make for a charming picture.*

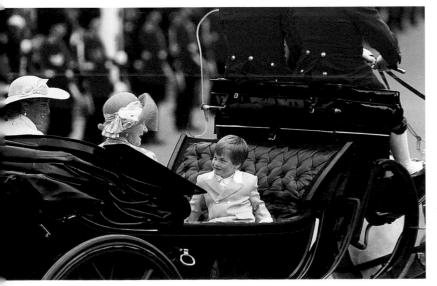

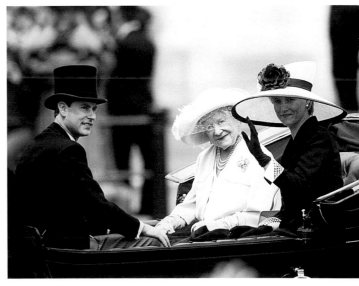

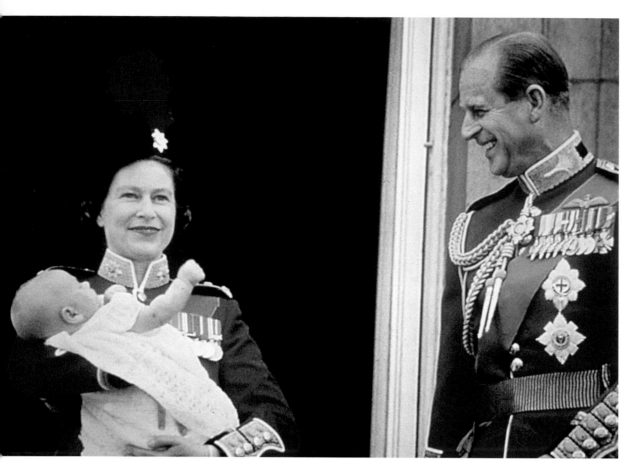

LEFT: *Following the Birthday Parade in 1964, the Queen and the Duke of Edinburgh appeared on the balcony with the newest addition to their family – three-month-old Prince Edward.*

BELOW: *Prince Harry, aged just nine months in June 1985, making his first appearance at Trooping the Colour in the arms of his father. All the children in this picture are now alarmingly tall and grown up.*

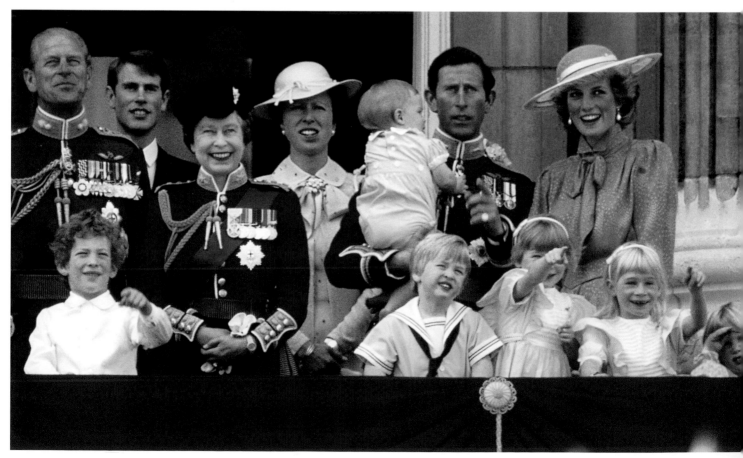

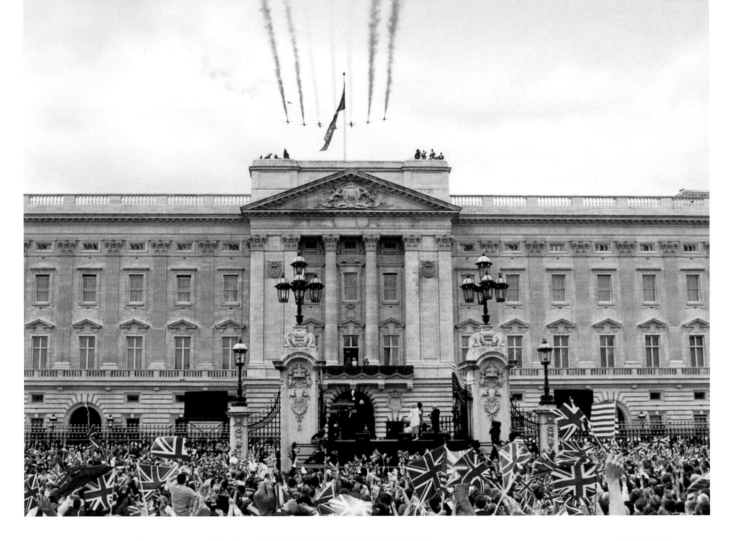

ABOVE: *The RAF fly-past at the end of the Royal Family's balcony appearance is timed precisely for one o'clock.*

ABOVE: *The Queen in June 1998 pointing out the approaching aircraft to her granddaughter Princess Eugenie and the grandchildren of the Duke and Duchess of Kent.*

The quality of pictures taken on the day depends entirely on air conditions. If it is hot and humid, the heat haze rising from the crowd in front of the palace totally degrades the image. Photographers therefore hope for cool weather.

ABOVE: *As the Royal Family disappeared from the balcony and I was packing my camera gear away, this lively group trundled across the courtyard in the carriage that the Queen had travelled in earlier. Prince Harry and*

Prince William shared the ride with Lord Frederick Windsor – son of Prince and Princess Michael of Kent – and Lady Davina and Lady Rose Windsor – daughters of the Duke and Duchess of Gloucester.

Family Matters

LOOK BENEATH the trappings of monarchy – the grand houses, the banquets, the pageantry, the bodyguards – and there is a family that has the same preoccupations as any other. Its members seek peace, security and happiness just as everyone else does, and they try to do so in ways familiar to us all.

Family is extremely important to the Queen, and like any mother she takes pride in her children's achievements. Many are the times in their younger years that she presented prizes to her sons and daughter for competing successfully in sporting events. She was particularly proud when Princess Anne was picked for the British show-jumping squad in the 1976 Montreal Olympics, and also took great pleasure in attending her sons' passing-out parades from Dartmouth. Merit rather than fear or favouritism made these achievements all the greater.

Despite the fact that her children are now grown and lead independent lives, the Queen continues to support them in all their endeavours. She has been warm in her praise of the Prince's Trust, a charity founded by the Prince of Wales to help disadvantaged young people realize their potential. She also recognized the unflagging work of the Princess Royal for Save the Children and many other worthy causes by appointing her to the Order of the Garter. In more recent times she has encouraged Prince Andrew to become a roving ambassador for overseas trade with Britain, and has supported Prince Edward in his efforts to establish a television production company.

As shown by family appearances at favourite occasions, such as the Windsor Horse Show or the Braemar Games, the Queen is a hands-on and affectionate grandparent. Like many of her generation, she has found it easier to have a relaxed and tactile relationship with her grandchildren than she did with her own offspring. In return, the youngest Windsors treat her like any other granny – with love, warmth and respect.

There are few times during the year when the whole Royal Family gets together, but one occasion that always rallies them is the Queen Mother's birthday. Coming as it does just before the Queen's long summer holiday in Scotland, it is a day that unites the family in happiness and marks the beginning of a period of rest and relaxation. This day perhaps more than any other reminds us that the dignified sovereign is also a devoted daughter, a warm-hearted mother and a loving grandparent.

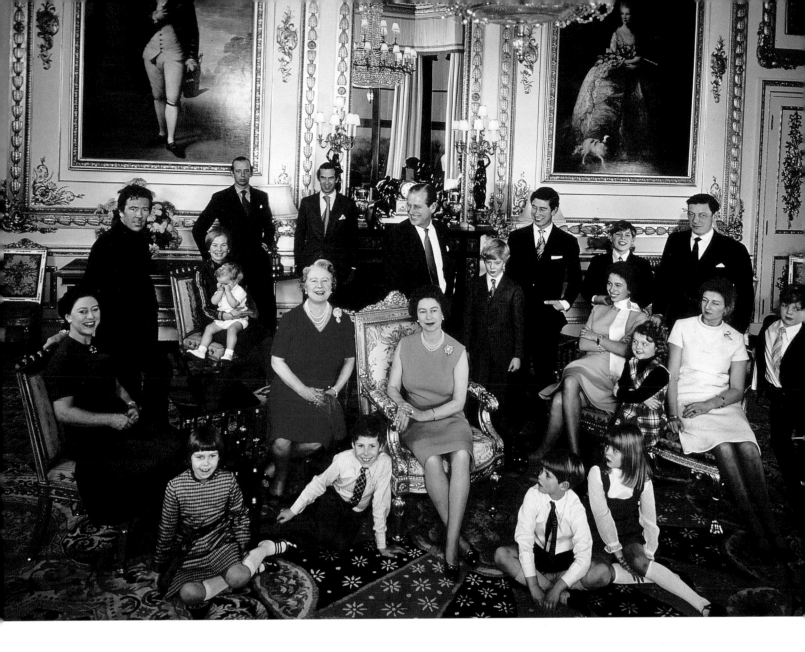

RIGHT: *Crammed into a go-kart and careering around the stable yard in 1972, Prince Charles and Prince Edward have to be reminded by the Queen that it's time for tea.*

ABOVE: *These days it's very rare for the Royal Family to be all together in the same place. On this occasion in 1972, the moment was captured by the Queen's cousin, Patrick Lichfield.*

Home and away, they are a team and it shows. On tour in the South Pacific in 1977 (above) and again in 1982 (right) the Queen greets the crowds with Prince Philip at her side.

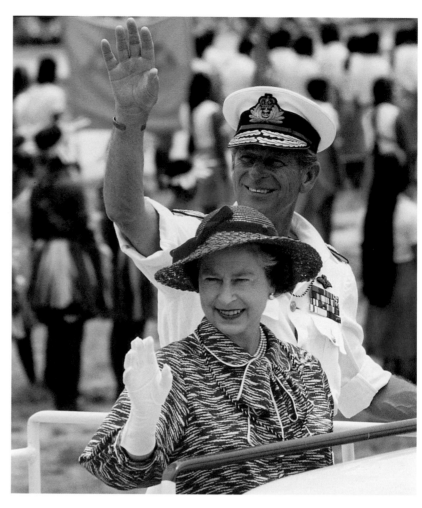

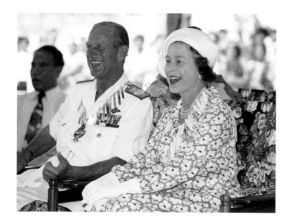

ABOVE: *On the tiny atoll of Tuvalu in 1982 the Queen and Prince Philip, wearing necklaces made of mother-of-pearl, watch a traditional welcome ceremony given to their great chief in the* maneapa *(meeting house). It was the first time that Tuvalu had had the opportunity of welcoming its head of state.*

RIGHT: *The Queen and Prince Philip share a moment during their trip to Fiji in 1982. Twenty years later, after more than 50 years together, I've noticed that they always seem to have a great deal to talk about.*

At their Golden Wedding luncheon hosted by the Prime Minister, the Queen paid a warm tribute to Prince Philip: 'He is someone who doesn't take easily to compliments but he has, quite simply, been my strength and stay all these years, and I, his whole family, and this and many other countries, owe him a debt greater than he would ever claim or we shall ever know.'

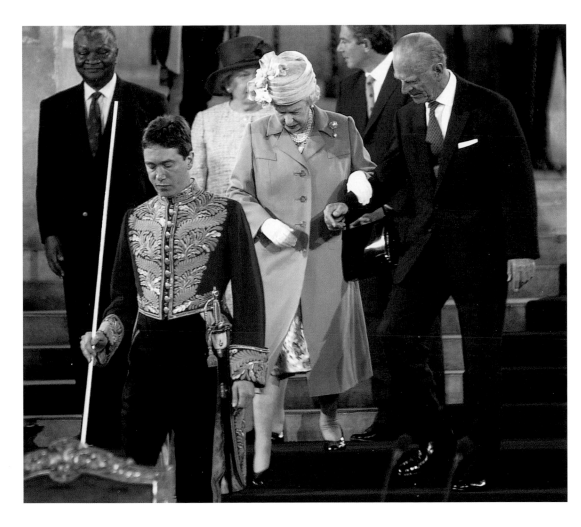

RIGHT: *Leaving Westminster Hall in London after a Commonwealth Parliamentary Conference in September 2000, the Queen reaches for Prince Philip's arm as she negotiates the stairs. Leading the way is the Lord Great Chamberlain, the Marquess of Cholmondeley. Following is Prime Minister Tony Blair.*

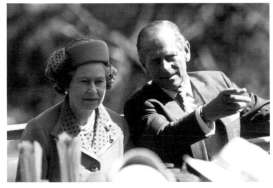

ABOVE: *At lunch on a boat trip on Lake Dianchi in China, Prince Philip acts as tour guide.*

RIGHT: *Since marrying there in 1947, the Queen and Prince Philip have been back to Westminster Abbey countless times for state, official or family occasions. Here they were arriving for the first Maundy Service of the new millennium.*

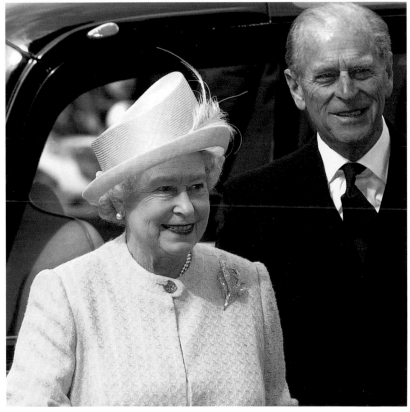

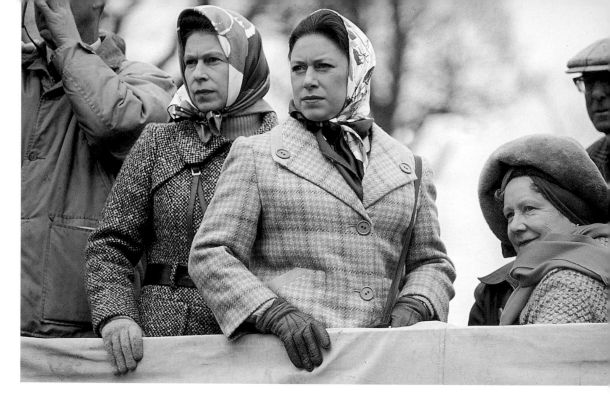

RIGHT: *The Queen, with Princess Margaret and the Queen Mother, anxiously watches Princess Anne and Mark Phillips (then her daughter's fiancé) negotiate the tough cross-country phase of the Badminton Horse Trials in 1973. Mark had won the event the year before.*

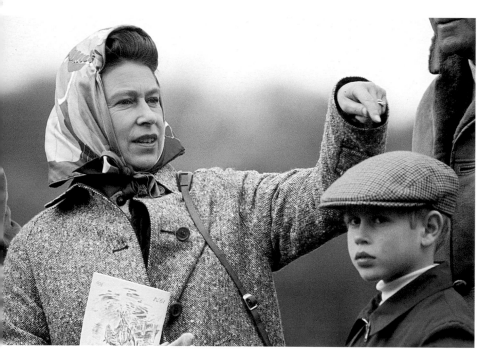

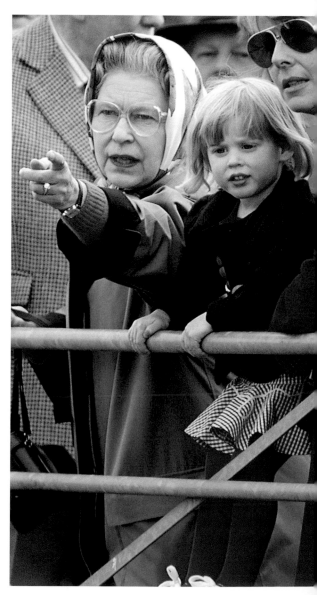

ABOVE AND RIGHT: *Three generations – the Queen with her nine-year-old son Prince Edward in 1973, and with her three-year-old grand-daughter Princess Beatrice in 1991. The little girl's grandfather is pointed out approaching with his horses.*

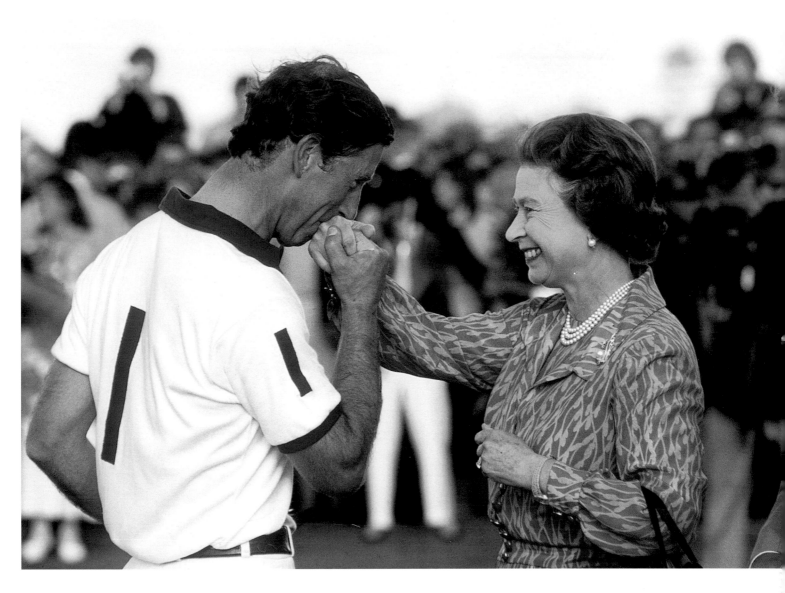

LEFT: *The latest generation of royal polo players – Prince William, aged 19, and Prince Harry, aged 16 – lining up for the prize-giving in Cirencester near their Gloucestershire home in July 2001. Here they applaud their team-mate and father as he receives the winning trophy. Their team, Highgrove, had beaten their opponents, Cirencester Park.*

ABOVE: *Monarch and mother – the Queen acknowledges with a proud smile her son's gallant greeting after a polo match at Windsor in 1985. His team had lost and she had presented him with a consolation prize.*

ABOVE: *More maternal pride, this time for Prince Andrew at his passing-out parade at Dartmouth in Devon in April* *1980. Little did she think that her son would be on active service just two years later in the Falklands War.* *She no doubt recalled that it had been at Dartmouth in 1939 that she had met a handsome cadet called Philip.*

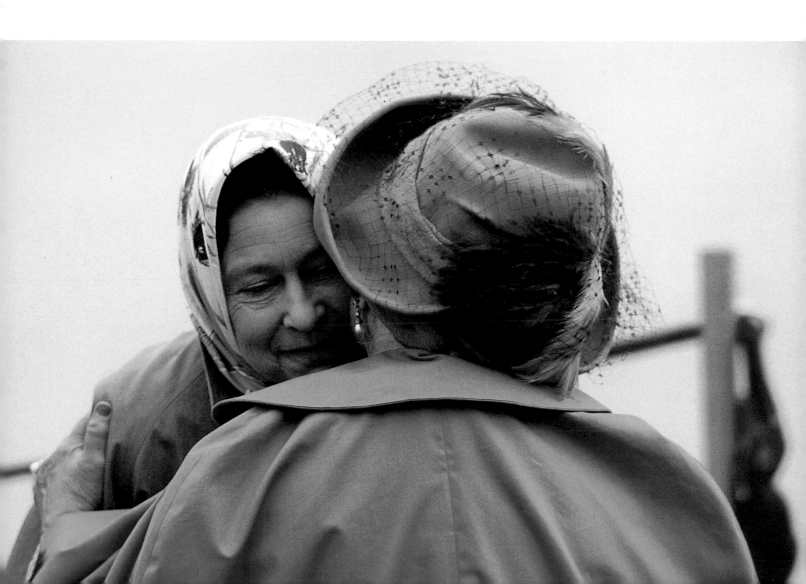

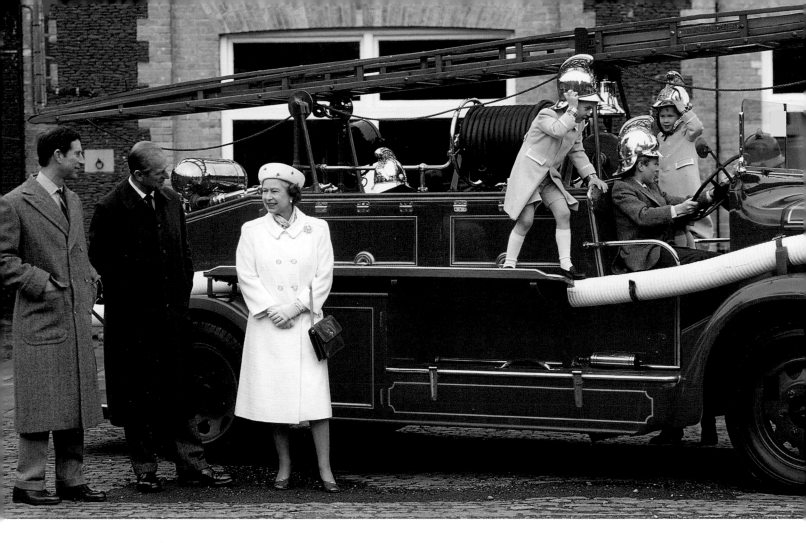

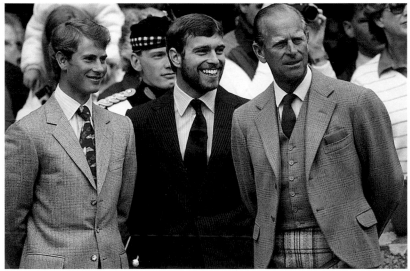

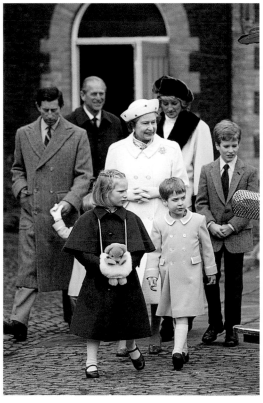

ABOVE: *Father and two sons at Balmoral in August 1983. Prince Andrew's beard didn't last long; within weeks he had tired of it. Prince Philip was the only one opting for a kilt. His sons chose to stick to plain suits.*

RIGHT: *Zara Phillips, aged six, and her cousin Prince William lead the way on a royal excursion.*

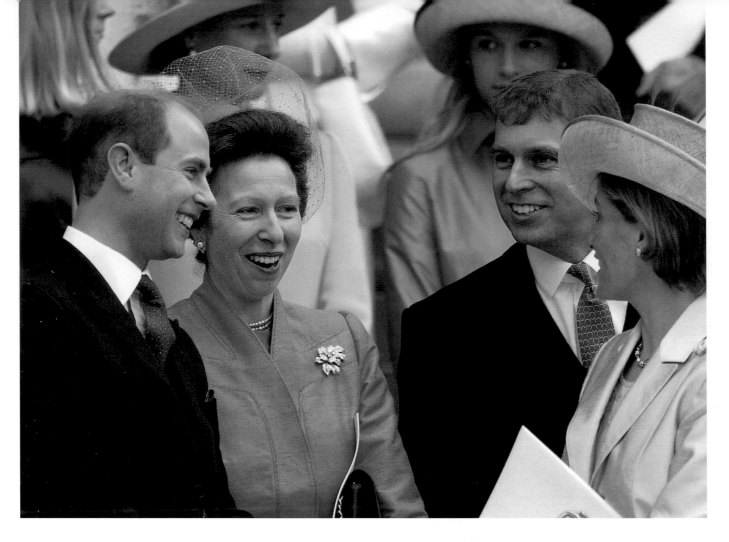

ABOVE: *Laughter always makes for good pictures, so I was pleased to get this shot of the Earl and Countess of Wessex laughing with the Princess Royal and the Duke of York after the service to mark the Queen Mother's 100th birthday in 2000. Sometimes the natural reserve of the Royal Family can make them look very serious.*

RIGHT: *Great-grandchildren Princess Beatrice and Princess Eugenie in matching outfits for their great-grandmother's centenary.*

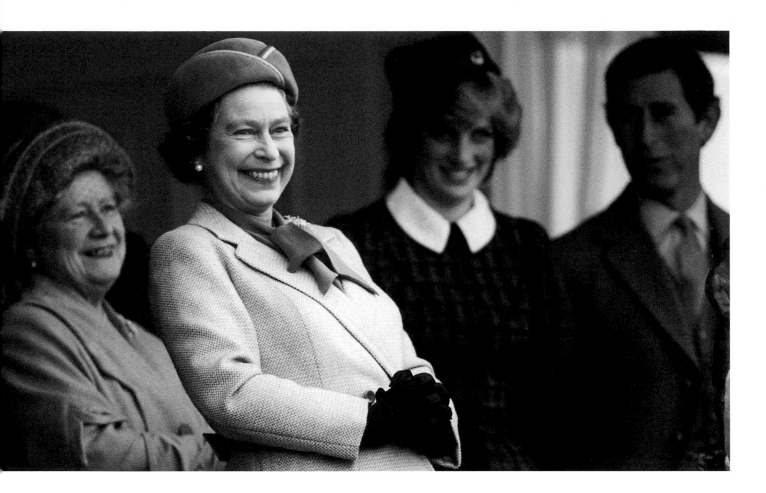

ABOVE: *The Queen loves
Scotland and looks forward
to her trip north every year.
When the Royal Yacht was
in service, the family would
take several days cruising
from Portsmouth to Aberdeen,
stopping en route for lunch
with the Queen Mother at her
Scottish castle and for picnics
on remote islands in the
Western Isles. Here the
Queen is laughing at displays
of skill and strength at the
traditional highland games at
Braemar near Balmoral in
August 1982.*

RIGHT: *The Princess of
Wales and the Duchess of
York enjoying a gossip and
a giggle at the Derby in
June 1987.*

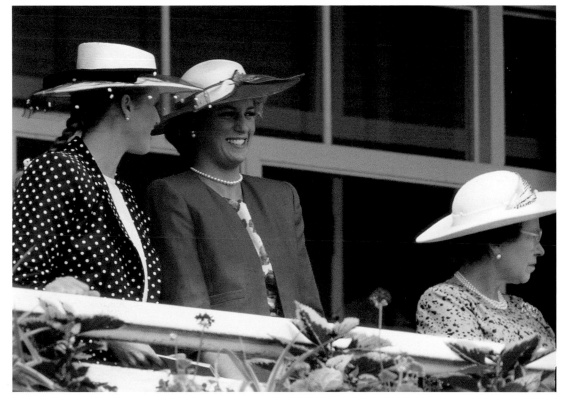

At the Races

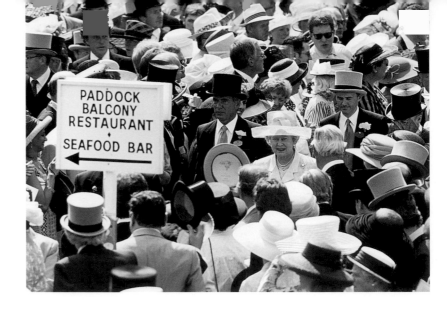

EVER SINCE THE AGE of three, when she first sat in a saddle, the Queen has had an abiding interest in horses – riding them, breeding them and racing them. All those connected with her breeding and racing operations say that her knowledge of the turf is comprehensive, and it is widely known that there is nothing she likes better than a day at the races.

One of the most eagerly anticipated events in the sporting and social calendar is the race meeting at Royal Ascot, which the Queen attends with great enthusiasm. Over the course of four days, she holds a house party at Windsor Castle, and in the afternoon she and her guests all go to the races. The royal party drives down the Long Walk, then transfers to carriages to enter the grounds and drive along the racecourse to the royal box. Personal guests of the monarch have access to the Queen's Lawn, which is just below the royal box, while others may apply for tickets to the Royal Ascot Enclosure.

Although there has been some relaxation of the regulations in recent years, strict rules of admittance still apply. Divorcees may now attend, but undischarged bankrupts and former convicts are *personae non gratae*. The dress code is similarly strict, but has made some concessions to changing fashions: women may wear day dresses or smart trouser suits (always with hats), while men wear uniform or morning dress.

Racing at Royal Ascot has enjoyed mixed reactions from monarchs since the racecourse was built in 1711 at the instigation of Queen Anne. However, it has been firmly in favour since the 1890s, when the enthusiasm of the Prince of Wales (later Edward VII) made it a highlight of the year.

The other great event in the racing calendar is the Epsom Derby, which was established in 1780 and run every year since in early June. This race, the most prestigious of the English Classics, is a test of speed and stamina, and the Queen, like every breeder of horseflesh, harbours a long-held ambition to produce a Derby winner. The nearest she has come to doing so was in 1953, when her colt Aureole came second. Since then, her stables have produced many fine horses, including several excellent polo ponies ridden by the Prince of Wales, but the ultimate prize still eludes her.

Like Royal Ascot, Derby Day is much anticipated, but its appeal is far broader. It is an occasion for dressing up and having fun, but it is not the fashion parade of Royal Ascot. Everyone gathers on the Downs to watch the races, have a 'flutter' and enjoy a picnic. The sport of kings and queens becomes a sport for everyone and a source of shared enjoyment.

ABOVE: *In 25 years of photographing at Ascot I have only ever seen a couple of races. From the first-floor balcony that is the press position there is no view of the racecourse, but it does provide an excellent vantage point to watch the comings and goings in the Royal Enclosure. Here the Queen is making her way back to the royal box through the crowd of race-goers, having been down to the paddock to study the horses in the next race.*

BELOW: *Bold colours and big grins from the Princess of Wales and the Duchess of York on the first day of Ascot Races in June 1990.*

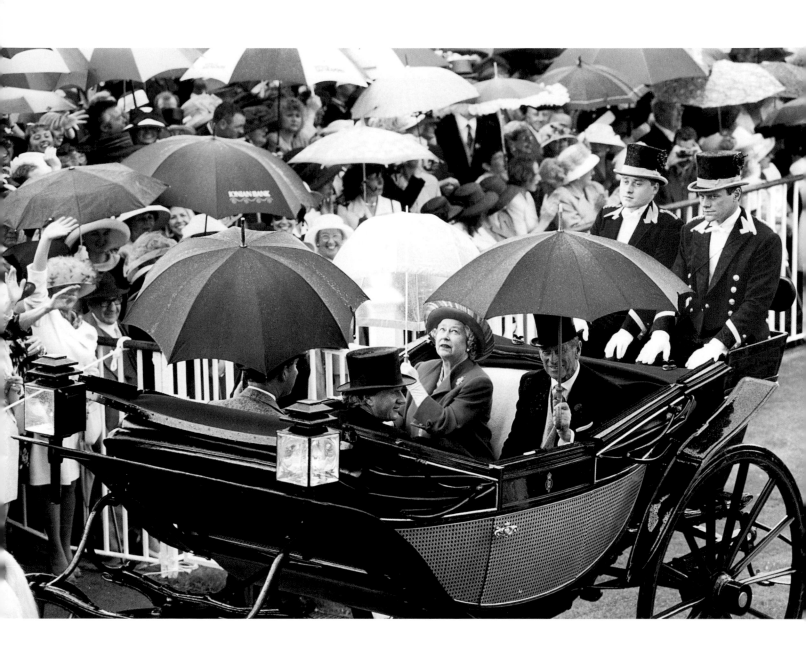

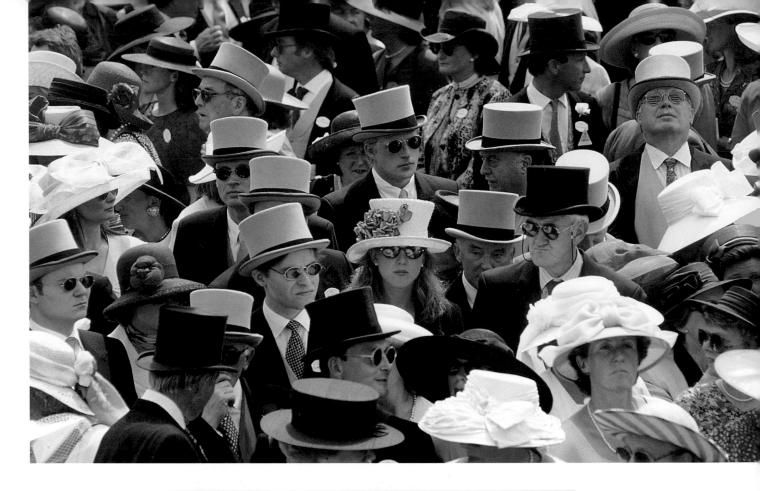

ABOVE: *During the reign of George IV (1820–30), one commentator described Ascot thus: 'The crowd was intense, like the heat; splendid, genteel, grotesque; many in masquerade, but all in good humour. Dandies of men, dandies of women…' It hasn't changed a bit!*

LEFT AND OPPOSITE: *Ascot remains one of those places where hats are essential to gain entry. Many of the ladies attending the races turn this restriction into a virtue by wearing hats that are stately, spectacular or downright silly. It all adds to the fun of a special day out.*

RIGHT: *Making a different kind of splash, one of the catering staff hurries through the rain with another consignment of canapés to accompany the champagne.*

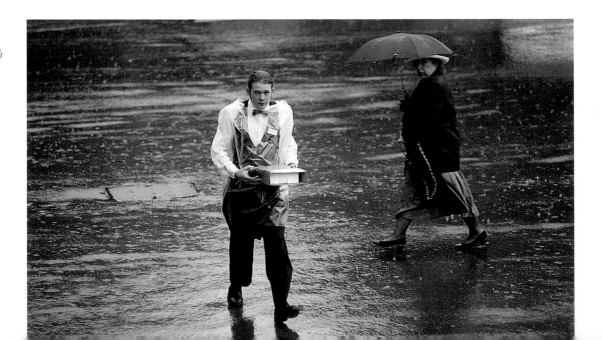

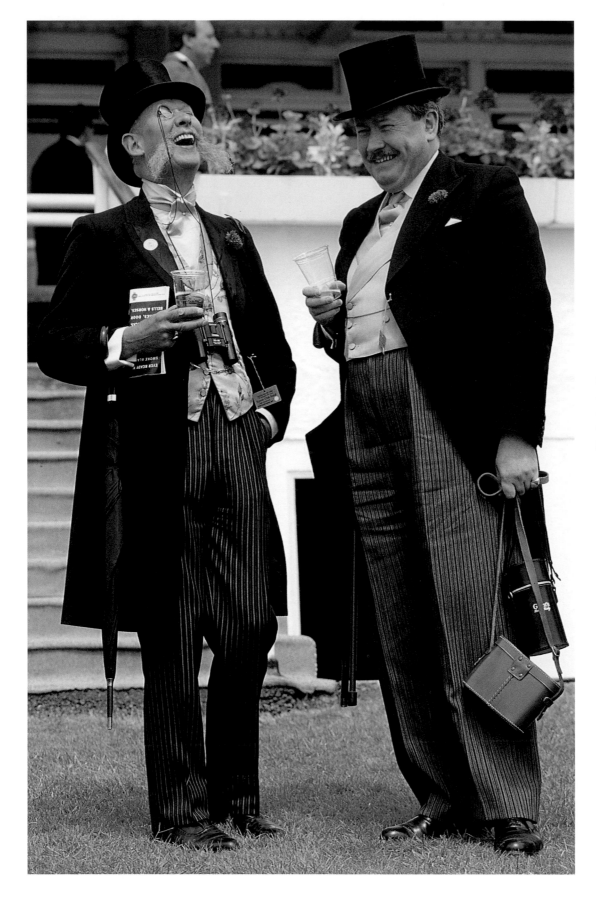

LEFT: *Fine examples of sartorial elegance on Derby Day, this pair would not look out of place in 1890, but the photo was actually taken 100 years later.*

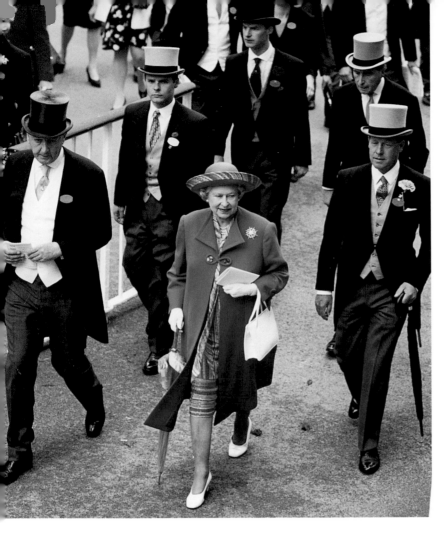

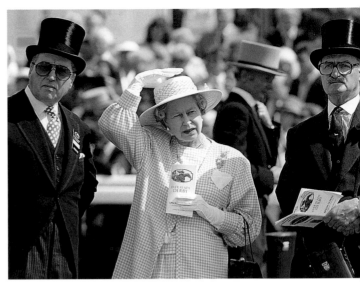

LEFT: *The Queen's team at Ascot in June 1998 included her racing manager, an equerry and assorted policemen – all wearing the same uniform of impeccable morning dress.*

ABOVE: *With racing friends on windy Epsom Downs in June 1992, the Queen watches the Derby runners head for the start. The Earl of Carnarvon (left) was her racing manager for many years until his death in 2001.*

LEFT AND RIGHT: *Traditional and contemporary Ascot fashions for men: Prince Charles in 1975 and a trendsetter in 2001.*

TOP LEFT: *The Princess Royal, taking after her grandmother and mother in her love of racing, enjoys checking the race programme at Ascot in 2001. In the 1980s she herself had donned jockey silks to race at Sandown, York, Lingfield and Kempton Park.*

THIS PAGE AND OPPOSITE: *Hats, hats and more hats… Obviously adhering to the old maxim, 'If you've got it, flaunt it', these women donned their most extravagant hats and cut a swathe through the crowds – probably poking a few eyes out on the way.*

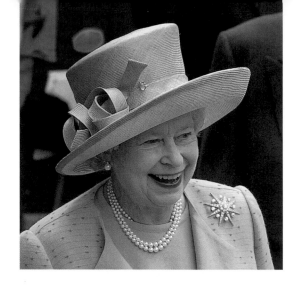

LEFT: *The Mad Hatter style was de rigueur at Ascot in 2000, and the Queen wore a fine example of it with her elegant outfit.*

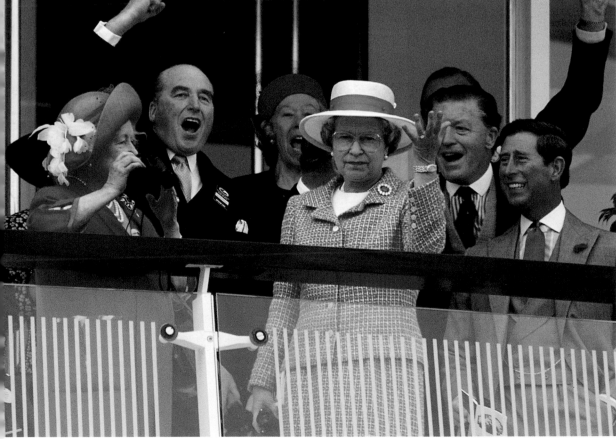

LEFT: *Four of a kind and their lone male escort make an arresting sight at Ascot in June 1990.*

LEFT: *Some had better luck than others at Ascot in 1993. Lord Carnarvon, the Queen's racing manager (second left), and Sir Michael Oswald, manager of the Royal Stud (second right), look delighted at the result of the race just run, but the Queen seems less satisfied with the outcome.*

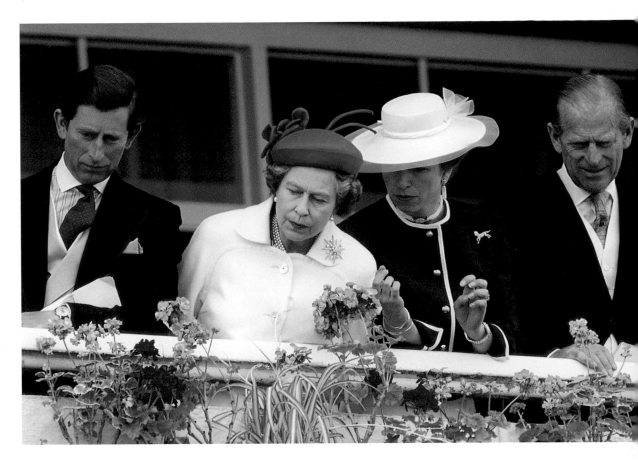

RIGHT: *While Prince Charles and Prince Philip look bemused by the sights below them on Derby Day in 1986, the Queen and Princess Anne seem far more riveted. Were they looking at horses or hats? We'll never know for sure.*

BELOW LEFT: *The Queen with her then Private Secretary, Sir William Heseltine, cheers the winning horse past the post at the Derby race meeting in 1989.*

BELOW RIGHT: *The Queen and the Queen Mother, seen here at the 1985 Derby, own around 30 racehorses between them. The Queen has had 700 winners and the Queen Mother nearly 500. They take this 'sport of kings' very seriously. The live racing commentary normally piped into betting shops – nicknamed 'the Blower' – was installed in Clarence House during the 1960s.*

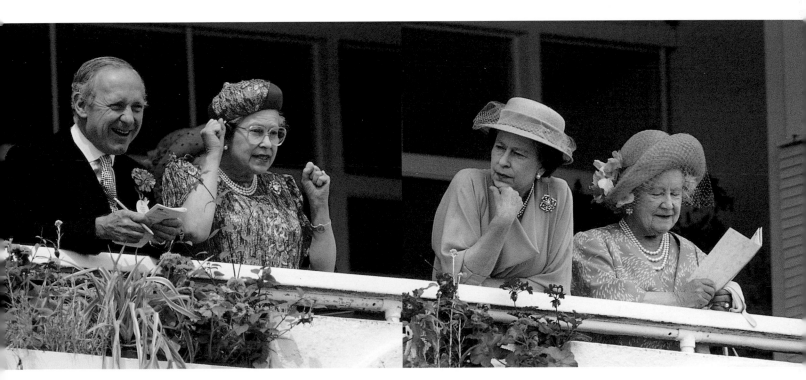

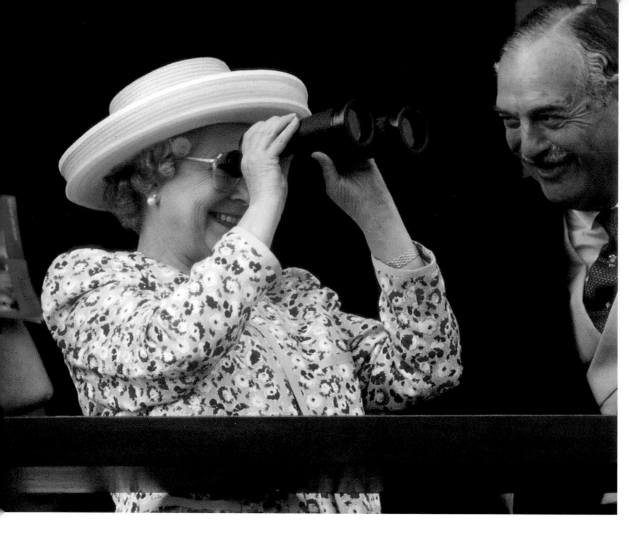

LEFT: *The Queen, seen here with her racing friend Colonel Sir Piers Bengough, has a thorough knowledge of the turf. A former racing manager once said: 'To describe her as a real authority on practically every aspect of the game is not a courtesy, just a statement of fact.'*

OPPOSITE: *Derby Day on Epsom Downs. Although many of the Queen's horses have raced in the Derby, none has ever won it. This supreme racing triumph remains one of the Queen's few unfulfilled ambitions.*

BELOW: *Binoculars for one and all at the Derby in 1996. No lover of the turf goes anywhere without them.*

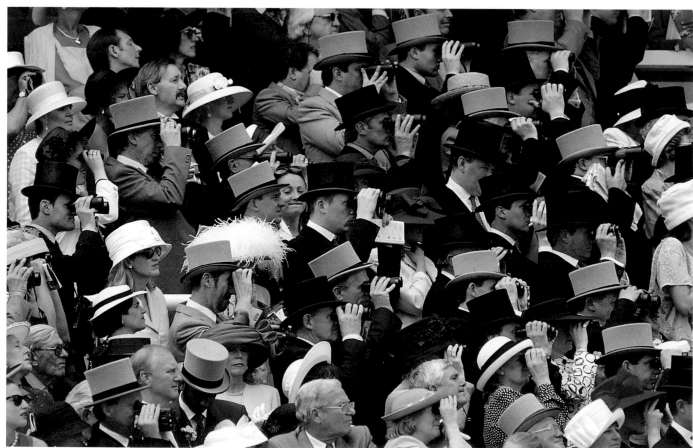

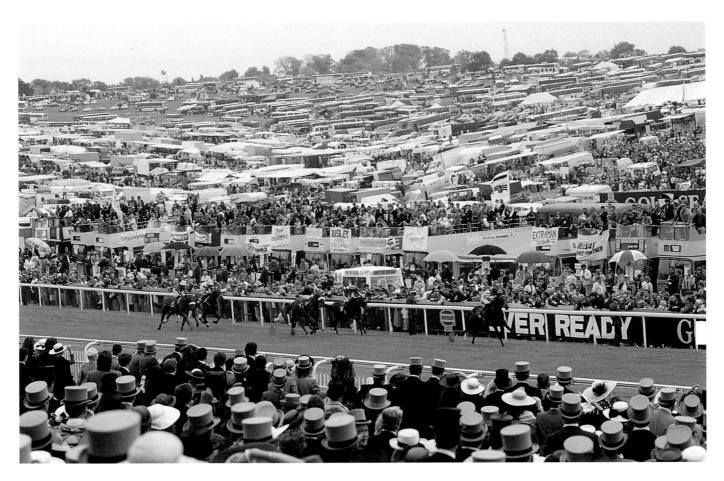

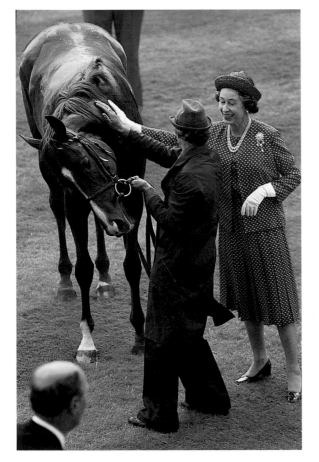

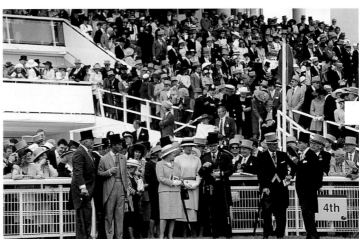

LEFT: *The huge grin from the Queen tells you that she is the proud owner of this winning horse, called Expansive, at Ascot in 1979.*

ABOVE: *At the 1993 Derby, the Queen and her party stood on the edge of the course to watch the horses run down to the start.*

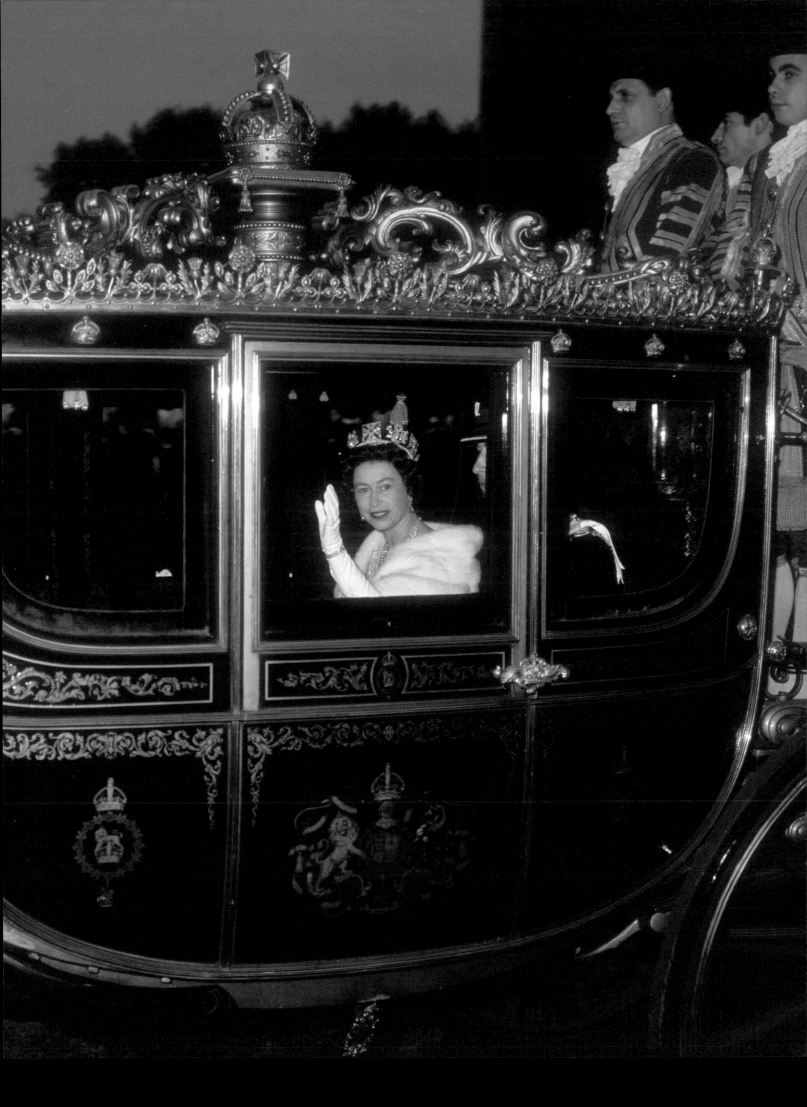

4

A great deal of time and effort goes into creating and maintaining the trappings of monarchy, and this section shows just how it's done. It also takes a look at the ancient ritual of distributing Maundy money and peeks behind the closed doors of some of the Queen's homes.

A wave from the Queen straight into my camera lens as she was on her way to the State Opening of Parliament. Taken just as the Irish State Coach was leaving Buckingham Palace, this picture – which appeared on the cover of The Economist *in November 1969 – was one of my earliest shots to be published.*

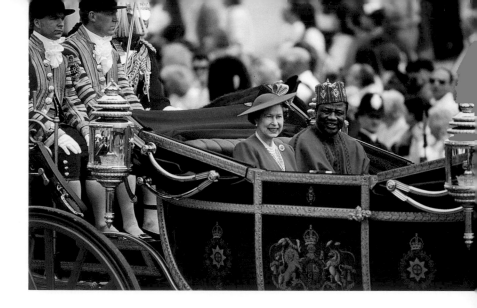

State Visitors

SINCE HENRY VIII MET FRANÇOIS I on the Field of the Cloth of Gold near Calais in an attempt to improve relations between England and France, visits between heads of state have become the accepted way of demonstrating goodwill and confirming the bonds of friendship.

About three times a year the Queen receives state visitors, and preparations for these visits start about six months in advance, when a draft programme of activities is drawn up and submitted to the Queen and the visitor for approval. About six weeks before the agreed date, a reconnaissance team from the visitor's country arrives to check the details of the itinerary, then the programme is printed and circulated.

For a typical visit hosted in London the head of state and his or her spouse are met by the Queen and Duke of Edinburgh at their point of arrival, then travel together by carriage along a processional route to Buckingham Palace. The official welcome also includes gun salutes fired from Hyde Park, Green Park and the Tower of London.

Once at Buckingham Palace, the party has lunch, and this is followed by an exchange of gifts and decorations. Foreign visitors are usually given items of silver or fine china, and may be invested in one of the orders of chivalry.

Later in the afternoon, the visitors go to Westminster Abbey, where they lay a wreath on the Tomb of the Unknown Warrior. Then they drive to St James's Palace, where they are given an address of welcome by the Lord Mayor of Westminster. This is followed by tea with the Queen Mother at Clarence House. In the evening there is a banquet at Buckingham Palace, the opening and ending of which are often televised.

For a Commonwealth head of state there would be a reception at St James's Palace to meet the high commissioners and ambassadors in London. Lunch with the Prime Minister at 10 Downing Street follows. The rest of the afternoon may be spent in talks with government ministers or at a reception attended by fellow nationals. The evening is dedicated to a banquet given by the Lord Mayor and the Corporation of the City of London at the Guildhall.

The last full day of the visit usually involves activities outside London, when the visitors are escorted by a senior royal. That night, as a mark of appreciation, the visiting head of state hosts a banquet attended by the Queen, the Duke of Edinburgh and other distinguished guests.

On Friday morning the visitors quietly depart for the airport, where the Lord Chamberlain says goodbye on the Queen's behalf. It has been a busy few days for all concerned, but the courtesy and hospitality extended to state visitors engender greater understanding and warmer relations – all part of making the world a safer place.

BELOW: *The Queen with her cousin King Harald of Norway in Edinburgh during his state visit to the UK in July 1994. All the carriages and horses had to be transported from the Royal Mews in London for this procession in Edinburgh.*

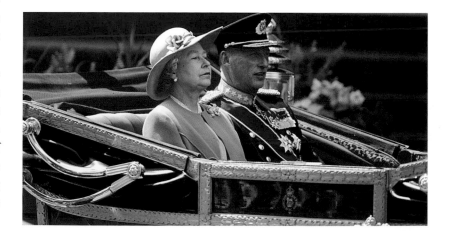

OPPOSITE: *Closed carriages are always on standby in case of bad weather for a state visit procession, but sunshine greeted President Babangida of Nigeria in May 1989.*

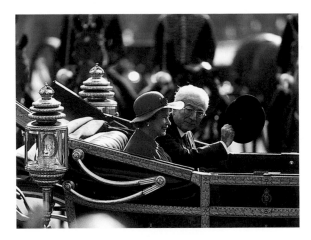

LEFT: *President Cossiga of Italy gives a gallant wave with his top hat in October 1990. Having flown into Gatwick, he was met by the Queen at Victoria Station, then taken in procession to Buckingham Palace.*

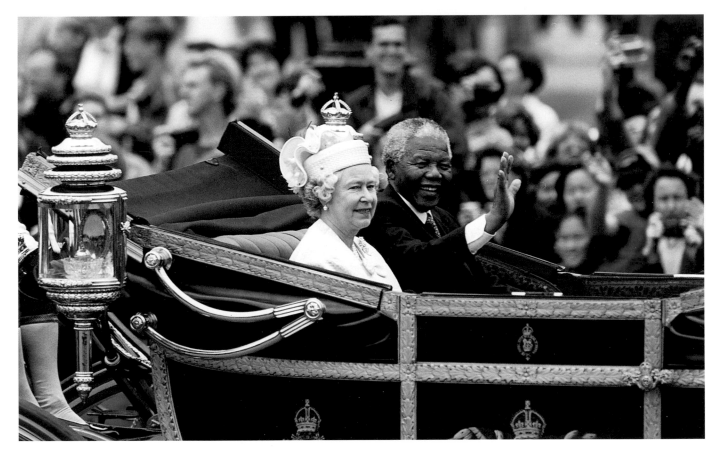

RIGHT: *President Soares of Portugal made a state visit to Britain in April 1993, allowing the Queen to reciprocate the hospitality she had received in Portugal eight years earlier.*

ABOVE: *As Head of the Commonwealth, the Queen must have anxiously watched the struggle for democratic multiracial freedom in South Africa. This state visit by President Nelson Mandela in July 1996 followed the Queen's historic visit to his country the previous year.*

The Story of a State Visit

LEFT: *A programme is printed for every state visit, even though the same well-rehearsed pattern is usually followed: a ceremonial arrival, a carriage procession, a banquet at Buckingham Palace, a visit to the Prime Minister, a banquet given by the Lord Mayor and the City of London, an out-of-town day, and then, on the last night, a return banquet hosted by the visiting head of state. The visits run from Tuesday to Friday and are sometimes hosted at Windsor Castle to avoid the congested London traffic.*

ALTHOUGH state visits are always colourful occasions, and each is planned with military precision, that of the President of France in May 1996 was notable for its rather more relaxed atmosphere. Perhaps this was because President Chirac speaks English fluently. Or perhaps it had something to do with his sense of showmanship. This suave and experienced politician obviously enjoyed the pageantry of the journey to Buckingham Palace, seeming totally at ease in the company of the Queen and appearing particularly charmed by the warm welcome from the crowds that lined the route. For her part, the Queen obviously enjoys entertaining official guests, and her task is made even more pleasant when the guest is as affable as President Chirac.

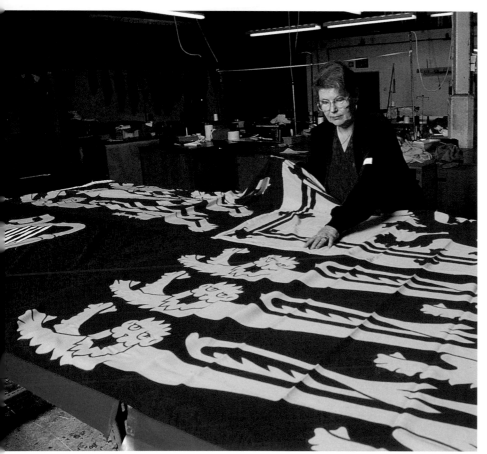

I went behind the scenes for the visit of President Chirac and photographed some of the preparations. Warrant holders Black & Edgington make the huge flags (left) that are flown along the processional route up The Mall, while John Paynter (above) of the Warrant-holding florist Page Munro collects the flowers specially ordered from New Covent Garden for the banquet at Buckingham Palace.

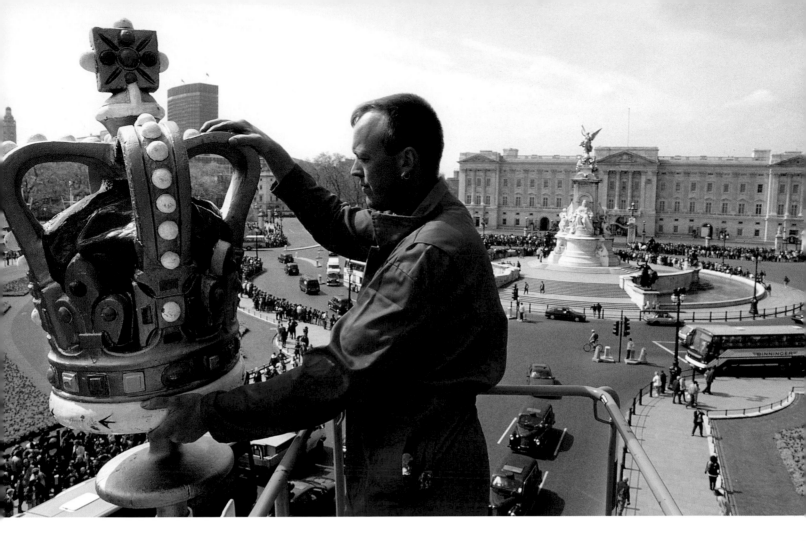

ABOVE: *From a cherry-picker high above The Mall I had a close-up view of decorative crowns being positioned on top of flagpoles along the processional route.*

LEFT: *Workmen hang French and British flags along The Mall for the state visit.*

RIGHT: *A last-minute wash and brush-up is given to the processional route at 6 a.m. on the morning of the state visitor's arrival.*

ABOVE: *Lieutenant Colonel Anthony Mather, with bowler hat and umbrella, is a member of the Queen's staff. Here he stands in for President Chirac during a final rehearsal of the guard of honour inspection on Horse Guards Parade in front of empty spectator stands.*

ABOVE: *The band practises 'La Marseillaise' (top right), the French national anthem, to honour the Queen's state visitor.*

LEFT: *Spit and polish – well, plenty of Brasso – applied by members of the Blues and Royals Queen's Escort at Kensington Barracks ensure that all the Queen's men and horses will do her credit for the ceremonial procession.*

Le Menu

Consommé Céléstine

———

Roulade de Sole à la Mousse de Homard
Sauce Safran et Ciboulettes

———

Carré d'Agneau aux Légumes de Printemps
Asperges au Beurre
Pommes Cretan
Salade

———

Pêches Toscane

Les Vins

Chassagne Montrachet, Morgeot 1988
Château Pichon Longueville,
Comtesse de Lalande 1982
Louis Roederer 1986
Warre 1970

Music Programme

March	CEREMONIAL PROCESSION	Washburn
Waltz	WESTMINSTER WALTZ	Farnon
Selection	BEST OF THE BEATLES	arr Custer
Vive La France	FRENCH FESTIVAL	Osser
String Feature	AIN'T MISBEHAVIN	Waller
Selection	BROADWAY TONIGHT	arr Chase
Song	SOMEWHERE OUT THERE	Horner
Polka	TRITSCH-TRATSCH	Strauss
Selection	SOUVENIRS DE FRANCE	Hanmer
Waltz	BY THE SLEEPY LAGOON	Coates
Selection	ANDREW LLOYD WEBBER	arr Chase
Piano Feature	FORGOTTEN DREAMS	Anderson
Show Feature	LES MISERABLES	Schonberg
March	ARMS PARK	Taylor

Major S. A. Watts
Director of Music, Welsh Guards

Pipe Programme

March	STAR OF THE COUNTY DOWN	
Strathspey	STRUAN ROBERTSON	
Reel	COLONEL MACLEOD	
March	ST. PATRICK'S DAY	

Pipe Major R. Tumelty
1st Battalion, Irish Guards

LEFT: *English lamb, French wines and the music of Andrew Lloyd Webber are on the menu for the President of France at the state banquet in Buckingham Palace.*

BELOW: *From my position on the steps of the Queen Victoria Memorial, and using a motor-driven camera, I was able to shoot a whole roll as the royal procession came alongside. As soon as I shot this one (the tenth frame in the sequence), I knew I had a picture full of Gallic charm.*

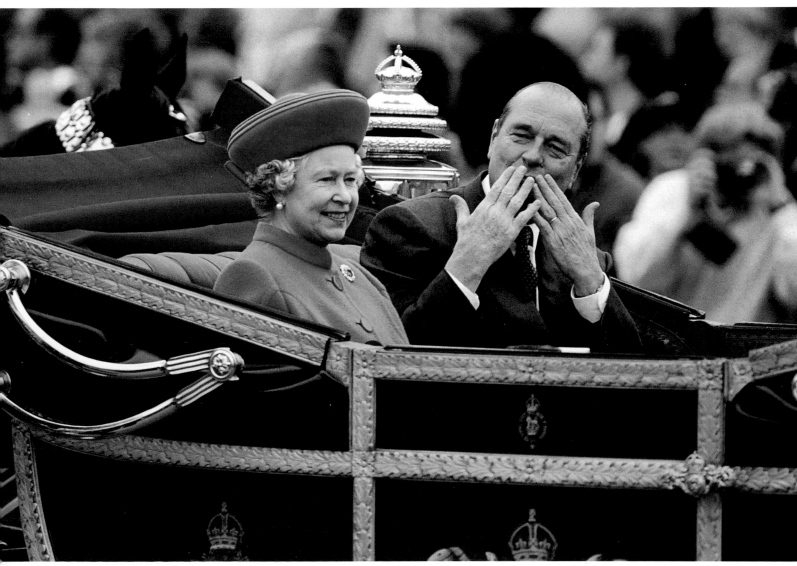

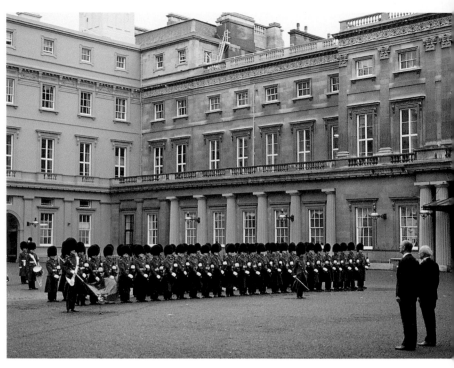

ABOVE: *When President Gorbachev paid his historic visit to Britain in April 1989, I had a position on the castle ramparts to photograph the welcoming ceremony.*

Prince Philip escorts visiting heads of state – President Goncz of Hungary (right) and the King of Malaysia (below) – as they inspect the welcoming guard of honour.

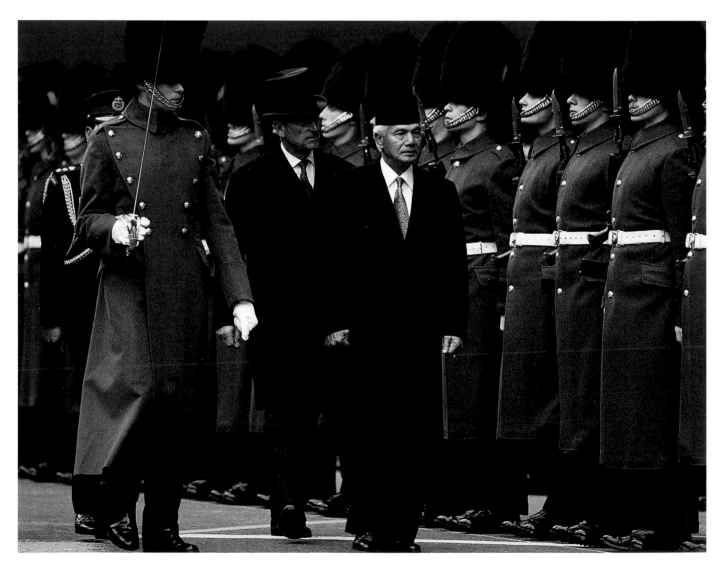

RIGHT: *No language barrier is apparent between the Queen and the wife of the President of Hungary as they chat and laugh at Windsor Castle.*

BELOW: *When President Weizman of Israel paid a state visit to Britain in February 1997, closed carriages were used for the procession back to Buckingham Palace to provide extra security.*

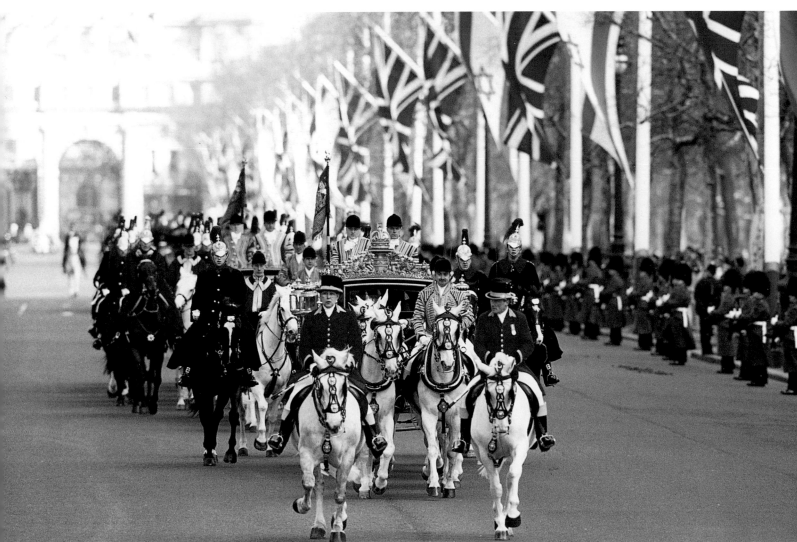

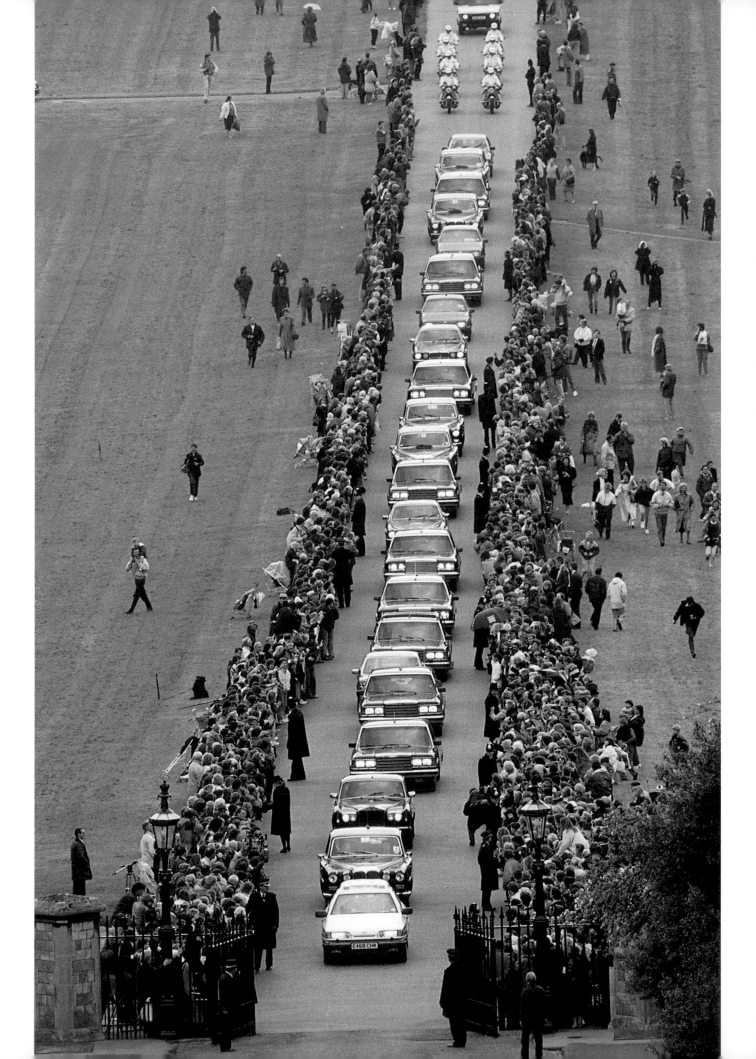

LEFT: *The Queen's equerry and future son-in-law, Timothy Laurence (back left) salutes as the national anthems are played at the start of President Gorbachev's visit.*

RIGHT: *The welcoming ceremony for the Amir of Bahrain in 1984 took place at Windsor Castle. I first visited Bahrain in 1968 for the opening of a new town named after the Amir.*

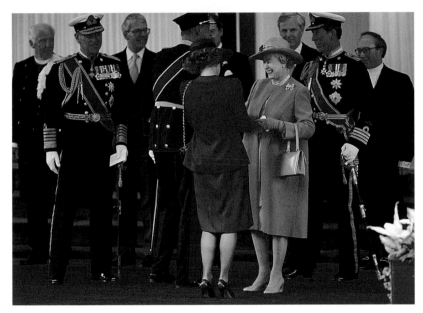

LEFT: *A state visit by the King and Queen of Norway in July 1994 was the first to be hosted in Scotland for 19 years. The Queen and Queen Sonja have become close friends and evidently enjoy each other's company.*

OVERLEAF: *The banqueting hall in Buckingham Palace. Hidden within the floral arrangements are lights controlled by the palace steward. Amber is the signal for the 76 footmen to take up their positions; green signals them to begin serving or clearing away.*

ABOVE: *As the US national anthem was played in the centuries-old quadrangle of Windsor Castle in 1982, President Ronald Reagan and his wife Nancy put hand on heart in the American tradition.*

RIGHT: *The Agong of Malaysia and his wife pose with the Queen, Prince Philip and the Queen Mother before a state banquet at Buckingham Palace.*

OPPOSITE: *President Mikhail Gorbachev's convoy of Russian Zil limousines arrives at Windsor Castle in April 1989.*

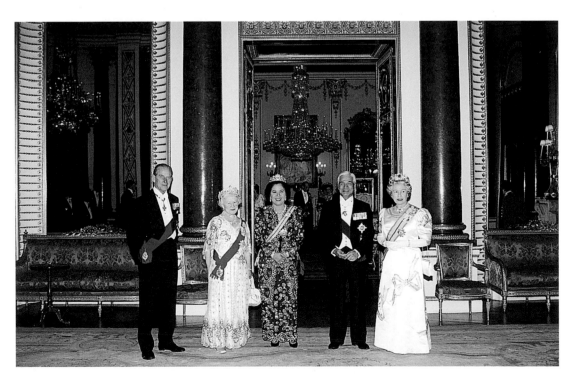

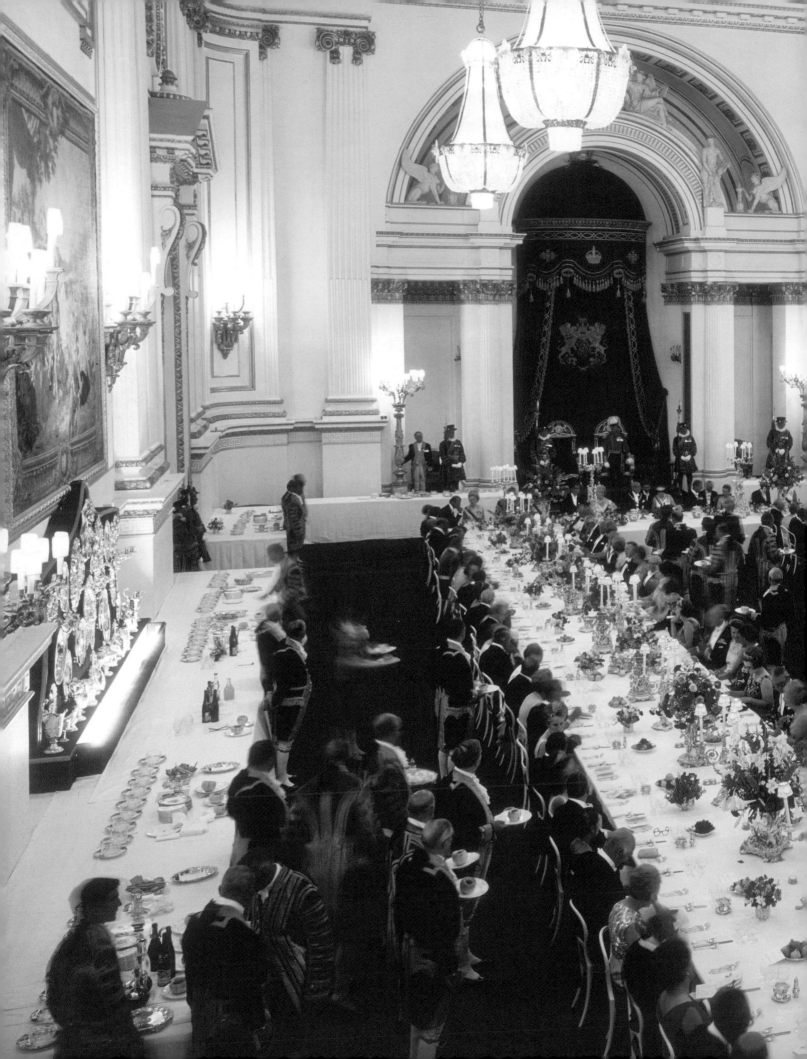

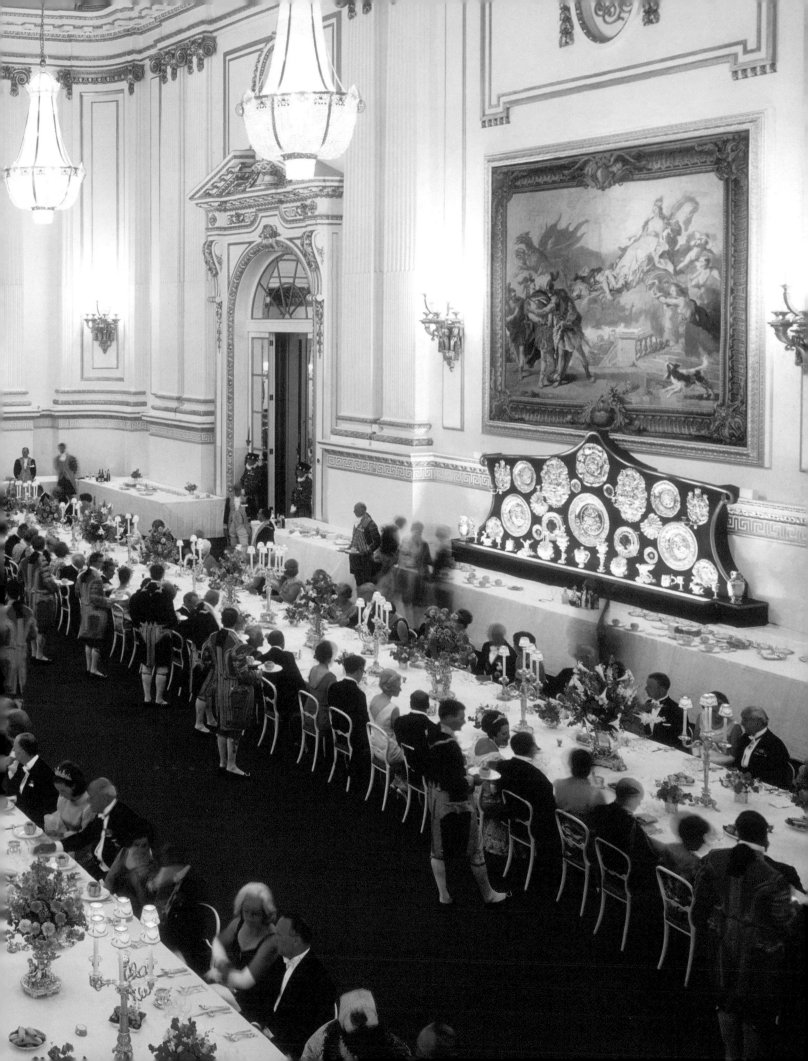

The Maundy Ceremony

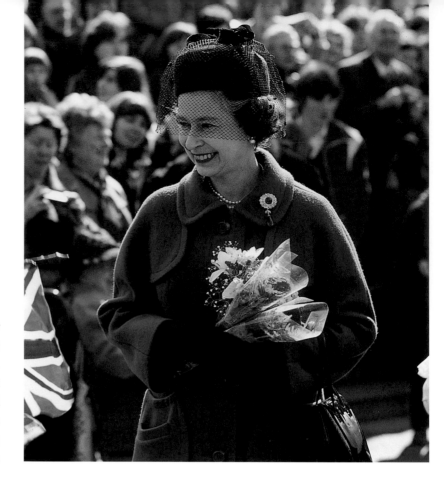

EACH DAY OF THE WEEK leading up to Easter Sunday has a special name that derives from the events preceding the resurrection of Christ. Maundy Thursday takes its name from the Latin word *mandatum*, meaning 'commandment', and refers to the instruction that Jesus gave his apostles after washing their feet himself at the Last Supper: 'You are to do as I have done for you…a servant is not greater than his master…'

In the years following the spread of Christianity around the world, ecclesiastics and then eminent people made a public display of their humility in the manner of Christ by washing the feet of the poor on the Thursday before Easter. The first record of an English monarch doing so was in 1213, when King John not only washed feet, but also gave gifts of food, clothing and money. Given the dirtiness and smelliness then endemic among the poor, the ritual was something of an endurance test, and a custom arose whereby the recipients of the monarch's attentions carried fragrant nosegays to mask their odour. (Nosegays still make an appearance at the ceremony, but now they are simply floral tributes presented to the Queen by children of the parish.)

From the early 18th century monarchs declined to present Maundy gifts personally, but King George V revived the custom of distributing Maundy purses in 1932. Each recipient receives two leather purses: a red purse with white strings contains a total of £5.50, which replaces the gifts of food and clothing given in earlier times; a white purse with red strings contains specially minted silver pennies – the same number of coins as the monarch has years, plus one for the year of grace. In 2002, the Queen celebrates her 76th birthday,

so each Maundy recipient will receive 77 pence. The 76 men and 76 women to whom the purses will be given are usually over the age of 65, come from all religious denominations and are chosen for their charitable works in the community rather than their poverty.

The purses make their entrance on large silver-gilt platters with the strings hanging over the edge like party streamers. Yeomen of the Guard carry the platters on their heads, a practice that derives from when bread and fish, rather than money, were distributed: holding the platters up high made the fishy smell less pervasive.

Following a short service, during which hymns and anthems are sung, the Queen presents the purses, first to the women, then to the men. While Maundy gifts have a very low face value by present-day standards, the honour of being chosen to receive them imparts a value and significance that is almost impossible to quantify.

For many years the Maundy Service took place in Westminster Abbey, but at the request of the Queen, who wanted to distribute the coins more evenly around the country and allow more people to observe the ceremony, it is now held in different cathedrals around her realm. In the year of her Golden Jubilee it takes place in Canterbury.

ABOVE: *The Queen after the Maundy service at Worcester Cathedral in April 1980.*

OPPOSITE: *A tickled-pink Maundy money recipient with the purses she received from the Queen.*

TOP LEFT: *The Queen distributes the Maundy money purses in Worcester Cathedral in April 1980 to 54 men and 54 women from the local diocese, the number of recipients in each group being equal to her age. I can understand why foot washing was abandoned. In this particular year the Queen would have had to wash 216 feet – a great picture but it would have taken all day.*

ABOVE: *The Royal Almoner arranging Maundy purses on silver platters which will be carried into the service by Yeomen of the Guard.*

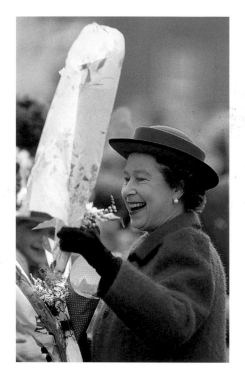

LEFT AND ABOVE: *Gusty winds, big smiles and bundles of flowers: Maundy Thursday in Chichester Cathedral, March 1986, enjoyed typical spring weather. The service was conducted by the Right Reverend Dr Eric Kemp (left).*

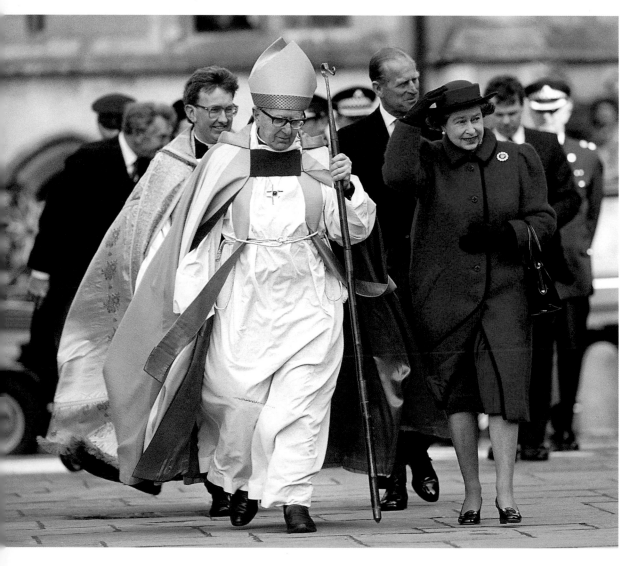

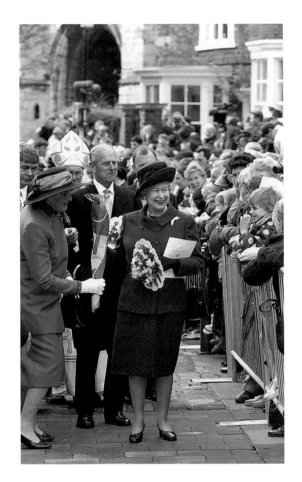

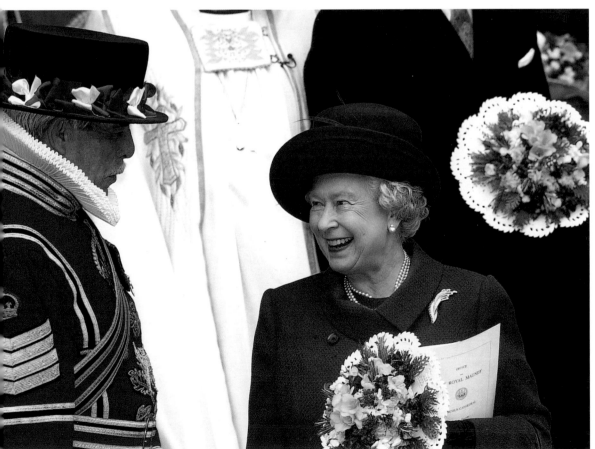

ABOVE LEFT: *The Queen holds on to her Maundy posy while her lady-in-waiting, the Duchess of Grafton, helps to carry some of the other flowers she receives. Those who wonder what happens to them will be pleased to know that patients in local hospitals often have their day brightened with flowers passed on by the Queen.*

ABOVE: *The great and the good in procession to Wells Cathedral for the Maundy service in April 1993.*

LEFT: *The Queen is pleased to see a familiar face among her Yeomen of the Guard after the Maundy service held at Lincoln Cathedral.*

The State Opening of Parliament

ALTHOUGH TIMES CHANGE and there has been some relaxation in attitude, many traditional customs and ceremonies associated with the monarchy are still in force. Among the best known of these is the State Opening of Parliament, which is usually held in the first week of November after the long summer recess has ended and the party conference season is over. It is the only annual state event, and, like all royal ceremonies, is full of colour and pageantry, much of it rooted in ancient traditions.

On the morning of the State Opening, the royal regalia, consisting of the Imperial State Crown, the Cap of Maintenance, the Sword of State and the Maces of the Sergeants-at-Arms, is transported in horse-drawn coaches to Parliament. The coaches are lit inside so that the regalia can be clearly seen by people lining the route.

The Queen, usually accompanied by the Duke of Edinburgh and one or two other members of the Royal Family, travels in the Irish State Coach, which is escorted by the Household Cavalry. On arriving at the Palace of Westminster at 11 a.m., the Queen is greeted by the Earl Marshal of England and the Lord Great Chamberlain. (While she is away from the palace, her own Lord Chamberlain remains behind as a 'hostage' to ensure the Sovereign's safe return – a practice dating back to the time when the Lord Chamberlain was a political rather than a personal appointment and mutual distrust characterized relations between Parliament and Crown.)

The Queen proceeds to the robing room, where her ladies-in-waiting help her to don the crimson robe of state and the Imperial State Crown. When ready, a fanfare is sounded and the royal procession then makes its way into the chamber of the House of Lords.

Those awaiting the Queen's entrance are dressed appropriately – peers in scarlet robes trimmed with ermine, their wives in evening dresses and tiaras; clergy in ecclesiastical garments; judges in robes and wigs. Even members of the public viewing from the gallery must dress formally: men wear morning coats or uniform, and women wear hats and gloves.

When everyone is assembled, Black Rod, whose role is to maintain order in the House, marches in frock coat, silk stockings and buckled shoes to the entrance of the Commons, where the door is symbolically slammed in his face. He then knocks three

OPPOSITE: *On its way to the Palace of Westminster in the Queen Alexandra State Coach, the Imperial State Crown is spotlit so that it can be clearly seen by spectators along the processional route.*

BELOW: *The Imperial State Crown is worn by the Queen once a year – at the State Opening of Parliament. It contains pearls, sapphires, emeralds, rubies and an incredible 2784 diamonds.*

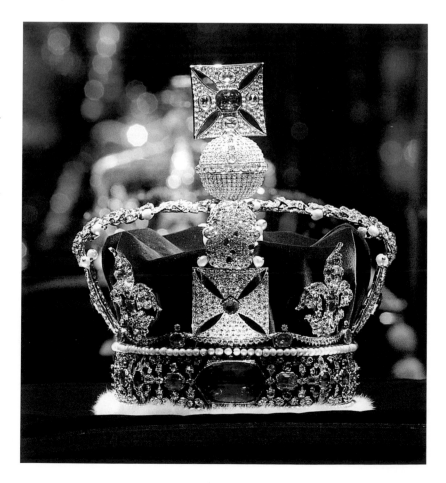

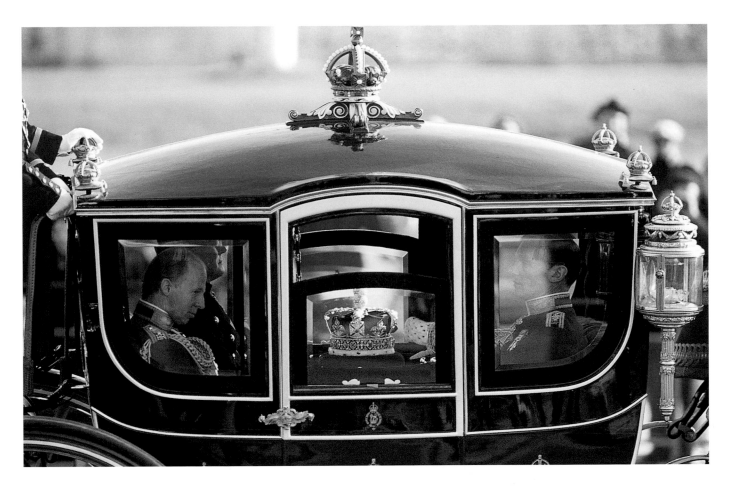

times with his staff of office and relays the traditional message from the Queen 'commanding this honourable House to attend her immediately in the House of Peers'. The Speaker leads the way, followed by the prime minister and leader of the opposition, with all the other Commons' members bringing up the rear. This procession is not allowed into the actual chamber of the Lords, so very few can see or hear anything of the proceedings. The public is somewhat luckier, as the ceremony has been televised since 1958.

The Queen then reads the speech that has been written for her by the prime minister, which outlines the programme of legislation that the government proposes to introduce during the coming year. This is one speech that Her Majesty is required to read exactly as written, a clear example of a constitutional monarchy at work.

About an hour later, the Queen returns to the robing room, removes her robe and crown and leaves for Buckingham Palace. This brief but significant state occasion is over for another year, having reinforced the ties between Sovereign and State, while also underlining their separateness.

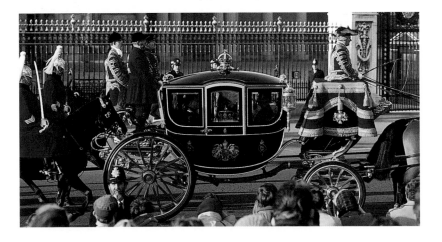

LEFT: *The mace, originally a weapon of protection, is now a symbol of authority. It is accompanied by guards on the journey to Westminster.*

BELOW: *Despite being the most valuable piece of jewellery in the world, the Imperial State Crown is not insured. It is well protected on its way to Parliament.*

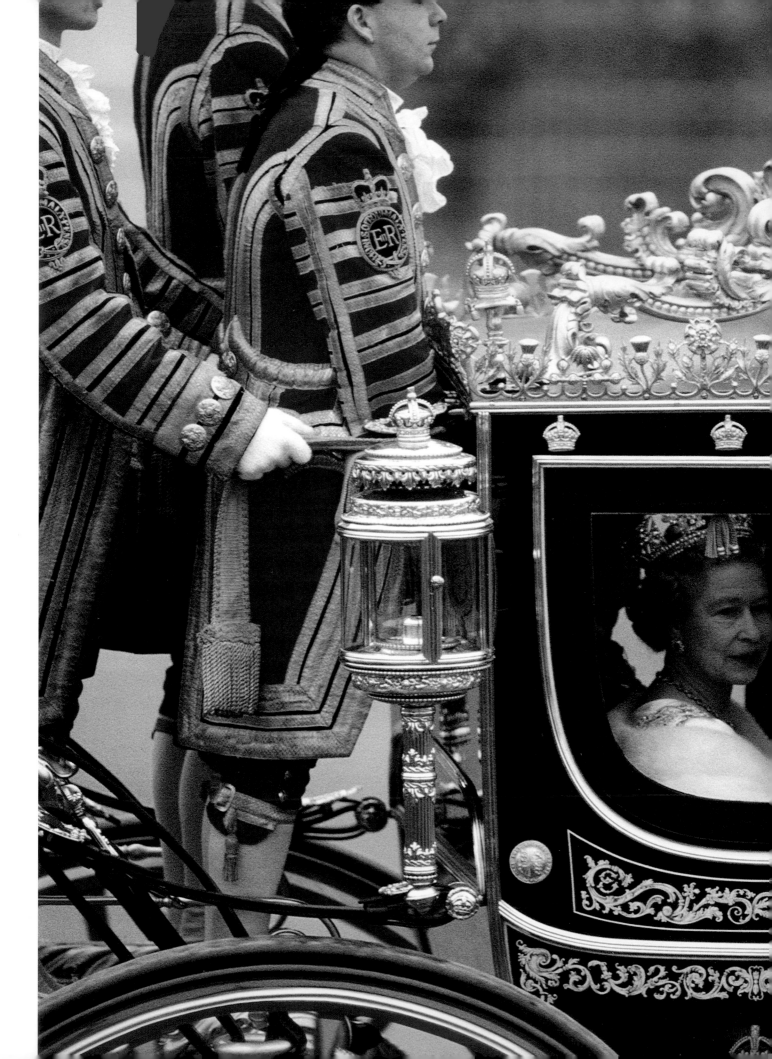

THE CEREMONIAL
TO BE OBSERVED AT THE
OPENING
OF PARLIAMENT

BY

Her Majesty
The Queen

ON WEDNESDAY THE TWENTIETH DAY
OF JUNE 2001

PREVIOUS PAGE: *Wearing the King George IV State Diadem, the Queen travels to the State Opening of Parliament in the Irish State Coach.*

OPPOSITE: *Wearing their parliamentary robes, members of the House of Lords await the Queen's Speech in December 2000.*

BELOW: *An official programme (right) is placed on every chair in the Royal Gallery. From these privileged seats, those invited see the Queen emerge from the robing room through the arched doorway and process directly in front of them.*

ABOVE: *Baroness Margaret Thatcher attends the State Opening of Parliament in December 2000.*

OVERLEAF: *The Imperial State Crown, carried on a velvet cushion by the Comptroller of the Lord Chamberlain's office, arrives at the Sovereign's Entrance en route to the robing room.*

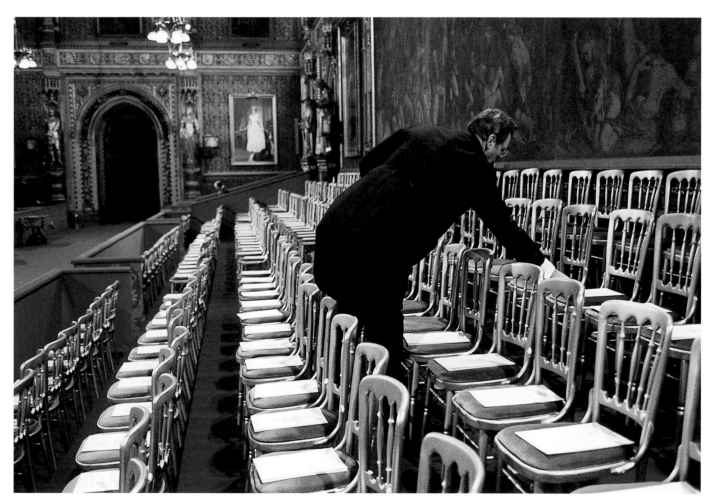

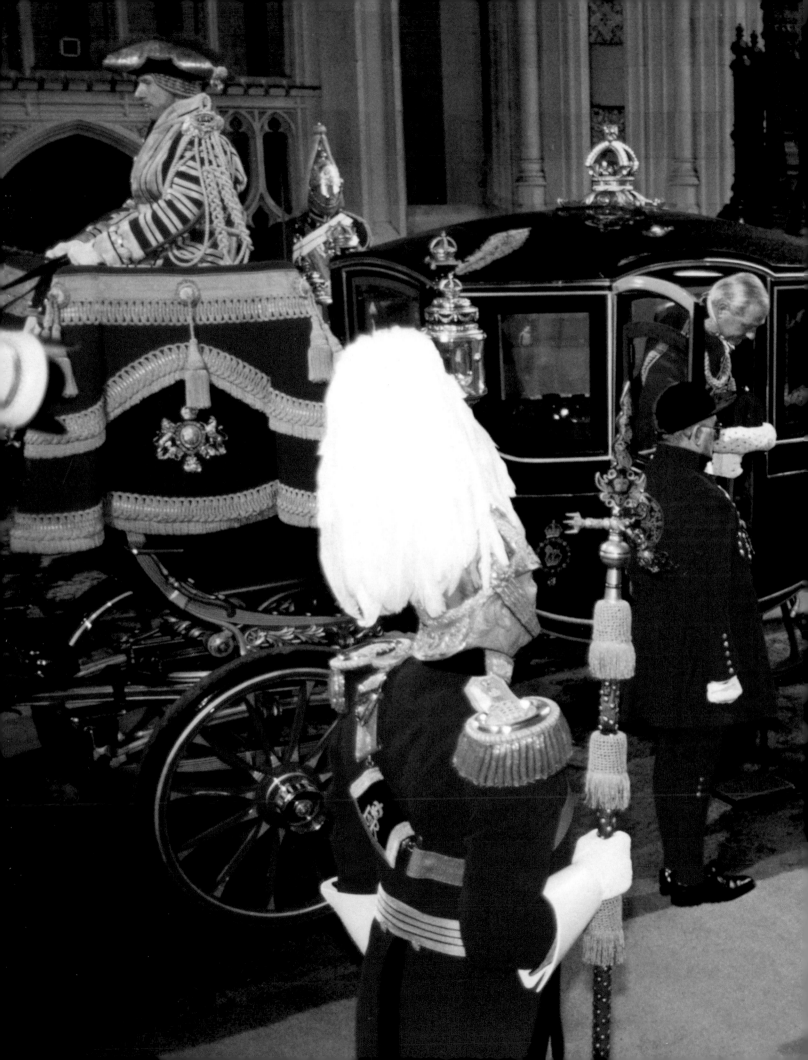

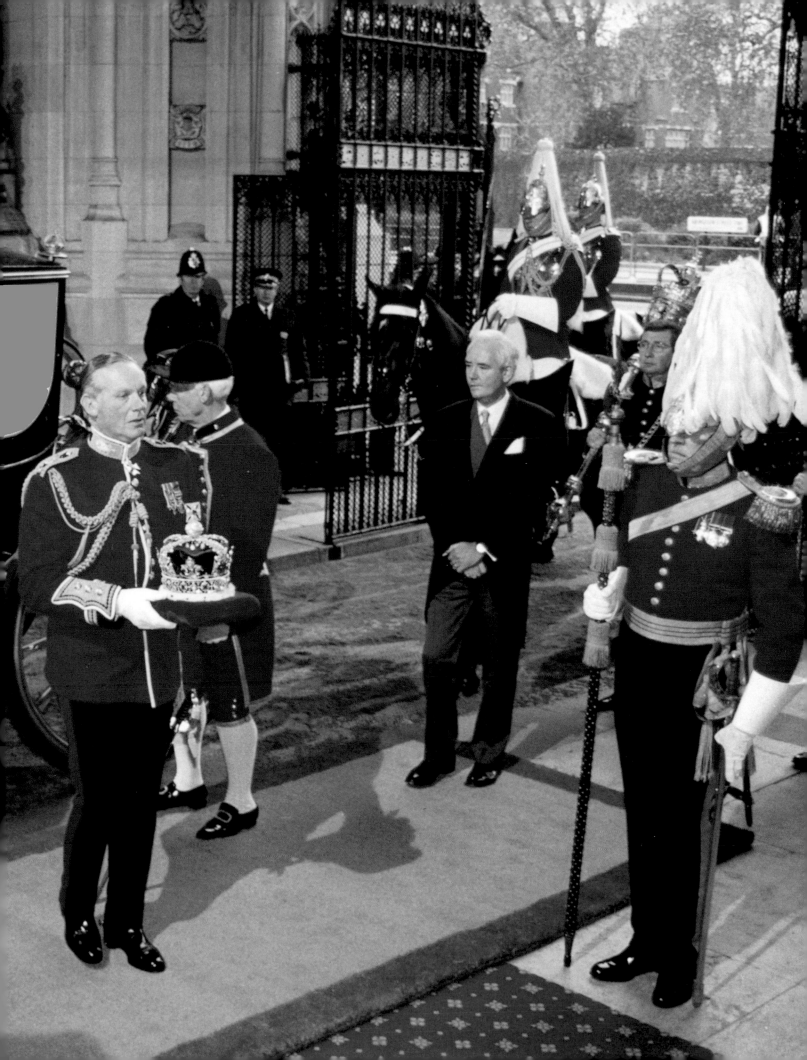

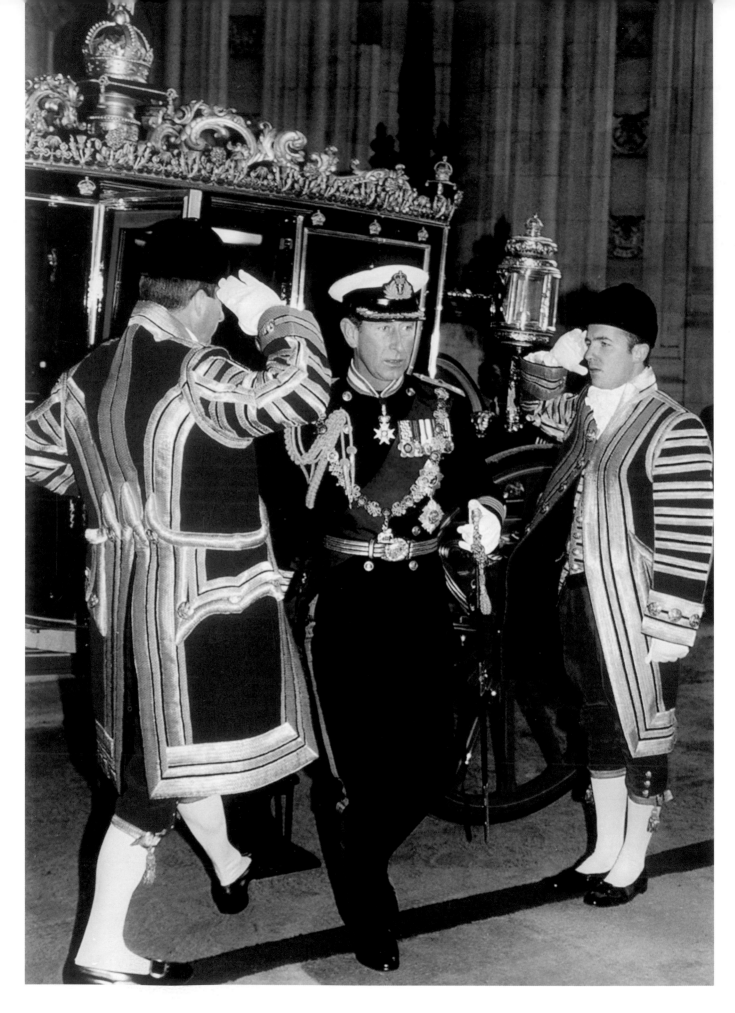

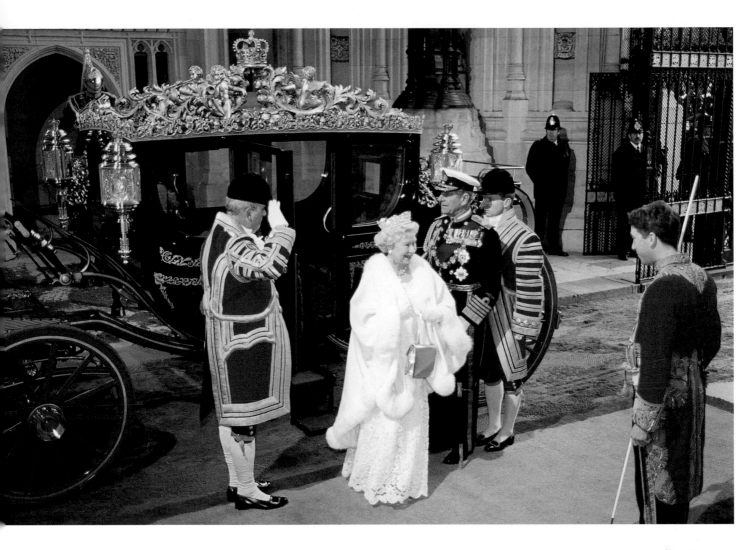

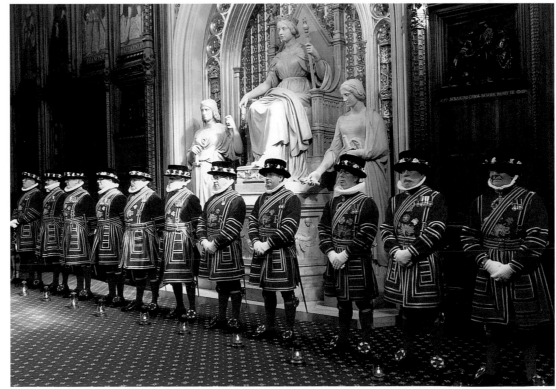

ABOVE: *On arrival at the Palace of Westminster in 1998, the Queen and the Duke of Edinburgh are welcomed by the Lord Great Chamberlain, the Marquess of Cholmondeley.*

OPPOSITE: *The Prince of Wales, in formal naval uniform, arrives at the Sovereign's Entrance of the House of Lords.*

RIGHT: *The Queen's Bodyguard of the Yeomen of the Guard are about to search the cellars of the Lords by lantern light to make certain that no modern Guy Fawkes is planning to blow up Parliament. This ritual, conducted before the monarch arrives, dates back to the Gunpowder Plot of 1605.*

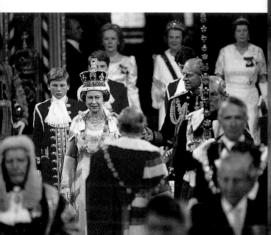

ABOVE: *Following the general election in June 1987, the Queen opens Parliament accompanied by the Duke of Edinburgh, who wears the full dress uniform of Admiral of the Fleet. The Earl Marshal walks backwards before the Queen.*

RIGHT: *The Queen has opened Parliament in every year of her reign except 1959 and 1963 – when she was expecting Prince Andrew and Prince Edward. Wearing parliamentary robes with the Imperial State Crown and the Garter collar with diamond George (badge), the Queen enters the Lords holding Prince Philip's hand and balancing the ever-present handbag.*

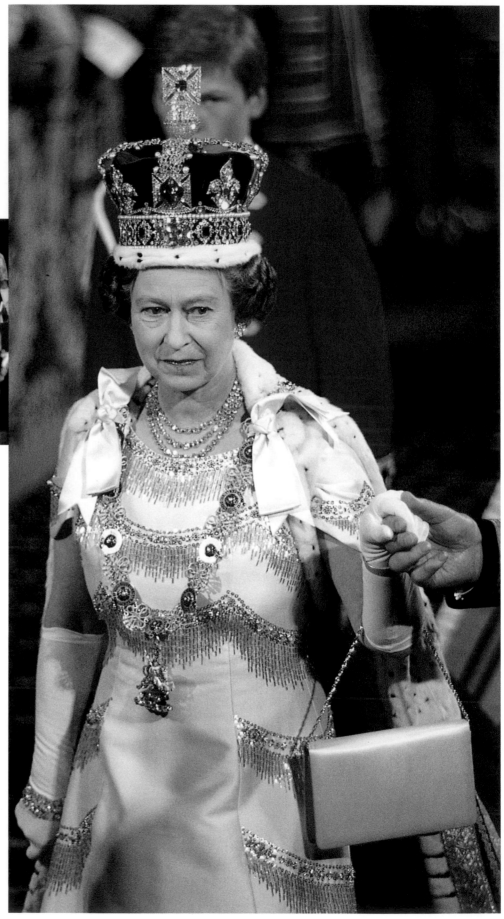

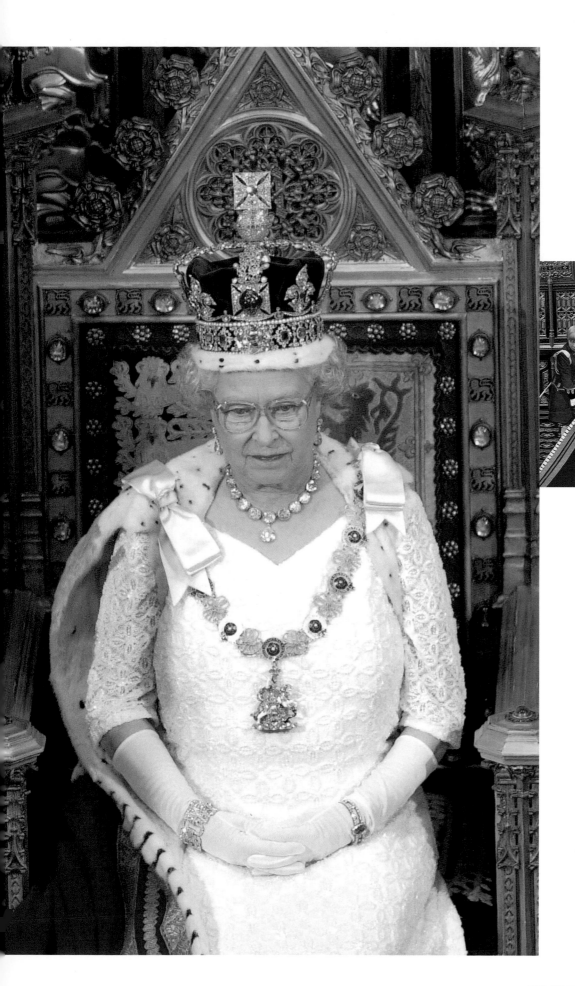

BELOW: *The Queen and Prince Philip seated on thrones, in a scene they have been part of for nearly 50 years. The Pages of Honour adjust the velvet and ermine robe of state, which has a train over 18 ft (5.5 m) long.*

LEFT: *The Queen waits to receive the speech that has been written for her by the government of the day. The speech, which outlines the legislation to be introduced by Parliament in the coming session, is taken from a silk purse by the Lord Chancellor, who kneels as he presents it.*

OVERLEAF: *The scene in the House of Lords as the Queen reads her speech. In more than 30 years of photographing the Royal Family, it wasn't until the year 2000 that I managed to draw the pass for this position – the only one that shows the monarch on the throne.*

PAGES 264–5: *I like the mood of this moment as the Queen, supported by the Duke of Edinburgh, returns to the robing room after her speech.*

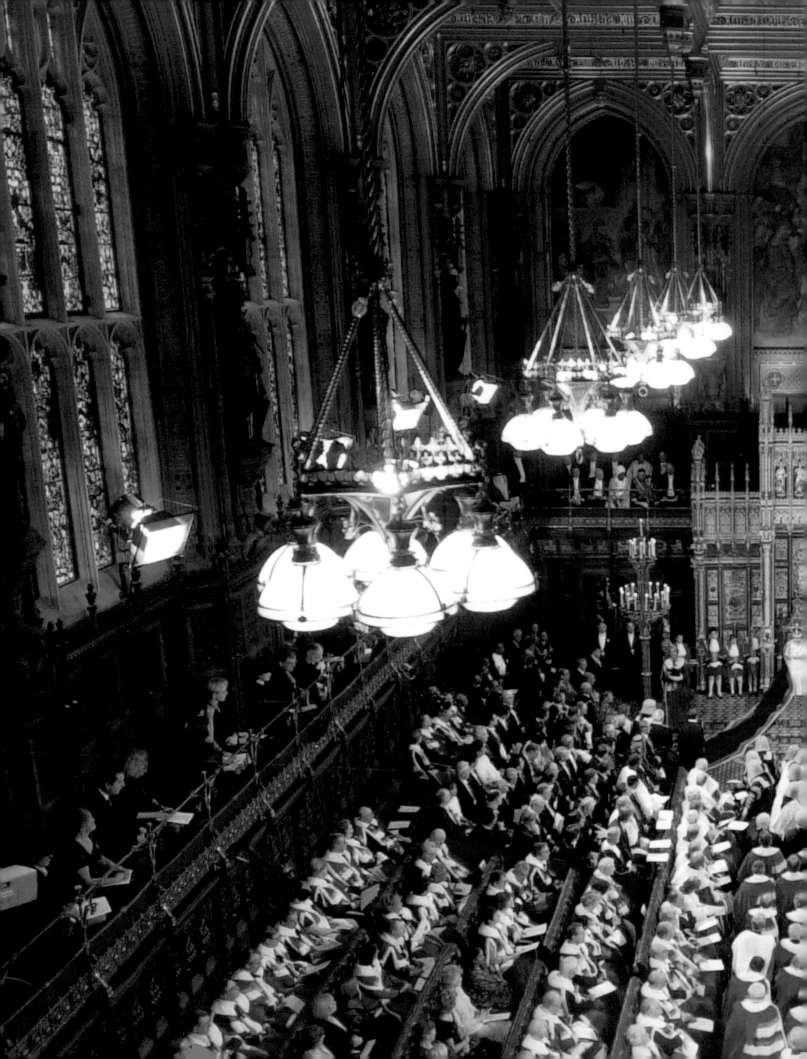

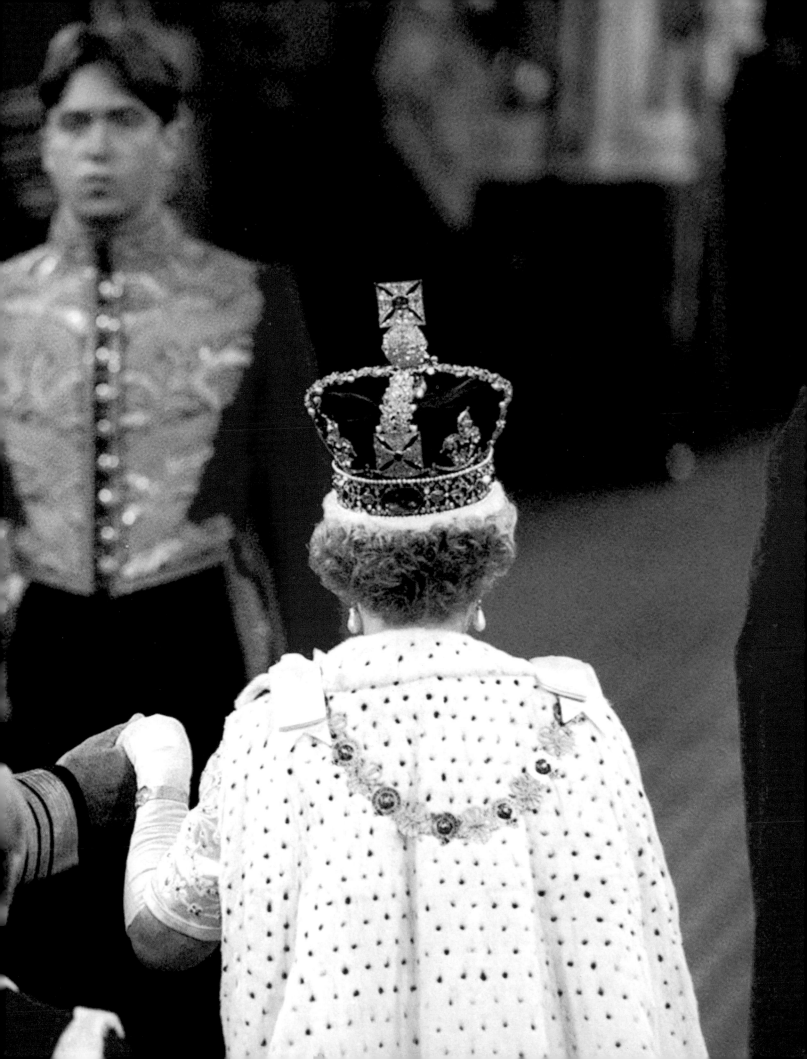

Keeping up Appearances

IT TAKES TIME, effort and a large number of people to keep the royal show up and running in the fashion to which we have all become accustomed. Everything is organized with military precision, and where the Queen goes, the Royal Household always follows.

All the domestic staff – some 300 of them – work under the aegis of the Master of the Household. The most senior domestic servant is the Palace Steward, and it is his responsibility to ensure that everyone working under him is on duty at the specified time. Most of the staff live in, and for them the day starts at 7.30 with breakfast in the Servants' Hall. Although this sounds very grand, it is actually quite informal, being run like a self-service cafeteria.

The working day starts soon afterwards as there is always a great deal to be done. Footmen tend to do what their name suggests – fetching and carrying in and around strictly demarcated areas of the palace. They work according to a rota devised by the Sergeant Footman. Housemaids and cleaners are supervised by the Chief Housekeeper, who also draws up a rota. For this last group the daily ritual of making beds, vacuuming floors, dusting and polishing is unchanging – a never-ending task in a residence of 400-odd rooms.

In addition to the usual domestic chores, there are certain other ongoing tasks that hardly impinge on the average household. These include polishing gold and silver, of which there are vast amounts, much of it used at official functions. Preparing the table for a state banquet, when there can be up to 200 guests, is several days' work if you take into account all the cleaning and polishing that goes on beforehand. Every piece of silver, glass and porcelain gleams to perfection, and the table itself – some 170 ft (50 m) long – glows from the exertions of several men, who put soft duster over-shoes on their feet and glide along the surface to bring it to a magnificent shine.

In fact, preparations for any kind of public occasion always require generous amounts of elbow grease: there are flags to be hung, red carpets to be swept, last-minute adjustments to be made… There are also many items that require special maintenance: carriages have up to 20 coats of paint and varnish that must be kept pristine, and gilding must also be renewed on a regular basis; ceremonial harness takes many hours to polish and put on the horses; and livery, some of it rather elderly and all of it very costly, needs inspection and repair.

The trappings of monarchy are many and various, and every aspect of them helps to preserve the grandeur and mystique of the institution. The thousands of hours that go into sustaining its colourful public image are the work of an unseen and often unacknowledged 'army', but some of them are revealed in the pictures that follow.

LEFT AND OPPOSITE: *Having photographed the Royal Yacht* Britannia *in so many countries around the world, I felt it was the end of an era when it was decommissioned in 1997. Its gleaming hull and bright white paintwork were the result of many hours of careful maintenance by its crew. After docking, marks from the anchors and ropes were always polished or painted away.*

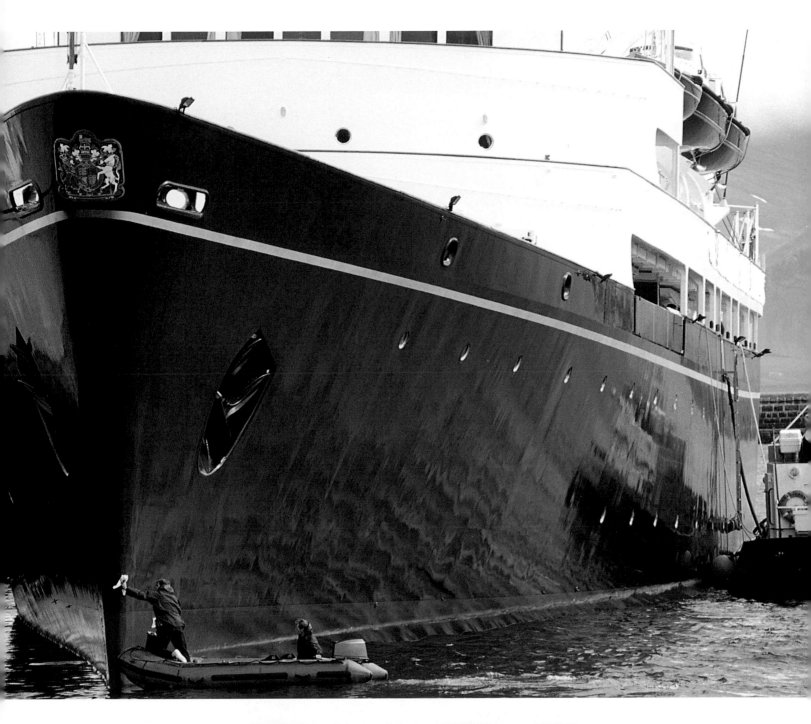

ABOVE: *Sailors polish the bow on arrival for the Queen's visit to Reykjavik, Iceland, in June 1990. The Royal Family could be excused for thinking that the whole world smells of paint and polish. Wherever they go, careful sprucing has preceded them.*

BELOW AND RIGHT: *Wearing soft-soled shoes, the crew of* Britannia *go into the well-established routine for disembarkation.*

LEFT: *Finishing touches of paint and polish are given to the gangplank support and handrails.*

ABOVE: *The preparations complete, the Queen leaves the Royal Yacht and is greeted with a bow by the British High Commissioner in Cyprus in October 1993.*

LEFT AND BELOW RIGHT: *Preparations begin early in the morning for the Royal Family's appearance on the balcony of Buckingham Palace. Staff begin to hang the swagged banner along the balcony at 8 a.m., making sure it is positioned dead centre and protected from rain.*

RIGHT: *The windows that open on to the balcony are given a last-minute clean.*

BELOW: *The Queen directs the young Peter Phillips and Lord Frederick Windsor towards the RAF fly-past that always concludes her Birthday Parade.*

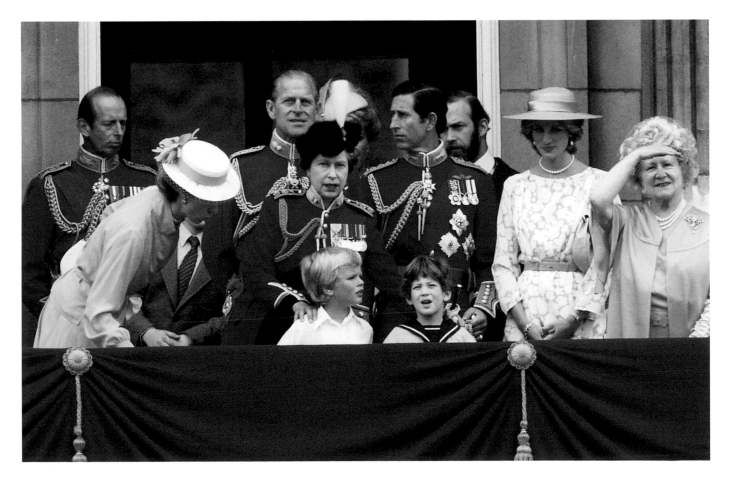

LEFT: *A superb example of the coachbuilder's craft is the 1902 State Landau built for King Edward VII. This carriage is used by the Queen to meet all foreign heads of state (see pages 234–5). It was also used during her Silver Jubilee celebrations, and at the time of her Golden Jubilee it celebrates its own centenary. Here one of the ornate carriage lamps is given a polish.*

ABOVE RIGHT: *Six grey postilion horses draw the 1902 State Landau, and their elaborate harness includes royal insignia such as this.*

RIGHT: *A decorative gold crown on a tasselled cushion adorns the front of the carriage.*

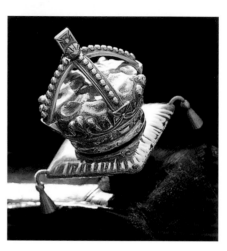

LEFT: *The Royal Mews is a world within a world – a 'village' behind the palace that has been home to the monarch's horses, horsemen and carriages since the 1850s. The 30 or so horses currently stabled there are used for all the major ceremonial events – even, on occasion, travelling the length of the country to be on parade for the Queen.*

Maintaining the historic collection of carriages is an ongoing process that requires many precision skills. Here one of the maintenance staff paints a carriage wheel, which, like the rest of the vehicle, has up to 20 coats of paint and varnish.

RIGHT: *The red plumes of the Blues and Royals – made from narrow strips of whalebone – are removed for helmet cleaning. The uniform of the regiment has hardly changed since its inception in the mid-19th century.*

BELOW: *The horses of the Blues and Royals Queen's Escort are based at Kensington Barracks. On the day of a parade, they are groomed till they gleam.*

BELOW: *Each soldier is responsible for cleaning his own tack. There are several sets for each horse, so quite a lot of time must be set aside for this task.*

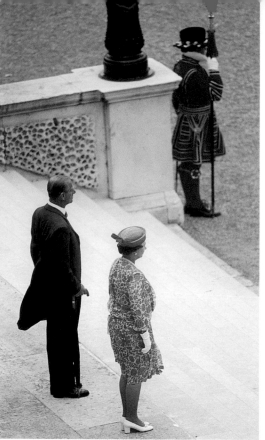

ABOVE AND RIGHT: *The steps at the back of Buckingham Palace are given a last-minute brushing before the Queen and Prince Philip take their position for the national anthem that signals the start of a garden party.*

ABOVE AND OPPOSITE: *Similar task, different location. Cleaners in Kuwait take carpet sweepers to the oriental rugs placed on the dockside in readiness for the Queen and Prince Philip disembarking from the Royal Yacht.*

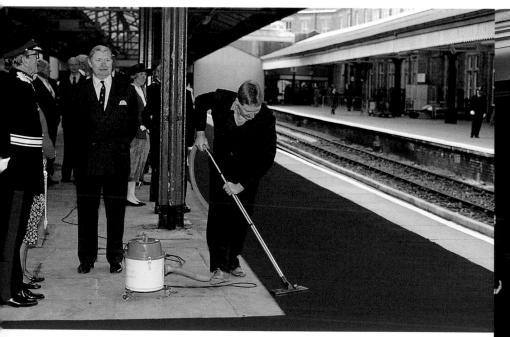

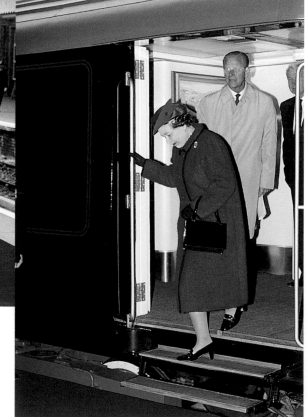

ABOVE: *The welcoming party at Swansea Station in April 1989 looks on as the red carpet is given a final once-over with* *a vacuum cleaner. Everything is pristine by the time the Queen steps off the Royal Train (right).*

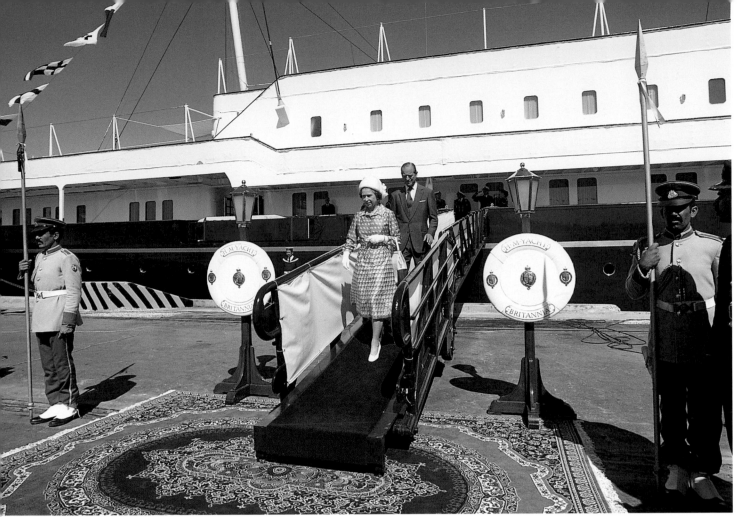

LEFT AND ABOVE: *The magnificent dining table in the banqueting hall at Windsor Castle is 170 ft (51 m) long and far too wide to stretch across, so polishing is done by a footman who has dusters tied to his feet. He has to take great care when gliding between candelabra,* *flower arrangements, glasses and place settings. Not long after the footman finished polishing the table on this occasion in June 1982, the Queen and Prince Philip posed with President Ronald Reagan and his wife Nancy before proceeding into the state banquet.*

All the Queen's Men

NO MATTER WHERE SHE GOES, the Queen is always surrounded by men whose function is to serve her to the best of their ability. From the footmen, pages and stewards who help keep the domestic scene running smoothly to the gardeners, gamekeepers and grooms whose responsibilities rest outside, men in uniform seem to dominate her life.

As the Queen is nominal head of all the armed services, it is hardly surprising that members of the military figure large in the pageantry surrounding her public appearances. Perhaps the best known of her men in uniform are the Yeomen of the Guard, reputed to be the oldest military corps in the world. Their distinctive scarlet uniform, virtually unchanged since Henry VII founded the corps in 1485, is decorated back and front with black and gold braid and embroidered with a Tudor crown, emblems of the United Kingdom and the motto 'Dieu et mon droit' (God and my right). The doublet is worn with red breeches and stockings, a white ruff and a black velvet hat trimmed with red,

white and blue ribbons. Other accoutrements include an undrawn sword and a 7-ft (2-m) halberd, known as a 'partisan'.

The Yeomen of the Guard were originally responsible for the personal safety of the sovereign, so they lived in the royal palaces and even acted as food tasters. Nowadays, headquartered at St James's Palace, they act as bodyguards on state occasions, and are also in attendance at garden parties and investitures. Although their uniform is virtually identical to that worn by the Yeomen Warders ('Beefeaters') who guard the Tower of London, the two corps are quite distinct. The Yeomen of the Guard are distinguished by wearing a cross-belt (sash) from the left shoulder.

Among the many other soldiers, sailors and airmen who play a regular part in the Queen's life are the Household Cavalry, consisting of two regiments – the Life Guards and the Blues and Royals, the latter an amalgamation of the Royal Horse Guards and the 1st Dragoons. Their

OPPOSITE AND BELOW: *I have photographed many of the Queen's men, from liveried Yeomen of the Guard to gamekeepers in their country tweeds. The three keepers and the Queen's black labradors below were taking part in a gundog show on the Sandringham Estate.*

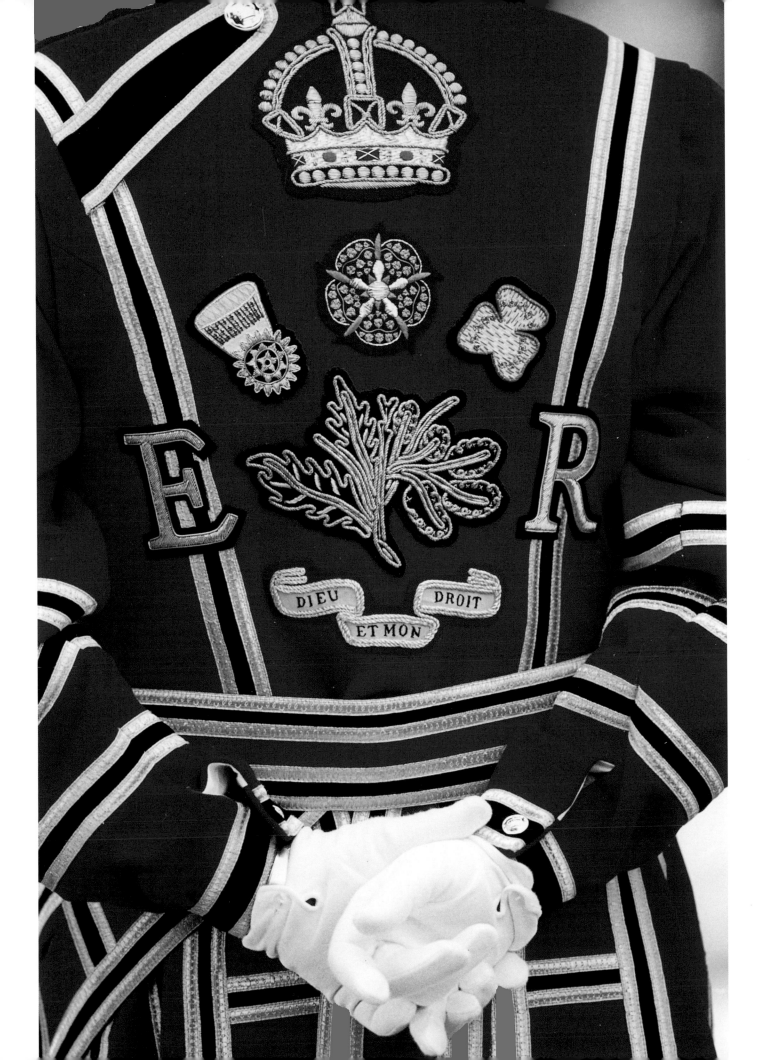

distinctive uniform includes a cuirass (metal breastplate) worn over a red or blue tunic, white leather breeches and a helmet with a white or red plume. Although both regiments are fully operational (battle ready), they are most often seen performing ceremonial duties, such as providing mounted escorts for the Queen on state occasions.

Firm favourites, of course, are the Grenadier Guards – models for the archetypal toy soldier, with their scarlet tunics and tall bearskins. As the minimum height requirement for this regiment is 6 ft (1.8 m), many of the men are well over 7 ft (2.15 m) in full uniform. They make an eye-catching sight on many ceremonial occasions.

Staff who work in the Royal Mews also wear uniforms that have changed little over the last 200 years. Coachmen may also be called upon to act as postilions and outriders, so they have three different uniforms for each function, and three or more variations to it, depending on the occasion. The daily uniform is a plain black jacket with fawn riding breeches, top boots and a silk top hat. Gilt buttons and gold braid on the hat are added for semi-State occasions. For Ascot and full State occasions, the jacket changes to red and has increasing amounts of gold braid and buttons. The top hat is also abandoned in favour of wig and cap or wig and tricorn hat.

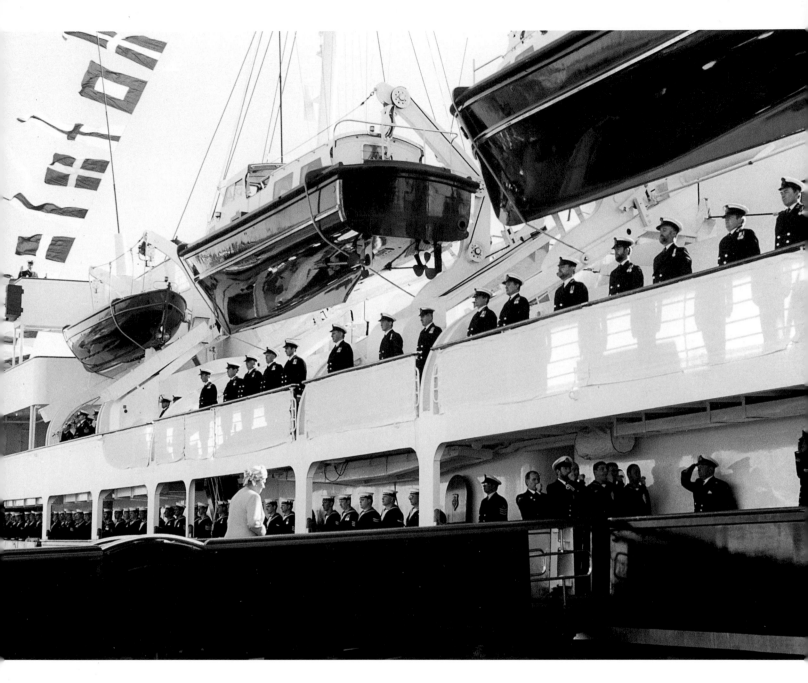

ABOVE: *The Queen being piped aboard the Royal Yacht* Britannia *in Portsmouth in 1996. The 21 officers, 256 yachtsmen and members of the Royal Marines band each had a tropical white uniform for wear in warmer climates. Tradition demanded that plimsolls be worn on board and that orders be given by hand signals so that the royals wouldn't be disturbed as the crew went about their daily chores.*

Special uniforms are also worn by those who take part in the ceremony of swan upping – marking the season's new broods of cygnets on the Thames between Blackfriars and Henley. On the third Monday in July the Royal Swan Keeper dons a scarlet jacket with brass buttons, white trousers and a white peaked cap bearing a badge of the royal crown. His staff, the Queen's Swan Uppers, wear scarlet jerseys and white trousers.

Only some of the swans on the Thames belong to the Queen. Others are owned by the Worshipful Companies of Vintners and Dyers, who wear uniforms to distinguish them from the Queen's men. The Vintners' Swan Marker wears a green jacket with white trousers, and his men wear all white, while the Dyers' Swan Master and his men wear blue and white. The swans are also distinguished by having nicks taken out of their beaks: two for the Vintners', one for the Dyers', none for the Queen's.

This ancient ceremony dates back to the 15th century, when swans were considered just another source of food and likely to be plundered by anyone who lived near the river. Now it is a way of keeping count of these beautiful birds and monitoring their health, but thanks to the uniforms, it is a colourful event that combines tradition with conservation.

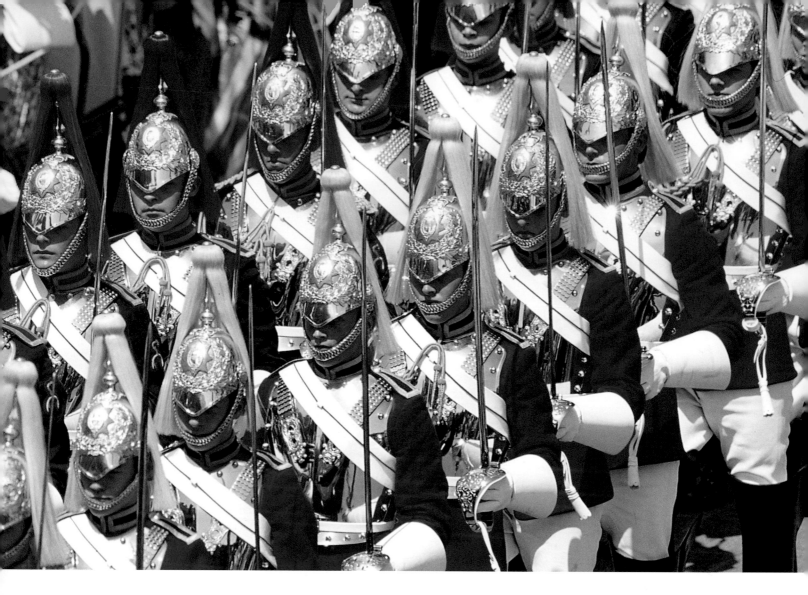

ABOVE: *The pointed helmets of the Life Guards give them a rather Prussian appearance. The steel cuirass is the only body armour still worn in the army.*

RIGHT: *The Coldstream Guards, one of the five regiments of foot guards in the Household Division, were formed in 1650 on the orders of Oliver Cromwell.*

As I can't be in two places at once, I tend to photograph the marching guards at the dress rehearsal the week before the Trooping ceremony proper so that I can be at the other end of The Mall on the day itself to photograph the Royal Family's procession and their appearance on the balcony at Buckingham Palace after the parade.

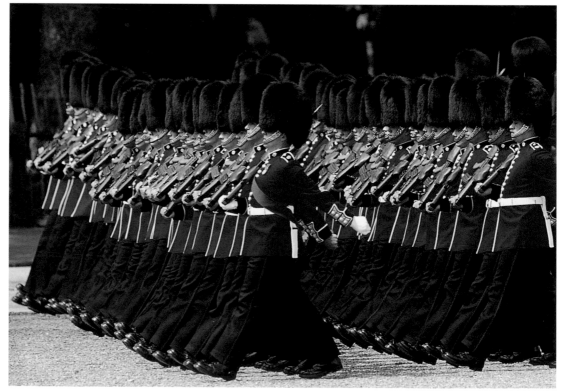

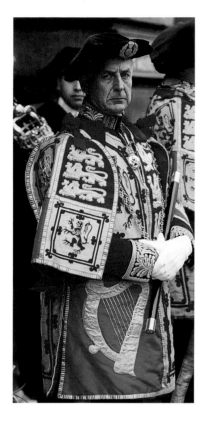

LEFT: *A herald from the College of Arms in his blue, red and gold tabard worn on ceremonial occasions. The College of Arms is part of the Royal Household and all members of it are appointed by the Queen. Applicants need to be genealogical, armorial, ceremonial or legal experts. Their work can include designing a complete coat of arms and helping to choose a family motto if there isn't one in existence. I think the heralds would not look out of place in the pages of Alice in Wonderland.*

RIGHT: *A Yeoman of the Guard on duty in the Throne Room of Buckingham Palace during an investiture ceremony.*

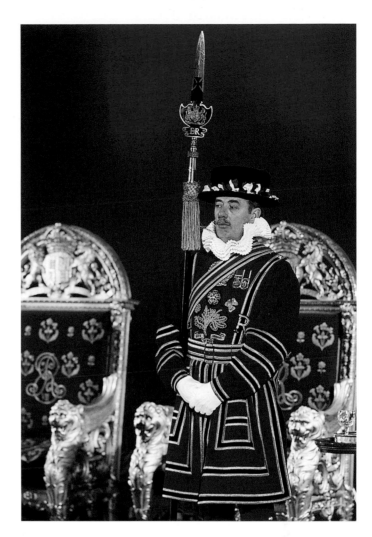

ABOVE: *Coachmen in their wet-weather cloaks take a break while the Queen attends the Order of the Thistle service at the Thistle Chapel in St Giles' Cathedral, Edinburgh.*

RIGHT: *Although the Imperial State Crown is no longer transported by boat from the Tower of London, the Queen's Bargemaster and a Waterman continue to escort it.*

LEFT: *David Barber, Her Majesty's Swan Marker, with his team on the River Thames for the annual ceremony of swan upping – marking the season's new brood of cygnets. In the Middle Ages swans were regarded as the sole property of the Crown, but charters of ownership were later granted to the Worshipful Companies of Vintners and Dyers.*

LEFT: *The badges belonging to each team of swan uppers. Her Majesty's (top); the Worshipful Company of Vintners' (centre); the Worshipful Company of Dyers' (bottom).*

RIGHT: *A member of the Dyers' team returns a swan to the water, having established who owns it from the number of nicks in the beak. Its brood of cygnets will then be marked accordingly.*

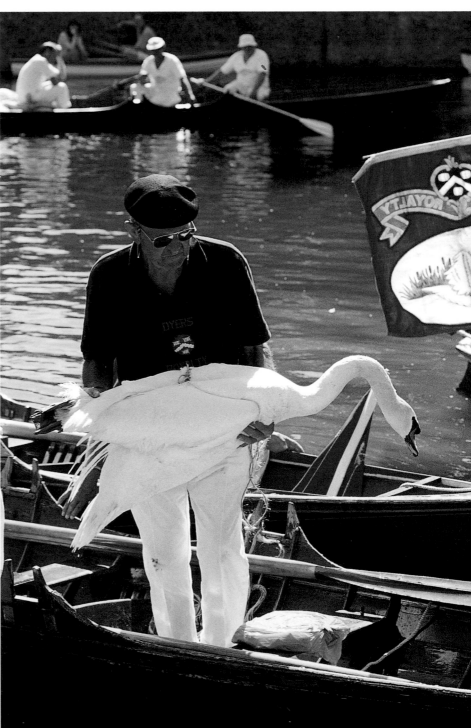

Royal Residences

ASK ANYONE WHERE THE Queen lives and the answer will more than likely be 'Buckingham Palace'. While she certainly spends a lot of time in that rather forbidding pile in central London, it's no great secret that she considers other of her homes more comfortable and welcoming.

There are numerous royal residences, only some of which the Queen actually stays in. Most of them are owned and maintained by the State, but are at the disposal of the monarch during his or her reign. Buckingham Palace, St James's Palace, Clarence House, Kensington Palace, Hampton Court Palace, Windsor Castle and Holyroodhouse all fall into this category.

The Queen's private homes, both of which she inherited from her father, King George VI, are at Sandringham and Balmoral. Family holidays tend to be spent in these relatively secluded places, and the cost of maintaining them comes from the Queen's private purse.

Buckingham Palace occupies a central site at the end of The Mall. Built for Lord Arlington in 1677, then redesigned and enlarged by the Duke of Buckingham in 1702–5, it was sold to King George III in 1762 and has been the monarch's main official residence since Queen Victoria acceded to the throne in 1837. The palace boasts three miles of corridors and 600 rooms, including 52 royal and guest bedrooms, 188 staff bedrooms and 78 bathrooms. Some 90-odd offices occupy the ground floor, the first floor being where the magnificent state rooms are located. Surrounding the palace are 40 acres of gardens, which help to muffle the ever-present roar of London traffic.

Kensington Palace, originally a private residence called Nottingham House, was bought by William

III in 1689 because it enjoyed cleaner air than nearby London and was conveniently close to the government at Westminster. The Jacobean building was substantially redesigned and rebuilt by Sir Christopher Wren, and underwent many further changes over the next 150 years. It remained the principal royal residence in London until 1837, when Victoria, who had been born there, chose to move to Buckingham Palace. Since that time, the Kensington Palace apartments have been home to many royal relatives. They currently house Princess Margaret, Princess Alice, the Duke and Duchess of Gloucester and Prince and Princess Michael of Kent.

TOP: *The telltale sign that you're standing in front of a royal residence is the orb that appears within the design of the railings around the palace.*

ABOVE: *A royal emblem on the façade of Buckingham Palace includes the motto of the Garter, 'Honi soit qui mal y pense', which means 'Evil he who evil thinks'.*

LEFT: *The arms of the United Kingdom, which appear on the gates of Buckingham Palace, were damaged in January 1995 when a vehicle crashed into them. Now repaired, they show the leopards of England, the lion of Scotland and the harp of Ireland. These gates are opened only for state occasions.*

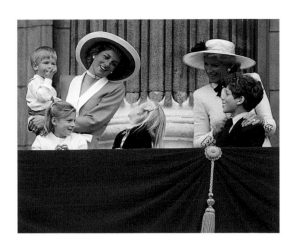

RIGHT: *The Royal Family regard Buckingham Palace as the office, and Windsor Castle as the weekend retreat. Much of the ceremonial begins and ends at the palace, but it's the venue for some lighter moments, too. Here the Princess of Wales and Princess Michael of Kent laugh with royal youngsters on the palace balcony in 1988.*

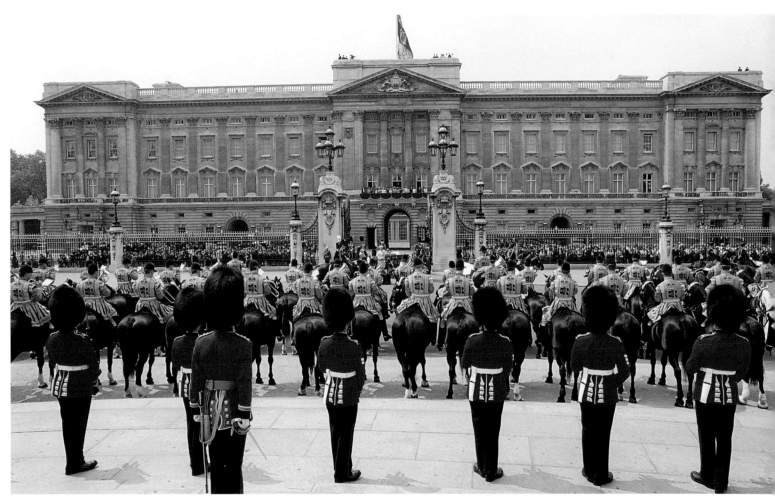

Buckingham Palace

ABOVE: *Buckingham Palace in all its glory on the Queen's official birthday in June. From a dais at the gates, she takes the final salute from her troops.*

The palace has its own cinema, tennis court, post office, chapel, swimming pool and boating lake. Every year since 1993, after the royal entourage has left for Balmoral, around 5000 visitors buy tickets to see inside this royal residence.

RIGHT: *A liveried footman takes the Queen's corgi and dorgi for a last-minute walk before a garden party.*

OVERLEAF: *The Queen, with Prince Philip and Prince Charles, stands for the national anthem, then joins her guests at a garden party.*

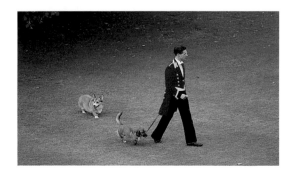

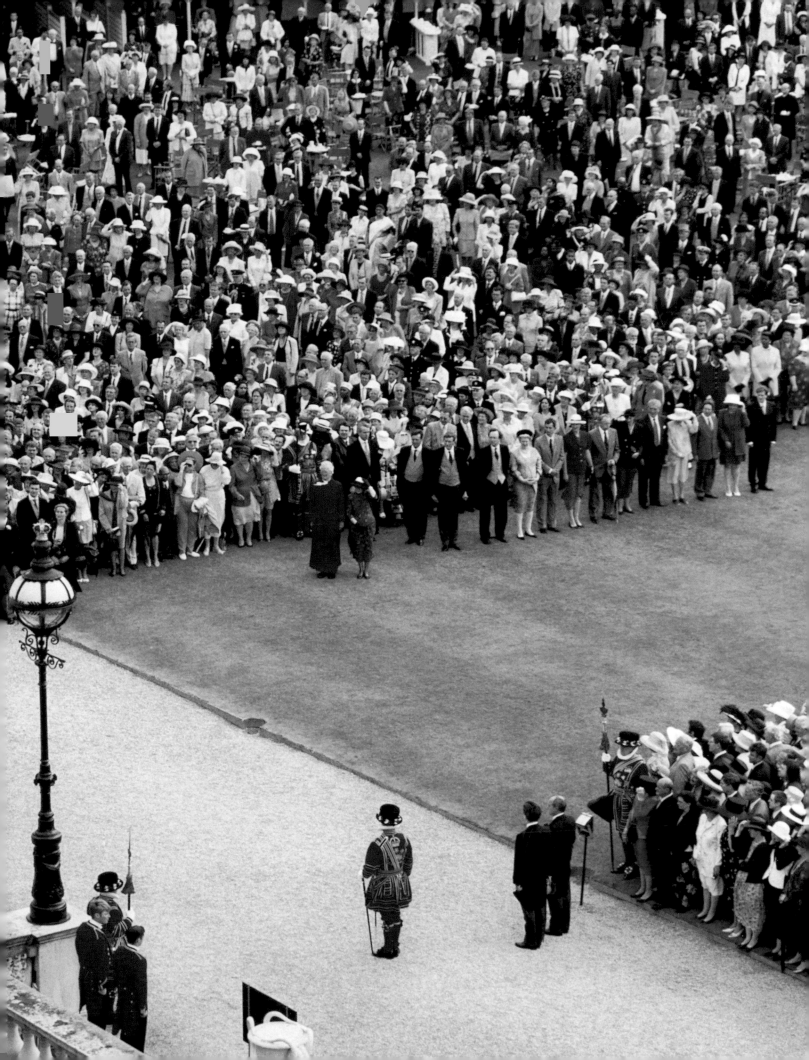

Windsor Castle

ABOVE: *The Queen's Standard is flown on the Round Tower at Windsor Castle to signify that the monarch is in residence.*

BELOW: *A rare view of the Queen as she strides around the grounds at Windsor in warm country clothes and heavy-duty brogues.*

RIGHT: *Windsor Castle seen from the Long Walk. This is the view that greets visiting heads of state as they arrive in their carriage processions. From her private rooms, the Queen can look straight down this 3-mile (5-km) avenue of trees which reaches to Windsor Great Park.*

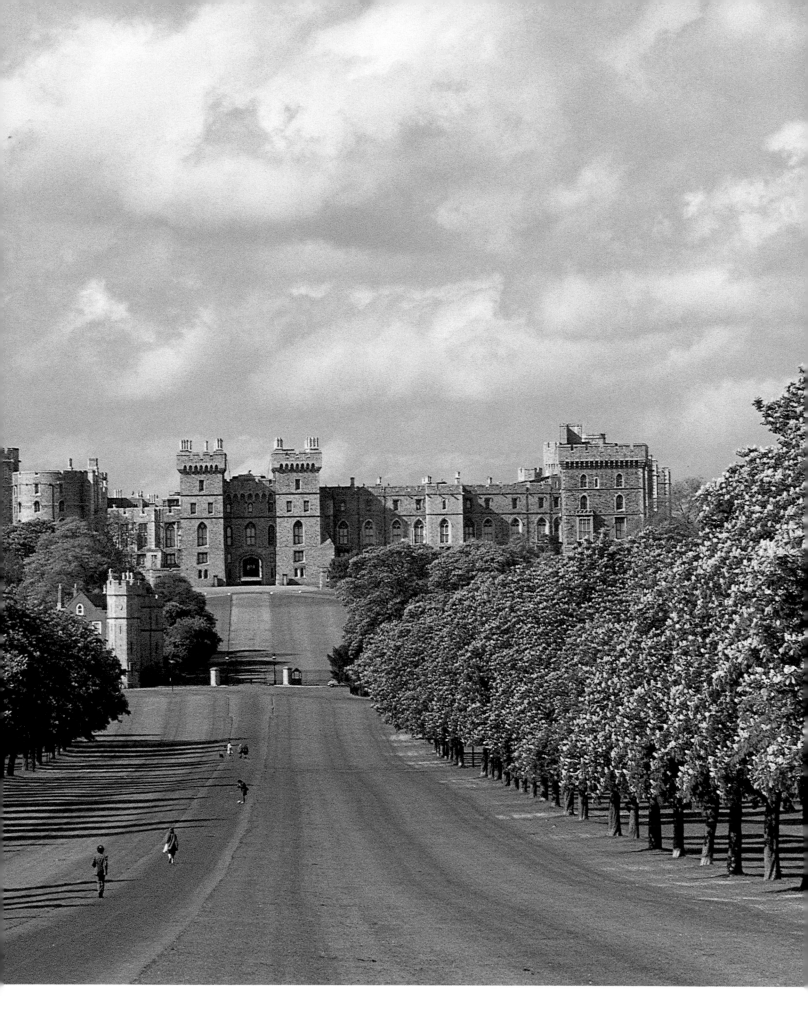

Windsor Castle, situated about 20 miles from London, is the Queen's regular weekend retreat, and the scene of many convivial gatherings, official and unofficial, during the year. Construction work on the 1000-room castle began shortly after William the Conqueror's conquest of England in 1066, and it has been in continuous use as a royal residence ever since. Having spent the years of the Second World War at the castle, the Queen has a particular fondness for it, and her private apartments have a cosiness that is not found in any other official royal residence. In 1992 a huge fire badly damaged state apartments and destroyed St George's Hall, part of which dated from 1362 and had historic links with the Order of the Garter. This has since been rebuilt, and the cost of doing so (an estimated £50 million) was recouped by opening Buckingham Palace to the public.

Holyroodhouse in Edinburgh is the Queen's official residence in Scotland. The present castle stands on the site of an abbey dating from 1128 and takes its name from a relic of the Holy Cross (rood) that had once belonged to St Margaret, mother of King David I of Scotland. The castle has seen much turbulence and change over the centuries, not least when it was all but destroyed by order of Henry VIII after his niece, Mary, Queen of Scots, refused to marry his son. Subsequently rebuilt and enlarged by several monarchs, Holyrood was revitalized as a royal residence by Victoria, who used it as a stop-over on her way to Balmoral. The present Queen spends two weeks in the castle during early July, when she undertakes engagements in Scotland and hosts a garden party.

Sandringham House in Norfolk is a rambling, red-brick building constructed in 1870 to replace a house that Queen Victoria had bought for her eldest son and heir. It currently has about 300 rooms and stands in an estate of 20,000 acres, much of which is let to tenant farmers. The house, which is open to the public for much of the year, has a homely atmosphere and, since the 1992 fire at Windsor Castle, has become the preferred venue for the Royal Family's Christmas and New Year celebrations.

Balmoral Castle sits by the River Dee in Aberdeenshire and, for many royals, is the perfect holiday retreat. Its 50,000-acre estate offers privacy from prying eyes, provides an abundance of

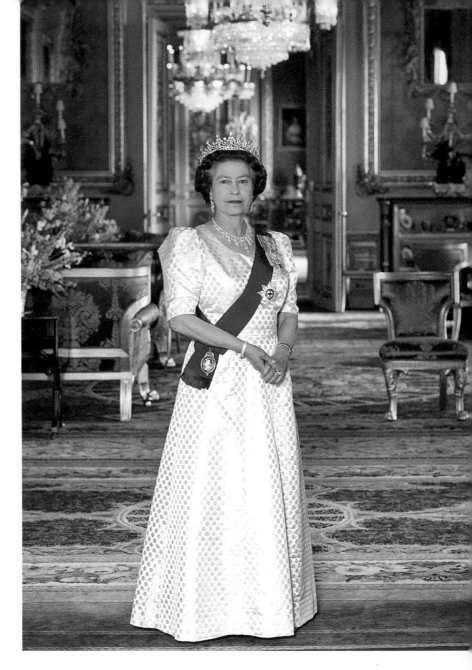

sporting activities and also generates the income from which the residence is maintained. The original building, a castle dating from the 15th century, was demolished and replaced by a design that was heavily influenced by Prince Albert. After his death Queen Victoria remained devoted to Balmoral, and, with the exception of Edward VII and Edward VIII, subsequent monarchs have been equally fond of it.

The cost of maintaining the official royal residences is immense – some £16 million in 2001 – but a substantial proportion of this is recouped from Crown Estate income, all of which the Queen surrenders to Parliament. Many would argue that the national heritage represented by these historic houses and their valuable collections of art are worth preserving at any price.

ABOVE: *At the invitation of the Queen, in April 1987 I went to Windsor Castle and took a series of exclusive photographs to be used for official purposes. Signed photographs in silver frames are presented to heads of state, ambassadors and other VIPs, and are also given as gifts on overseas tours. This picture was taken in the Green Drawing Room, which was badly damaged by fire in 1992.*

OPPOSITE: *The same room 10 years later, having been faithfully restored to its former glory.*

RIGHT: *I was at home in London when the first report of a fire at Windsor Castle came on the radio. Thinking that it would probably have been put out by the time I got there, I nonetheless set off on the 45-minute journey. In fact, it took two days to put out the fire. Some 250 fire fighters with 39 fire engines fought the blaze that had started at 11.37 a.m. on 20 November 1992 – the Queen's 45th wedding anniversary. In all, more than a hundred rooms in the castle were damaged by fire or the million gallons of water needed to extinguish it. Three hundred castle staff joined soldiers and policemen to form a human chain to remove valuable carpets, furniture and paintings.*

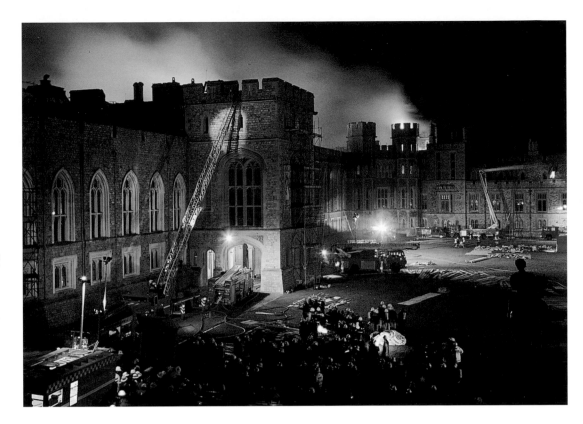

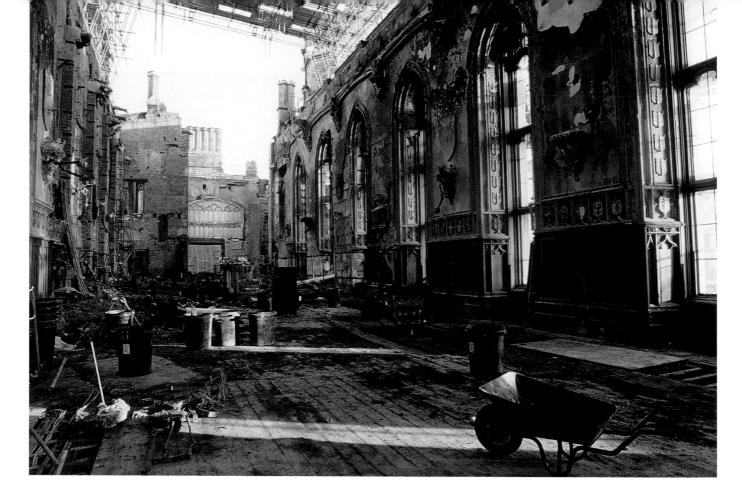

ABOVE: *It felt very strange to stand in the ruined shell of a once-grand room, with ashes up to 6 ft (2 m) deep, where I had stood a decade earlier to photograph the glittering banquet given for President Reagan on his state visit.*

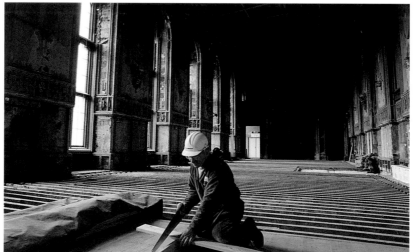

LEFT: *Seventy English oaks were needed to supply the timber for the new roof of St George's Hall, the 150-ft (45-m) long ceremonial chamber destroyed by the fire. Yet more timber was required to replace the damaged floor.*

RIGHT AND FAR RIGHT: *Once the frame of the roof was back on, workmen began the monumental task of restoring the interior.*

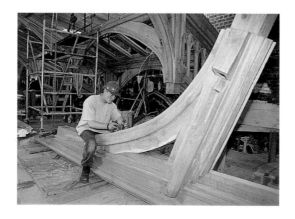

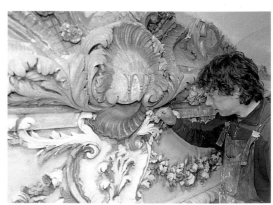

ABOVE: *The Queen and Prince Edward discussing the fire with a member of her staff.*

BELOW: *St George's Hall restored to its former glory.*

RIGHT: *At Prince Philip's suggestion, stained-glass windows depicting scenes of castle staff rescuing works of art and firefighters tackling the blaze were incorporated into the chapel restoration.*

ABOVE: *Just behind where I am standing for this shot of Sandringham House in Norfolk, there is a neat row of small gravestones. Their inscriptions (see opposite, lower right) pay tribute to the Queen's loyal canine friends.*

LEFT: *When the Royal Family escape from public scrutiny behind the gates of one of their homes, they have acres of stunning gardens to roam in. Sandringham, stretching over more than 20,000 acres, is one of the few great private estates left in England. It was bought in the 19th century for the future King Edward VII, and his son, George V, was born and died there. The Queen cherishes Sandringham as a family home.*

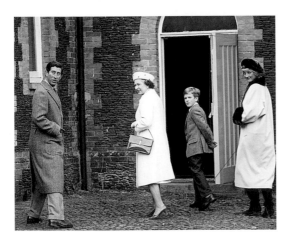

LEFT: *The Queen with the Prince and Princess of Wales and her grandson Peter Phillips at Sandringham in 1988.*

BELOW: *Although the Queen doesn't attend the Sandringham Flower Show hosted on her estate each summer, her mother and her eldest son are always there. Walking among the various exhibits, they chat to estate workers, neighbours and visitors passing through.*

RIGHT: *These beautiful labradors belonging to the Queen are working gundogs as well as privileged pets. Left to right, their names are Pocklea Jess, Chalford Astra and Garry of Tay, commonly known as Brag, Astra and Garry.*

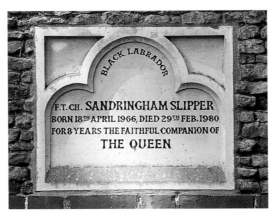

LEFT AND BELOW: *Each dog's faithful service is recorded after its death in a commemorative plaque set into the wall on the Sandringham estate. The Queen's love of labradors is inherited from her father, King George VI.*

BLACK LABRADOR

F.T.CH. SANDRINGHAM SLIPPER
BORN 18TH APRIL 1966, DIED 29TH FEB. 1980
FOR 8 YEARS THE FAITHFUL COMPANION OF
THE QUEEN

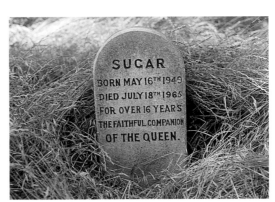

SUGAR
BORN MAY 16TH 1949
DIED JULY 18TH 1965
FOR OVER 16 YEARS
THE FAITHFUL COMPANION
OF THE QUEEN.

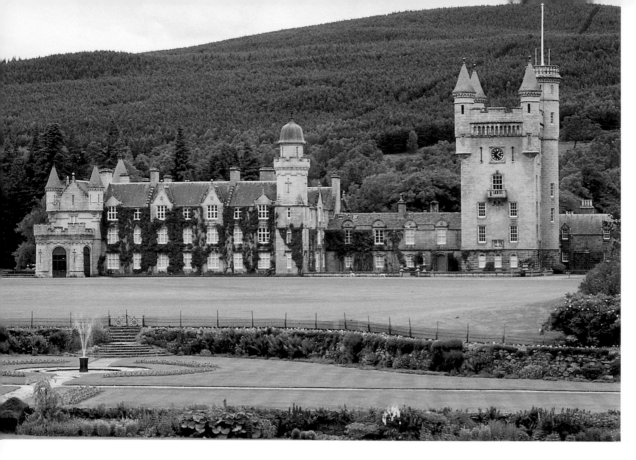

The Queen has described Balmoral as 'a place one looks forward to very much as the summer goes on' and admits she likes to 'hibernate for a bit'. Within its 50,000 acres she can easily escape from the world outside. The lifestyle at Balmoral, virtually unchanged since the house came into royal hands, includes deer-stalking, shooting, horse-riding, fishing, picnicking and walking the dogs along the banks of the River Dee. Hearty breakfasts of porridge and kedgeree kick off the day's activities.

Balmoral Castle and Holyroodhouse

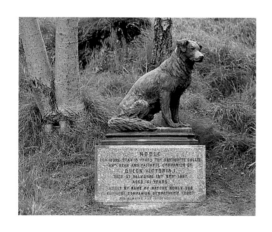

RIGHT: *On arrival at Balmoral Castle, the Queen takes the salute from a guard of honour of her foot soldiers – a touch of formality before the relaxation of her six-week holiday can begin.*

BELOW: *The Queen wakes to the sound of bagpipes when she stays at Balmoral. Here the pipers march through the main gates of the castle.*

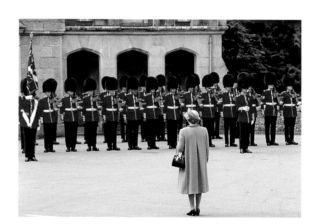

ABOVE: *Dog memorials also feature at Balmoral. The inscription here reads:*
NOBLE
For more than fifteen years the favourite collie and dear and faithful companion of Queen Victoria Died at Balmoral 18th September 1887 aged sixteen and a half years 'Noble by name, by nature noble, too. Faithful companion, sympathetic, true.' His remains are interred here.

OPPOSITE: *Holyroodhouse is actually a palace – one of the most ancient in the kingdom – and has the royal arms of Scotland above the main entrance. The Queen is in residence here for two weeks in July with members of her family and the Royal Household. From time to time she hosts visits here for distinguished foreign visitors.*

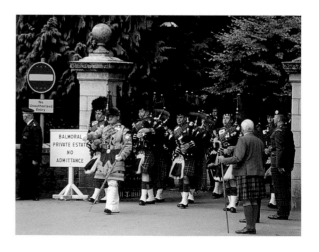

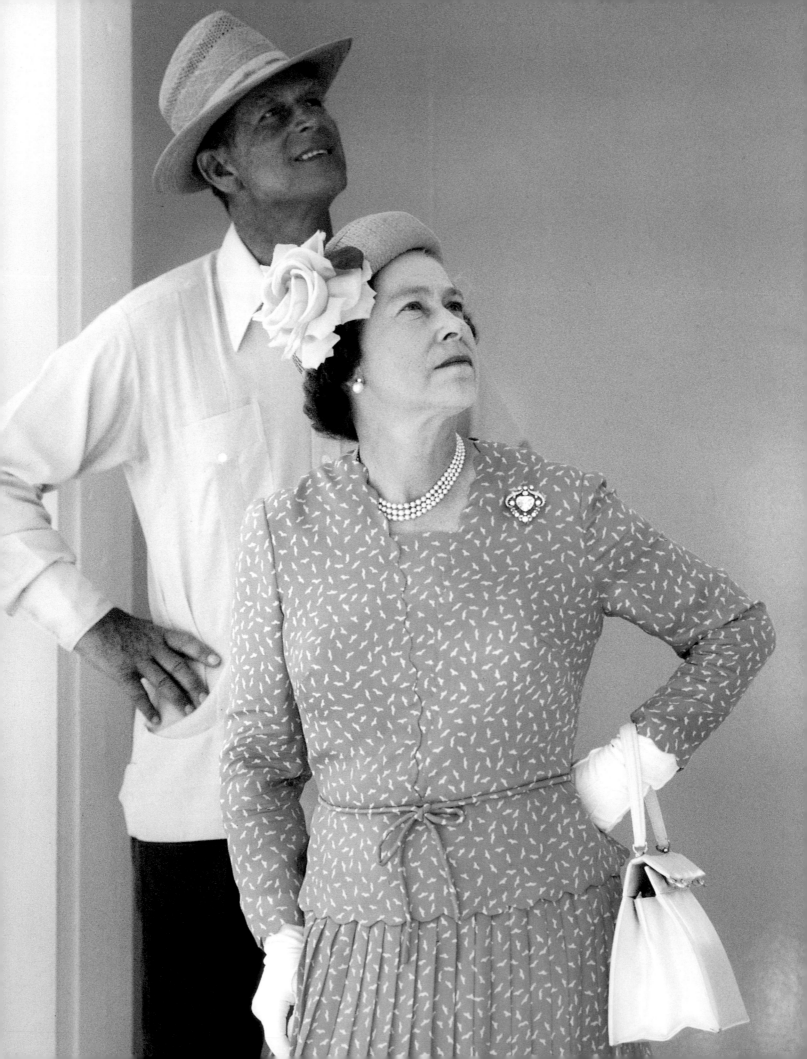

5

This final section shows some of the Queen's many visits to Commonwealth countries, explores the Royal Mews to find out how her transport is arranged, and reveals how businesses are appointed to supply the Royal Household. It also describes the people she works with most closely and how she spends her time off duty.

I like the mood of this picture – a calm moment in Tuvalu on a hectic tour of the South Pacific in October 1982. The Queen and Prince Philip are watching a boy climb to the top of a palm tree and throw down coconuts for them to drink from.

The people of Tuvalu were really friendly. With time on our hands after the Queen had left on Britannia, *we strolled around the island and were invited by a villager in native dress to sit and share a coconut in his open-sided house. He talked about his way of life and we found out that he had been prime minister of Tuvalu at the time of the wedding of the Prince and Princess of Wales and had travelled all the way to St Paul's to represent his country at the ceremony.*

The Commonwealth

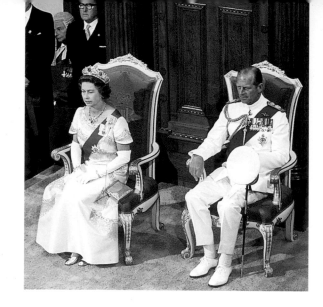

THE INDEPENDENT STATES that constitute the Commonwealth were once part of the British Empire, but it is not nostalgia for times past that unites them now. Representatives of these countries meet every two years to consult on economic, scientific, education, legal and military matters and try to coordinate policies.

The Commonwealth currently has 54 member countries, most of which are parliamentary democracies. The only conditions of membership are that they were once ruled or administered by Britain or other Commonwealth country and that they accept the British monarch as the symbolic head of the organization. This in no way compromises the wish of some countries to remain republics.

It was in 1926 that the Inter-Imperial Relations Committee laid down the formula for the Commonwealth, which was given legal weight in 1931 by the Statute of Westminster. The founder members were the UK and the-then dominions of Australia, Canada, the Irish Free State, Newfoundland, New Zealand and South Africa. Most subsequent members joined after the Second World War, and the membership has fluctuated

ever since. The Irish Free State left the Commonwealth in 1949 when it became a republic, and several countries, including India, Pakistan, Fiji and South Africa, have joined and left more than once.

Commonwealth heads of government meet every two years, reaching decisions by consensus rather than voting. The Queen may be consulted and advise or warn, but in no way does she rule the Commonwealth. She usually speaks on the advice of the prime minister, but her Christmas and Commonwealth Day messages are, uniquely, all her own.

The Commonwealth has been described as a 'family of nations'. In a spirit of brotherhood, members seek to help each other overcome problems such as famine, racism and illiteracy, and to encourage economic development by acting as a trading bloc. In the words of President Julius Nyerere of Tanzania, 'The Commonwealth is people meeting together, consulting, learning from each other, trying to persuade each other and sometimes cooperating with each other, regardless of economics or geography or ideology or religion or race.' The Queen, in her role as head of the Commonwealth, would undoubtedly agree.

ABOVE: *The Queen and Prince Philip at the State Opening of the New Zealand Parliament in Wellington during her Silver Jubilee year in 1977.*

OPPOSITE: *I'd never seen a 'tiara' like this before… The Queen had been presented with this headdress of stephanotis flowers and a necklace of mother-of-pearl at a South Sea Island feast in Tuvalu in 1982.*

BELOW LEFT: *Cyprus played host to the Commonwealth heads of government meeting in 1993, so the Queen became the first British monarch to visit the island since 1191. For the traditional group photograph on the Royal Yacht before dinner the Queen squeezed between the President of Gambia and the President of Cyprus.*

The most difficult thing with any large group photograph is getting everyone to look at the camera at the same time. Photographers use all sorts of tricks for this – whistles, football rattles, bad jokes, arm waving and the like. In this situation it would be a brave man who used any such devices.

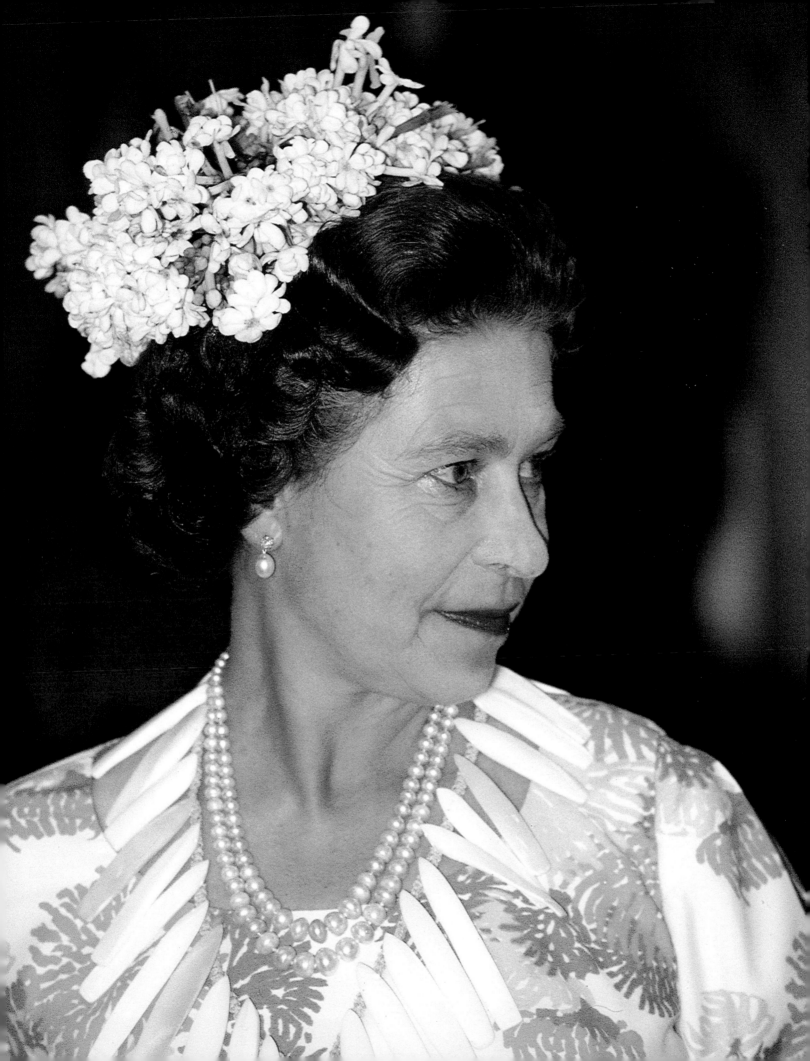

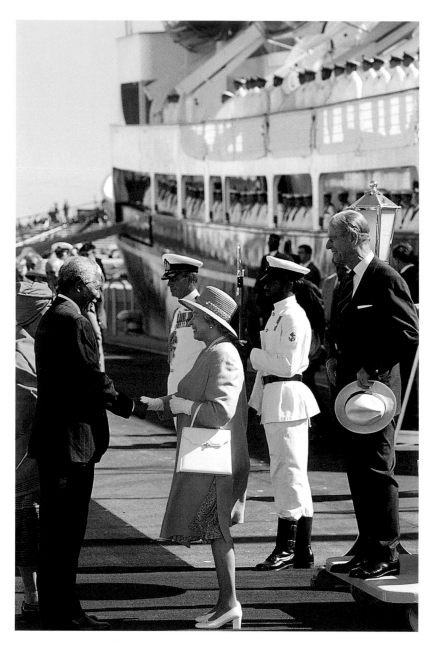

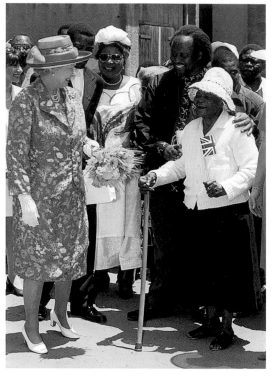

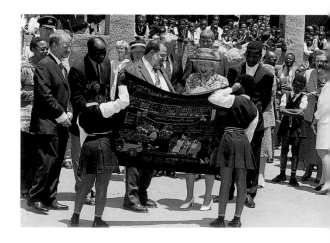

ABOVE: *Nelson Mandela, President of South Africa's first multiracial democratic government, greets the Queen on her arrival in 1995. The Queen was moved to declare, 'It's a miracle… Through turmoil and tragedy your nation has become a shining example to the world.' Later that day she presented the President with the Order of Merit – one of the highest decorations within her gift.*

TOP RIGHT: *In 1999 the Queen was back, this time in Johannesburg, where a warm welcome awaited her at the Alexandra Township, one of the poorest and most dangerous in South Africa. This elderly lady's wait was rewarded when the Queen stopped for a chat.*

CENTRE RIGHT: *I love this picture. It was taken at Skeen Primary School, and the pupils' faces lit up as they spotted the Queen.*

RIGHT: *The Queen was delighted when pupils of the school presented her with a work of art for her collection – an amusing scene depicting her visit.*

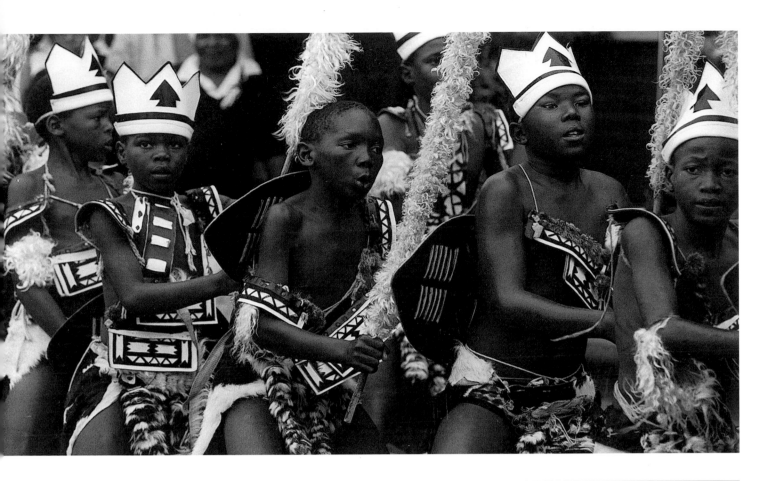

ABOVE: *Zulu 'warriors' in Durban greeted their royal visitor with an energetic dance. They were pupils of the Vukuzakhe High School and were delighted to be given time off their lessons.*

RIGHT: *Prince Philip, who accompanies the Queen on all her major tours, usually has interesting observations to make on everything they see.*

OVERLEAF: *On her last overseas visit of the 20th century, the Queen returned to Africa, where she had begun her reign almost 50 years earlier. After winding her way through the packed streets of Accra, capital of Ghana, she was escorted by President Jerry Rawlings (in yellow robes on her left) to the Durbar of Chiefs of Tribes gathered in her honour. The riot of colour, gold jewellery and huge parasols made a wonderful photograph.*

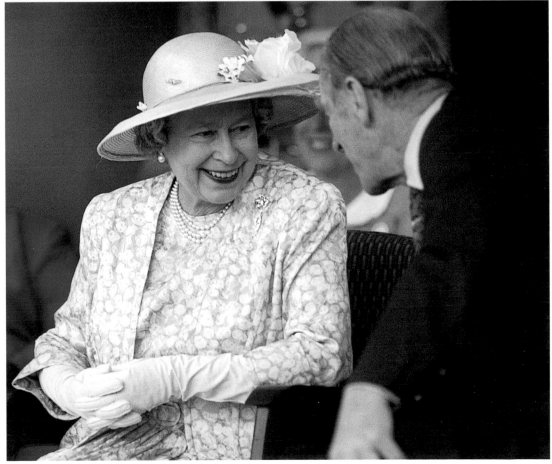

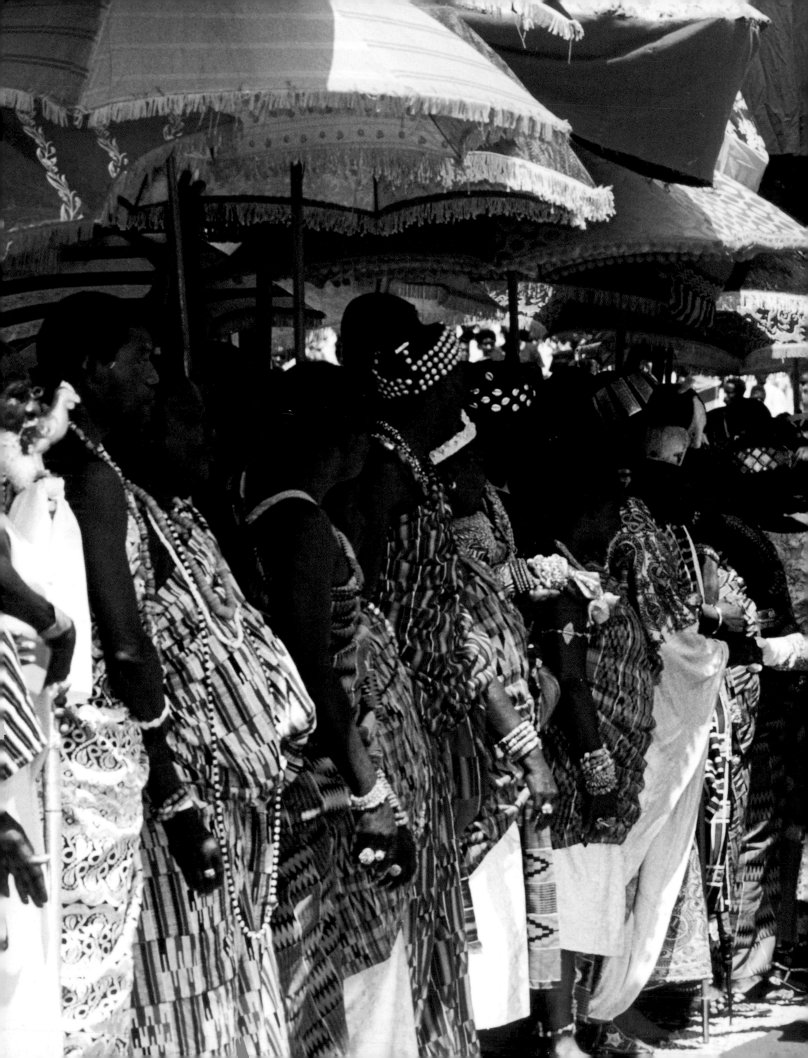

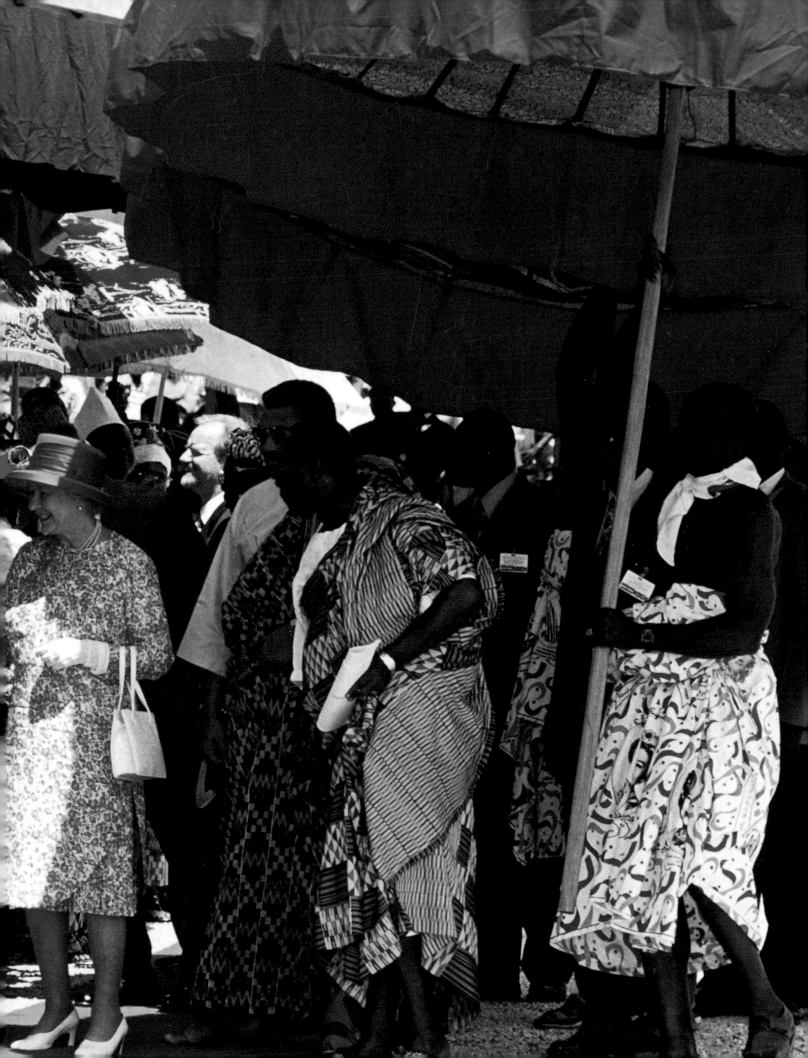

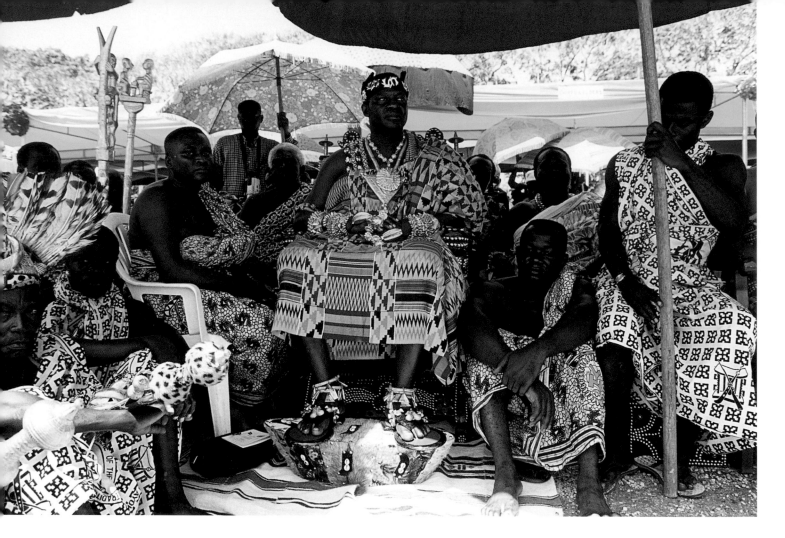

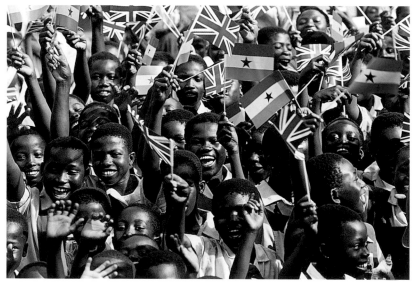

LEFT: *Crowds of cheering schoolchildren greeted our convoy as we pulled into the Wireless Cluster Junior School in Accra. There's never much time for photographers to get in the right position when a hectic tour schedule means leap-frogging the Queen's convoy to be in place to photograph her arrival at each venue.*

ABOVE: *Waiting for the Queen's arrival at the Durbar of Ghanaian Chiefs in Accra, a chief of the Ashanti tribe sits bedecked with solid gold jewellery around his neck, head, arms and ankles. Gold is a symbol of status and power among the Ashanti. Sometimes the bangles are so heavy that young helpers walk alongside the wearer, holding his arms to take some of the weight.*

RIGHT: *I like faces at a window – they are naturally framed and make interesting photographs. These young boys were patiently waiting for the Queen's arrival in Accra.*

RIGHT AND FAR RIGHT: *The Queen's visit to Treetops in Kenya in 1983 brought back poignant memories of her previous visit in February 1952. After enjoying the prime views of jungle and wild animals that Treetops afforded, Princess Elizabeth learnt of the death of her father, George VI.*

On this occasion my colleagues and I were guilty of putting the Queen at risk in the interests of a more memorable picture. For the Queen and Treetops to be in the same frame we persuaded her guide to lead her to the far side of the water-hole. There she was watched by a lone buffalo, which some months later had to be shot when it charged one of the staff.

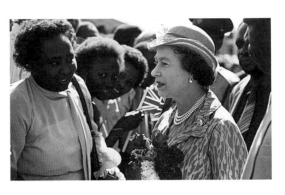

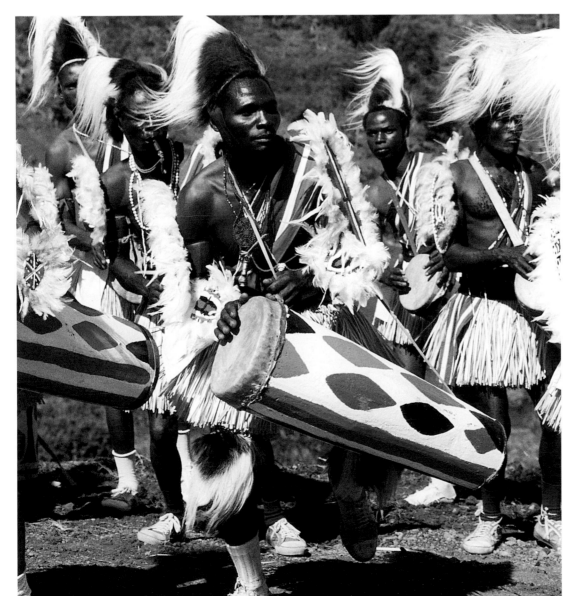

ABOVE: *Questions such as, 'Have you been waiting long?' or 'Do you come from around here?' tend to be repeated all over the world as the Queen spends just a few seconds talking to complete strangers. Here she chats to women in Nairobi, Kenya.*

ABOVE LEFT: *The entry in the Treetops visitors' book from 1952 reads: 'For the first time in the history of the world a young girl went up into a tree a Princess and, after having had what she described as one of her most thrilling experiences, came down from the tree a Queen.' With these words, Colonel Jim Corbett, her guide, recorded an important moment in history.*

LEFT: *Plimsolls – not quite traditional costume – are the only discordant note struck by these Kenyan drummers welcoming the Queen.*

305

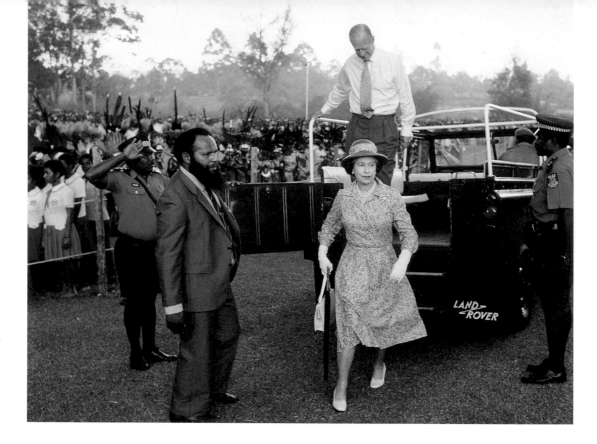

RIGHT: *Thunderous drums greeted the Queen and Prince Philip on their arrival at Mount Hagen in the highlands of Papua New Guinea for a 'sing sing' – a gathering of all the tribes.*

LEFT: *Pidgin is not one of the languages in which the Queen has any fluency, but she does know that Prince Philip is referred to as 'Him-bilong-Mrs-Kwin'.*

ABOVE: *'Rainmaker' was added to the Queen's impressive list of titles on this trip when, just as she started her speech, the heavens opened, breaking a four-month drought. The downpour also made her audience disappear, as the tribesmen ran for the shelter of trees to protect the valuable bird of paradise feathers in their headdresses.*

OPPOSITE: *Such large gatherings of the tribes are extremely rare in Papua New Guinea, but people turned out in force to see the Queen. Many had taken days to walk to the gathering, and everyone spent hours painting their faces, oiling their bodies and putting on their best clothes – which in this case included bones, feathers, beads and headdresses.*

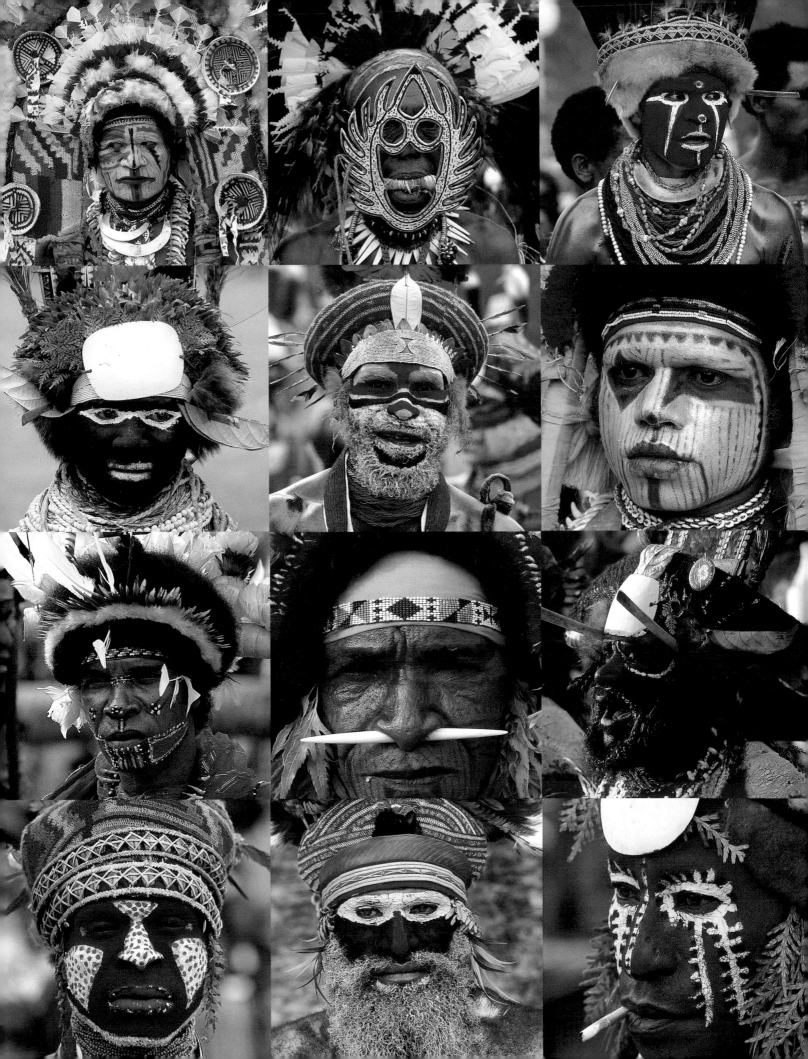

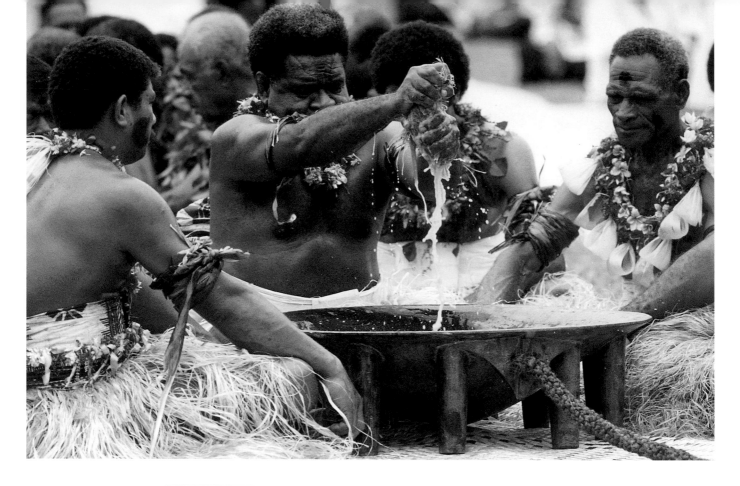

ABOVE AND RIGHT: *Fijian chiefs prepare* kava, *a gritty liquor infused from the peppery root of the kava plant. Ritual drinking always opens the conference of chiefs, and this was to be the first opened by the Queen.*

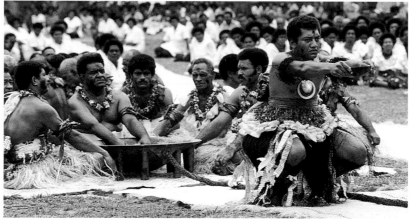

OPPOSITE, TOP LEFT: *In Kiribati (pronounced Kiri-bas) the Queen was served a coconut 'cocktail' called* moimoto, *while in Nauru (centre right) she enjoyed some tea in a bone china cup. She was glad of this pick-me-up after a difficult landing in the rough seas that surround this remote and rocky island on the Equator.*

RIGHT: *The first cup, which must be drunk in one brave gulp, is for the Queen, as the most senior chief present. Not too long ago the traditional method of preparing this drink required male and female virgins to chew the root before spitting it into a bowl of water to infuse.*

OPPOSITE: *In honoured chief tradition, the Queen is rowed ashore to Tuvalu in a dug-out canoe. Prince Philip was similarly perched in a separate canoe behind her. As they reached the beach, the oarsmen leapt out and lifted the canoes on to their shoulders for a triumphal procession into town with dancing girls leading the way.*

LEFT: *On this tour of the South Pacific the Queen grew used to the taste of coconut milk, but here in Tuvalu she is drinking from a very special coconut, freshly picked from a tree planted by her son, the Prince of Wales.*

OVERLEAF: *As she passed me, the Queen grinned down and confided, 'I hadn't realized how high it would be.'*

I had undertaken the long trip across the world almost entirely with this picture in mind, but everything depended on the weather. If it had rained, a launch would have brought the Queen ashore from Britannia *and this remarkable picture would not exist.*

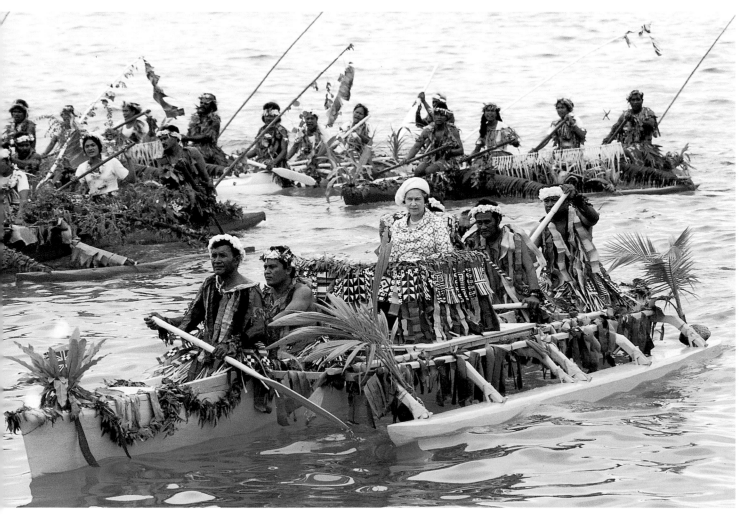

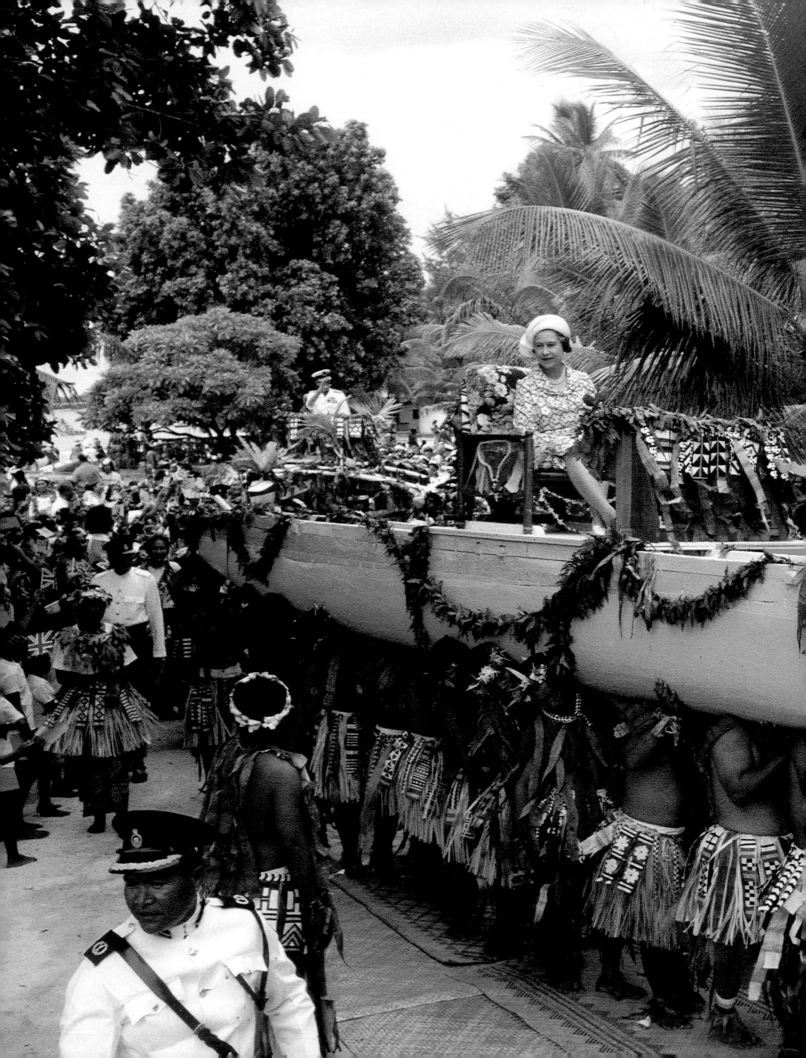

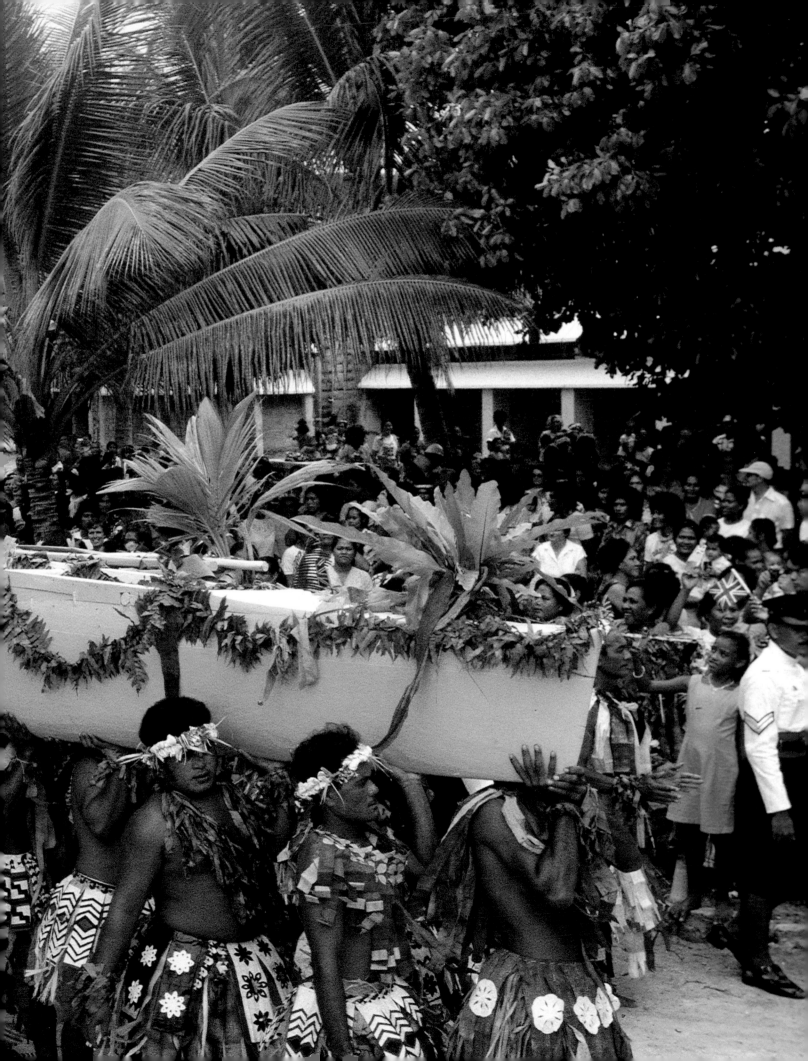

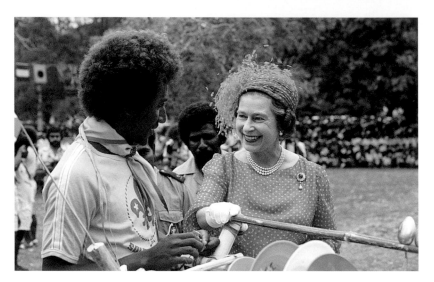

ABOVE AND TOP RIGHT: *With some of them knee deep in the ocean, the people of Honiara, capital of the Solomon Islands, turned out in huge numbers to see the Queen arrive on* Britannia *in October 1982. The Royal Barge brought her into the shallow port to a uniquely Pacific greeting – a fanfare of conch shells.*

LEFT: *The Queen, as patron of the Scout Association, discusses the finer points of washing up with one of its members.*

BELOW: *With their host giggling behind his hand, the Queen and Prince Philip laughed too as girls in grass skirts swung their hips in front of them. It was the first time that Tuvalu had had the opportunity of welcoming its head of state, and there was no holding back.*

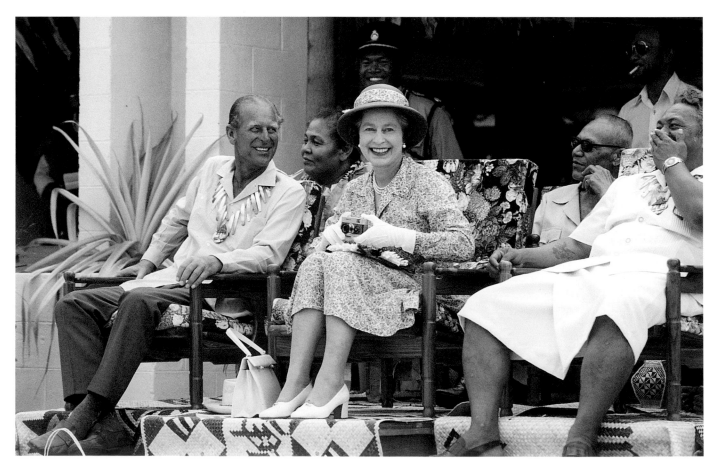

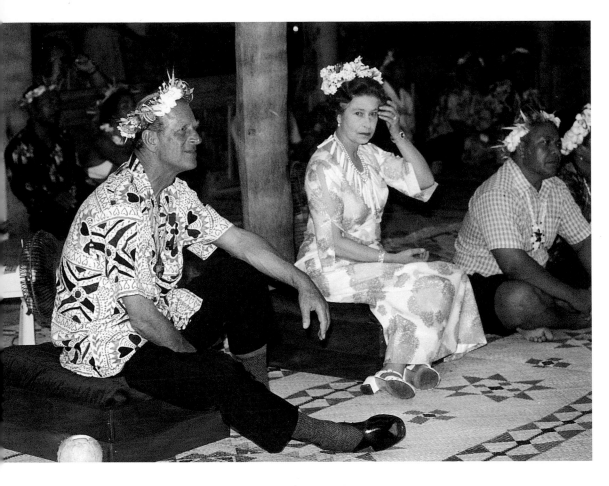

LEFT: *At the feast given in her honour, the Queen was crowned with stephanotis. Native singers and dancers entertained the guests as they dined on roast pig and tropical fruits eaten from palm-leaf platters. The press, too, were invited to the banquet, where one of the more interesting delicacies took us a while to identify. It was barbecued bat – not hugely filling.*

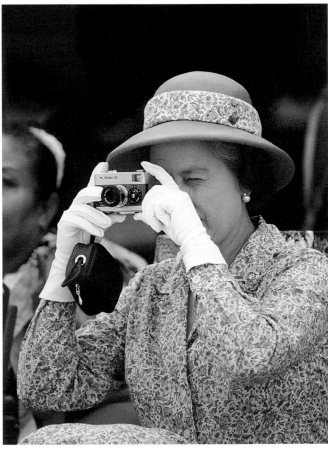

LEFT: *Taking photos for the album back home. The South Pacific tour offered many colourful sights and memorable experiences for everyone who went on this tour.*

ABOVE: *Nauruan islanders watch the Royal Yacht* Britannia *sail away, framed by a gantry that is normally busy loading tons of phosphate for export. This single product, which has made the tiny island immensely rich, derives from massive deposits of guano left by centuries of nesting birds.*

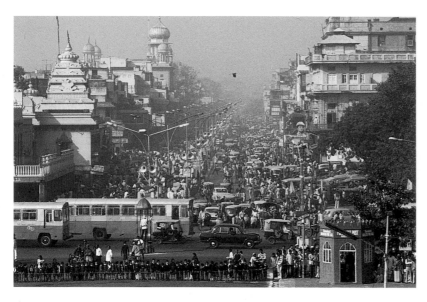

I've been to India many times on royal visits. It's a country I love: the sounds, sights and scents are like nowhere else in the world.

ABOVE: *A typical crowded street scene with a little bit of order in the foreground as schoolchildren start to line the Queen's route to Rashtrapati Bhavan, the Presidential Palace in Delhi.*

TOP RIGHT: *The Queen inspects a guard of honour before meeting Indira Gandhi in November 1983. Two guards were to assassinate Mrs Gandhi less than a year later.*

RIGHT: *Before laying a wreath at the memorial to Mahatma Gandhi, the Queen is helped to remove her shoes. I'm not sure whose idea the in-flight socks were.*

CENTRE RIGHT: *Normally I would be in the throng of photographers waiting for the Queen's arrival, but on this occasion in Delhi, having travelled on the Royal Flight, I ended up behind her. This picture was shot from the top of the aircraft steps.*

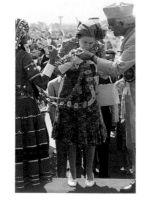

LEFT: *In Hyderabad the Queen smells the distinctive scent of sandalwood in a garland of delicately carved flowers.*

RIGHT: *Preparing for her speech at the state banquet at Rashtrapati Bhavan. A second microphone in case the first one fails is a typical element in royal planning.*

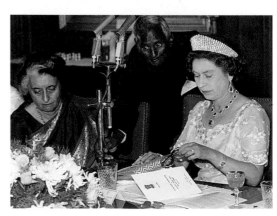

LEFT: *The Queen in a bus –
well, minibus – in torrential
rain in Sri Lanka. The open
window gave me my only
chance for a clear shot as the
bus passed.*

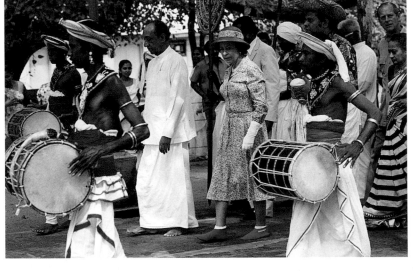

ABOVE: *It is the warmth of
the welcome that is so
apparent when, as Head of
the Commonwealth, the Queen
visits one of the member
countries. Here in Kandy, Sri
Lanka, in 1981 the streets
were packed with those want-
ing to catch a glimpse of her.*

RIGHT: *Meeting women and
their babies while visiting a
Save the Children Fund
hospital in Dacca,
Bangladesh. The Queen is
patron of the charity, and her
daughter, the Princess Royal,
is its president.*

ABOVE: *A visit to the Sacred
Bo Tree in Sri Lanka called
for shoes to be removed.
Wearing airline socks again,
and to the beat of drums, the
Queen walked with President
Jayawardene to this holy and
historic site.*

LEFT: *Mineral water is among
the drinks served to the Queen
at a banquet in Sri Lanka.
Malvern mineral water, in a
customized leather case, is
packed for all the Queen's
travels.*

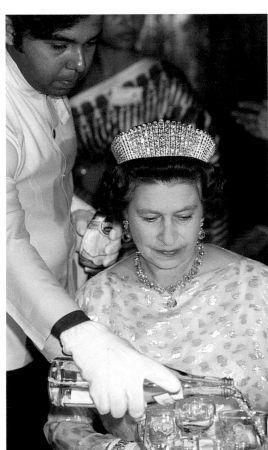

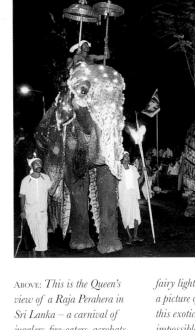

ABOVE: *This is the Queen's
view of a Raja Perahera in
Sri Lanka – a carnival of
jugglers, fire-eaters, acrobats
and elephants decorated with*
*fairy lights. I really wanted
a picture of the Queen with
this exotic scene, but that was
impossible as she was high
up in a royal box.*

RIGHT: *Dancers in the town of Bhaktapur, where the Queen went sightseeing during her visit to Nepal in March 1986.*

ABOVE: *A young girl watches the Queen's arrival from her ornately carved window.*

LEFT: *Waiters in the royal palace in Nepal await the arrival of the Queen and her entourage for a formal luncheon.*

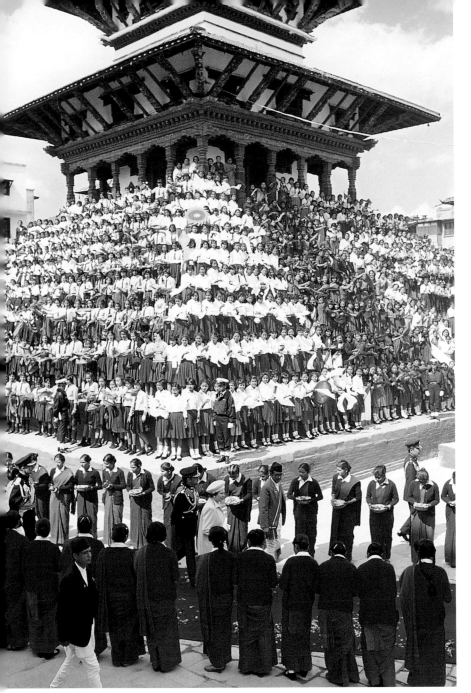

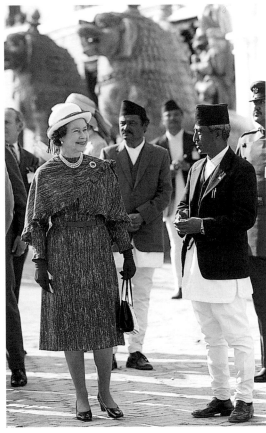

ABOVE: *When visiting the Kasthamandap Temple in Kathmandu, Nepal, the Queen walked with King Birendra on a red carpet strewn with flower petals.*

TOP RIGHT: *The 9th-century city of Bhaktapur is full of exquisite wood carvings, which the Queen evidently enjoyed seeing. I love Nepal. Apart from being a fascinating country, the sky is always blue, the air clear, and the light wonderful for photography.*

ABOVE: *The Queen and Prince Philip with King Birendra and Queen Aishwarya at the state banquet at Narayanhity Royal Palace in Kathmandu. It's hard to imagine the tranquil palace as a scene of carnage following the massacre of the Nepalese royal family 14 years later.*

LEFT: *A formal bow for the Queen as she leaves the Prime Minister's residence in Kathmandu.*

RIGHT: *In a break with royal tradition, the Queen agrees to sign a football for a Manchester United fan inside the Petronas Twin Towers Building in Malaysia in September 1998.*

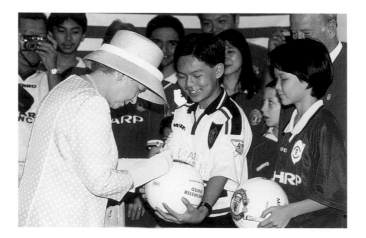

BELOW: *The Queen with the recently crowned Agong of Malaysia in the royal palace in Kuala Kangsar in October 1989. The Queen had presented the Agong with signed photographs of herself and Prince Philip in monogrammed silver frames (bottom right). I was pleased to see that they were pictures I had taken of them in Windsor Castle two years earlier.*

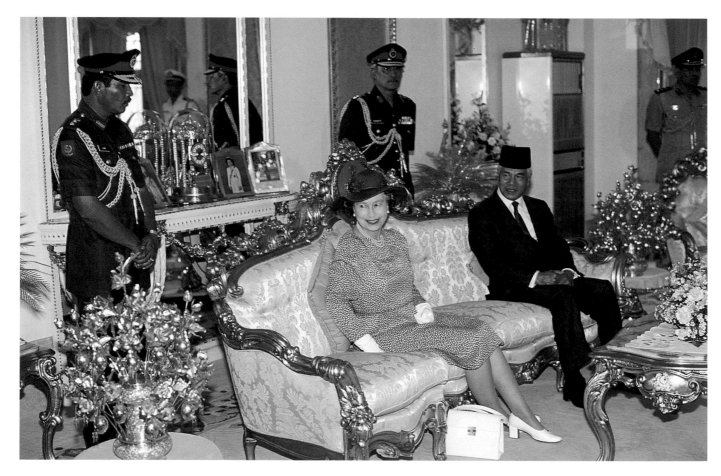

RIGHT: *On her arrival at the 1770-room Nurul Iman Palace in September 1998, the Queen was escorted by the Sultan of Brunei along a yellow carpet – the colour for royalty in that part of the world. The Sultan – one of the world's richest men – is an Anglophile, having done his military training at Sandhurst.*

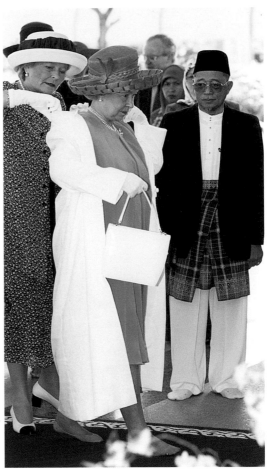

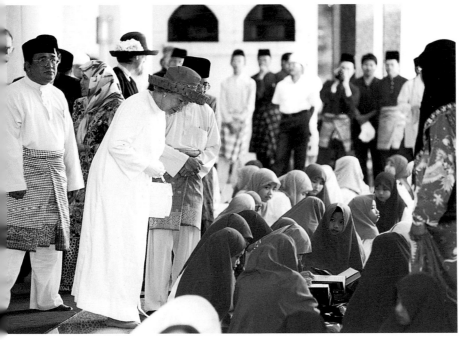

TOP LEFT: *The Jame 'Asr Hassanal Bolkiah Mosque in Brunei.*

LEFT: *As the Queen visited the mosque on a Friday, the Muslim sabbath, she saw young girls learning passages from the Koran.*

ABOVE: *The Queen, barefoot, is helped into a long white robe by her lady-in-waiting for her visit to the mosque.*

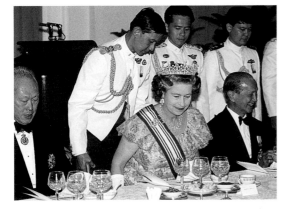

LEFT: *Helped into her seat at a state banquet in Singapore in October 1989, the Queen is seated between President Wee Kim Wee and Prime Minister Lee Kuan Yew.*

RIGHT: *The exotic delights on the banquet menu include Shark's Fin with Three Treasures and Chinese Pancake with Mashed Lotus Seeds.*

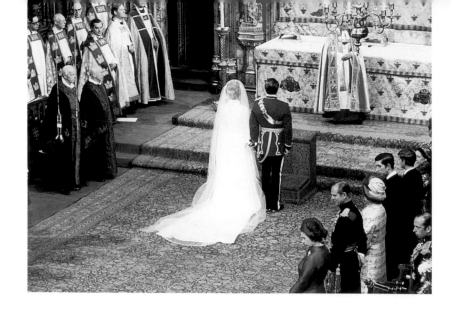

Family Weddings

EVERYONE LOVES A WEDDING, and the bigger it is, the greater the rejoicing. Since the advent of television, they don't come any bigger than royal weddings, and organizing these occasions takes an enormous amount of preparation.

As head of the Royal Household, the Lord Chamberlain is responsible for arranging royal weddings, and usually has about six months in which to do so. He coordinates the activities of all those involved, from the Archbishop of Canterbury to the cooks and coach-drivers, times every element of the ceremonial, oversees security and checks the million other details that any wedding involves.

Westminster Abbey is today inextricably linked in the public mind with royal weddings, but before 1919 none had been held there for the previous 650 years. Nowadays, it is unusual for a royal wedding not to take place in the abbey, but there are exceptions, usually to do with maximizing the number of people who can see the procession.

Inevitably, royals do some things differently from commoners. Royal bridegrooms, for example, have a supporter rather than a best man, the ceremony takes place in the morning, and this is followed by a wedding breakfast, which is actually eaten at lunchtime. For all the differences, however, the weddings remain essentially the same as everyone else's – joyous occasions on which people celebrate the happiness of the bride and groom.

The first close family member to marry during the Queen's reign was Princess Margaret, who had caused something of a rumpus during the 1950s by falling for Captain Peter Townsend, a divorced man. Abandoning that match in favour of someone less controversial, she married Antony Armstrong-Jones, a photographer, in May 1960.

When Princess Anne, the Queen's only daughter, married in November 1973, she was the first of her generation of royals to do so, and there was huge interest in the event. Children were given the day off school and there was endless speculation in the newspapers about her dress, the length of her veil, whether she would have a train, who would be her bridesmaids… Her second marriage, in December 1992, involved just a small private service in Crathie Church near Balmoral, and was a complete contrast in style.

Public interest in royal weddings reached an all-time high when the heir to the throne married in July 1981. Prince Charles's bride, Lady Diana Spencer, was barely out of her teens when the so-called 'fairy-tale' marriage took place, and her youth, innocence and prettiness soon ensured that the media elevated her to iconic status. An estimated

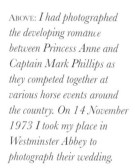

ABOVE: *I had photographed the developing romance between Princess Anne and Captain Mark Phillips as they competed together at various horse events around the country. On 14 November 1973 I took my place in Westminster Abbey to photograph their wedding.*

LEFT: *Union Jack hats and periscopes were much in evidence among the crowds gathered outside St Paul's Cathedral for the wedding of the heir to the throne and his 20-year-old bride. To make sure of a good view, people had to claim their spot the day before and stay all night.*

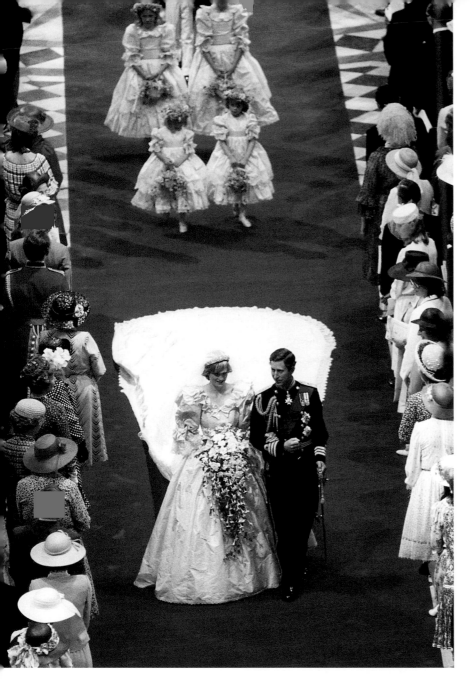

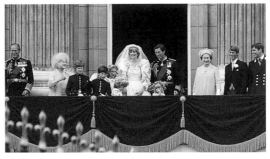

1000 million people worldwide reportedly watched the wedding on television, the largest audience ever recorded for any televised event.

Prince Andrew seemed to have found the perfect match in Sarah Ferguson, whom he married in July 1986. She was hearty and enjoyed the outdoor life, just as he did. This wedding, too, attracted great public interest, not least because the future Duchess of York appeared to be confident and outgoing, and was used to moving in royal circles, thanks to her father being polo manager to the Prince of Wales.

The world had to wait 13 years for the next royal wedding, and by that time the media circus was less frenetic. Prince Edward married Sophie Rhys-Jones in June 1999, and the occasion was deliberately low key. It took place in St George's Chapel, Windsor, and compared to previous weddings seemed a more intimate family occasion.

ABOVE: *I had only a few seconds to get a close-up shot and an overall view of the Prince and Princess of Wales, so I got some technical wizards to build a system that enabled me to fire three cameras with lenses of three different focal lengths at the same time. I also had special blimps (soundproofing bags) made so that the noise of the cameras couldn't be heard.*

RIGHT AND TOP RIGHT: *The new royal bride had begun to relax and enjoy herself by the time these pictures were taken back at Buckingham Palace.*

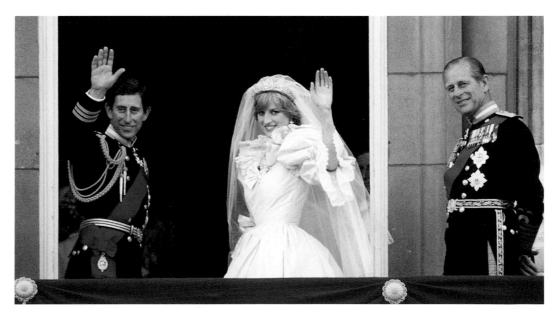

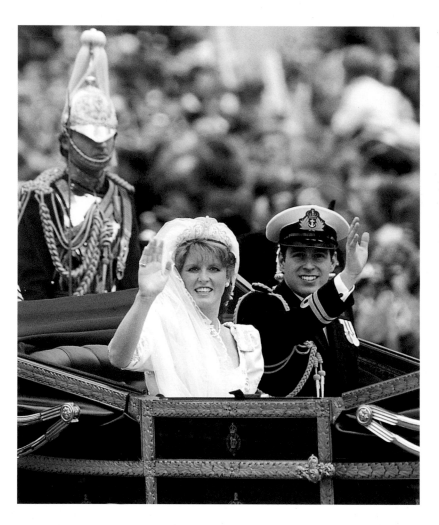

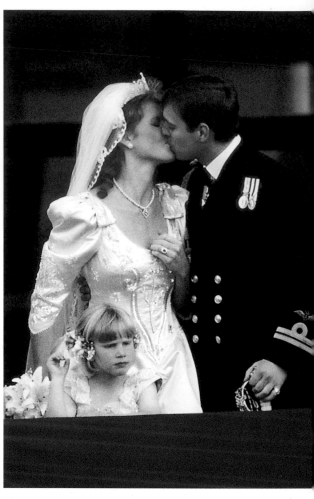

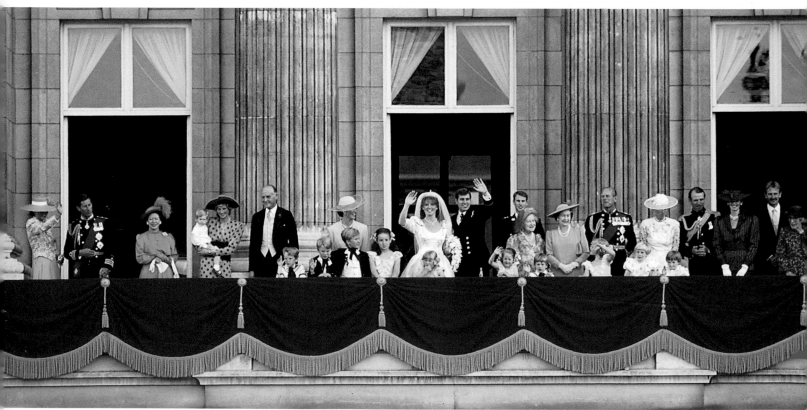

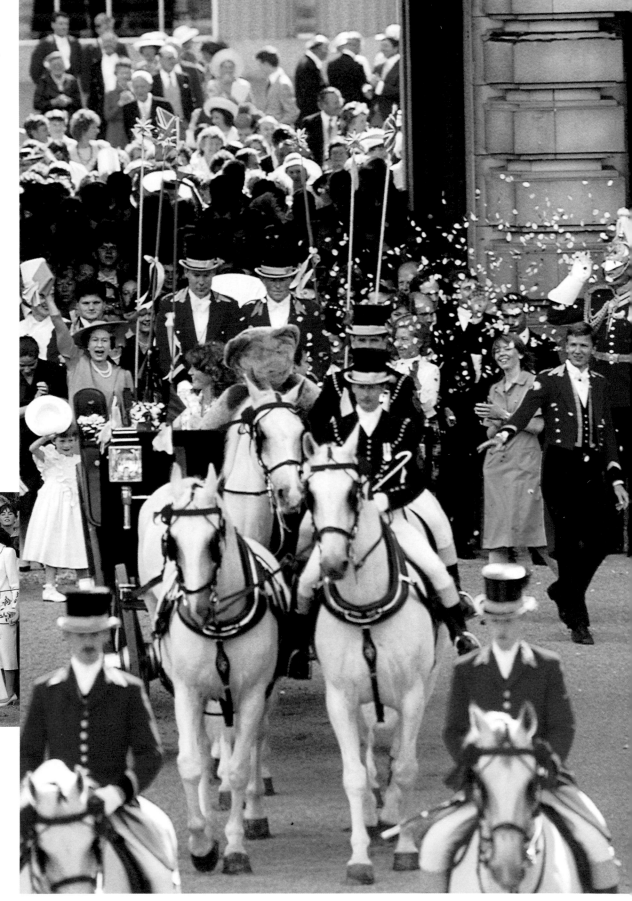

OPPOSITE: *I was particularly anxious to get good shots of the new Duke and Duchess of York as I was working on a book about their romance and wedding. In fact, the printing presses were literally waiting for the cover shot and the final chapter.*

As the royal carriage came alongside my position, the royal couple smiled and waved in unison. Fantastic! I had my cover picture and could relax for the rest of the day's coverage. When the couple appeared on the balcony, I knew they were likely to kiss, but when? I had to ration my shots with each camera so that I wouldn't miss the picture by changing film at the wrong moment.

RIGHT: *It was a real surprise when the Queen came outside to see the newlyweds off on honeymoon. It's not often you see her so animated.*

ABOVE: *As the couple drove off, the Queen put a protective arm around her grandson, Prince William. These moments of tenderness are very rare in front of the cameras.*

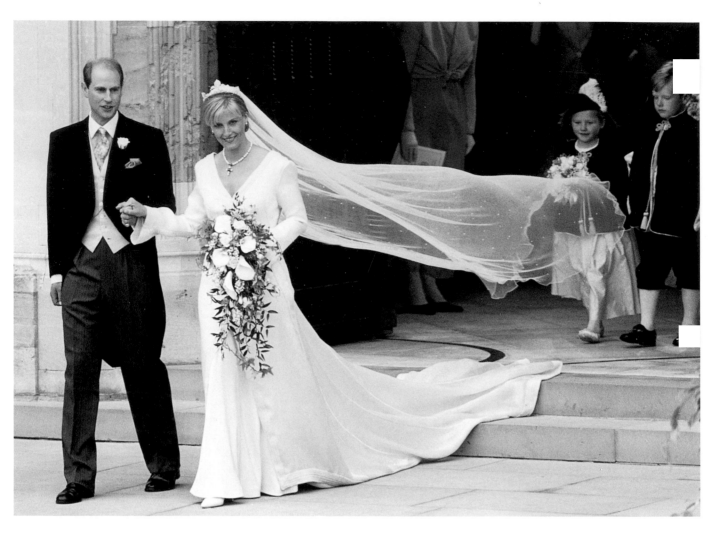

ABOVE: *My press pass directed me to a really hopeless position at Windsor Castle for the wedding of Prince Edward and Sophie Rhys-Jones. It wouldn't have given me a view of the newly married couple leaving St George's Chapel – one of the most important pictures of the day. Some colleagues and I talked our way into a kitchen that overlooked the main door of the chapel. We had to shoot through the window, so we quickly cleaned the glass and pressed our long lenses against it. Just as the bride appeared, a gust of wind raised her veil and turned it into a more interesting picture.*

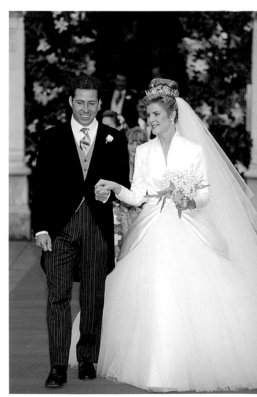

LIST OF INTENDED MARRIAGES

MARRIAGE (SCOTLAND) ACT 1977

M11(R)
581

Section 4(2) of the Marriage (Scotland) Act 1977 requires the district registrar to display a list of marriages for which he has received statutory notice. This list shows the names of the parties to intended marriages and the proposed date of the marriages.

Any person who claims that he may have reason to submit an objection to an intended marriage may inspect the entry relating to that marriage in the Marriage Notice Book which is held by the registrar.

Entry number in marriage notice book	Bridegroom's name	Bride's name	Proposed date of marriage
41	Timothy James Hamilton Lawrence	Anne Elizabeth Alice Louise	December 12th 1992.

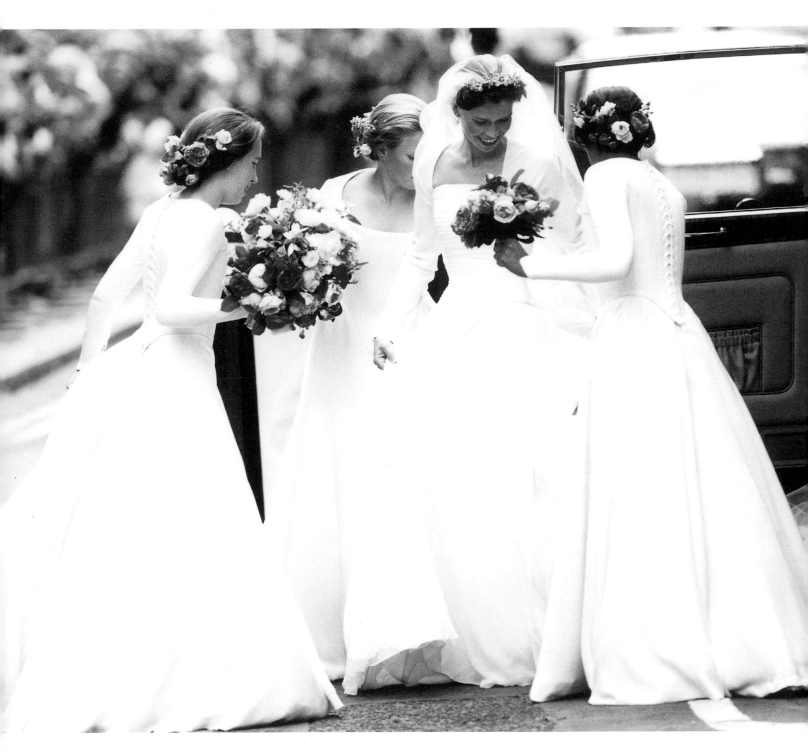

OPPOSITE, FAR LEFT: *The banns for Princess Anne's marriage to Commander Timothy Laurence. The wedding, in Crathie Church near Balmoral on 12 December 1992, made the princess the first British royal to divorce and remarry since King Henry VIII.*

OPPOSITE, NEAR LEFT: *Wearing a dress not dissimilar to that chosen by her mother-in-law in 1960, the Hon. Serena Stanhope married Viscount Linley, the Queen's nephew, at St Margaret's, Westminster, in October 1993.*

ABOVE: *I like the way this picture came together, with bridesmaids fussing around a very happy bride. Lady Sarah Armstrong-Jones was marrying Daniel Chatto at St Stephen Walbrook, a small Wren church in the City of London in July 1994. The wedding was attended by a full complement of royals, including the Queen.*

Getting About

OPPOSITE: *The Gold State Coach was last used for the Queen's Silver Jubilee in 1977. Its coachmen and postilions wear ornate livery.*

WHAT SPRINGS TO MIND when the words 'royal transport' are mentioned? Most people would think of luxury, and perhaps the Gold State Coach, which resembles something from a fairy story. Built in 1762, it is ornately carved and heavily gilded, and has been used at every coronation since that of George IV in 1821.

Other historic vehicles housed in the Royal Mews behind Buckingham Palace include the Irish State Coach, generally used for the State Opening of Parliament, the Scottish State Coach, used during the Queen's 60th birthday celebrations, and the Glass Coach, almost always used for royal weddings. All of them add immeasurably to the colour and atmosphere of state occasions.

The Mews are also home to the royal cars – outwardly duller than the coaches and carriages, but lacking no creature comfort inside. The motor fleet currently includes five Rolls-Royces and three Daimlers, which are used for state occasions.

The Royal Train has been a favourite method of transport with monarchs and their families since 1842. In a cost-saving exercise in early 2001, the number of carriages was reduced from 14 to nine, but the high level of comfort remains.

The Royal Yacht *Britannia* was decommissioned in 1997, a sad day for everyone in the Royal Family, as there had been many happy times spent on board. It had been an invaluable home away from home on long overseas tours, and a wonderful location for the Queen to reciprocate the hospitality she had received. Nowadays, a hotel or conference centre is the utilitarian replacement.

Flights are generally provided by 32 Squadron, a Royal Air Force unit based at RAF Northolt in Middlesex. The squadron currently has seven aircraft – two BAe 146 jets, which carry 19–23 passengers, and five HS125 jets, which carry seven passengers. All are specially fitted inside, but are comfortable rather than luxurious. Larger commercial aircraft tend to be chartered for major overseas state visits.

The Queen's Helicopter Flight operates from Blackbushe Aerodrome in Hampshire and has one Sikorsky S-76 helicopter. The Queen is known to dislike this method of travel, so uses it infrequently.

All these forms of travel may be used (with the Queen's permission) by members of the Royal Family, senior government ministers and visiting heads of state, so the cost of maintaining them is justified by the number of times they are used. In the Queen's working life, which averages about 100,000 miles a year, her various modes of transport offer security, efficiency and sometimes an appropriate level of ostentation.

TOP LEFT: *The Queen steps from her carriage in the Maifeld Stadium, Berlin, in May 1978. During the war years, the stadium had been the scene of Hitler's rallies.*

ABOVE AND BELOW: *Details of the box seat drape and harness used on the Glass Coach for royal weddings.*

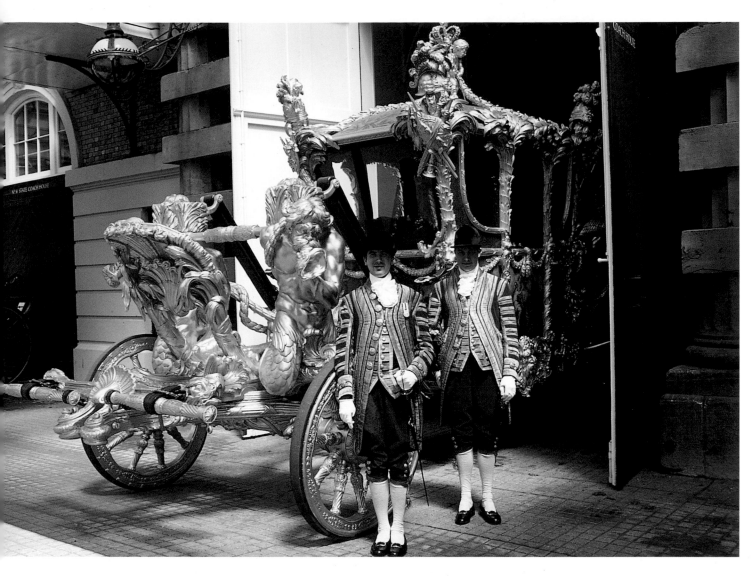

BELOW: *A door handle on the Gold State Coach.*

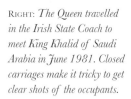

RIGHT: *The Queen travelled in the Irish State Coach to meet King Khalid of Saudi Arabia in June 1981. Closed carriages make it tricky to get clear shots of the occupants.*

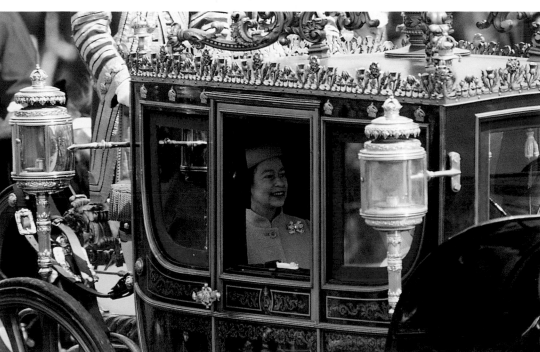

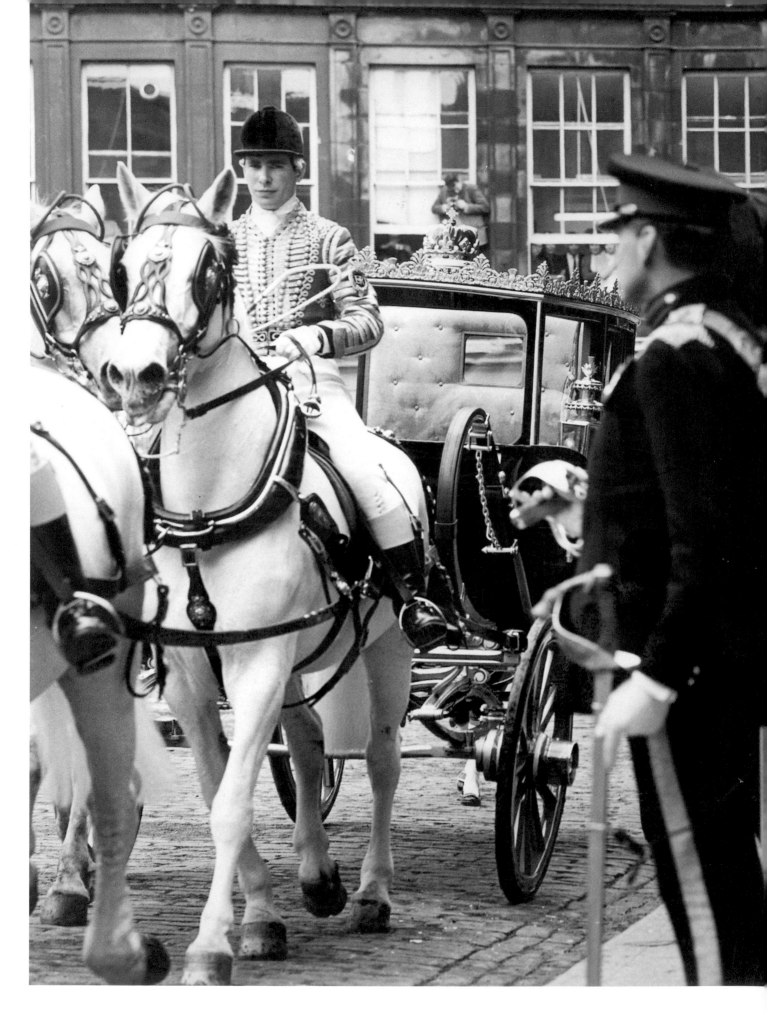

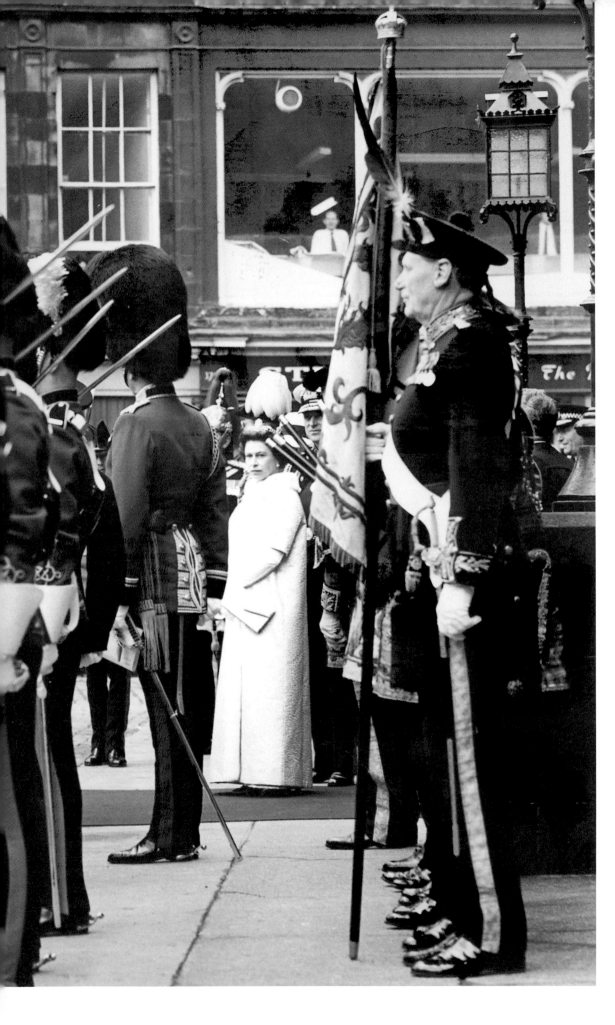

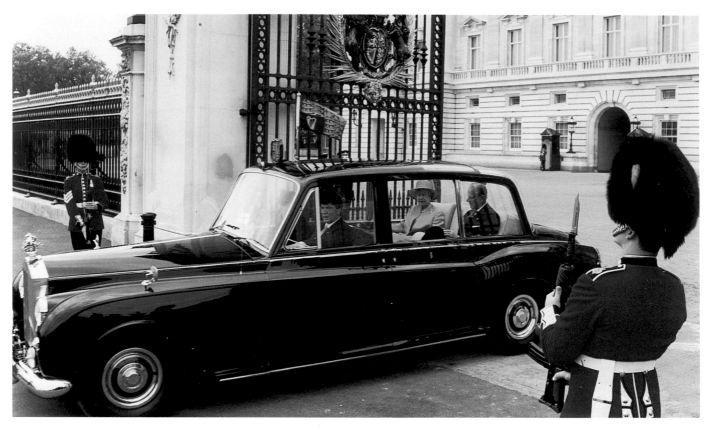

ABOVE: *The Queen's Phantom VI Rolls-Royce was a Silver Jubilee gift to her from the Society of Motor Manufacturers and Traders in 1978. On this occasion in May 1995 she was leaving Buckingham Palace on her way to meet the Amir of Kuwait, who was arriving in Britain for a state visit.*

King Edward VII was the first member of the Royal Family to purchase a 'horse-less carriage' – a Daimler. The seal of royal approval did much to make cars fashionable.

ABOVE: *The silver mascot used on the Queen's official cars was designed by Edward Seago. It depicts St George killing the dragon.*

LEFT: *It's a long way to the ground from such a big limousine. The Queen Mother's car has a step that slides forward to reduce the distance to the ground.*

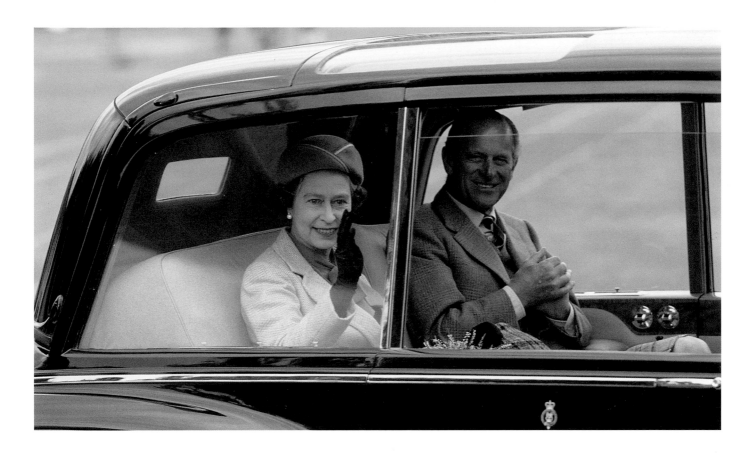

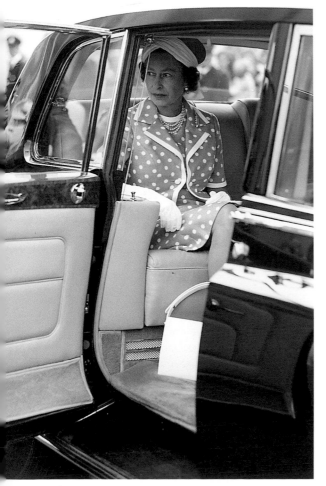

TOP: *The large windows of the official car give people a clear view of their monarch, here accompanied by Prince Philip in Scotland in 1982.*

ABOVE: *The Queen's car is the only one allowed on public roads without a number plate.*

LEFT: *It is not normally the Queen who waits, but she did on this occasion in New Zealand in the 1970s.*

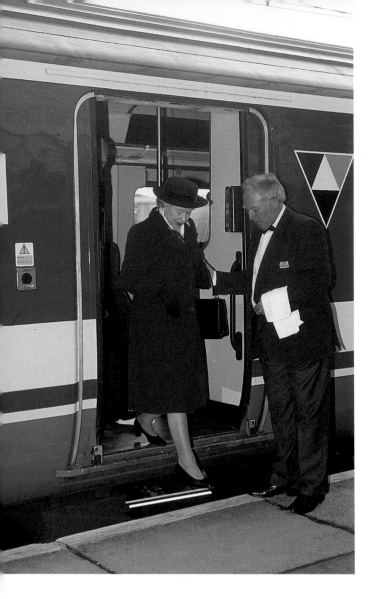

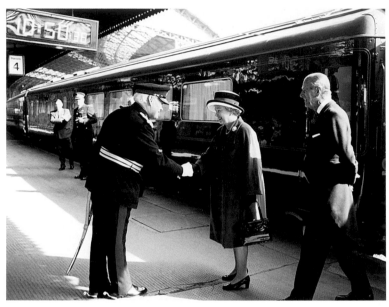

LEFT: *From time to time the Queen will catch a scheduled train. Here she gets a helping hand from the train steward on arrival at Cambridge station in March 1996.*

BELOW: *The Royal Train is the more usual form of transport for the Queen when she travels within the UK. The present Royal Train dates from 1986 and cost £7 million. The Queen has a personal saloon, dining room, bedroom and bathroom. The decor is pastel beige with paintings of steam engines on the walls.*

LEFT: *The Queen's essential mail follows her wherever she goes. This sack was delivered to the port of Heysham in Lancashire to meet the Royal Yacht.*

OPPOSITE: *With standard flying to indicate that the monarch is on board, HMY* Britannia *leaves Portsmouth at the start of her final Western Isles cruise in August 1997. A few months later, with over a million miles on the clock and 135 countries in its logbook, the Royal Yacht was decommissioned. Like many, I was sad to see it go. It had been such an ambassador for Britain and I had hugely enjoyed visiting the places its travels with the Queen had taken me.*

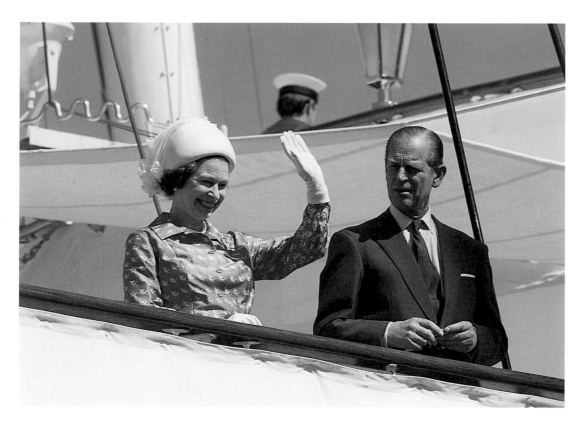

ABOVE: *The Queen's crest on the bow of the Royal Yacht – the only sign of its identity. Britannia was unique in being exempt from displaying its name.*

LEFT: *The Queen waves goodbye from the Royal Yacht on leaving Kuwait in 1979.*

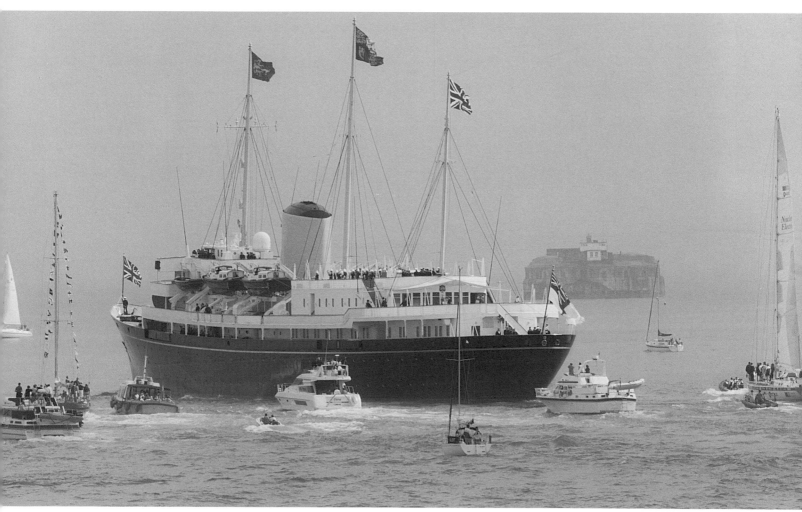

LEFT: *The rolled-up red carpet indicates the end of another royal visit as the Queen leaves Malaysia on a BAe 146 in October 1989.*

BELOW: *The insignia of the Queen's Flight.*

LEFT: *Security patrols as the Queen's luggage is loaded at Amman airport after her official visit to Jordan in March 1984. On some tours, particularly those in hot climates, the Queen changes her outfit two or three times a day.*

RIGHT: *The Queen is the most travelled monarch ever, having visited every corner of the world during her reign. Her arrival in China in 1986 (shown here) marked the fulfilment of a long-held ambition to visit that remarkable country.*

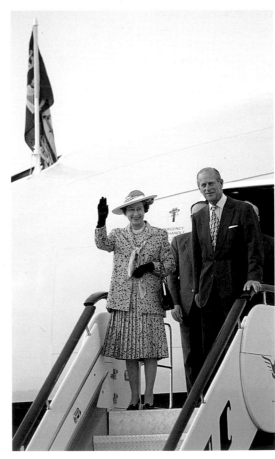

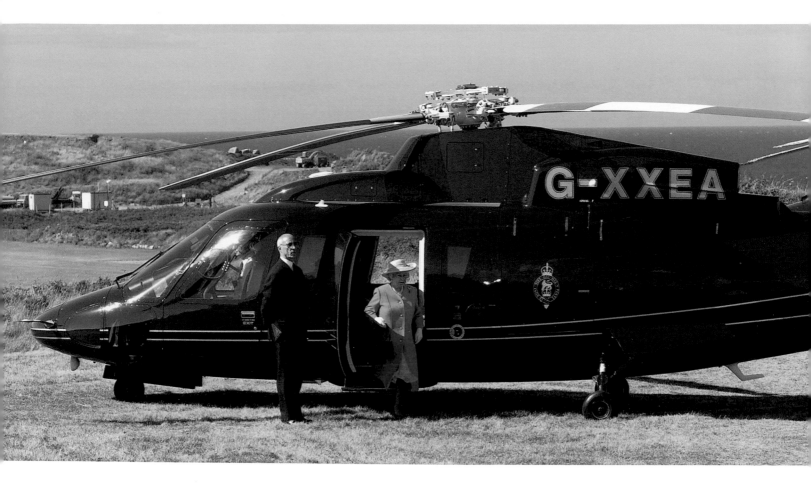

ABOVE: *Helicopters are not the Queen's favourite method of transport. They tend to be used only when security and timing demand. Here she is arriving on Guernsey in the summer of 2001 in the latest Royal Flight helicopter, a Sikorsky S-76.*

RIGHT: *The RAF refuelling a Wessex helicopter of the Queen's Flight in a field in Gloucestershire. Royal Flight helicopters always try to land as close as possible to the royal engagement venue, often setting down on farmland or playing fields, much to the delight of local school-children, who are given time off to witness the comings and goings.*

Royal Warrant Holders

SINCE THE EARLIEST DAYS of the monarchy, trades-men and women have provided the sovereign with goods and services, which can include anything from making a crown to supplying a pot of jam or shoeing a horse. Loyal service was first rewarded by Henry II in 1155 when he began granting Royal Charters to the trade guilds. During the 15th century, Royal Charters gave way to Royal Warrants of Appointment, and this form of recognition has been used ever since.

While Henry VIII appointed a tradesman to provide 'Swannes and Cranes and all kinds of Wildfoule' and Charles II had a 'Goffe-club maker', the Royal Household now appoints people to supply more modern needs, such as computer software systems, spark plugs and ready-mixed concrete. Some requirements, however, never change: there's always a need for a robe-maker, a goldsmith and a coach-builder.

These days tradesmen may apply to the Lord Chamberlain's office to become Royal Warrant Holders, but they must have supplied the house-hold of the Queen, the Duke of Edinburgh, the Queen Mother or the Prince of Wales with sub-stantial goods or services for at least five consecutive years. If successful, they are allowed to use the words 'By Appointment' and to display the arms of the Royal Household(s) they supply on their products, premises, delivery vehicles, stationery and advertisements.

Every year between 20 and 30 new applicants are granted warrants, and about the same number lose them. There are currently about 800 Royal Warrant Holders – almost exclusively British companies, apart from the sherry and champagne suppliers – and between them they hold over 1100 Royal Warrants (some serve more than one Royal Household, and a select few serve all four).

Like the institution they serve, Royal Warrant Holders are part of a noble tradition. They represent the highest standards of manufacture and service, and are a source of pride to Queen and country.

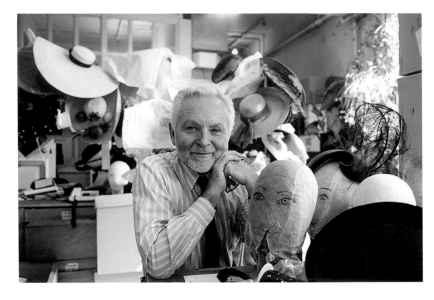

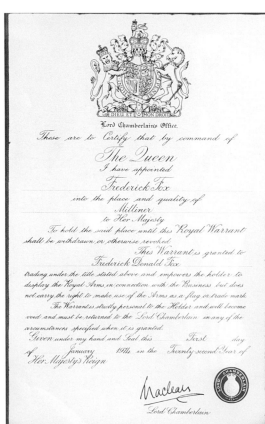

ABOVE: *Frederick Fox, shown here in his Mayfair salon, is one of the milliners who has been awarded a Royal Warrant by the Queen.*

LEFT: *The Royal Warrant issued by the Lord Chamberlain to Frederick Fox in 1974.*

OPPOSITE: *During his career, Sir Norman Hartnell produced hundreds of designs for the Queen, the most important being her wedding dress and her coronation robe. One of his freelance designers, Maureen Rose, later teamed up with tailor Peter Enrione, and both have now been awarded Royal Warrants in their own right. Along with milliner Marie O'Regan, they have produced many outfits for the Queen, including the peach ensemble worn in Rome (see page 117) and the unusual black lace suit for her visit to the Pope in 2000 (see page 115).*

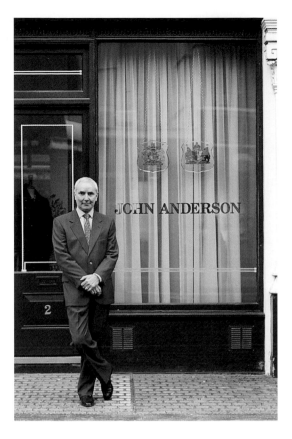

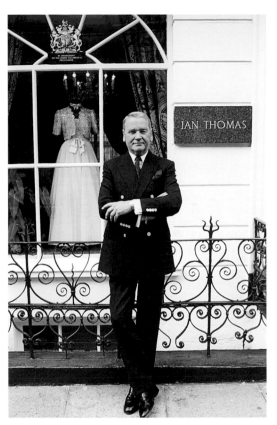

FAR LEFT: *The late John Anderson for many years designed day dresses and evening wear for the Queen. His former assistant Karl-Ludwig Rehse now holds a Royal Warrant himself.*

NEAR LEFT: *Until his death in 1993, Ian Thomas had designed many outfits for the Queen. As a young designer at Hartnell, he designed all the emblems of the Commonwealth that were incorporated into the Queen's coronation dress.*

BELOW: *Hardy Amies received many accolades for his work, culminating in a knighthood at the age of 80. Royal commissions at his couture house are now undertaken by the design director, Jon Moore.*

Grand and not-so-grand suppliers to the Royal Household are proud to display their warrants.

BELOW: *In the town of Ballater, close to the Balmoral estate, many of the local shops display the crest that shows they are favoured by the Royal Family. The chemist, the supplier of fishing tackle and the gunsmith are among them.*

LEFT: *The long-established firm of Hatchards has held its Royal Warrant as bookseller for many years. This branch is situated in Piccadilly, conveniently close to Buckingham Palace.*

BELOW: *The Royal Warrant at Lobb in St James's Street states 'By Appointment to Her Majesty Queen Elizabeth II Bootmaker'.*

RIGHT: *In Knightsbridge the Royal Warrant hangs above the doorway of Rigby & Peller. The lingerie in the window reveals the company's role as corsetier to the Queen.*

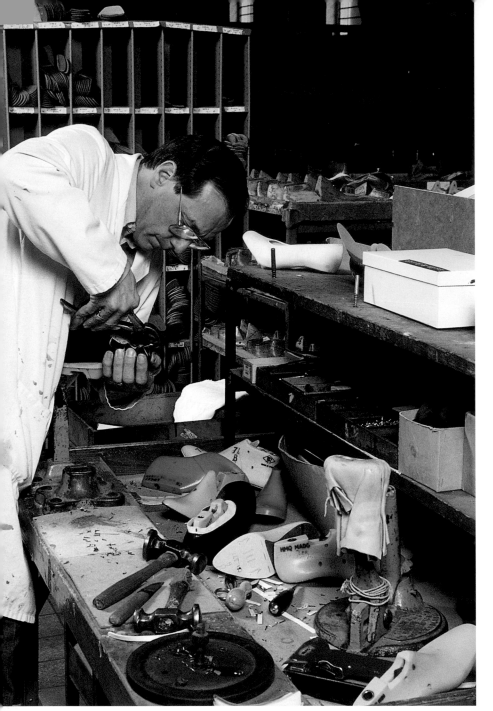

LEFT: *Lasts of the Queen's feet, originally created by H. & M. Rayne, are still in use many years later at Anello & Davide, where David Hyatt produces many of the classic designs that have become the Queen's 'trademark'. Styles with names such as 'Aretha', 'Bari' and 'Condessa' are among those favoured by the Queen.*

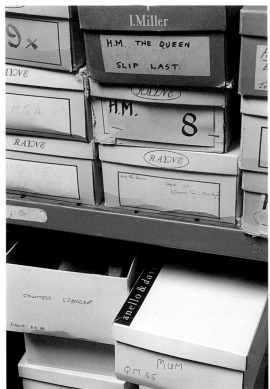

LEFT AND RIGHT: *Although her clothes designers have tried to persuade the Queen into more adventurously coloured accessories to coordinate with their outfits, she usually prefers to stay with traditional black or white.*

LEFT: *The Queen always wears gloves for her public engagements. If you think of the number of hands she has to shake on each visit, you can understand why. She has dozens of mainly black and white pairs, chosen from the 250 styles made by the firm of Cornelia James in Brighton.*

RIGHT AND BELOW: *The Queen makes use of the very best English craftsmen for her leather goods. Here Barry Cummins, benchworker at Launer, is finishing a new handbag in the style favoured by the Queen.*

The Team

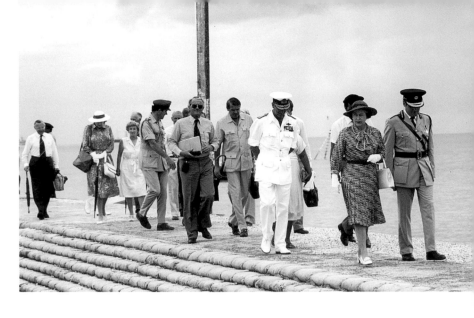

IT'S TOUGH AT THE TOP, as the Queen knows only too well, but her trusted inner circle help her to shoulder the burden and keep the wheels of the monarchy running smoothly.

The most important person in this respect is her Private Secretary. He is the Queen's closest aide, and must fulfil his role of liaising between government and monarch while remaining politically neutral. His loyalty is to the Queen, who is also strictly non-partisan. His other responsibilities include dealing with the London-based Secretariat of the Commonwealth, handling all official correspondence addressed to the Queen and accompanying her on overseas visits. For all these tasks, discretion, sound judgement and diplomacy are vital. He is in daily contact with the Queen and to a large extent acts as her eyes and ears in political matters.

The next most important role within the palace is that of the Press Secretary, a role that has existed since the reign of George III, when the job title was Court Newsman. The Press Secretary and the press office staff deal with all the media coverage about the Royal Family, handling huge numbers of queries every day of the week from journalists, authors and film-makers. Press officers share responsibility for different members of the Royal Family and liaise with the appropriate Private Secretary about anything that brings their particular royals into the public gaze. The Press Secretary also accompanies the Queen on all overseas tours, liaising in advance with local and international media and ensuring that everything on the ground runs smoothly.

Other important members of the inner circle are the Queen's ladies-in-waiting, who could be

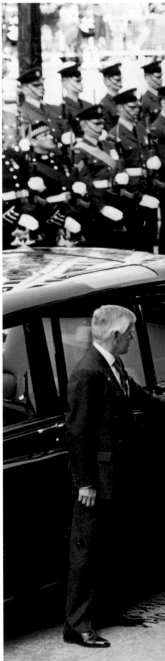

described as her closest companions. Working a rota system of two weeks on, four weeks off, they accompany her whenever she goes out in public, help with official entertaining and deal with correspondence, often from children. Always a few steps behind the Queen, they can be seen carrying the flowers she is given by well-wishers, holding her handbag or providing money for sudden purchases, as the monarch by tradition never carries cash. They also undertake some of her personal shopping. All these appointments are by invitation only, the ladies being drawn from wealthy backgrounds because, apart from receiving travel costs and expenses, their royal duties are unpaid.

The security of the Queen and the Royal Family is always of paramount concern, and is the responsibility of the Royalty and Diplomatic Protection Department, a subdivision of the Metropolitan Police. All the officers attached to the department are volunteers: those who work as personal protection officers accompany their designated member of the Royal Family on public engagements. As these can range from opening a school in suburban England to climbing a mountain in Africa or visiting a hut in the South Seas, the bodyguards must be fit and adaptable. Their brief is to be alert and close by but never obtrusive – more James Bond than Arnold Schwarzenegger – so they have a wardrobe of clothes designed to cover every occasion. That man in a DJ accompanying the Queen to a film premiere, or wearing tropical whites as he follows her around Samoa, is her discreet and highly trained protector – one of her invaluable team of helpers who tries to make life on the royal round a little easier.

OPPOSITE: *Senior members of the Queen's household always accompany her on overseas tours. Here they are coming ashore from the Royal Yacht in Kiribati in October 1982.*

RIGHT: *The whole entourage dress appropriately for every visit, including this one to the Vatican, which demanded that they wear black or uniform.*

BELOW: *The Queen keeps her staff close. On this visit to St Paul's Cathedral in May 1995 she was accompanied by her personal protection officers, her private secretary, her equerry, and her lady-in-waiting.*

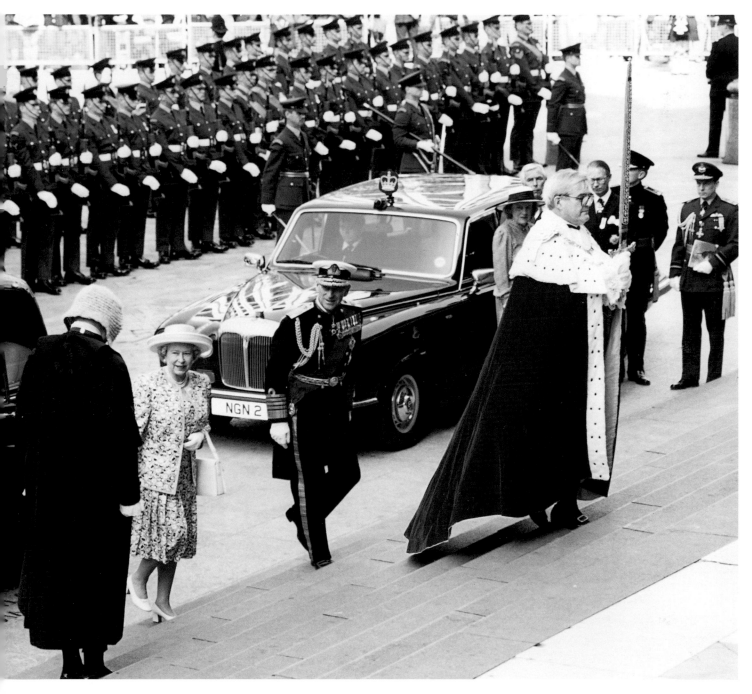

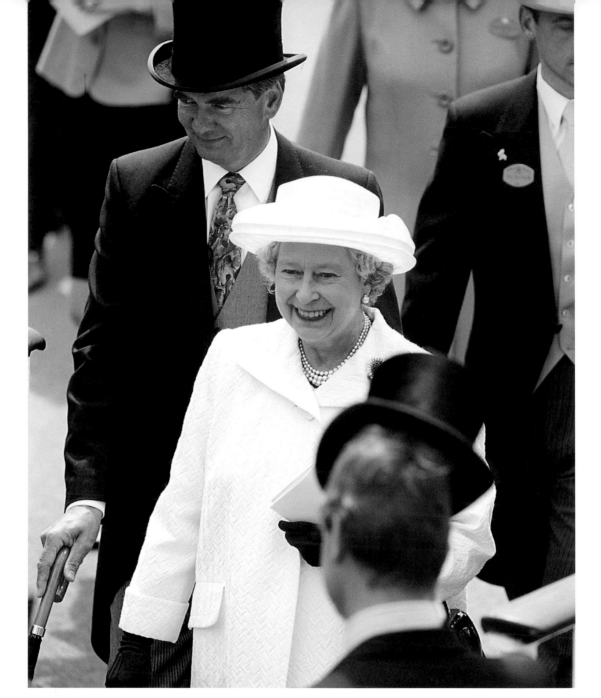

RIGHT AND BELOW: *Although security for the Queen is essential, it is her wish that it should appear as low key as possible. Always at her side is a personal protection officer from the Royalty and Diplomatic Protection Department of the Metropolitan Police. The officer always dresses to suit the occasion – morning dress here, black tie and dinner jacket below, country wear opposite.*

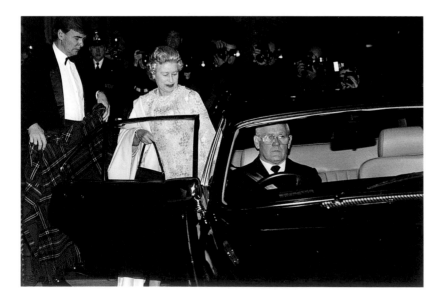

RIGHT: *As she strolls around the Windsor Horse Show every year, the Queen goes mostly unnoticed. Her choice of headscarf, tweeds and sensible shoes is a 'uniform' common to most of the spectators. Her protection officer is one step behind.*

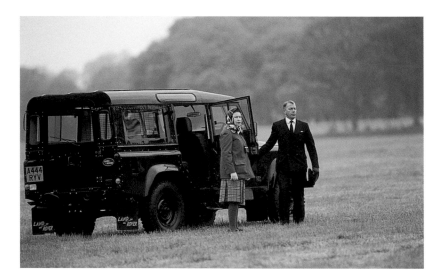

RIGHT: *The Queen emerges from the shiniest of Land Rovers as her chauffeur, cap in hand, holds the door for her in Windsor Great Park, May 1985.*

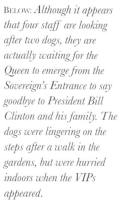

BELOW: *Although it appears that four staff are looking after two dogs, they are actually waiting for the Queen to emerge from the Sovereign's Entrance to say goodbye to President Bill Clinton and his family. The dogs were lingering on the steps after a walk in the gardens, but were hurried indoors when the VIPs appeared.*

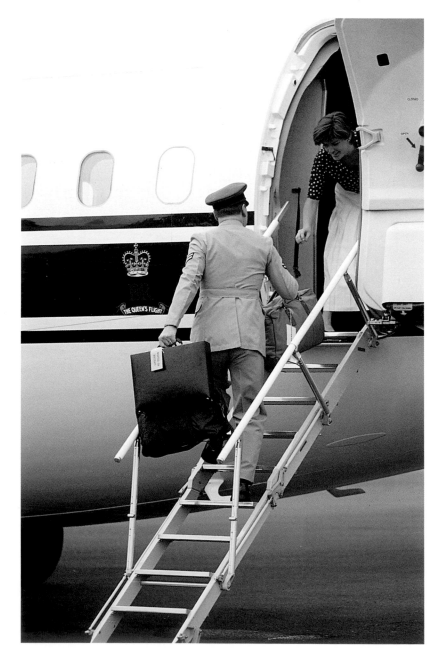

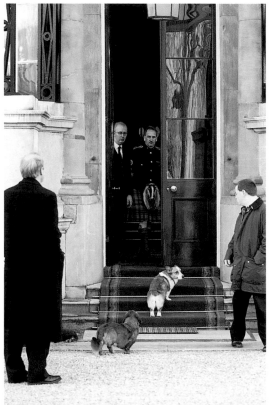

LEFT: *Loading hand luggage on to the Queen's flight. The label bears the legend 'Wanted on Aircraft'. The team behind the Queen makes sure nothing is left to chance or on the airport tarmac.*

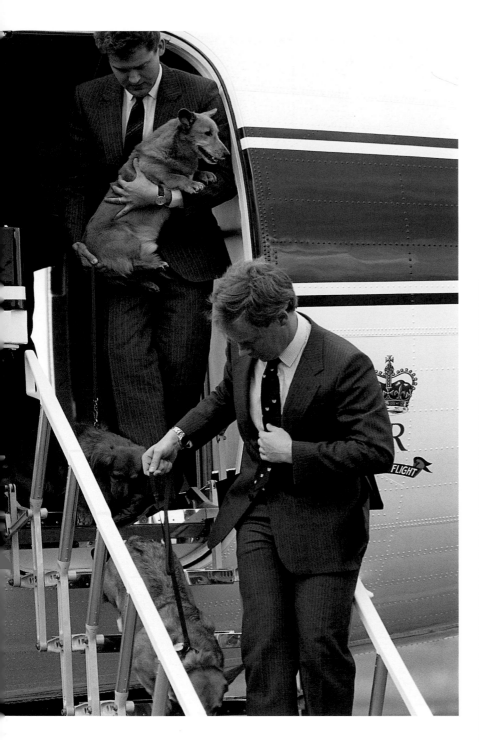

ABOVE: *The corgis are escorted off the royal flight at Heathrow at the end of the Queen's holiday in Scotland. Although they have large dog tags, they are also fitted with microchips so that they can be reunited with the Queen if they stray too far. At the top of the steps is the Queen's footman Paul Burrell, who later became butler to the Prince and Princess of Wales.*

BELOW: *Royal pages on duty at the Derby carry luggage to the Royal Box. Every bag has a colour-coded label with the name of its owner – a simple but efficient system that ensures bags are in the right places at the right time. The Queen's footmen and pages travel with her wherever she goes, and their duties include serving meals, attending to guests and delivering messages.*

LEFT: *The Queen's Private Secretary is one of her most vital appointments. As the Queen's principal adviser and organizer, he is involved in every aspect of her life. His role involves liaison at the highest levels of Government and Commonwealth, and he is trusted with many secrets. Here Sir Robin Janvrin, the seventh Private Secretary of the Queen's reign, guides her in Alderney during a visit to the Channel Islands in 2001.*

LEFT: *At the state banquet in the royal palace at Oslo in Norway, Sir Robin Janvrin is ready with the speech that he and the Queen have prepared together.*

There are different ranks of ladies-in-waiting. Most senior is the Mistress of the Robes (usually a duchess). Below her are two ladies-of-the-bedchamber (usually the wives of a marquess or earl), and below them are women-of-the-bedchamber.

ABOVE: *Lady Dugdale, whose official title is Woman-of-the Bedchamber, acts as lady-in-waiting to the Queen in Portsmouth in August 1996 as she arrives to board* Britannia *for her cruise in the Western Isles. Ladies-in-waiting are personal friends of the Queen.*

RIGHT: *In 1989 the-then Lord Chamberlain, the Earl of Airlie, accompanied the Queen and Prince Philip at a Buckingham Palace garden party. In his role as head of the Royal Household, the Lord Chamberlain supervises state visits, royal weddings, garden parties and ceremonial events. Lord Airlie's wife, Virginia, is a lady-of-the-bedchamber to the Queen.*

BELOW: *The Queen's Equerry, Major Hugh Lindsay, accompanies her on a visit to Oporto, Portugal, in 1985. Tragically, Major Lindsay was killed in an avalanche when skiing with Prince Charles and others in Switzerland. The equerry is always a serving officer selected in rotation from one of the three armed services.*

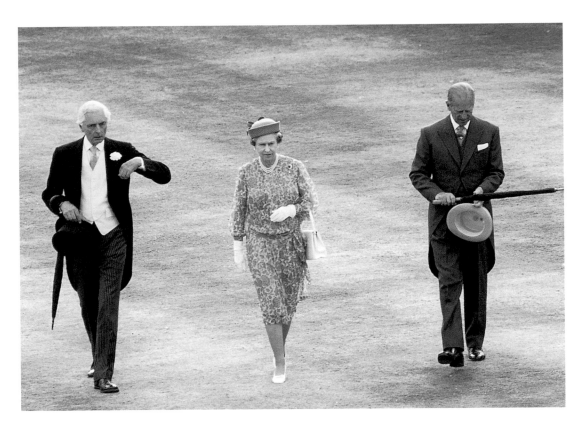

RIGHT: *An armed policeman trying to be unobtrusive at Royal Ascot. There are three levels of security surrounding the Queen: her own personal protection officer, a team of plain-clothed policemen as back-up and then uniformed police at each venue.*

BELOW: *Wherever the Queen travels, her doctor goes too. In China, Surgeon Commander Dr Norman Blacklock was the Queen's Physician. He is qualified to deal with anything from sunburn to emergency surgery.*

Free Time

ALTHOUGH THE QUEEN has several long holidays every year – at Christmas, Easter and during the summer – she actually has only two days completely free of work: Christmas Day and Easter Sunday. On every other day of the year she has to do the Red Boxes, which contain Cabinet and ministerial papers that she must read and approve. It is thanks to this workload that the Queen has such a good knowledge of national and international affairs, but there must be many times when the ever-present boxes (even on overseas tours) feel like a wearisome burden.

How, then, does the Queen relax and get away from the concerns of State? A typical day at Balmoral might mix business and pleasure. While she is breakfasting, her piper will play outside for about 15 minutes, then at 9.30 she might receive her private secretary. By 10.15 she is at the stables and will ride for an hour, accompanied by a female groom. Then it is back to the Red Boxes until lunch. At 12.45 she will greet guests, and quite often entertain them at a picnic lunch. She will walk back with the dogs and work again until teatime, when she herself will pour tea for her guests. Very often after dinner she will relax by playing patience.

Inevitably, her family is extremely important to her and she supports them in all their endeavours. Like many a parent, she has spent hours watching her sons and daughter indulging in their particular interests – polo and three-day eventing among them – and also watched her husband taking part in carriage-driving and yachting competitions.

In a family of fishing enthusiasts, the Queen stands apart because she sees little pleasure in being waist-deep in cold rivers. However, she does enjoy deer-stalking when at Balmoral, and is happy to accompany shooting parties – and wring the necks of pheasants – although she never actually shoots anything herself.

While the Queen is well used to hordes of photographers vying to take her picture and catch her in unguarded moments, she is no stranger to the other side of the camera. In fact, she is a keen pho-

tographer and has a fascinating collection of family photos, and many albums of shots she has taken on overseas tours. Only rarely are these photos seen outside the family.

Another hobby in which the Queen is very hands-on is jigsaws. She and Princess Margaret have long been members of the British Jigsaw Puzzle Library and enjoy borrowing their large and difficult puzzles, which they piece together over several weeks, particularly around Christmas-time.

As her activities show, the Queen is both a highly public and intensely private figure. Whether driving herself in a trusty Land Rover, striding about the countryside in a headscarf or even doing a spot of pigeon fancying (an activity she indulges in at Sandringham), she is at once the dignified sovereign, but also the warm-hearted mother and sensible countrywoman.

ABOVE: *Some are surprised that the Queen drives herself. She remained loyal to her old Vauxhall for many years.*

BELOW: *Walking with her corgis and dorgis at Windsor.*

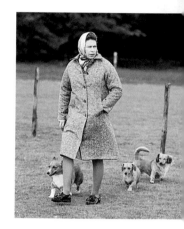

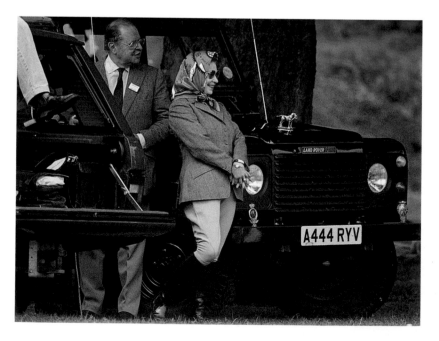

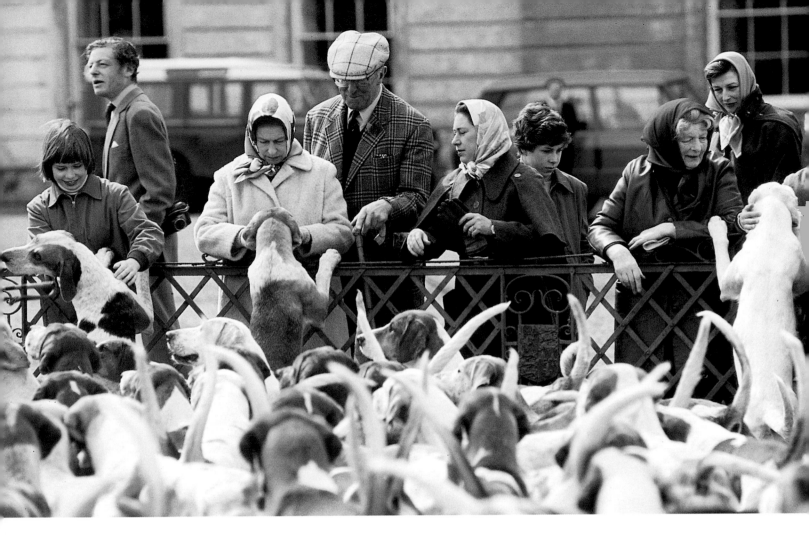

ABOVE: *The 10th Duke of Beaufort and his wife show their royal houseguests the foxhounds on their estate at Badminton in April 1977.*

BELOW: *Riding her favourite horse, Burmese, at Windsor. The Queen has resisted advice to wear a protective riding hat, opting instead for a favourite headscarf.*

RIGHT: *The Queen laughs with Countess Andrassy, who puts an arm round her shoulder. When Prime Minister Paul Keating of Australia put his arm round the Queen there was a rather unnecessary outcry in the British press. It was, after all, a welcoming gesture. Nonetheless, I have only ever taken a handful of pictures of anyone touching the Queen: four of them are in this book.*

OPPOSITE, BOTTOM: *The Queen in jodhpurs watches Prince Philip competing in the cross-country phase of the Windsor Horse Show. Next to her stands Count Andrassy, a relative of Prince Philip's, who had been invited to the house party that the Queen hosts over the four days of the event.*

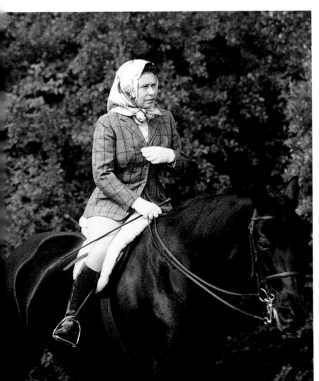

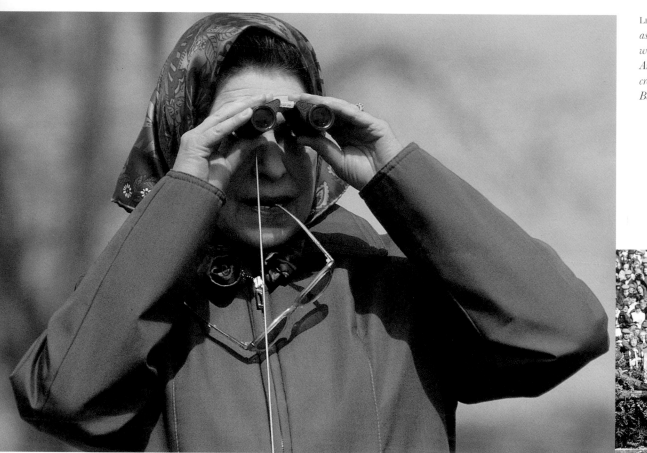

LEFT AND BELOW: *As anxious as any mother, the Queen watches her daughter Princess Anne tackle the challenging cross-country jumps at the Badminton Horse Trials.*

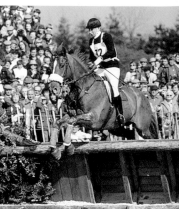

LEFT: *A shopping trip among the stalls at Windsor. One can never have too many gloves…*

BELOW: *Until we arrived in a press Land Rover at the water obstacle section of the carriage-driving championships, no one in the crowd of spectators realized that the Queen was among them, waiting to see her husband compete.*

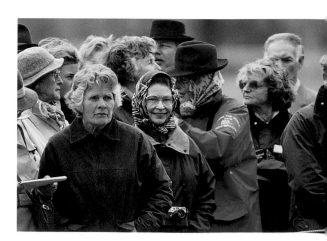

A quiet moment between husband and wife before Prince Philip takes his turn in the dressage section of the International Driving Grand Prix at Windsor in May 1982. The Prince takes his competing seriously: in 1975 he became a member of the British Carriage-Driving Team, and in 1980 he won the International Gold Medal.

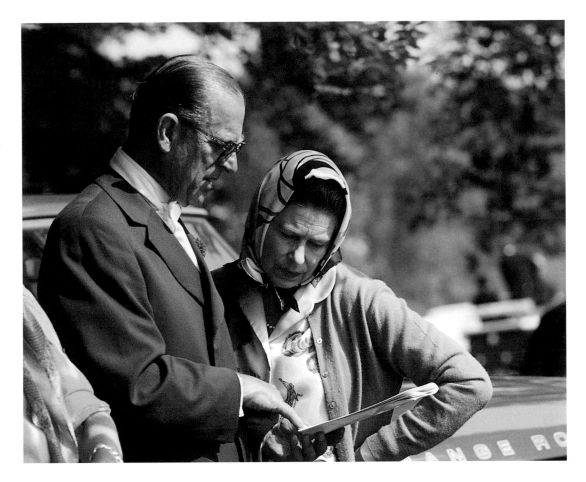

BELOW: *Prince Philip and his team yell encouragement to the horses as they negotiate the water obstacle.*

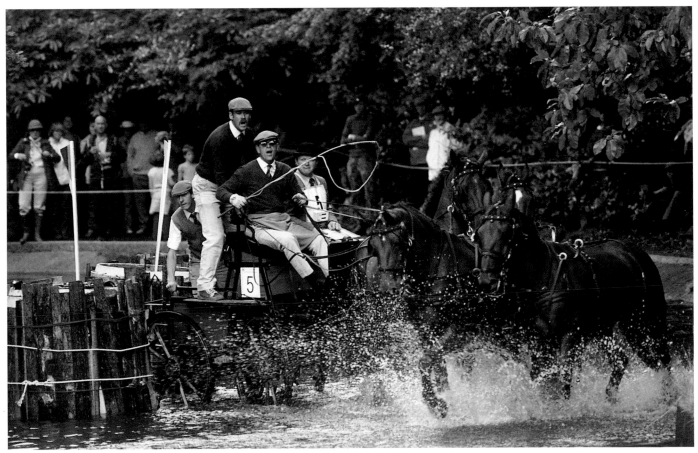

Line of Descent of Queen Elizabeth II

CERDIC, first king of the West Saxons (d. 534)
|
Crioda
|
CYNRIC (d. 560)
|
CEAWLIN (d. 591)
|
Cuthwine
|
Cuthwulf
|
Ceolwald
|
Cenred, under-king of Sussex (d. 692)
|
Ingild (d. 718), brother of King Ine
|
Eoppa
|
Eaba
|
Ealhmund, under-king of Kent (d. 786)
|
EGBERT (d. 839) = Redburh
|
ETHELWULF (d. 855) = Osburh
|
ALFRED THE GREAT (d. 899) = Ealhswith
|
EDWARD THE ELDER (d. 924) = Edgiva
|
EDMUND I (d. 946) = Elgiva
|
EDGAR (d. 975) = Elfrida
|
ETHELRED THE UNREADY (d. 1016) = Elfreda
|
EDMUND IRONSIDE (d. 1046) = Ealdgyth
|
Edward Athling (d. 1057) = Agatha
|
St Margaret (d. 1093) = Malcolm III of Scotland

WILLIAM I (the Conqueror, d. 1087) = Matilda of Flanders

HENRY I (d. 1135) = Matilda
|
Matilda (d. 1167) = Geoffrey Plantagenet, Count of Anjou
|
HENRY II (d. 1189) = Eleanor of Aquitaine
|
JOHN (d. 1216) = Isabelle of Angoulême
↓

HENRY III (d. 1272) = Eleanor of Provence

EDWARD I (d. 1307) = Eleanor of Castile

EDWARD II (d. 1327) = Isabella of France

EDWARD III (d. 1377) = Philippa of Hainault

John of Gaunt, Duke of Lancaster (d. 1399) = Catherine Swynford

Edmund, Duke of York (d. 1402) = Isabel of Castile

John Beaufort, Marquess of Dorset (d. 1410) = Margaret Holland

Richard, Earl of Cambridge (d. 1415) = Anne Mortimer

John Beaufort, Duke of Somerset (d. 1444) = Margaret Beauchamp

Richard, Duke of York (d. 1460) = Cecily Neville

Margaret Beaufort = Edmund Tudor, Earl of Richmond

EDWARD IV (d. 1483) = Elizabeth Woodville

HENRY VII (d. 1509) = Elizabeth of York

James IV of Scotland (d. 1513) = Margaret Tudor

HENRY VIII (d. 1547) = Anne Boleyn

James V of Scotland (d. 1542) = Mary of Lorraine

ELIZABETH I (d. 1603)

Mary, Queen of Scots (d. 1587) = Henry Stuart, Lord Darnley

JAMES I (d. 1625) = Anne of Denmark

Elizabeth Stuart (d. 1662) = Frederick, King of Bohemia

Sophia (d. 1714) = Ernest Augustus, Elector of Hanover

GEORGE I (d. 1727) = Sophia Dorothea of Celle

GEORGE II (d. 1760) = Caroline of Brandenburg-Anspach

Frederick Lewes, Prince of Wales = Augusta of Saxe-Gotha

GEORGE III (d. 1820) = Charlotte of Mecklenburg-Strelitz

Edward, Duke of Kent = Victoria of Saxe-Coburg-Saalfeld

VICTORIA (d. 1901) = Albert of Saxe-Coburg-Gotha

EDWARD VII (d. 1910) = Alexandra of Denmark

GEORGE V (d. 1936) = Mary of Teck

GEORGE VI (d. 1952) = Lady Elizabeth Bowes-Lyon

ELIZABETH II = Prince Philip, Duke of Edinburgh

Index

First published in Great Britain in 2002 by Cassell & Co

Text copyright © 2002 Patricia Burgess & Tim Graham
Photos copyright © 2002 Tim Graham, apart from those
specified in the picture credits (right)
Design and layout © 2002 Cassell & Co

A CIP catalogue record for this book is available from
the British Library.

ISBN: 0 304 36230 1

Design Director: David Rowley
Design: Nigel Soper
Jacket design: Chris Shamwana
Additional picture research: Caroline Wood
Index: Tarrant Ranger Indexing
Printed and bound in Italy

Cassell & Co
Wellington House
125 Strand
London WC2R 0BB

Picture credits

All photographs by Tim Graham, including:
Tim Graham/*Daily Mail* 184 t, 185, 188 t, b, 189 t, bl,
br, 190, 191 cl, bl, br, 192 t, b, 193 t, b, 212 tl, back jacket
2nd l; Tim Graham/Hulton Archive 47 bl, 50-1, 120 t,
br, 232, 328-9

Non-Tim Graham photographs:
Cecil Beaton/Camera Press 8 tr, 27, 210 t; Tom
Blau/Camera Press 32; Camera Press 15, 30-1; Hulton
Archive 1, 8 tc, tl, 9 tl, ct, tr, 10 tl, 16 t, b, 17, 28 t, b, 29
tl, 33 t, b, 118 tl, 208 t, 210 b, 211 b, 244-5; Patrick
Lichfield/Camera Press 10 ct, 211 t; *The Times*/Camera
Press 29 tr, b

Tim Graham's photographs are available worldwide at:
www.corbis.com
And in the UK at:
timgraham.co.uk or royalpix.com

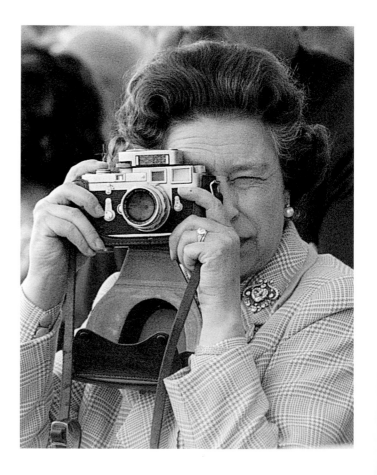

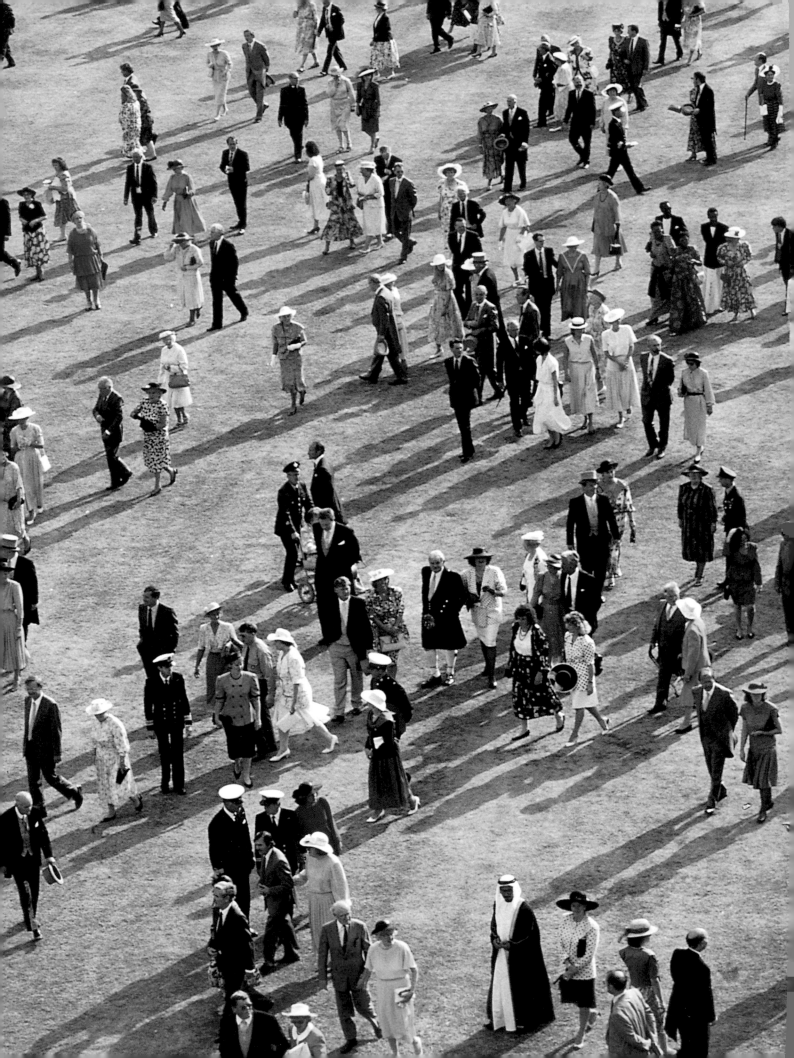